HISTORY of ART

Publisher and Creative Director Nick Wells
Project Editor Sarah Goulding
Designer Mike Spender

This is a **STAR FIRE** book

First published in 2005

05 07 09 08 06
1 3 5 7 9 10 8 6 4 2

STAR FIRE BOOKS
Crabtree Hall, Crabtree Lane
Fulham, London SW6 6TY
www.star-fire.co.uk

Star Fire is part of The Foundry Creative Media Company Limited

Copyright © 2005 The Foundry

A CIP record for this book is available from the British Library.

ISBN 1 84451 329 7

Printed in China

HISTORY of ART

From the Middle Ages to Renaissance, Impressionism and Modern Art

STAR FIRE

Contents

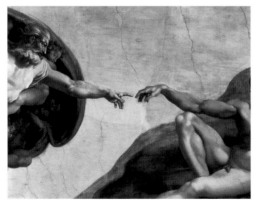
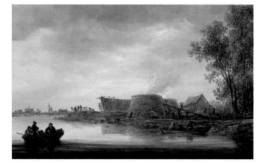
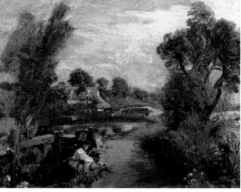

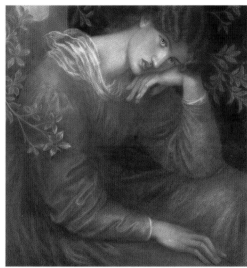
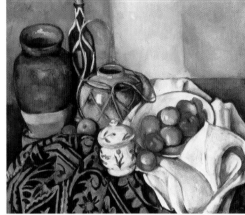
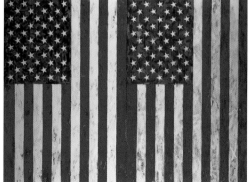

Introduction

For most people, the process of viewing something aesthetically pleasing can be a momentarily life-enhancing experience. The same people might also feel that there is a big difference between looking at a painting for its own sake, and accepting the concept of art as a medium conveying a set of intellectual theories and arguments. Many would ask why should we bother with art? The enjoyment provided by the visual is an acceptable motivation in itself. However, it does not tell us very much about anything – after all, sweets can provide enjoyment too. Unlike sweets, though, art has the potential to enrich life in a manner that goes well beyond mere enjoyment, agreeable décor or a more superficial gratification through popular imagery. Moreover, because the art of our own time often simply reaffirms our own values and expectations, being familiar with the art of other times and places is a useful portal into the aesthetics, ideologies, morals, philosophies, politics and social customs of others. This familiarity, in turn, may well invite us to question our own ideologies and social customs; in fact, much art was never meant to be enjoyed at all, in the common sense of the word. Art's most fundamental importance is therefore not as décor but as an avenue of intellectual communication. This makes insight into art an invaluable part of an advanced comprehensive education.

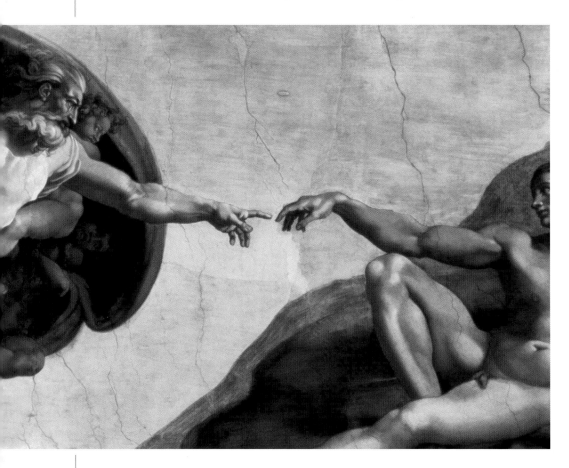

For a long time there was little doubt that one of the higher expressions of a culture was its advanced visual art. For the layperson, the word 'Renaissance' remains to this day more likely to conjure up the works of Leonardo da Vinci and Michelangelo than those of, for example, the composers Heinrich Isaac and Jasquin des Préz. However, it is difficult to say the same of the visual art of our own time, unless we are speaking specifically of the mass media. With a few notable exceptions, such as Picasso, modern and contemporary art is much less likely than that of the Renaissance to spring to the average person's mind as an example of their own culture's higher accomplishments. For the purposes of this book, when we talk about art we are really referring to paintings, since for most laypeople, paintings act as their first serious introduction into art interpretation, and for many it is the medium that they find most accessible.

The History of Art

Humankind has made images and marks since the dawn of time. Art predates history, as well as the current notion of what constitutes art. What we think of as art tends to be that art produced by urban civilizations, and more specifically, western urban civilizations. With the creation of the first art museum – the Louvre in Paris – a new world of art emerged that would establish a western hegemony on the idea of art and export it to the world. The 200 years since can rightfully be called the age of art museums, even though artists of the modern age would consistently rage against them, calling them irrelevant and anachronistic.

The world is a big place and art has increasingly taken on proportions unimaginable to the first art historians, leaving a daunting task to those who wish to revise that history, or add to it. One can liken art in the world to the presence of water, its properties and actions, as water covers much of our world. The earliest cartographers were obsessed with the outline, and circumnavigation was the best way to determine the shape of a landmass. So, too, for the obsession of art historians. Much of art has been mapped through individuals, forming schools and movements of type and style, and so the mapping approach of this book has been by chronology, stratified by regions of activity. Events and information accumulate faster than our ability to provide historical perspective, and the same is true for the world of art. As the American George Kubler has said, the role of the art historian is to uncover the shape of time – cultural activity that is only known to us by the things we make, or the things that survive. That is what this book attempts to explore in the seven sections explained here.

The Gothic & Medieval Era

It was the art historian and pupil of Michelangelo, Giorgio Vasari, who coined the term 'Gothic' to describe the art and architecture of the Middle Ages, assuming that this style had originated with the Goths, the Teutonic barbarians

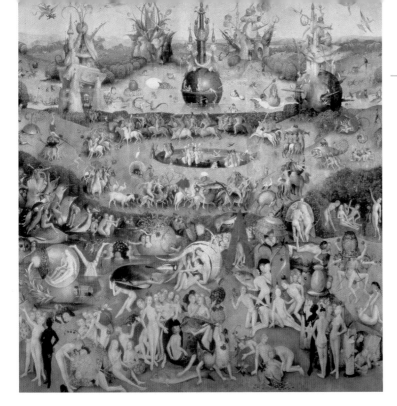

The Baroque & Rococo Era

The French word for 'irregular', Baroque was applied to a style in art and architecture very fashionable in the seventeenth century and distinguished by extravagant forms and ornamentation which became so elaborate as to verge on the grotesque. Indeed, in its more extreme form it described a style of decorative art allegedly derived from caves and grottoes and characterized by fantastic human or animal forms merged with natural motifs. A new naturalism would later lead to greater realism and the vogue for landscapes in the eighteenth century. Rococo, fashionable in the same period, is an Italian term derived from the French *rocaille* ('rock work'), a word that describes the shell work decorating grottoes and rockery dells in French gardens in the late seventeenth and early eighteenth centuries. The new style, with its asymmetrical curves, lightness and frivolity captivated the French and spread rapidly to Italy and other parts of western Europe. It reflected the spirit of the age, when beliefs in religious dogma and the divine rights of kings were constantly being challenged. In painting it was reflected in the love of nature and the rise of the landscape, but it also impacted on the great allegorical compositions – especially ceilings and murals.

who attacked the Roman Empire. Gothic thus came to represent the opposite of Classic (the art that derived from Greece and Rome). Strange as it may seem, Vasari's theories were not dismissed until the nineteenth century, and the label Gothic has remained to describe the fantastic spires and grotesque ornament of cathedrals, as well as the style in stained glass, tapestry and the applied arts. It found expression in the fine arts of the fourteenth and fifteenth centuries, mainly through the medium of the richly illuminated books of hours and other devotional works. The finest exponents of this art were the three brothers – Pol, Hermann and Janneken Malouel from Limbourg in Flanders (now Belgium) – who flourished around the end of the fourteenth century and executed many fine miniature paintings for Philip the Bold and his brother John, Duke of Berri. Pol studied in Italy and his style reflects the influence of contemporary artists there.

The Renaissance Era

Renaissance, a French word meaning 'rebirth', alludes to the humanistic revival of the Classical influence in western Europe in the fourteenth to sixteenth centuries. Although the fall of Constantinople in 1453 and the consequent flight of the intellectuals to the west is often cited as the starting point of the Renaissance, the 'rebirth of learning' had begun several generations earlier as Arab arts and crafts filtered through Spain. It was marked by an unprecedented flowering of the arts and literature as well as the beginning of modern science. In the fields of the fine arts and architecture, the Renaissance had its greatest impact in Italy. Significantly it was in the great mercantile centre of Florence, rather than in the religious centre of Rome, that the movement developed initially, and it was in the liberal world of the merchant princes that the new art flourished most vigorously. Wealthy patrons like the Medici, Sforza and Strozzi families encouraged the art of da Vinci and Michelangelo. The term 'Renaissance man', denoting a person of wide interests and expertise, was never truer than when applied to Leonardo da Vinci, who excelled as a sculptor, architect, inventor and military engineer, as well as painter.

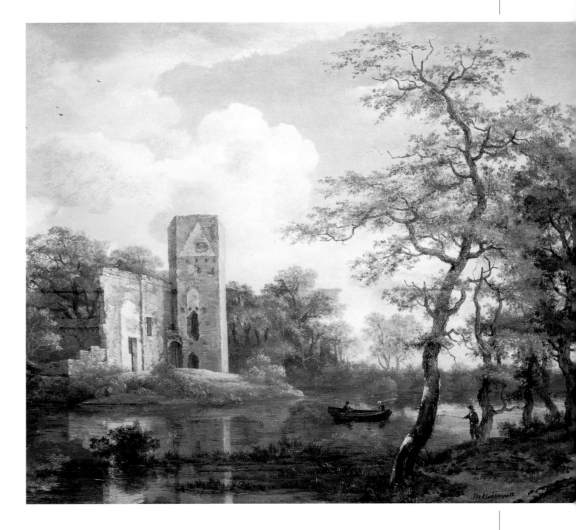

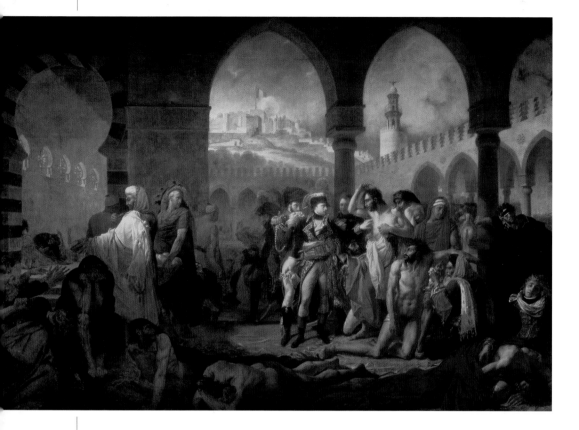

The Impressionists took ordinary subjects and used colour to illustrate the play of light and shadow on surfaces to suggest rather than delineate faithfully what they saw. In its heyday, between the late 1860s and about 1879, Impressionism was a remarkable revolution against Classicism, seeking to achieve immediacy and spontaneity, playing on the emotions as much as the imagination to achieve results. It lingered on fitfully until the end of the century, spawning offshoots such as the Neo-Impressionism of Pissarro and the Pointillism of Seurat, but most of its practitioners moved on to Post-Impressionism.

The Post-Impressionist Era

On the fringe of Impressionism was Paul Cézanne, who felt uneasy at the lack of discipline in this style and wished to return to a greater reliance on form and content without sacrificing the feeling for light and brilliant colours. Out of this evolved Post-Impressionism, a term that originally meant merely 'after Impressionism', but which became the springboard to all the varied 'isms' that that come under the heading of modern painting and which, accordingly, are described in the final section. Apart from Cézanne, the leading Post-Impressionists included Georges Seurat. Neither of them was particularly concerned with the emotional content of their paintings, but this was the principal feature of the lithographs and paintings of Henri de Toulouse-Lautrec and the works of Van Gogh and Gauguin.

The Neoclassic & Romantic Era

The discovery of the ruins of Pompeii in 1748 triggered off an interest in, and enthusiasm for, the antiquities of Greece and Rome. This was given direction by the German archaeologist and art historian Johann Joachim Winckelmann, who argued that beauty depended on calmness, simplicity and correct proportion, the complete antithesis of the Rococo, which was then at the height of fashion. Neoclassicism was an almost inevitable reaction to the frivolity of Rococo, and it was given a political dimension when it became the preferred style in France in the aftermath of the Revolution. A reaction against the sterile academic disciplines of Neoclassicism came towards the end of the eighteenth century with Romanticism, which began as a literary and philosophical movement and soon involved the fine arts. Individual aspirations, feelings, emotion and atmosphere were all emphasized, with the remote, the rugged and the exotic celebrated. The works of the great classical authors were out; the plays of Shakespeare, the poetry of Byron and the novels of Scott were in, as painters such as Delacroix, Gros, Caspar David Friedrich, Constable and Turner documented man's puny struggle against the forces of nature.

The Impressionist Era

The term impressionism was coined by the journalist Louis Leroy in 1874 and used in an article in the satirical magazine *Charivari* to attack the paintings of Claude Monet, which were exhibited that spring. The term derived, in fact, from one of Monet's canvasses simply entitled *Impression: Sunrise*, leading the critic to dismiss it as 'an impression of nature, nothing more'.

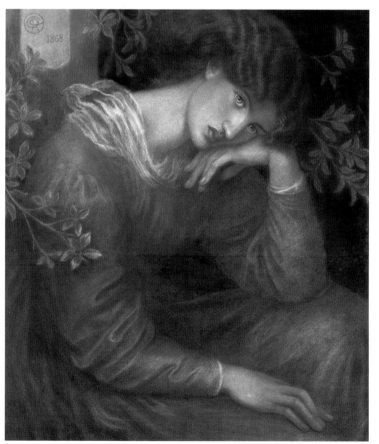

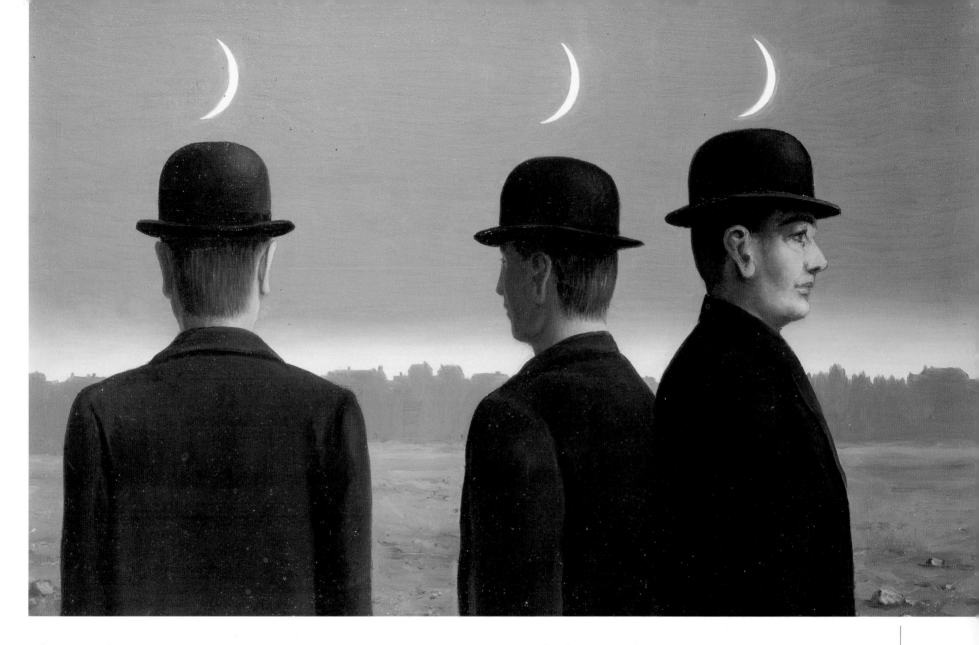

The Modern Era

Modernism is a general term used to cover a multiplicity of movements seen in retrospect as working towards comparable ends. As the twentieth century gathered pace, so society began to change ever more quickly. New art styles and movements appeared and disappeared equally rapidly, from Fauvism and Expressionism to Cubism and Surrealism, Abstract Art, Pop Art and Post-Modernism. The advent of photography removed the need for artists to represent faithfully what they saw, giving rise to new forms of expression using myriad new and experimental techniques. Boldness and self-confidence were the keys to the artistic revolutions of the early twentieth century. The colourful abandon of the Fauvists, the staggering boldness of Cubism, the absurdity of Dada, the simplicity of De Stijl – developments like this were born of a deep conviction that it was up to art to define humanity's relation to its world. In many ways a history of modern art equates to a history of the twentieth century, with artists such as Matisse, Picasso, Kandinsky and Mondrian playing prominent roles. These artists and many others redefined what it was for the individual to perceive, to think, to be. Understanding modern art, if indeed it can or is meant to be 'understood', is not just about reading its history or precedents but more about engaging with an ethos.

How To Read This Book

The reader is invited to use this book in any way they see fit. We do, however, ask them to keep in mind that its final purpose is to see art as a way to exercise our hearts, imaginations and minds – not only to expand our knowledge of others' ideologies and social customs but also to question our own. These poles of respect and critique provide the parameters within which this book will achieve its purpose.

You may find that you end up reading this book, or at least sections of it, more than once. Dipping into the entries selectively will allow you to be drawn into the subject of art through the artists, or pieces, that most appeal to you. Finally, don't think of the book's selection of works as the final word on the subject – art history's canonical 'greatest hits', as it were. Think of them instead as exercises to prepare you for the great adventure of art – to explore a world that could never be encapsulated within the covers of one book.

Dr Robert Belton

HISTORY OF ART

The Gothic
& Medieval Era

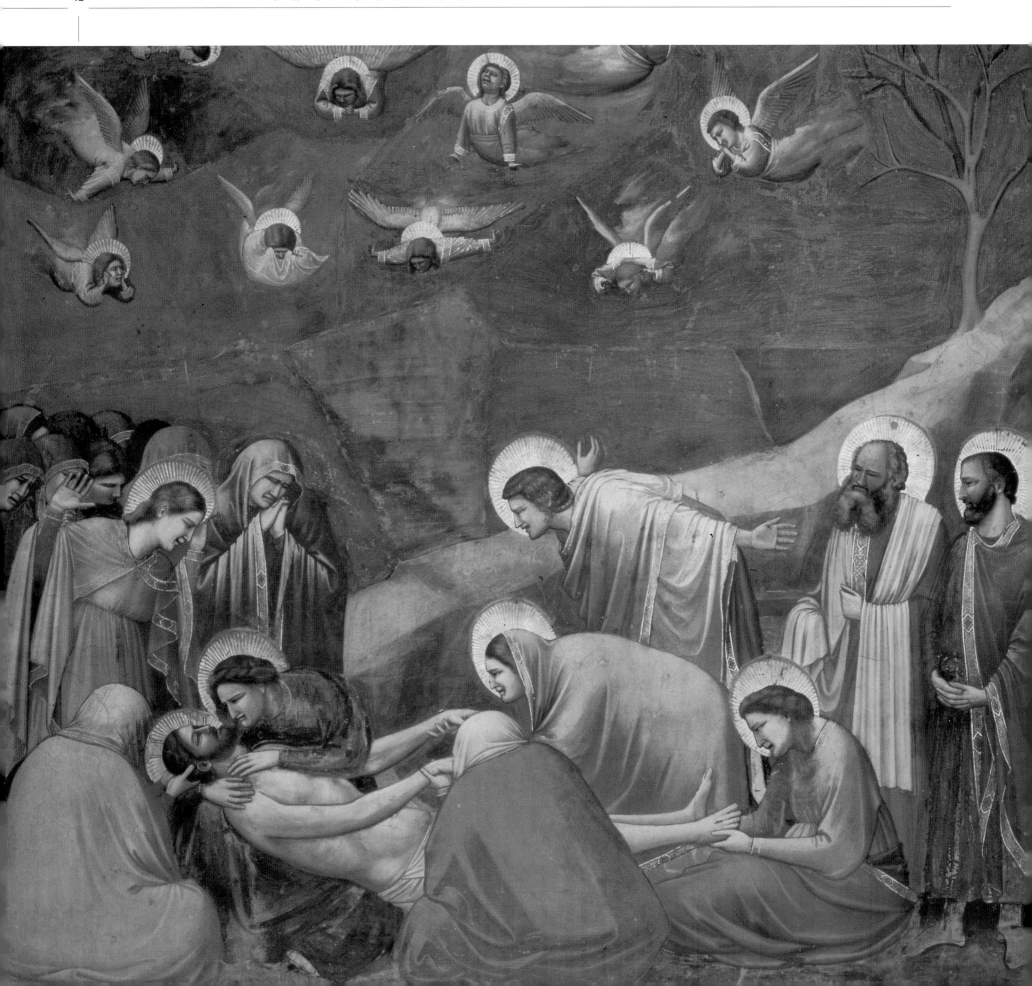

Giotto (Giotto di Bondone)
Lamentation of Christ, c. 1305

Courtesy of Scrovegni (Arena) Chapel, Padua, Italy/Bridgeman Giraudon

One of the founding fathers of the Renaissance, Giotto was revered by early
commentators as the greatest artist since antiquity, and it is clear that he was still
influencing painters more than a century after his death. His greatest achievement was to
rid Italian art of the repetitive stylizations deriving from Byzantine painting. In the process,
he became one of the first Western artists to stamp his own personality on his work. In
particular, Giotto displayed an unparalleled degree of naturalism, both in his ability to
depict solid, three dimensional forms and in his grasp of human psychology. He was also a
gifted storyteller, conveying his religious narratives with absolute clarity and simplicity.

The details of Giotto's own life are, however a mystery. There is a tale that his
master, Cimabue, first spotted his talent when he saw him as a shepherd-boy, sketching a
lamb on a slab of rock. This is probably apocryphal, however, and the identification of
Giotto's pictures presents even greater problems. The marvellous frescoes in the Arena
Chapel, Padua, are usually cited as his masterpiece, but most other attributions are hotly
disputed. Even his three signed altarpieces may only be workshop pieces.

Movement Renaissance
Other Works *Arena Chapel Frescos; Madonna and Child; Ognissanti Madonna*
Influences Cimabue, Pietro Cavallini
Giotto *Born c.* 1267. *Painted in* Italy. *Died* 1337

Duccio di Buonisegna
Madonna and Child, c. 1315

Courtesy of National Gallery, London, UK/Bridgeman Art Library

Western art begins with Duccio di Buonisegna, who learned his craft from studying
the illuminated manuscripts created by unknown Byzantine limners. His earliest
recorded work, dating about 1278, was to decorate the cases in which the municipal
records of Sienna were stored. In 1285 he was commissioned to paint a large Madonna
for the church of Santa Maria Novella. This is now known as the Rucellai Madonna,
for centuries attributed to Cimabue. Duccio painted the magnificent double altarpiece
for the Cathedral of Siena, regarded as his masterpiece and one of the greatest paintings
of all time. Many other works documented in the Sienese records have been lost, but
sufficient remain to establish Duccio as the last and greatest of the artists working in
the Byzantine tradition, as well as the founder of the Sienese School, and thus the
progenitor of modern art. In his hands the degenerate painting of the Gothic style was
transformed and the principles of expressive portraiture established.

Movement Sienese School, Italy
Other Works *The Crucifixion; Majestas; Madonna with Three Franciscans*
Influences Byzantine illuminations
Duccio di Buonisegna *Born c.* 1255 Siena, Italy
Painted in Siena and Florence. *Died* 1319 Siena

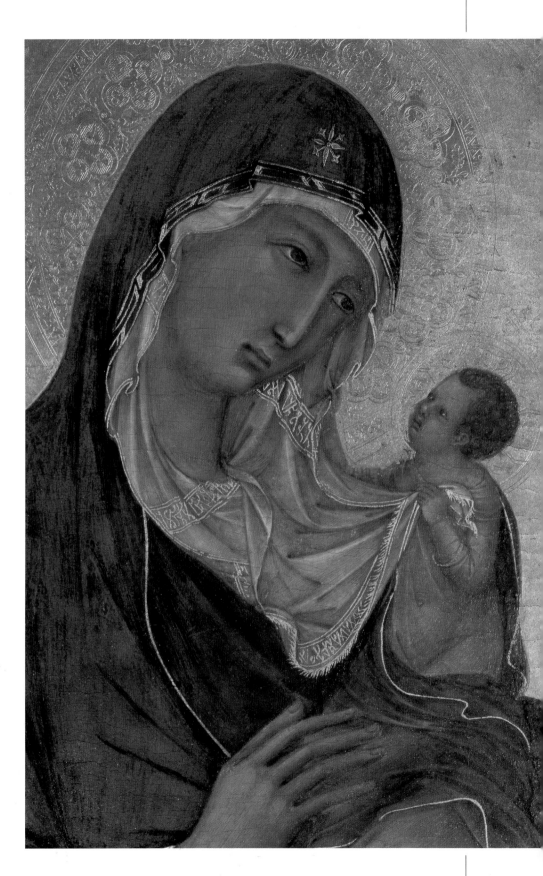

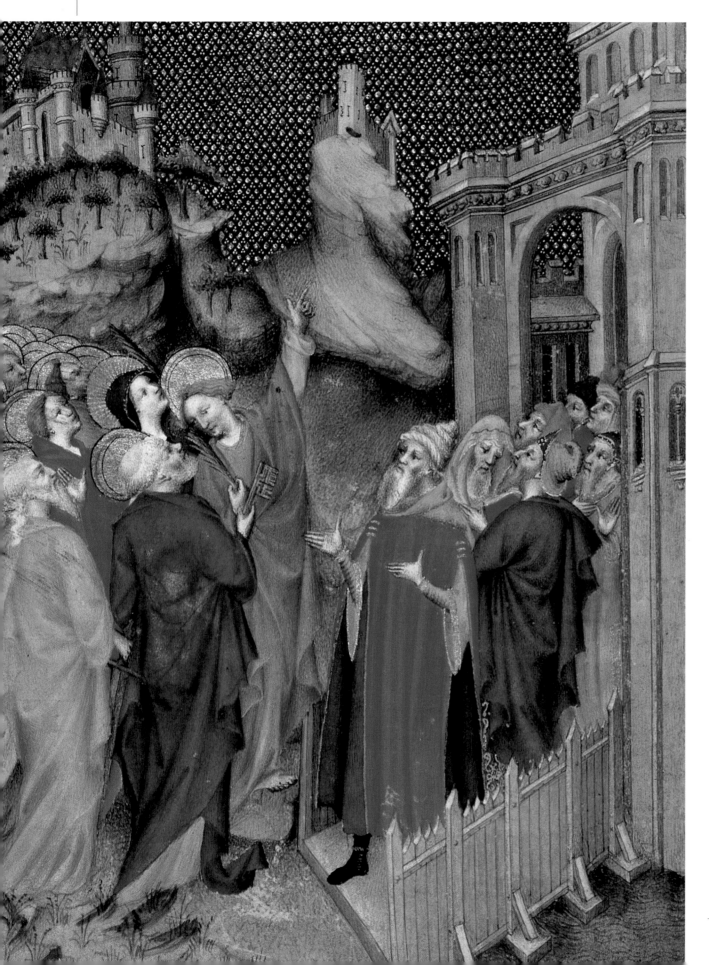

Limbourg Brothers

Breviary of John the Fearless, *c.* 1415

Courtesy of British Library, UK/Bridgeman Art Library

It was the art historian and pupil of Michelangelo, Giorgio Vasari, who coined the term 'Gothic' to describe the art and architecture of the Middle Ages, assuming that this style had originated with the Goths, the Teutonic barbarians who attacked the Roman Empire. Gothic thus came to represent the opposite of Classic (the art which derived from Greece and Rome), and the label has remained to describe the fantastic spires and grotesque ornament of cathedrals, as well as the style in stained glass, tapestry and the applied arts. It found expression in the fine arts of the fourteenth and fifteenth centuries, mainly through the medium of the richly illuminated books of hours and other devotional works. The finest exponents of this art were the three brothers – Pol, Hermann and Janneken Malouel from Limbourg in Flanders (now Belgium and the Netherlands) – who flourished around the end of the fourteenth century.

Movement International Gothic
Other Works *Très Riches Heures du Duc de Berri*
Influences Gentile da Fabriano
Pol, Hermann & Janneken Malouel
Born 1389 Limbourg, Flanders
Painted in France
Died 1416 France

Jan van Eyck
Portrait of Giovanni Arnolfini and Wife, 1434

Courtesy of National Gallery, London,
UK/Bridgeman Art Library

Jan van Eyck settled in Bruges in 1431, where he became the leading painter of his generation and founder of the Bruges School. He and his elder brother Hubert are credited with the invention of oil painting. Van Eyck's paintings have a startlingly fresh quality about them, not only in the dazzling use of light and colour but also in their expression and realism, which was something of a quantum leap in portraiture. Van Eyck was very much a pillar of the establishment, being successively court painter to John of Bavaria, Count of Holland, and Philip the Good of Burgundy. He was equally versatile in painting interiors and outdoor scenes, and exhibited a greater attention to detail than in the works of his predecessors. It is not surprising that he should not only sign and date his paintings but add his motto Als ich kan ('As I can').

Movement Bruges School of Flemish Painting
Other Works *A Man in a Turban*
Influences Hubert van Eyck
Jan van Eyck *Born c.* 1389 Maastricht, Holland
Painted in Maastricht and Bruges
Died 1441 Bruges

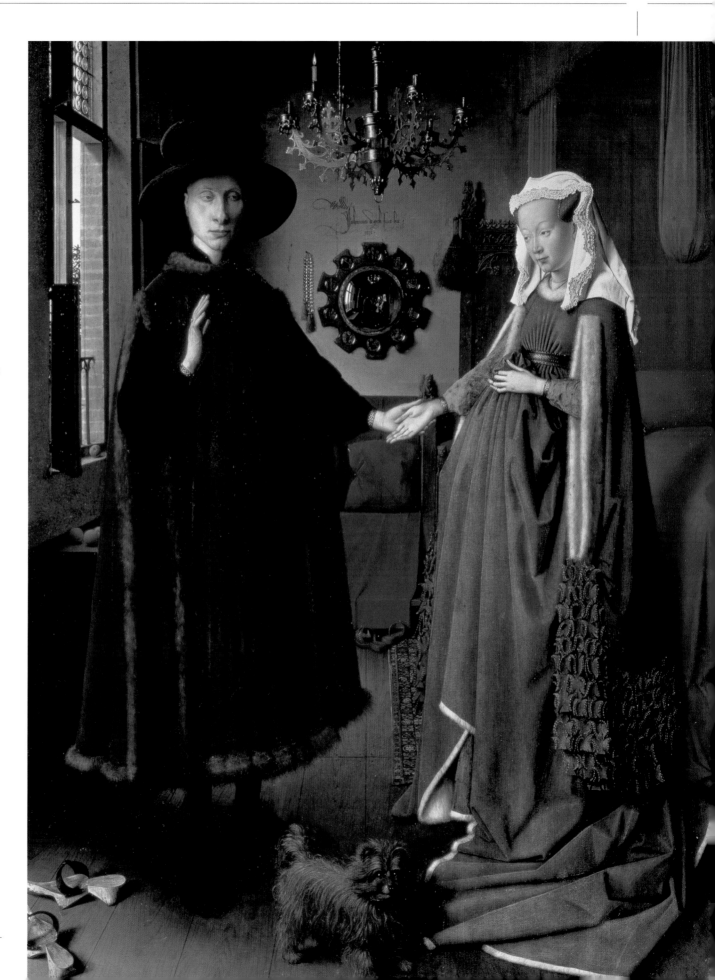

Hans Memling
Adoration of the Magi
(central panel of triptych),
c. 1470

Courtesy of Prado, Madrid, Spain/Bridgeman Art Library

Although born in Germany Memling spent most of his life in
Bruges (now in Belgium), where he was probably a pupil of
Rogier van der Weyden. This is borne out by the great triptych,
whose central panel was painted by Rogier but the wings by
'Master Hans'. Bruges, which had been the commercial centre of
the duchy of Burgundy, was then in decline and it has been said
that Memling's genius alone brought lustre to the city. He was
certainly residing in Bruges by 1463 and four years later enrolled
in the painters' guild. In 1468 he painted the triptych showing
the Virgin enthroned, flanked by the family of the donor, Sir John
Donne, who was in Burgundy for the wedding of Charles the
Bold that year. Although best known for his altarpieces and other
religious paintings, Memling also produced a number of secular
pieces, mostly portraits of his contemporaries. His paintings are
characterized by an air of serenity and gentle piety enhanced by
the use of vivid colours and sumptuous texture.

Movement Flemish School
Other Works *The Mystic Marriage of St Catherine;*
The Virgin Enthroned
Influences Rogier van der Weyden
Hans Memling *Born c.* 1433, Germany
Painted in Bruges, Belgium. *Died* 1494 Bruges

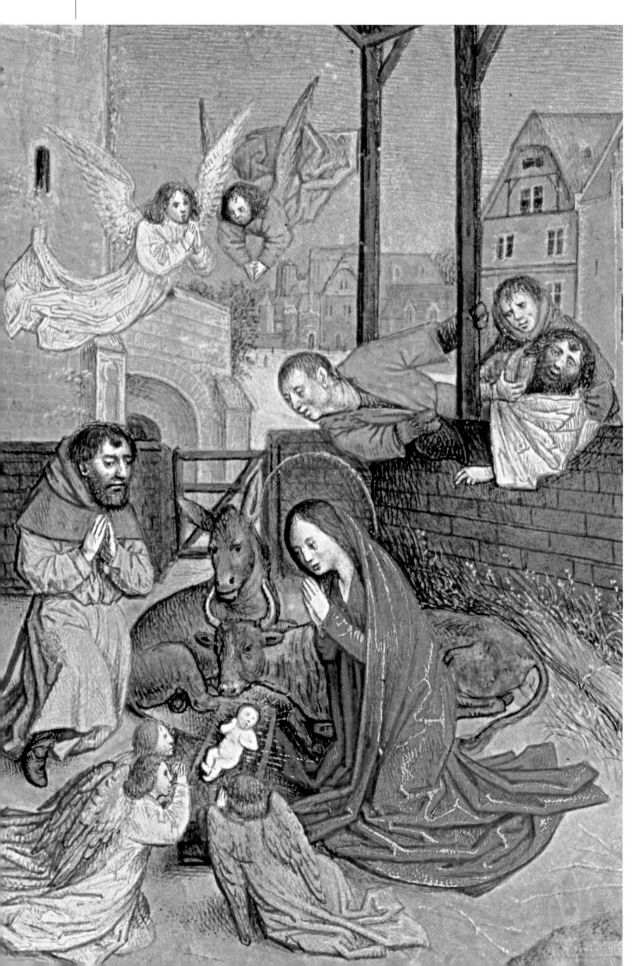

Jean Fouquet
The Nativity, c. 1445

Courtesy of British Library, London, UK/Bridgeman Art Library

The most representative French painter of the fifteenth century, Jean Fouquet originally came under the influence of Van Eyck, but a period in Italy – where he was commissioned to paint the portrait of Pope Eugenius IV – brought him in contact with the new styles emerging in Tuscany. On his return to France he combined the Flemish and Tuscan elements to create a wholly distinctive French style. Highly influential on the succeeding generation of French artists, Fouquet's supreme importance was not fully realized until 1904, when his surviving works were brought together for an exhibition in Paris. His painting combines the skills and precision acquired during his early career as a limner and miniaturist with a new-found expressiveness that places him in the forefront of the painters who could get behind the eyes of their subjects and reveal the underlying character.

Movement French Primitives
Other Works *Virgin and Child; Saint Margaret and Olibrius; Jouvenal des Ursins*
Influences Van Eyck, Piero della Francesca
Jean Fouquet *Born c.* 1420 Tours, France
Painted in France and Italy.
Died c. 1481 Tours, France

Hieronymus Bosch

The Garden of Earthly Delights, (detail) *c.* 1500

Courtesy of Prado, Madrid, Spain/Bridgeman Art Library

Born Jerome van Aken, Hieronymous Bosch was known by the Latin version of his first name and a surname from the shortened form of his birthplace 's Hertogenbosch in North Brabant, where he spent his entire life. He painted great allegorical, mystical and fantastic works that combined the grotesque with the macabre. His oils are crammed with devils and demons, weird monsters, dwarves and hideous creatures, barely recognizable in human form. His quasi-religious and allegorical compositions must have struck terror in the hearts of those who first beheld them, but centuries later he would have a profound influence on the Surrealists. In more recent times there have been attempts to analyse his paintings in Jungian or Freudian terms, the theory being that he tried to put his more lurid nightmares onto his wood panels. This is his best known work, executed on four folding panels, in which he develops the story of the Creation and the expulsion of Adam and Eve. At the core of the work is a vast sexual orgy, symbolizing the sins of the flesh that caused man's downfall.

Movement Surrealism
Other Works *The Temptation of St Anthony;
Last Judgment*
Influences Gothic art
Hieronymus Bosch *Born c.* 1450,
Hertogenbosch, Holland (now in Belgium)
Painted in Hertogenbosch, Holland
Died 1516 Hertogenbosch, Holland

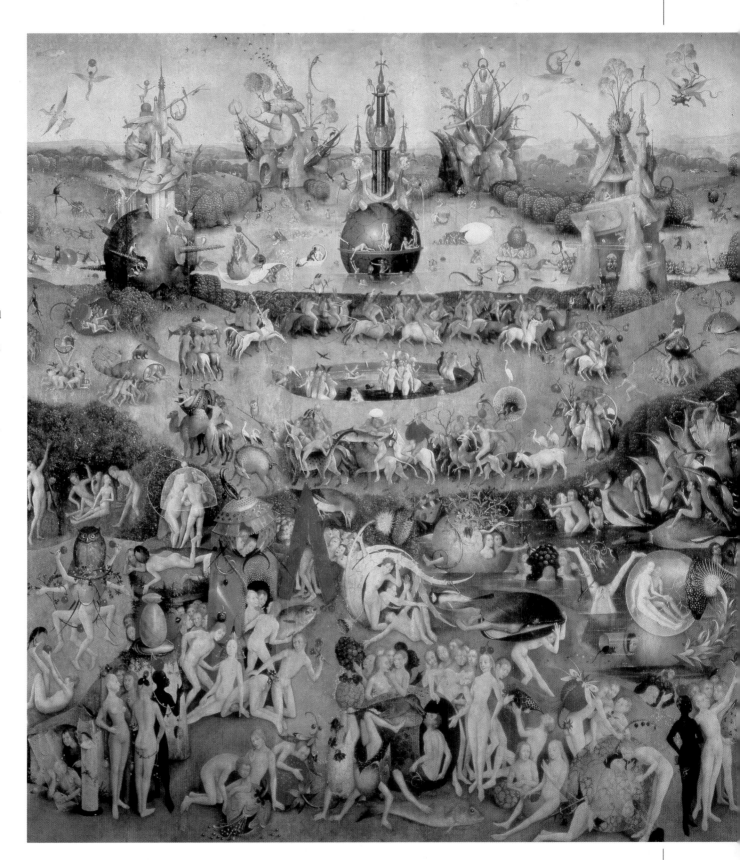

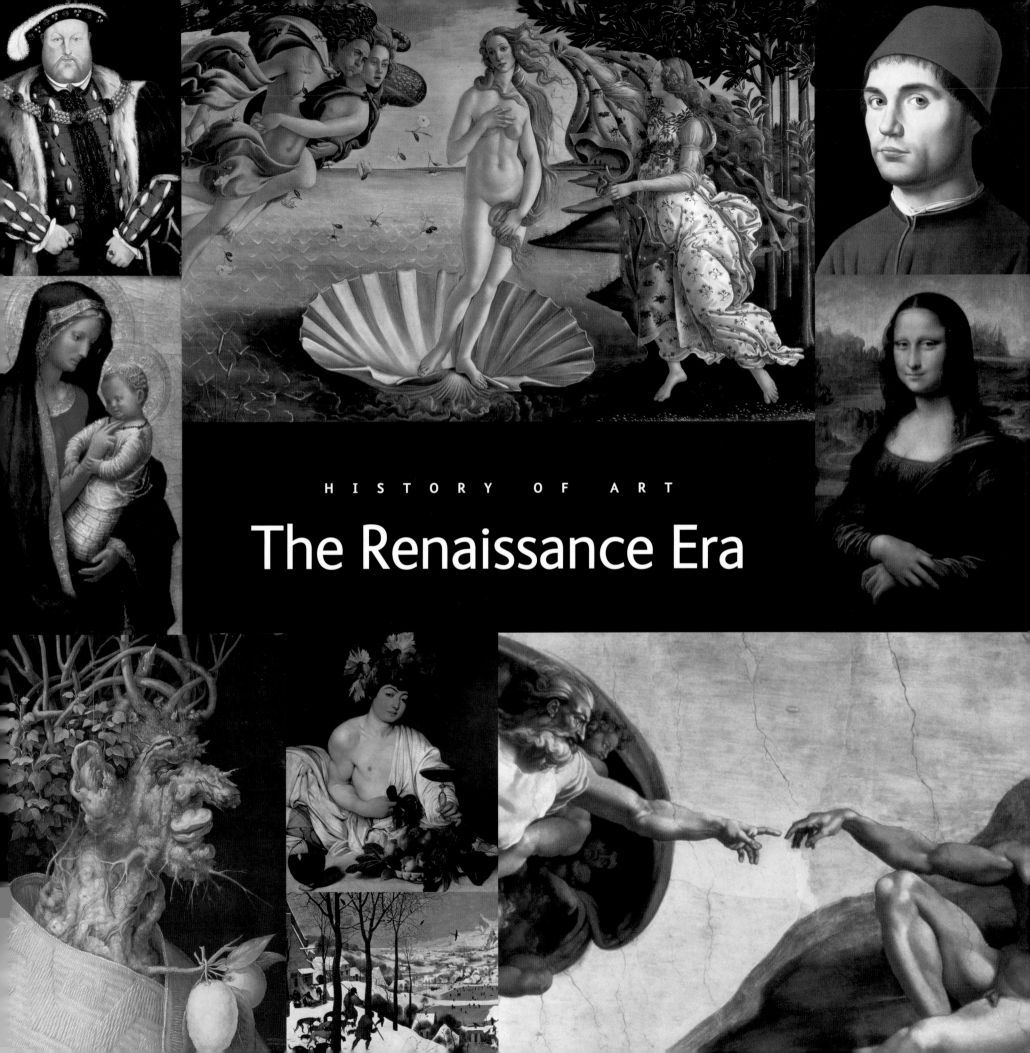

HISTORY OF ART

The Renaissance Era

Fra Angelico (Guido di Pietro)
The Annunciation (detail) *c.* 1420

Courtesy of Prado, Madrid, Spain/Bridgeman Art Library/Christie's Images

Fra Angelico was one of a select band of Renaissance artists who combined the monastic life with a career as a professional painter. Little is known about his early years, apart from the fact that he was born at Vicchio, near Florence, and that his real name was Guido di Pietro. He became a Dominican friar *c.* 1418–21, entering the monastery of San Domenico in Fiesole. For the remainder of his life, he placed his art at the service of his faith, earning the nickname 'Angelic', by which he has become known to posterity.

Angelico's earliest surviving works are small-scale and betray an astonishing eye for detail, suggesting that he may have begun his career as a manuscript illuminator. They also display the influence of the International Gothic style, which was starting to fall out of fashion. The painter-monk learned quickly, however, absorbing Tommaso Masaccio's revolutionary ideas about the organization of space and perspective. He also tackled the most prestigious form of religious art: frescoe painting. In this field, Angelico's greatest achievement was a magnificent cycle of frescoes at the newly restored monastery of San Marco in Florence (*c.* 1438–45).

Movement Renaissance
Other Works *Linaiuoli Triptych; Coronation of the Virgin*
Influences Masaccio, Monaco
Fra Angelico *Born c.* 1400
Painted in Italy. *Died* 1455

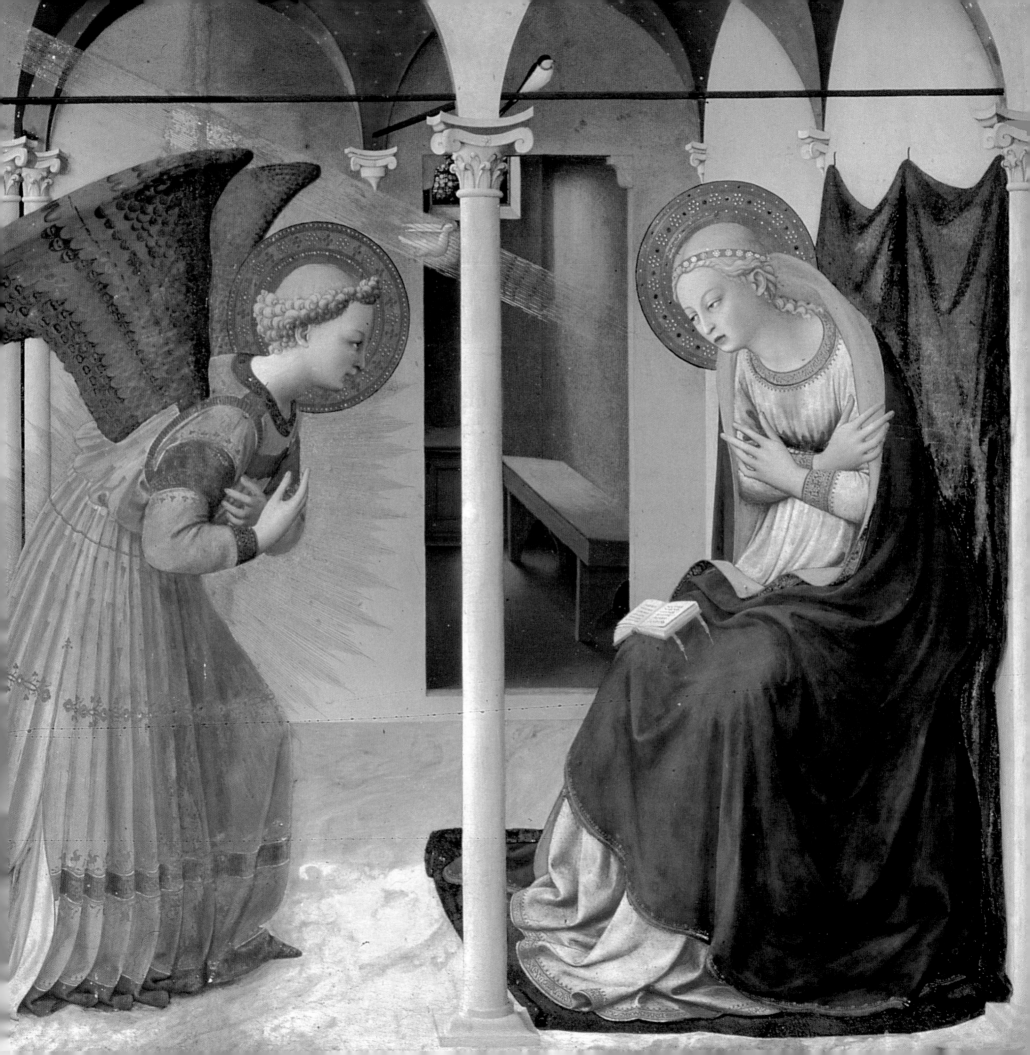

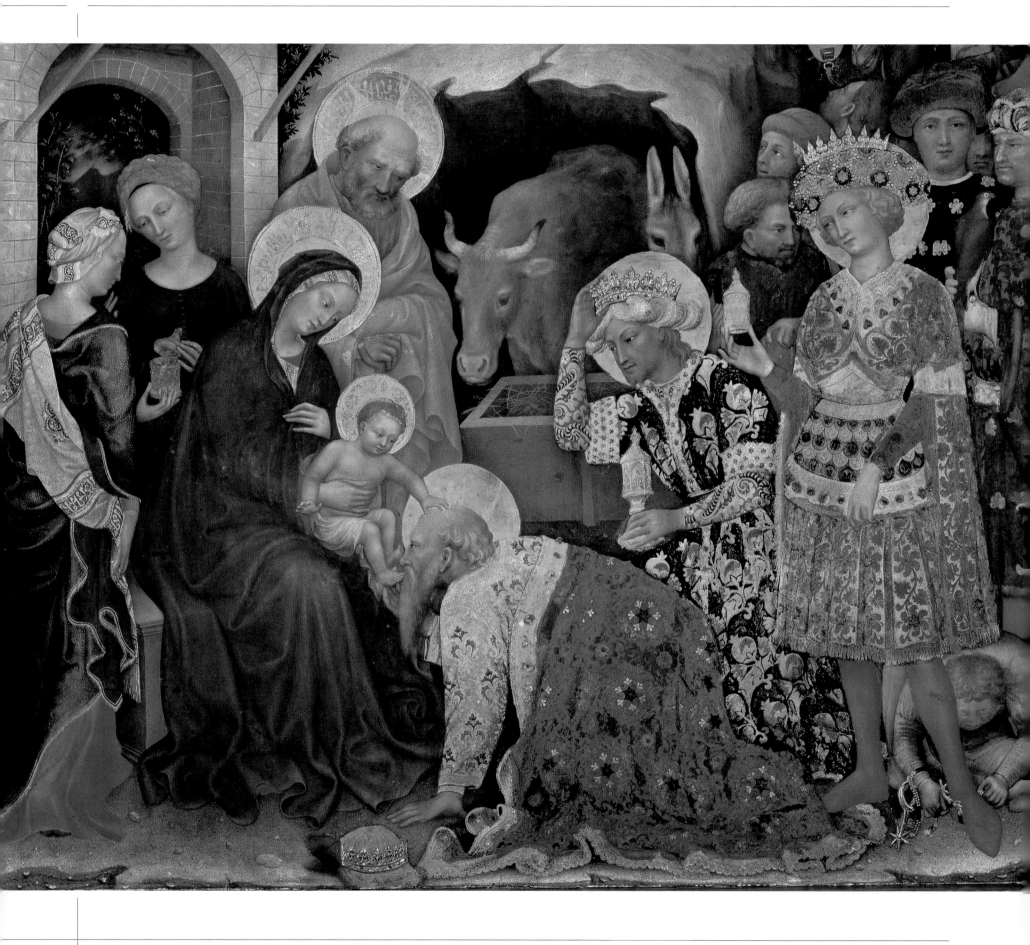

Gentile da Fabriano
The Adoration of the Magi (detail of Virgin and Child with Three Kings), 1423

Courtesy of Galleria Degli Uffizi, Florence, Italy/Bridgeman Art Library

Born in the little north Italian town of Fabriano, Gentile worked as a painter mainly in Venice and later Brescia before settling in Rome in about 1419, although subsequently he also worked in Florence and Siena. There he executed a great number of religious paintings although, regrettably, comparatively few of these works appear to have survived. His most important work was probably carried out in Florence where he enjoyed the patronage of Palla Strozzi, the richest magnate of the city in his day. About 1423 Strozzi commissioned him to paint the magnificent altarpiece depicting the Adoration of the Magi for the sacristy-chapel in the church of the Holy Trinity, intended by the patron as a memorial to his father Onofrio Strozzi. This is Gentile's undoubted masterpiece. The very epitome of the Italian Renaissance, it is now preserved in the Uffizi Gallery. It is an extraordinary work, crammed with figures – among whom we may discern the Strozzi family and their friends.

Movement Florentine School
Other Works *Madonna and Child; Madonna with Angels*
Influences Filippo Brunneleschi
Gentile da Fabriano *Born c.* 1370 Fabriano, Italy
Painted in Venice, Brescia, Rome, Florence and Siena. *Died c.* 1427 Venice

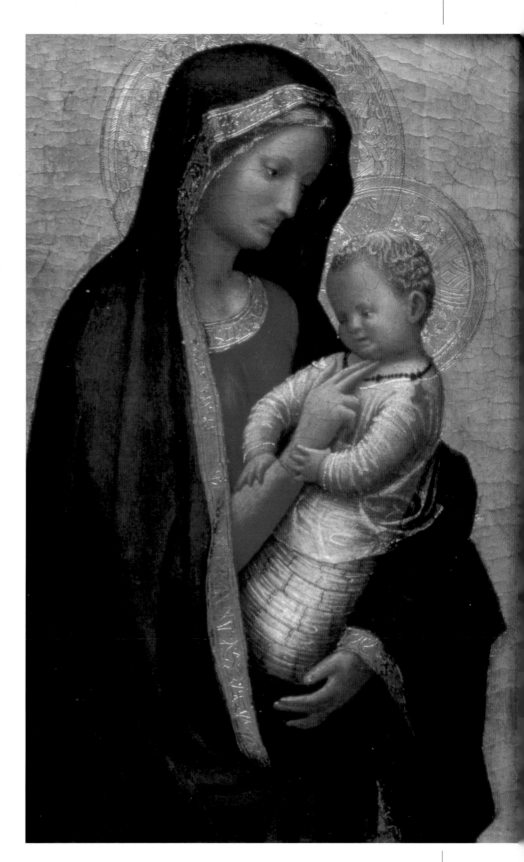

Tommaso Masaccio
Madonna Casini, after 1426

Courtesy of Galleria Degli Uffizi, Florence, Italy/Bridgeman Art Library

Born Tommaso de Giovanni di Simone Guidi at Castel San Giovanni di Altura in the duchy of Milan, this painter was nicknamed Masaccio ('massive') to distinguish him from another Tommaso who worked in the same studio. Who taught him is not recorded, but Masaccio was one of the most brilliant innovators of his generation, ranking with Brunelleschi and Donatello in revolutionizing painting in Italy. Biblical figures and scenes became infinitely more realistic in his hands. The human body is more fully rounded than before and Masaccio's handling of perspective is a marked improvement over his predecessors. He wielded enormous influence over his contemporaries and successors, notably Michelangelo. His greatest work consisted of the series of frescoes for the Brancacci Chapel in the Church of Santa Maria del Carmine in Florence (1424–27).

Movements Italian Renaissance, Florentine School
Other Works *The Virgin and Child; The Trinity with the Virgin and St John*
Influences Donatello
Tommaso Masaccio *Born* 1401 Castel San Giovanni di Alturo, Italy
Painted in Milan and Florence. *Died* 1428 Rome

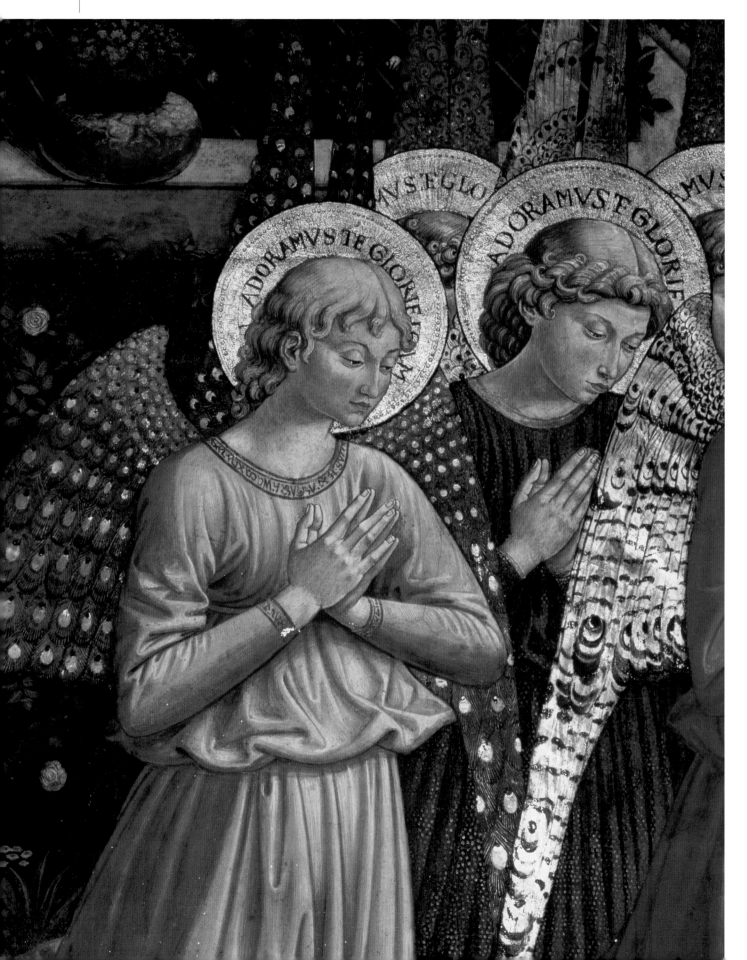

Benozzo Gozzoli
Angels, *c.* 1459

Courtesy of K & B News Foto,
Florence/Bridgeman Art Library/Christie's Images

Born Benozzo di Lese di Sandro, Benozzo
Gozzoli studied painting under Fra
Angelico and assisted his master in the
decoration of the Palazzo Medici-Riccardi
in 1456–60. Gozzoli's major contribution
was the *Journey of the Magi*, an ambitious
work crammed with the portraits of the
Florentine council and members of the
Medici family. Later he moved with his
master to Rome and later worked in
Orvieto, also executing numerous frescoes
and large murals for churches in
Gimignano and Pisa. After leaving Angelico
he went to Montefalco in Umbria, where
he painted a number of smaller, individual
works and altarpieces. As well as the
obligatory religious subjects he painted a
number of portraits, including Dante,
Petrarch and Giotto. His paintings are
characterized by their light, lively
appearance, their vivacity enhanced by
his use of bright, brilliant colours.

Movement Florentine School
Other Works *St Thomas Receiving
the Girdle of the Virgin*
Influences Fra Angelico
Benozzo Gozzoli
Born 1420 Florence, Italy
Painted in Florence, Rome, Orvieto
and Montefalco Gimignano and Pisa
Died 1497 Pistoia

Antonello da Messina

Portrait of a Man, *c.* 1475

Courtesy of National Gallery,
London/Bridgeman Art Library

Probably born at Messina, Sicily, whence
he derived his surname, Antonello travelled
in north-western Europe and spent some
time in the Netherlands where he studied
the techniques of the pupils of Jan Van
Eyck, taking them back to Messina about
1465. Subsequently he worked in Milan
and then, in 1472, settled in Venice, where
he executed commissions for the Council
of Ten. His paintings are remarkable for
their blend of Italian simplicity and the
Flemish delight in meticulous detail,
although some of his earlier works do not
always result in a perfect blend of
techniques. The majority of his extant
authenticated works are religious subjects,
mainly painted in oils on wood panels, but
he also produced a number of half-length
portraits of Venetian dignitaries in the last
years of his life. By introducing Flemish
characteristics Antonello transformed
Italian painting, notably in the use of oil
paints, which revolutionized technique.

Movement Italian Renaissance
Other Works *Ecce Homo; Madonna*
Influences
Jan Van Eyck, the Flemish School
Antonello da Messina
Born c. 1430 Italy
Painted in Messina and Venice
Died 1479 Messina

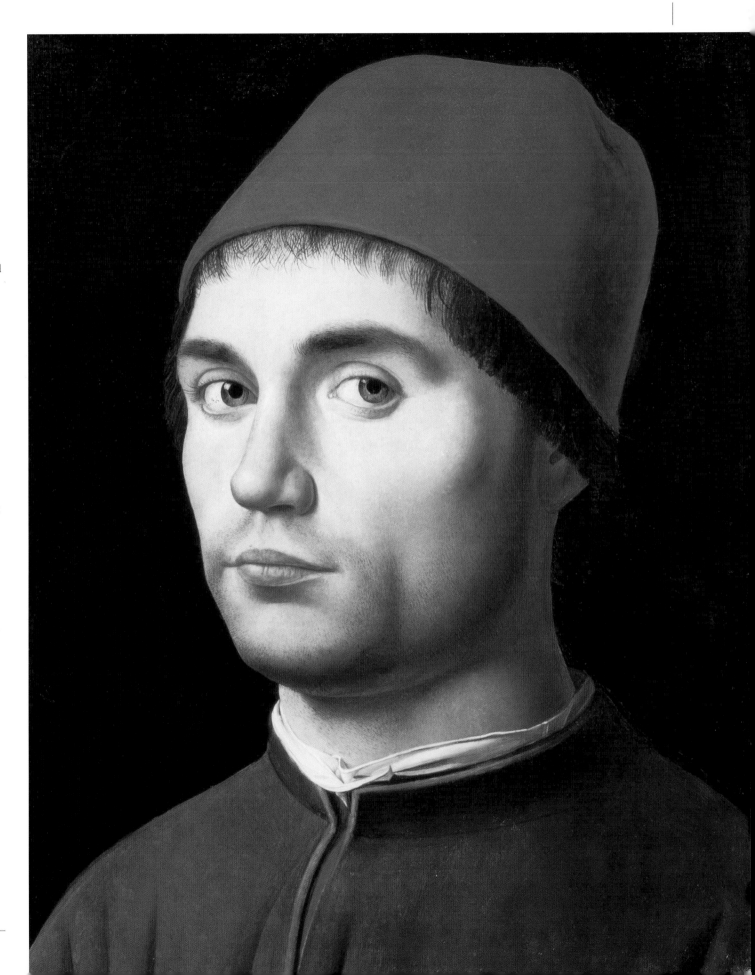

Sandro Botticelli

The Birth of Venus, *c.* 1485

Courtesy of Galleria Degli Uffizi, Florence/Bridgeman Art
Library/Christie's Images

Born Alessandro Di Mariano dei Filipepi, Botticelli
acquired his nickname ('little barrel') from his brother
Giovanni, who raised him and who was himself thus
named. From 1458 to 1467 he worked in the studio of Fra
Lippo Lippi before branching out on his own. By 1480 he
was working on the frescoes for the Sistine Chapel and his
lesser works consist mainly of religious paintings, although
it is for his treatment of allegorical and mythological
subjects that he is best remembered. Outstanding in this
group are his paintings *Primavera* (1477) and *The Birth of
Venus* (1485), both now in the Uffizi. He also excelled as a
portraitist and provided the illustrations for Dante's *Divine
Comedy*, which he executed in pen and ink and silver-point
(1402–5).

Movement Florentine School
Other Works *Venus and Mars*
Influences Fra Lippo Lippi, Verrocchio
Sandro Botticelli *Born* 1445 Florence, Italy
Painted in Florence and Rome
Died 1510 Florence

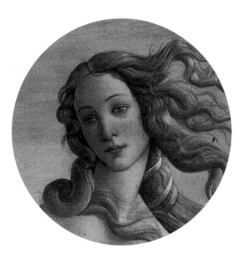

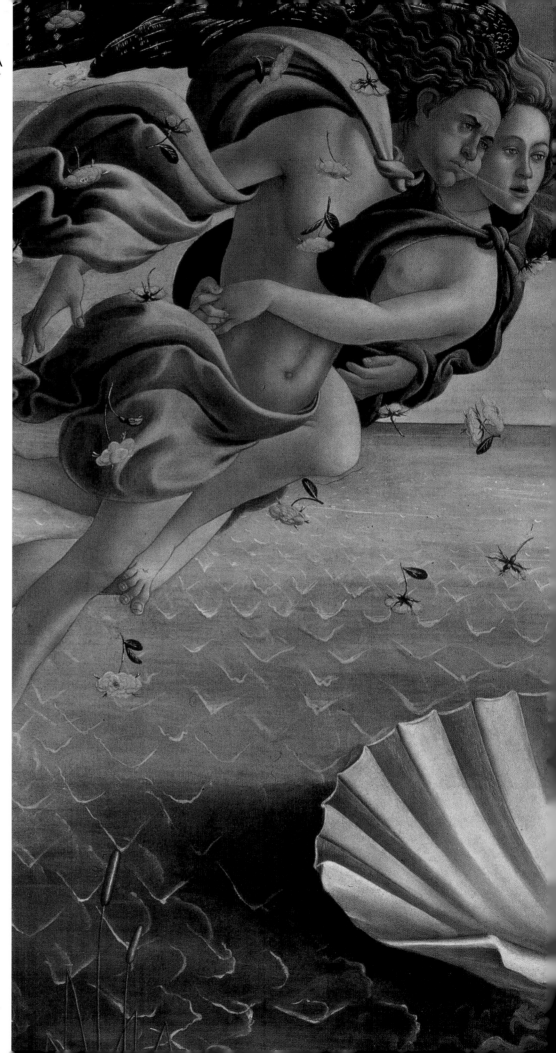

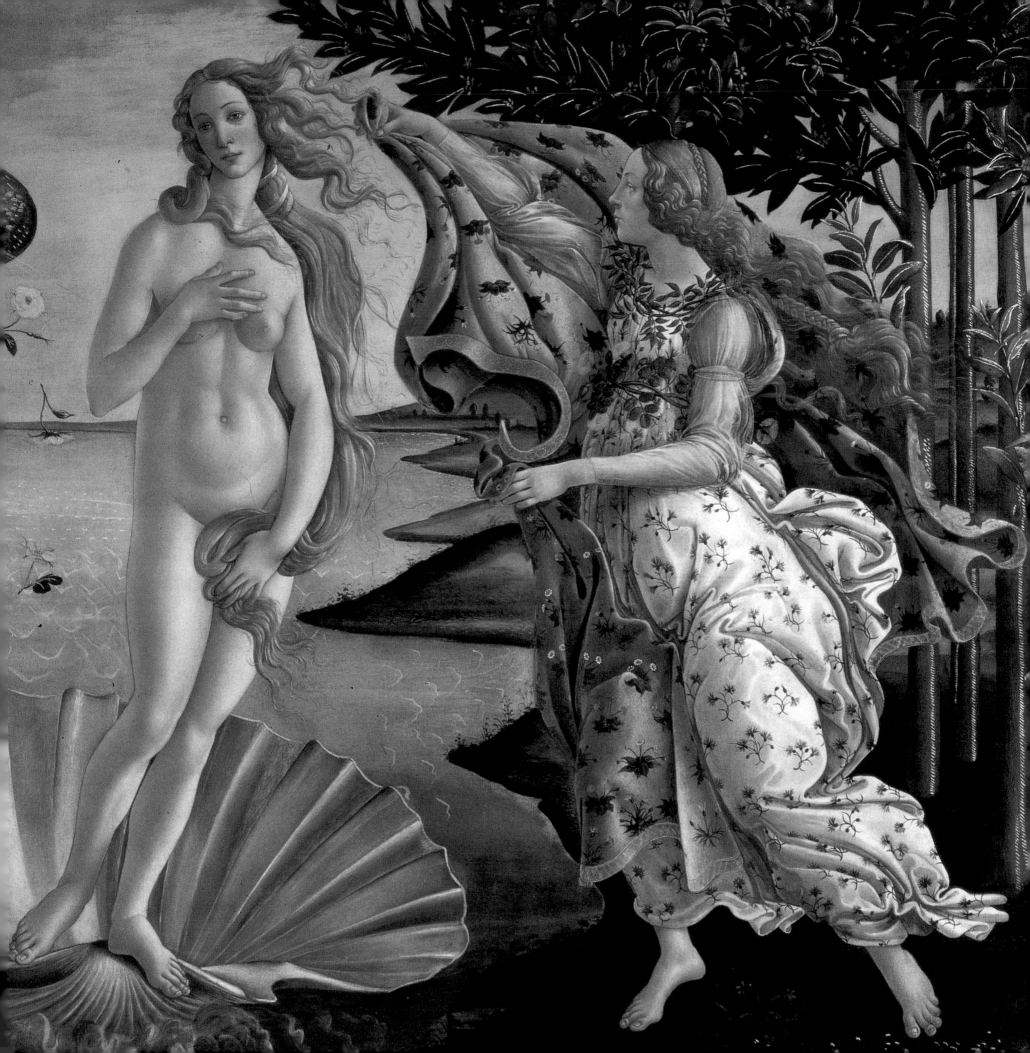

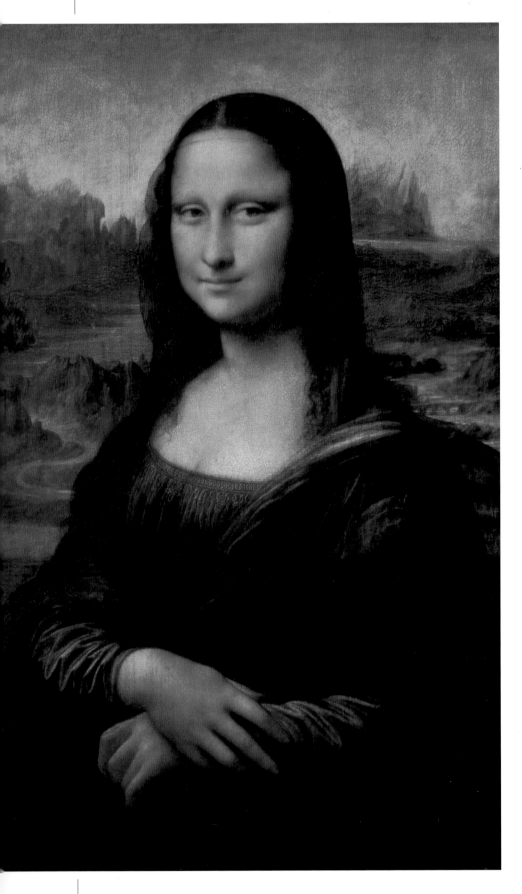

Leonardo da Vinci
Mona Lisa, *c.* 1503–06

Courtesy of Louvre, Paris/Bridgeman Art Library/Christie's Images

Florentine painter, scientist and inventor, da Vinci was the supreme genius of the Renaissance. Leonardo was the illegitimate son of a notary and probably trained under Verrocchio. In 1482 he moved to Milan, where he worked for the Sforzas. His chief work from this period was a majestic version of *The Last Supper*. The composition dazzled contemporaries, but Leonardo's experimental frescoe technique failed and the picture deteriorated rapidly. This was symptomatic of Leonardo's attitude to painting: the intellectual challenge of creation fascinated him, but the execution was a chore and many of his artistic projects were left unfinished. Leonardo returned to Florence in 1500, where he produced some of his most famous pictures, most notably the *Mona Lisa*. These were particularly remarkable for their *sfumato* – a blending of tones so exquisite that the forms seem to have no lines or borders. Leonardo spent a second period in Milan, before ending his days in France. Leonardo's genius lay in the breadth of his interests and his infinite curiosity. In addition to his art, his notebooks display a fascination for aeronautics, engineering, mathematics and the natural world.

Movement Renaissance
Other Works *Virgin of the Rocks; The Last Supper*
Influences Verrocchio
Leonardo da Vinci *Born* 1452 Italy. *Painted in* Italy and France. *Died* 1519

Michelangelo
Creation of Adam, Sistine Chapel detail, 1510

Courtesy of Vatican Museums and Galleries, Rome, Bridgeman Art Library/Christie's Images

Italian painter, sculptor and poet Michelangelo was one of the greatest artists of the Renaissance and a forerunner of Mannerism. He was raised in Florence, where he trained briefly under Ghirlandaio. Soon his obvious talent brought him to the notice of important patrons. By 1490, he was producing sculpture for Lorenzo di Medici and, a few years later, he began his long association with the papacy.

Michelangelo's fame proved a double-edged sword. He was often inveigled into accepting huge commissions, which either lasted years or went unfinished. The most notorious of these projects was the Tomb of Julius II, which occupied the artist for over 40 years. Michelangelo always considered himself primarily a sculptor and he was extremely reluctant to take on the decoration of the Sistine Chapel. Fortunately he was persuaded, and the resulting frescoes are among the greatest creations in Western art. The ceiling alone took four years (1508–12), while the Last Judgment (1536–41) was added later on the altar wall. In these, Michelangelo displayed the sculptural forms and the terribilità ('awesome power'), which made him the most revered artist of his time.

Movements Renaissance, Mannerism
Other Works *David; Pietà*
Influences Ghirlandaio, Giotto, Masaccio
Michelangelo *Born* 1475 Italy. *Painted in* Italy. *Died* 1564 Italy

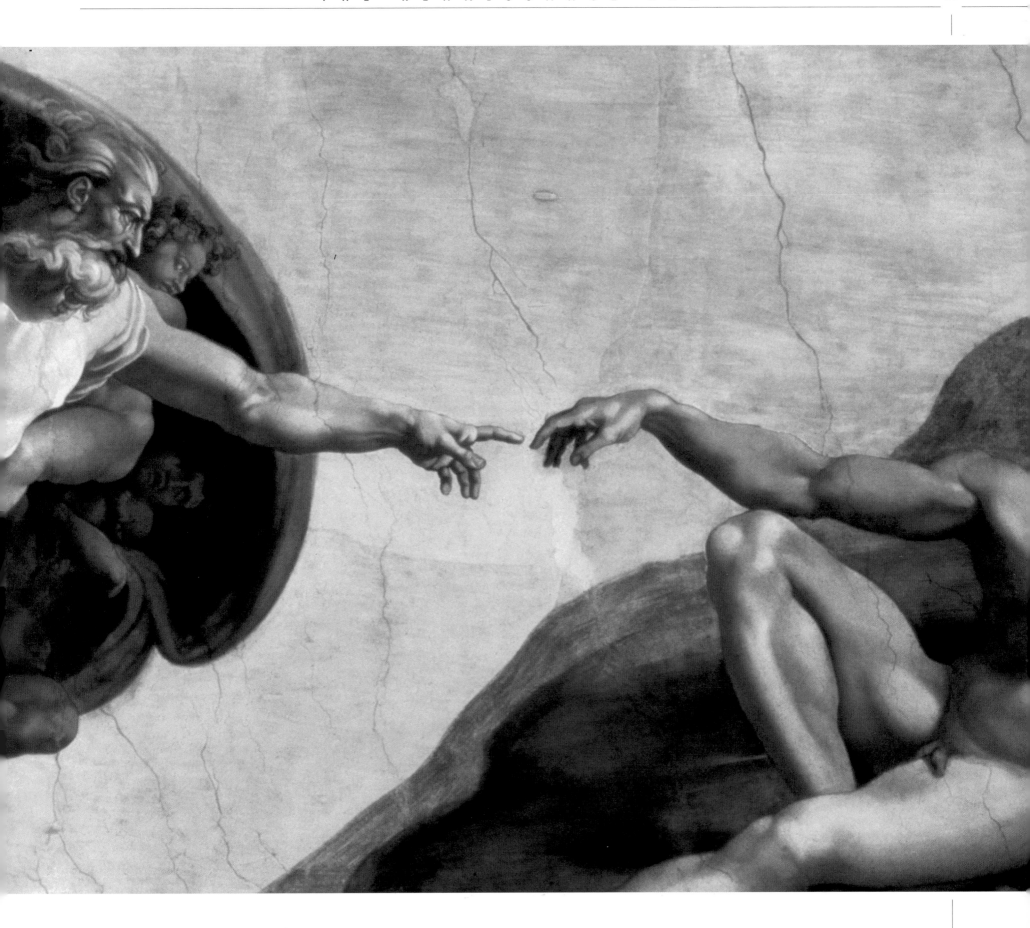

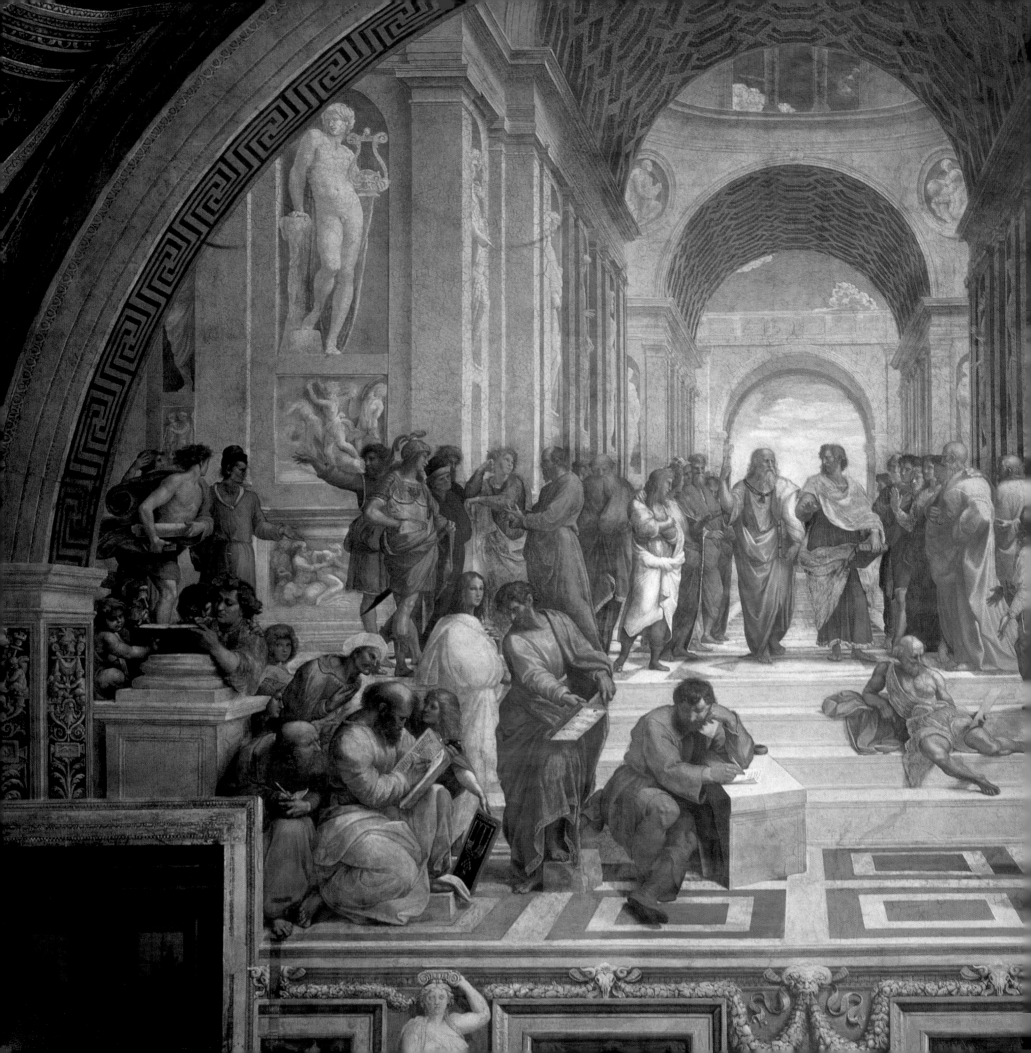

Raphael (Raffaello Sanzio)
School of Athens, 1510–11

Courtesy of Vatican Museums and Galleries, Vatican City, Italy/Bridgeman Art Library

The archetypal artist of the High Renaissance, Raphael received his education in Perugino. In 1504 he moved to Florence, where he received many commissions for portraits and pictures of the Virgin and Child. Soon, his reputation reached the ears of Pope Julius II, who summoned him to Rome in 1508. Deeply influenced by Michelangelo he added a new sense of grandeur to his compositions and greater solidity to his figures. Michelangelo grew jealous of his young rival, accusing him of stealing his ideas, but Raphael's charming manner won him powerful friends and numerous commissions.

The most prestigious of these was the decoration of the Stanze, the papal apartments in the Vatican. This was a huge task, which occupied the artist for the remainder of his life. *The School of Athens* is the most famous of these frescoes. Other commissions included a majestic series of cartoons for a set of tapestries destined for the Sistine Chapel and a cycle of frescoes for the banker, Agostino Chigi. In the midst of this frantic activity, however, Raphael caught a fever and died, at the tragically young age of 37.

Movement Renaissance
Other Works *Galatea; The Sistine Madonna*
Influences Pietro Perugino, Leonardo da Vinci, Michelangelo
Raphael *Born* 1483 Urbino, Italy
Painted in Italy
Died 1520

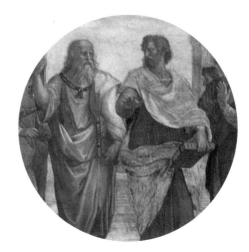

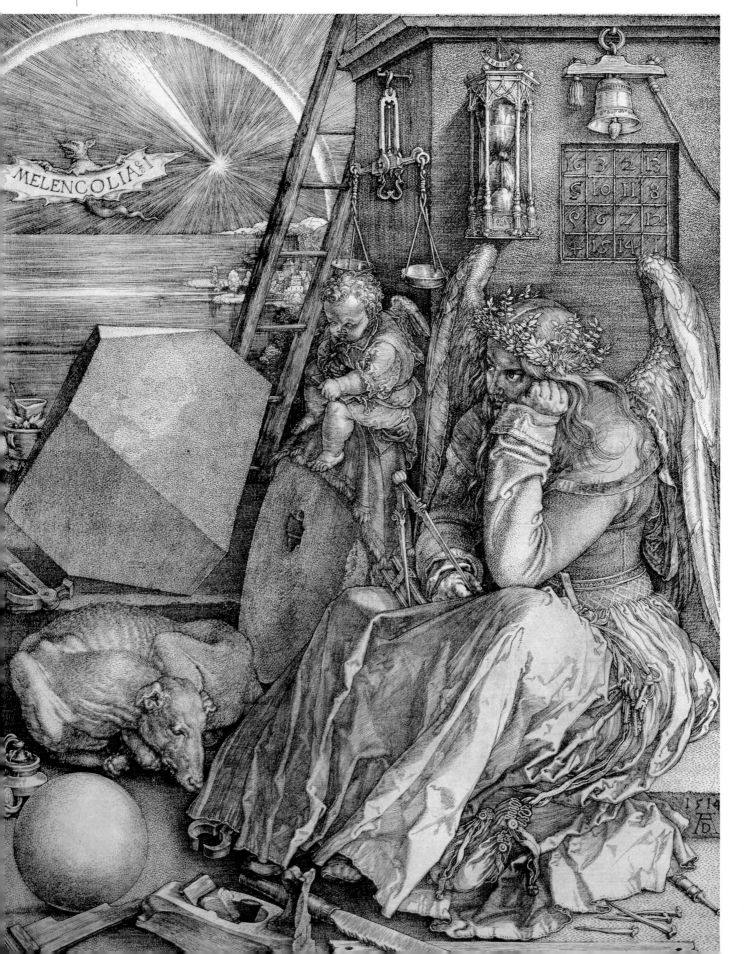

Albrecht Dürer

Melancholia, 1514

Courtesy of Private Collection/Christie's Images

Albrecht Dürer was the son of a goldsmith who taught him the art of drawing in silver-point. In 1484 he was apprenticed to the leading Nuremberg painter and book illustrator of his time, Michael Wolgemut (1434–1519), from whom he learned the techniques of woodcut engraving. He then travelled extensively in Italy, where the works of Leonardo, Bellini and Mantegna had a profound influence on his later career, both as a practicing artist and as an art theorist who wrote extensively on the subject. Dürer was thus responsible for introducing many of the ideas of the Italian Renaissance to northern Europe. Although now remembered chiefly for his engravings (including the *Triumphal Car*, at nine square metres the world's largest woodcut), he was an accomplished painter whose mastery of detail and acute observation have seldom been surpassed.

Movement German School
Other Works *Wing of a Hooded Crow*
Influences Leonardo da Vinci, Bellini, Mantegna
Albrecht Dürer
Born 1471 Nuremberg, Germany
Painted in Nuremberg
Died 1528 Nuremberg

Correggio
Noli Me Tangere,
c. 1534

Courtesy of Prado, Madrid, Spain/Bridgeman Art Library

Antonio Allegri, known to posterity by his nickname of Correggio, was born in the town of that name in the duchy of Modena. Originally he began training as a physician and surgeon, and studied anatomy under Giovanni Battista Lombardi – believed to be the doctor portrayed in the painting entitled *Correggio's Physician*. In 1518 he embarked on his epic series of frescoes for the Convent of San Paolo in Parma and followed this with the decoration of Parma Cathedral. He was the first Italian artist to paint the interior of a cupola, producing *The Ascension* for the church of San Giovanni in Parma. He also executed numerous religious and biblical paintings, but also occasionally drew on classical mythology for inspiration. His wife Girolama (b 1504) is believed to have been his model for the *Madonna Reposing*, sometimes known as *Zingarella* ('Gipsy Girl').

Movement Parma School
Other Works *Mystic Marriage of Saint Catherine; Ecce Homo*
Influences Leonardo da Vinci, Andrea Mantegna, Lorenzo Costa
Correggio *Born* 1494 Correggio, Italy *Painted in* Correggio and Parma *Died* 1534 Correggio

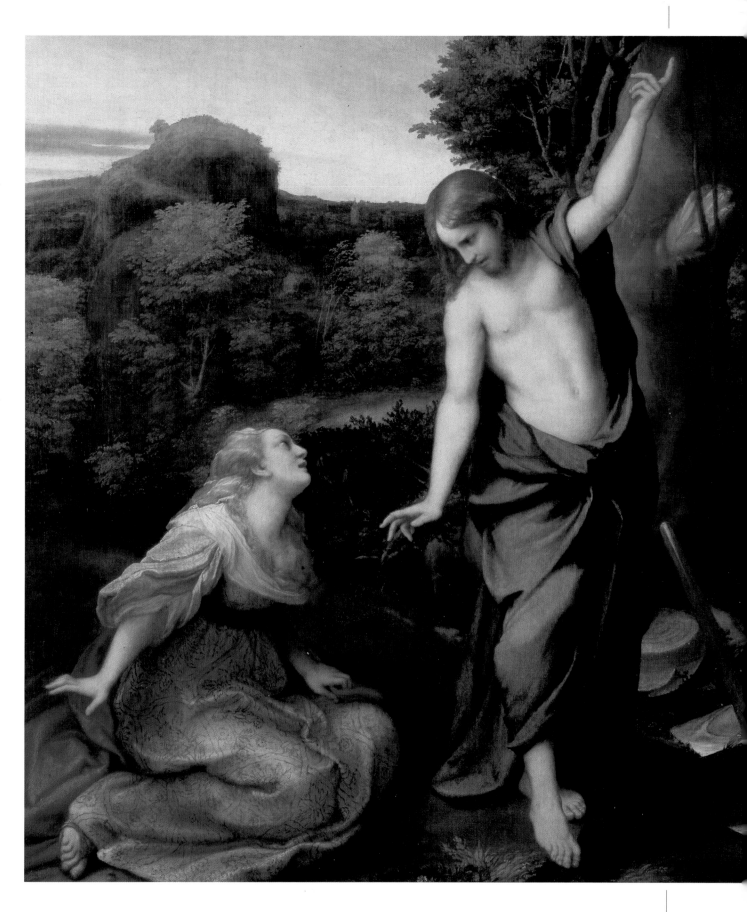

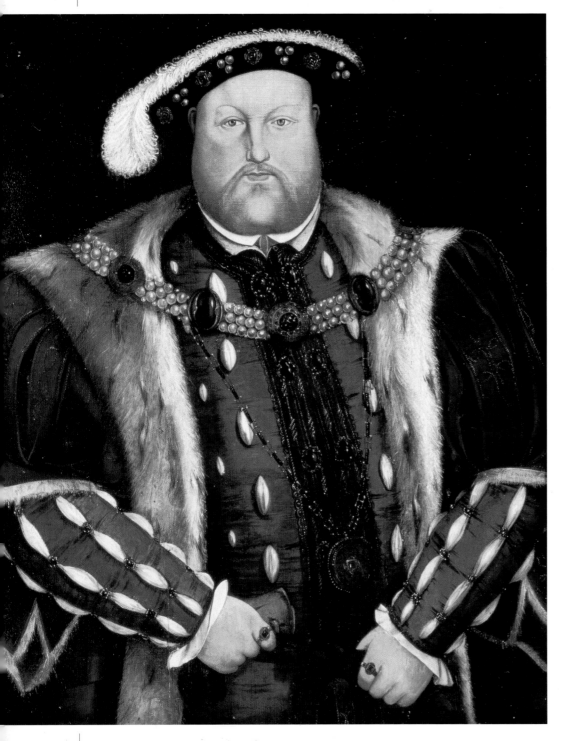

Hans Holbein
(after) Henry VIII, *c.* 1540s

Courtesy of Private Collection/Christie's Images

Born at Augsburg, Germany, the son of Hans Holbein the Elder, Hans Holbein studied under his father and then went to Basle with his brother Ambrosius as apprentice to Hans Herbst. Subsequently he worked also in Zurich and Lucerne. He returned to Basle in 1519, married and settled there. To his Swiss period belong his mostly religious works. In 1524 he went to France and thence to England in 1526, where he finally took up residence six years later. There being no demand for religious paintings in England at that time, he concentrated on portraiture, producing outstanding portraits of Sir Thomas More and Henry VIII, whose service he entered officially in 1537. From then until his death he produced numerous sensitive and lively studies of the King and his wives, his courtiers and high officials of state. He also designed stained-glass windows and executed woodcuts.

Movement German School
Other Works *Dead Christ; The Triumphs of Wealth and Poverty,*
Influences Hans Holbein the Elder, Hans Herbst
Hans Holbein *Born* 1497 Augsburg, Germany
Painted in Germany, Switzerland, France and England. *Died* 1543 London, England

Titian (Tiziano Vecellio)
Venus and Adonis, 1555–60

Courtesy of Private Collection/Christie's Images

The greatest and most versatile artist of the Venetian Renaissance, Titian excelled equally at portraiture, religious pictures and mythological scenes. Born in the Dolomite region, he arrived in Venice as a boy and was apprenticed to a mosaicist. Turning to painting, he entered the studio of Giovanni Bellini, before joining forces with Giorgione. After Giorgione's premature death in 1510, Titian's star rose quickly. In 1511, he gained a major commission for frescoes in Padua, and in 1516 was appointed as the official painter of the Venetian Republic.

This honour enhanced Titian's international reputation and soon, offers of work began to flow in from the princely rulers of Ferrara, Urbino and Mantua. The painter did not always accept these commissions, as he was notoriously reluctant to travel, but some patrons could not be refused. The most distinguished of these was the Emperor Charles V. After their initial meeting in 1529, Titian was appointed Court Painter in 1533 and given the rank of Count Palatine. In 1548, he worked at the Imperial Court at Augsburg and his services were also prized by Charles's successor, Philip II.

Movement Renaissance
Other Works *Bacchus and Ariadne; Man with a Glove; Sacred and Profane Love*
Influences Bellini, Giorgione
Titian *Born c.* 1485. *Painted in* Italy and Germany. *Died* 1576

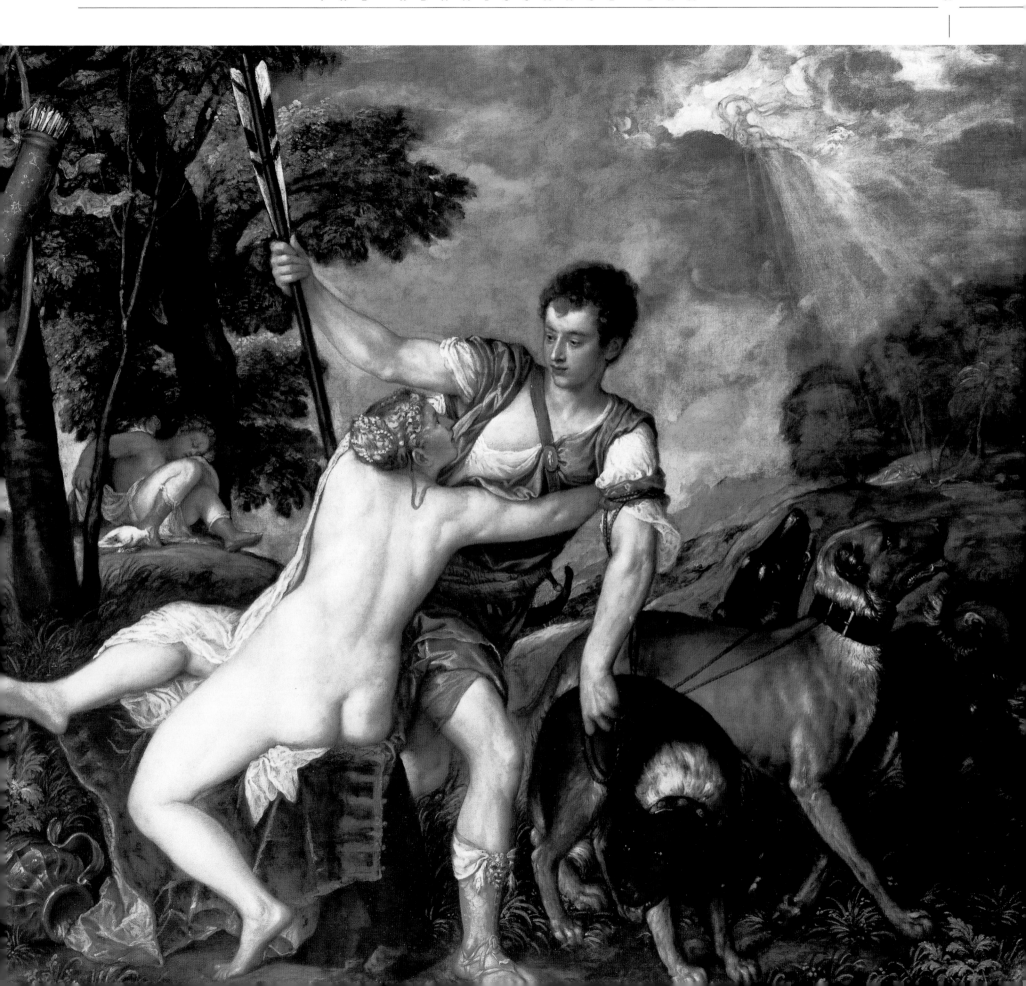

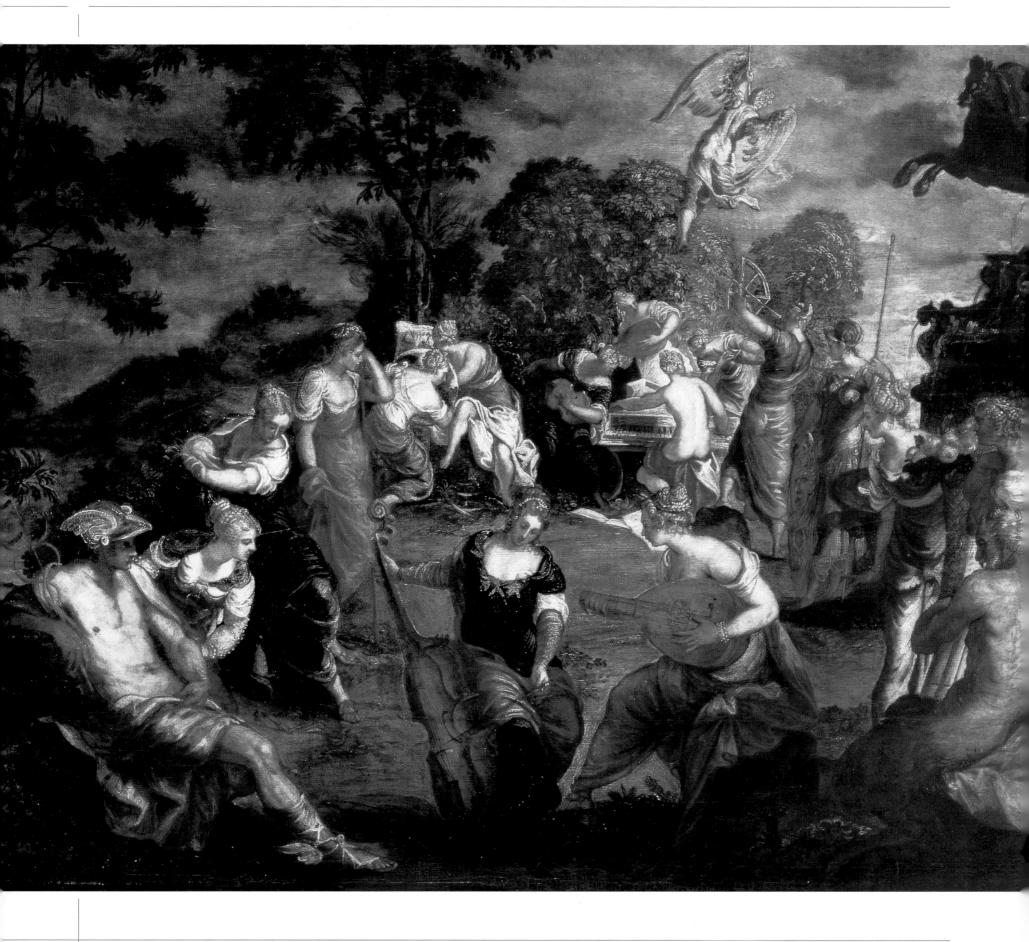

Tintoretto
The Concert of Muses

Courtesy of Private Collection/Christie's Images

Born Jacopo Robusti, Tintoretto derived his nickname, meaning 'little dyer', from his father's trade. He was very briefly a pupil of Titian (who is said to have been jealous of the boy's talents) and though largely self-taught, was influenced by his master as well as Michelangelo and Sansovino. Apart from two trips to Mantua he spent his entire working life in Venice, painting religious subjects and contemporary portraits. His most ambitious project was the series of 50 paintings for the Church and School of San Rocco, but his fame rests on the spectacular *Paradise* (1588), a huge work crammed with figures. He was a master of dark tones illumined by adroit gleams of light. Three of his children became artists, including his daughter Marietta, known as La Tintoretta. His output was phenomenal and he painted with great rapidity and sureness of brushstrokes, earning him a second nickname of 'Il Furioso'.

Movement Venetian School
Other Works *The Annunciation; The Last Supper; The Nine Muses*
Influences Michelangelo, Titian, Sansovino
Tintoretto *Born* 1518 Venice, Italy
Painted in Venice and Mantua
Died 1594 Venice

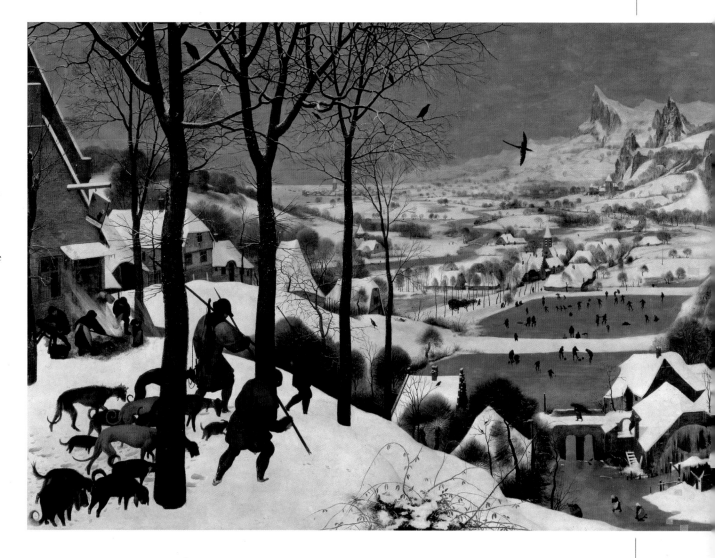

Pieter Brueghel
Hunters in the Snow, 1565

Courtesy of Kunsthistoriches Museum, Vienna/Bridgeman Art Library/Christie's Images

Also known as Brueghel the Elder to distinguish him from his son Pieter and younger son Jan, Pieter Brueghel was probably born about 1520 in the village of the same name near Breda. He studied under Pieter Coecke van Aelst (1502–50) and was greatly influenced by Hieronymous Bosch, from whom he developed his own peculiar style of late-medieval Gothic fantasy. About 1550 he travelled in France and Italy before returning to Brussels, where his most important paintings were executed. He was nicknamed 'Peasant Brueghel' from his custom of disguising himself in order to mingle with the peasants and beggars who formed the subjects of his rural paintings. Although he was a master of genre subjects his reputation rests mainly on his large and complex works, involving fantastic scenery and elaborate architecture, imbued with atmosphere and a sensitivity seldom achieved earlier.

Movement Flemish School
Other Works *Tower of Babel; Peasant Wedding*
Influences Pieter Coecke, Hieronymus Bosch
Pieter Brueghel *Born c.* 1520 Brögel, Holland. *Painted in* Breda and Brussels, Belgium. *Died* 1569 Brussels

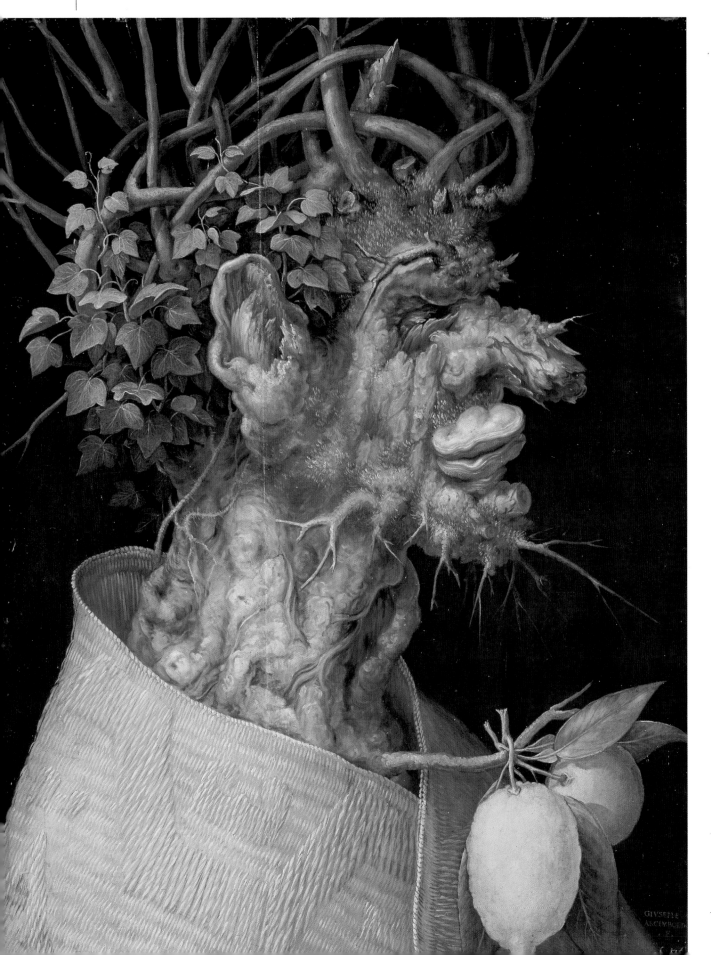

Giuseppe Arcimboldo
Winter, 1573

Courtesy of Kunsthistoriches Museum,
Vienna/Bridgeman Art Library

Giuseppe Arcimboldo began his artistic career by working on the stained-glass windows in the Duomo (Cathedral) in Milan. Later he moved to Prague which, under Charles V, became for a time the centre of the Holy Roman Empire. Here he was employed by the Habsburg rulers as an architect (of the civic waterworks among other public projects), impresario of state occasions, curator of the imperial art collection and interior designer. It was in Prague that he painted the works on which his reputation now rests. In his exploration of human portraits composed of non-human and inanimate objects he was far ahead of his time, anticipating the Surrealists by several centuries. His fantastic heads symbolizing the four seasons were made up of pieces of landscape, flowers, vegetables and animals, even pots and pans and other mundane articles from everyday life, all executed in brilliant colours with an extraordinary attention to detail.

Movement Surrealism
Other Works *Summer*
Influences Medieval stained glass
Giuseppe Arcimboldo *Born* 1527 Milan, Italy
Painted in Milan and Prague
Died 1593 Milan

Michelangelo Merisi da Caravaggio

The Young Bacchus, c. 1591–93

Courtesy of Galleria Degli Uffizi,
Florence/Bridgeman Art Library/Christie's Images

Born Michelangelo Merisi in the village of
Caravaggio, Italy, this painter studied in Milan and
Venice before going to Rome to work under the
patronage of Cardinal del Monte on altarpieces
and religious paintings. His patron was startled not
only by Caravaggio's scandalous behaviour but also
by his rejection of the Roman ideals and
techniques in painting. Instead, Caravaggio headed
the *Naturalisti* (imitators of nature in the raw),
developing a mastery of light and shade and
concentrating on realism, regardless of theological
correctness. As a result, some of his major
commissions were rejected and in 1606, after he
had killed a man in an argument, he fled from
Rome to Naples and thence to Malta. On his
return to Italy in 1609 he contracted a fever and
died at Porto Ercole, Sicily. The years of exile
produced one of his greatest portraits, the full-
length *Grand Master of the Knights*.

Movement Baroque
Other Works *Christ at Emmaus; The Card Players*
Influences Annibale Carracci
Caravaggio *Born c.* 1572 Caravaggio, Italy
Painted in Venice, Rome and Malta
Died 1610 Porto Ercole, Sicily

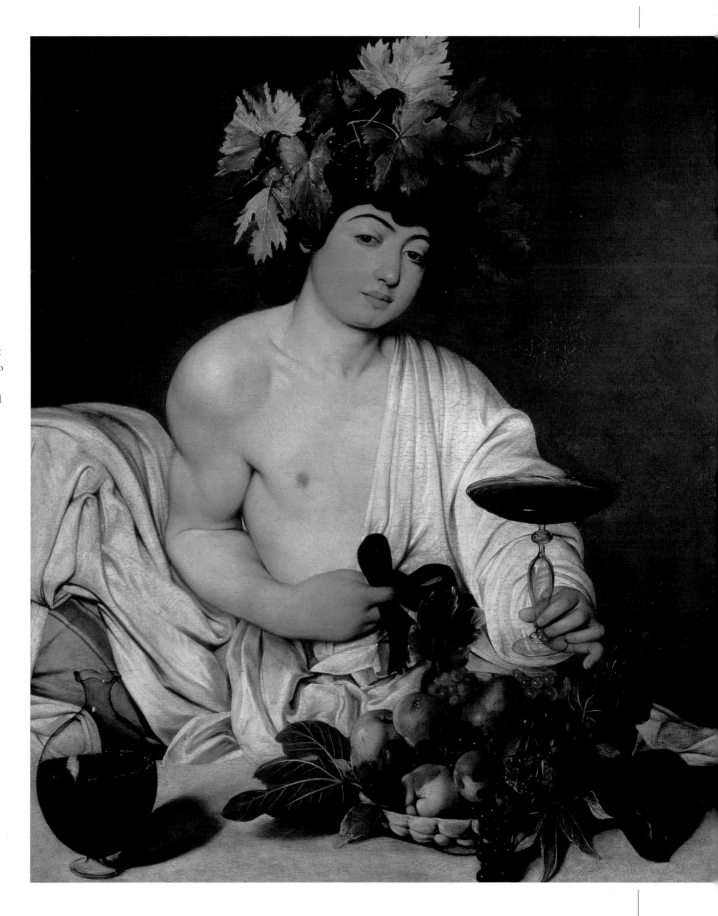

HISTORY OF ART

The Baroque
& Rococo Era

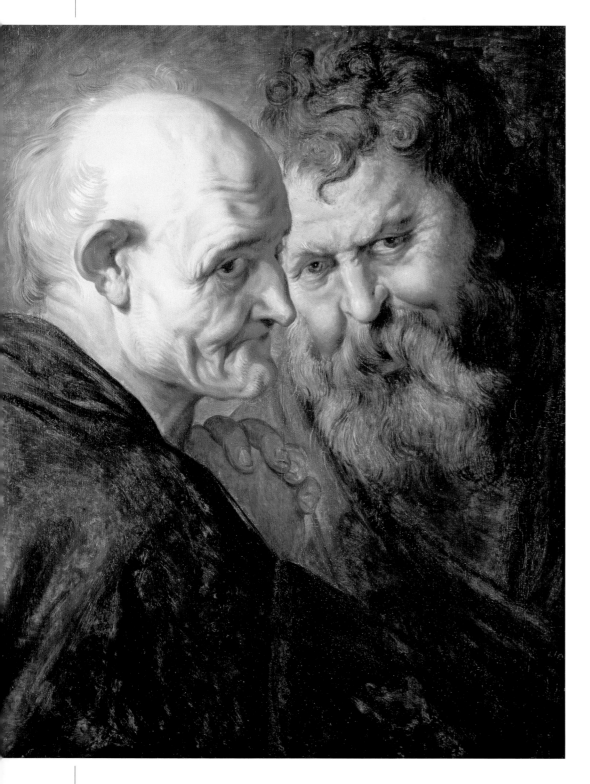

Peter Paul Rubens
(attributed to) Two Saints

Courtesy of Private Collection/Christie's Images

Born at Siegen, Westphalia, now part of Germany, Peter Paul Rubens was
brought up in Antwerp in the Spanish Netherlands. Originally intended for
the law, he studied painting under Tobias Verhaecht, Adam Van Noort and
Otto Vaenius and was admitted into the Antwerp painters' guild in 1598.
From 1600 to 1608 he was court painter to Vincenzo Gonzaga, Duke of
Mantua, and travelled all over Italy and Spain, furthering his studies and also
executing paintings for various churches. Shortly after his return to Antwerp
he was appointed court painter to Archduke Albrecht of the Netherlands. In
the last years of his life he combined painting with diplomatic missions
which took him to France, Spain and England and resulted in many fine
portraits, as well as his larger religious pieces. He was knighted by both
Charles I and Philip IV of Spain. In 1630 he retired from the court to Steen
and devoted the last years of his life to landscape painting.

Movement Flemish School
Other Works *Samson and Delilah; The Descent from the Cross; Peace and War*
Influences Tobias Verhaecht, Adam Van Noort
Peter Paul Rubens *Born* 1577 Siegen, Germany. *Painted in* Antwerp,
Rome, Madrid, Paris and London. *Died* 1640 Antwerp, Belgium

Nicolas Poussin
The Triumph of David, c. 1631–3

Courtesy of Dulwich Picture Gallery, London, UK/Bridgeman Art Library

One of the leading exponents of Baroque painting, Nicolas Poussin settled in
Paris in 1612. Ignoring the Mannerist painting then fashionable, he took
Raphael as his model and studied the great Classical works of the Italian
Renaissance. He left Paris in 1623 and began travelling in Italy, studying the
works of the Italian masters at first hand. He settled in Rome the following
year. Apart from a brief sojourn in Paris (1640–42) he spent the rest of his
life in Rome, executing commissions for Cardinal Barberini. Eschewing the
increasingly popular Baroque style, he clung to the Classical style and became
its greatest French exponent. He drew upon the rich store of Greek and
Roman mythology for his subjects, while utilizing the techniques of colour
developed by Titian. His greatest canvasses deal with vast subjects, crowd
scenes crammed with action and detail. Later on he tended to concentrate
more on landscapes, although still steeped in the Classical tradition.

Movement Classicism
Other Works *The Rape of the Sabines; The Worship of the Golden Calf*
Influences Raphael, Bernini
Nicolas Poussin *Born* 1594 Les Andelys, France. *Painted in* Paris
and Rome. *Died* 1665 Rome

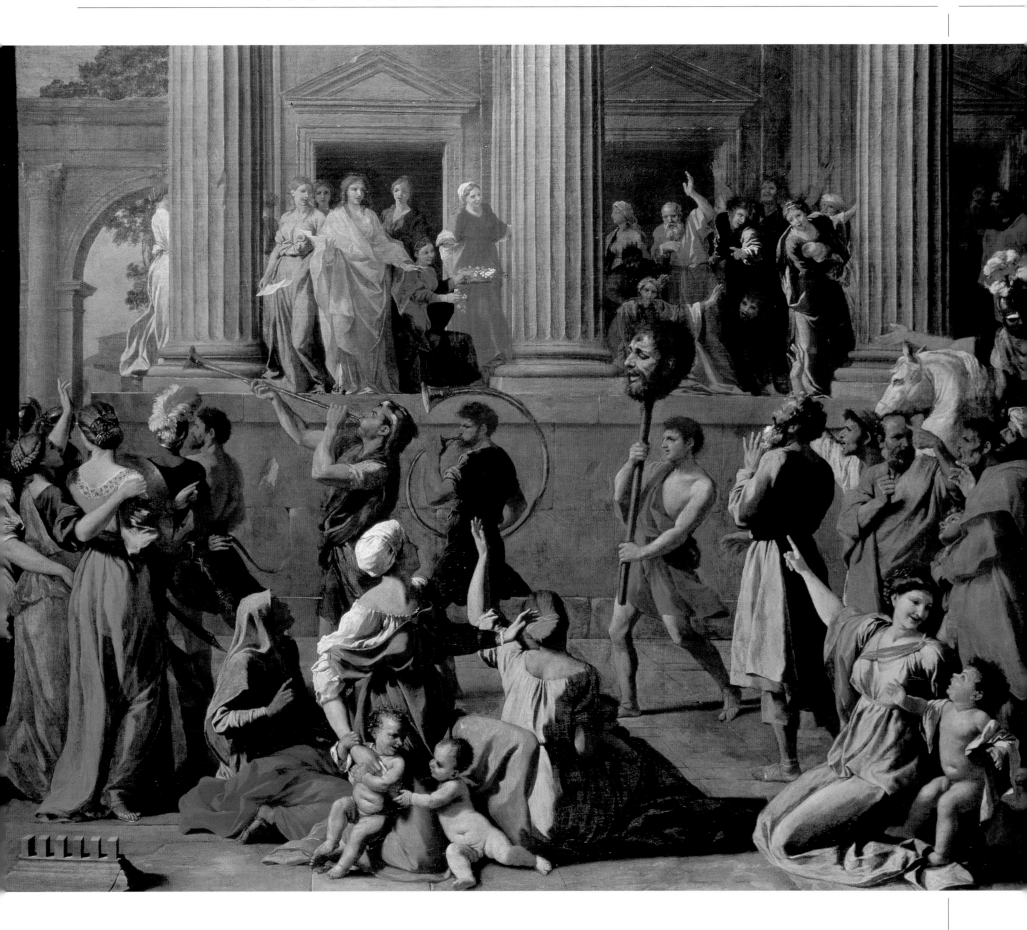

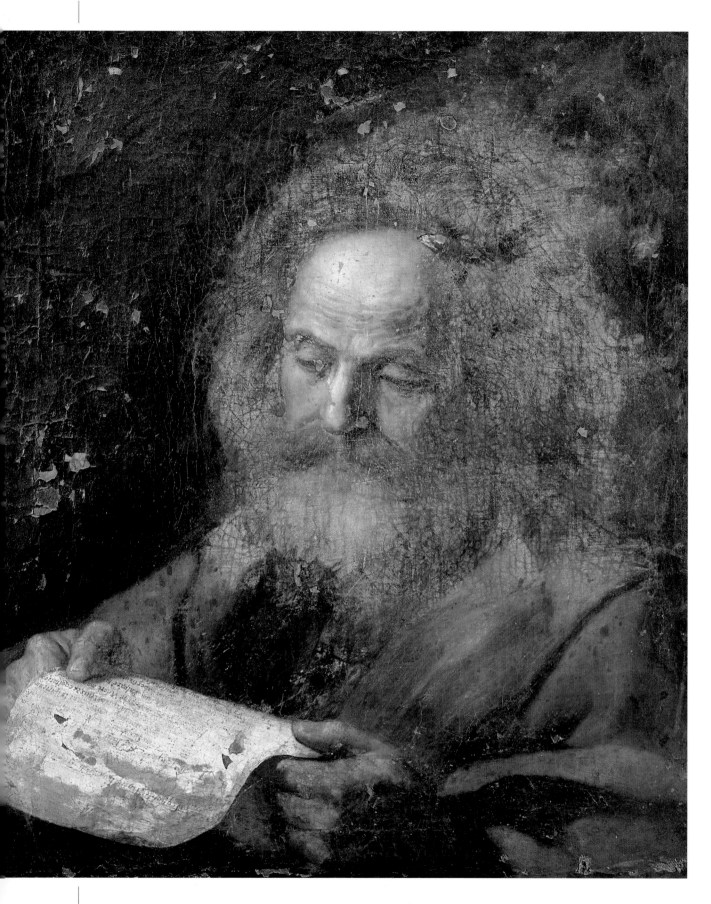

Il Guercino
Saint Luke

Courtesy of Private Collection/Christie's Images

Born Giovanni Francesco Barbieri, Il Guercino is
invariably known by his nickname, which means
'squint-eyed', but in spite of this handicap he
showed early promise for sketching and drawing.
He was trained in the rigorous classical mode at
the Carracci Academy but was later influenced by
the realism of Caravaggio, whose lighting
techniques he modified by the richness of his
colours. Like most artists of his generation he
specialized in religious works – his major project
being the fresco of *Aurora* which decorated the
ceiling at the Villa Ludovisi, commissioned by
Pope Gregory XV. From 1642 onwards he was the
leading painter in Bologna, where he died. His oil
paintings matched the rich density of their colours
with the knack of conveying a wide range of
emotions which heighten the dramatic impact of
his work. There is invariably a dominant central
figure, set against a background in the best
Baroque tradition.

Movement School of Bologna
Other Works *Jacob Receiving Joseph's Coat*
Influences Caravaggio
Il Guercino *Born* 1602 Cento, Italy
Painted in Rome and Bologna
Died 1666 Bologna

Sir Anthony van Dyck

(circle of) Self Portrait with a Sunflower, after 1632

Courtesy of Private Collection/Philip Mould,
Historical Portraits Ltd, London, UK/Bridgeman Art Library

Anthony van Dyck worked under Rubens and later travelled all over Italy, where he painted portraits and religious subjects. He first visited England in 1620 and was invited back in 1632 by King Charles I, who knighted him and appointed him Painter-in-Ordinary. Apart from a two-year period (1634–35) when he was back in Antwerp, van Dyck spent the rest of his life in England and on his return to London he embarked on the most prolific phase of his career. He not only painted numerous portraits of King Charles, Queen Henrietta Maria and their children, but also many pictures of courtiers and other notable figures, creating a veritable portrait gallery of the great and good of the period. His immense popularity was due not only to his technical mastery, but also his ability to give his sitters an expressiveness, grace and elegance, which few other artists have ever equalled.

Movement Flemish School
Other Works *Charles I in Hunting Dress; The Three Royal Children*
Influences Peter Paul Rubens
Sir Anthony van Dyck *Born* 1599 Belgium
Painted in Antwerp and London
Died 1641 London

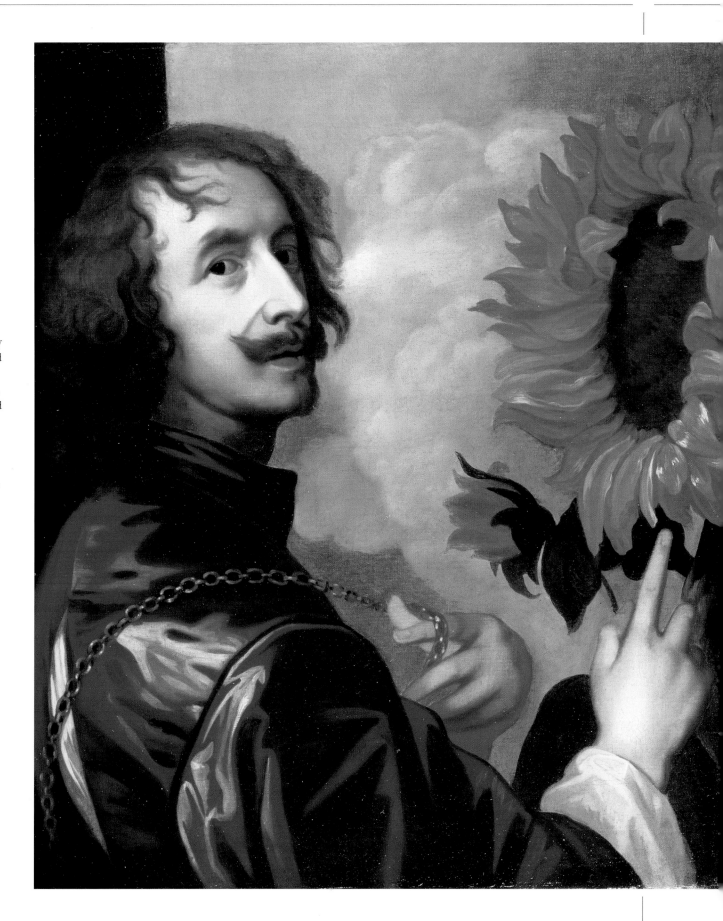

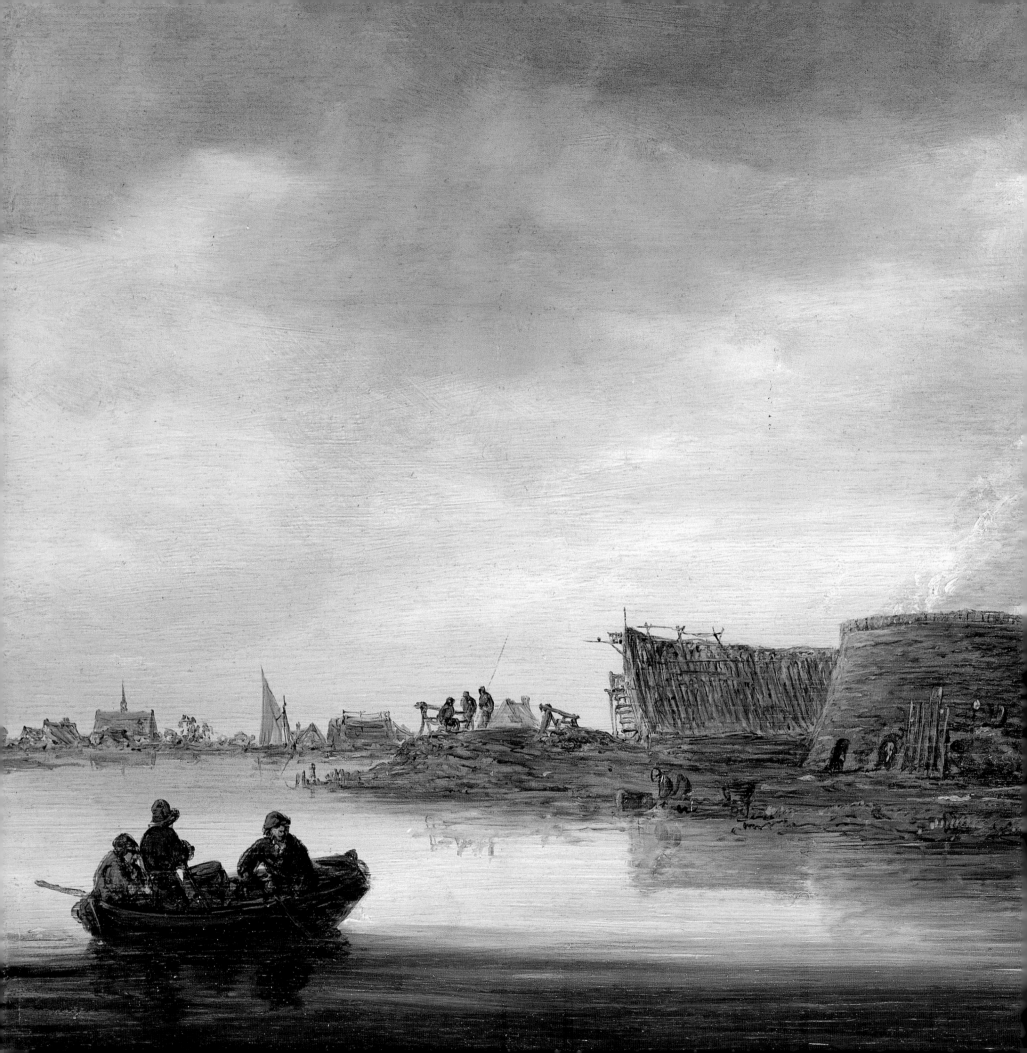

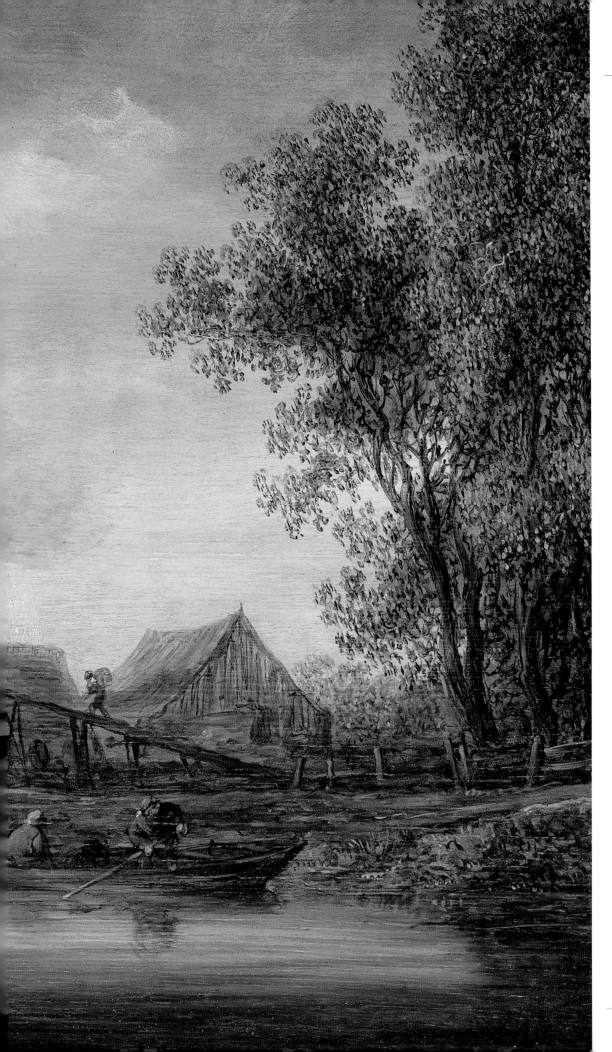

Jan van Goyen
River Landscape with Lime Kilns, 1640s

Courtesy of Private Collection/Christie's Images

Jan van Goyen visited France in his youth and may have been influenced by the painters in that country, but he also travelled all over Holland and imbibed the ideas of his older contemporaries. With Salomon van Ruysdael he helped to establish the Dutch School of landscape painters and he had numerous pupils and imitators. In his travels he made countless sketches and drawings that formed the basis of his later oil paintings. He was a prolific artist but a poor businessman and died in debt. His landscapes divide into two periods, those dating from 1630 onwards being in more muted colours, predominantly shades of brown, but much more atmospheric. Towards the end of his life he began using a much greater range of colours again, coupled with that poetic sensibility which was the hallmark of the next generation of Dutch artists.

Movement Dutch School
Other Works *A Castle by a River with Shipping at a Quay*
Influences Esaias van de Velde, Jan Porcellis
Jan van Goyen *Born* 1596 Leyden, Holland
Painted in Leyden and The Hague
Died 1656 The Hague

Pieter Claesz
A Vanitas Still Life, 1645

Courtesy of Johnny van Haeften Gallery, London, UK/Bridgeman Art Library

Born at Haarlem in the Netherlands in 1597 or 1598, Pieter Claesz grew up in a town which was the centre of the Dutch flower trade, so it was not surprising that he developed an early interest in floral painting. He grew up at a time when this style was being introduced to Holland by Flemish refugees, notably Ambrosius Bosschaert the Elder and Balthasar van der Alst. Claesz went on to develop the type of still life known as the breakfast or banquet picture – much less ebullient than the colourful flower paintings with more somber tones suited to the intimate atmosphere of domestic interiors. Claesz in fact took this further than his contemporaries, creating an almost monochrome effect and relying on the precise juxtaposition of each object which then took on a symbolic meaning. He pioneered a style that was emulated by many Dutch artists of the succeeding generation.

Movement Dutch School
Other Works *Still Life with a Candle*
Influences Ambrosius Bosschaert, Balthasar van der Alst, Caravaggio
Pieter Claesz *Born c.* 1597 Haarlem, Holland
Painted in Haarlem
Died 1660 Haarlem

Pietro da Cortona
Allegory of the Arts (ceiling painting)

Courtesy of Palazzo Barberini, Rome, Italy/Bridgeman Art Library

An Italian painter, architect, decorator, and designer, Pietro da Cortona was a versatile genius in the full Roman Baroque style. His first major works were frescos in Sta Bibiana, Rome, commissioned by Pope Urban VIII (Maffeo Barberini), and the patronage of the Barberini family played a major part in his career. For their palace he painted his most famous work, the huge ceiling fresco Allegory of Divine Providence. This was begun in 1633, but he interrupted the work in 1637 to go to Florence and paint two of four frescos commissioned by the Grand Duke of Tuscany for the Pitti Palace. He returned to finish the Barberini ceiling in 1639. This, one of the key works in the development of Baroque painting, is a triumph of illusionism, for the centre of the ceiling appears open to the sky and the figures seen from below appear to come down into the room as well as soar out of it. In 1640–47 Pietro returned to Florence to finish Pitti Palace frescos, where he received a new commission for seven ceilings, one of which is shown here.

Movement Baroque
Other Works *The Triumph of Divine Providence* (ceiling fresco)
Influences Bernini
Pietro da Cortona *Born* 1596 Tuscany, Italy
Painted in Rome and Florence. *Died* 1669 Rome, Italy

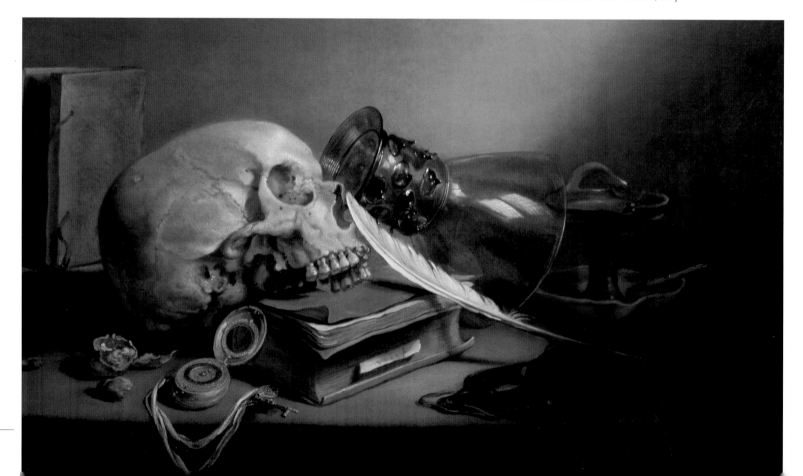

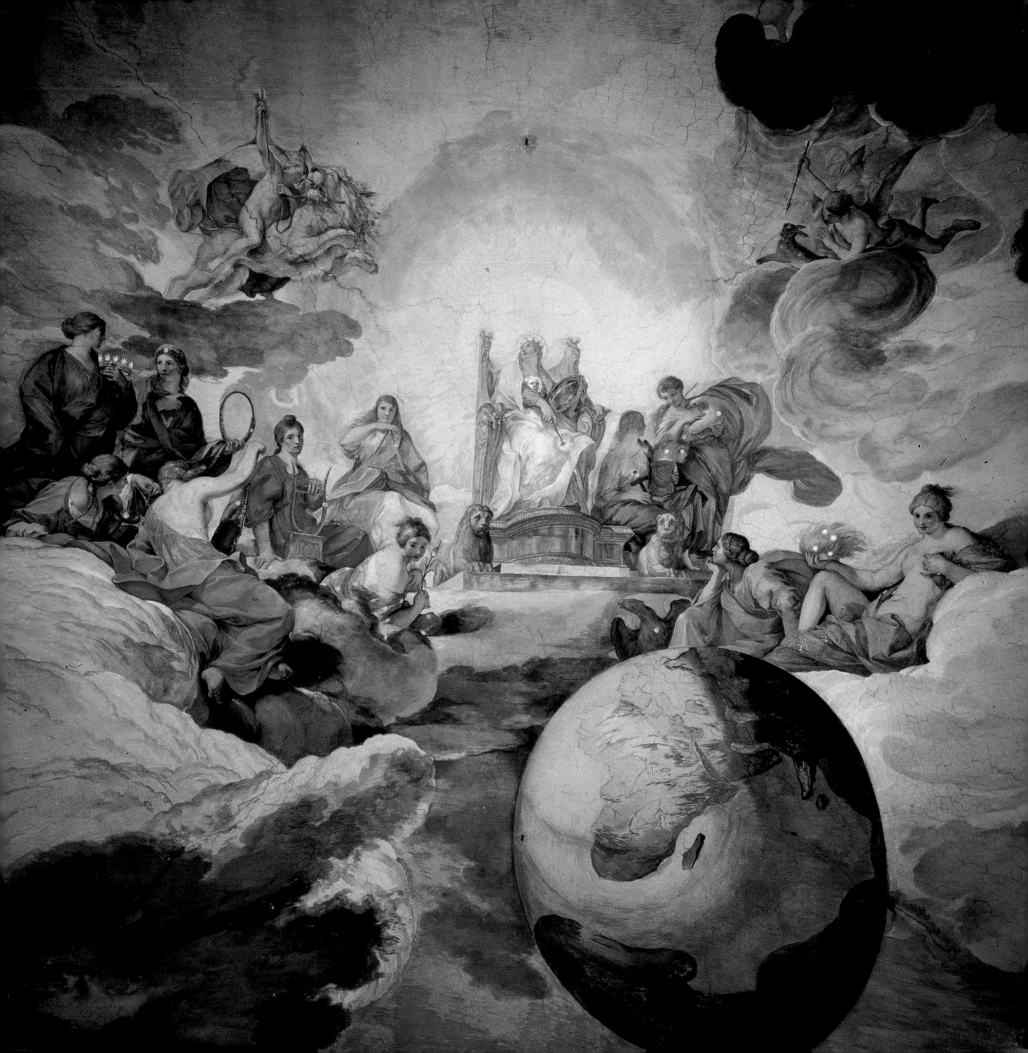

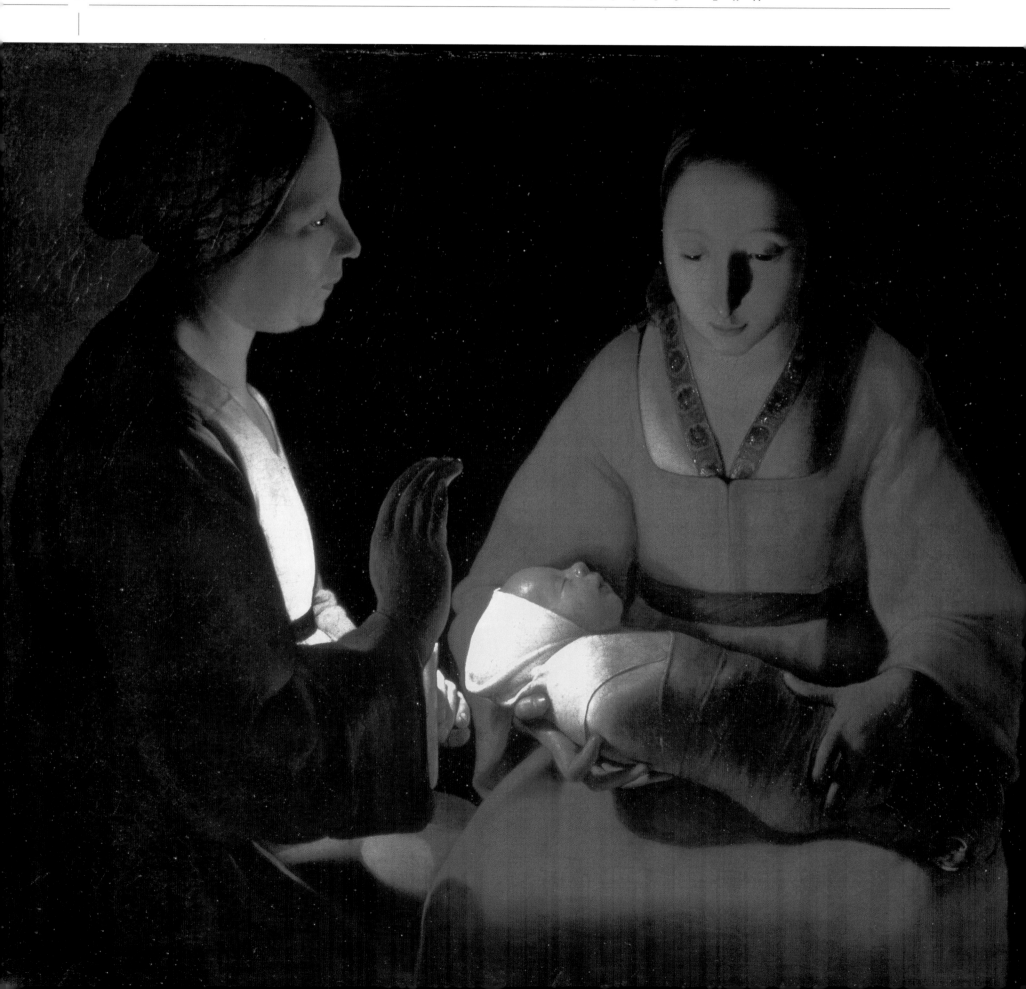

Georges de la Tour
The Newborn Child, late 1640s

Courtesy of Musee des Beaux-Arts, Rennes, France/Bridgeman Art Library

Born at Vic-sur-Seille, France, in 1593, Georges de la Tour established himself at Luneville about 1620, where he received many important commissions from the Duke of Lorraine. He also presented one of his paintings to King Louis XIII, who was so enchanted by it that he decided to remove paintings by all other artists from his private apartments. De la Tour concentrated on religious subjects, many of which were rather sombre with large areas of dark shadows and muted colours subtly illumined by a candle to create dark, dramatic and essentially realistic scenes. In this regard he was heavily influenced by Caravaggio and was, indeed, the leading French exponent of his particular brand of naturalism, although eschewing Caravaggio's penchant for the macabre. De la Tour's paintings exude serenity in keeping with their subject matter. Like his paintings, however, he languished in obscurity for many years and was not rediscovered until 1915.

Movement French School
Other Works *St Peter Denying Christ*
Influences Caravaggio
Georges de la Tour *Born* 1593 France. *Painted in* Luneville and Paris
Died 1652 Paris

Frans Hals
Portrait of a Gentleman, *c.* 1650–52

Courtesy of Private Collection/Christie's Images

Born at Antwerp about 1580, Frans Hals moved with his family to Haarlem at an early age and spent the whole of his life there. It is believed that he received his earliest instruction from Adam Van Noort in Antwerp but continued his studies under Van Mander. None of his earliest works appears to have survived, but from 1618 onwards, when he painted *Two Boys Playing* and *Arquebusiers of St George*, his works show great technical mastery allied to that spirit and passion which made him the equal of Rembrandt in portraiture. His most famous work, *The Laughing Cavalier* is universally recognized, but it is only one of many expressive portraits, distinguished by a liveliness that was far ahead of its time and anticipating the work of the Impressionists. After 1640 his work mellowed and he adopted a darker and more contemplative style.

Movement Dutch School
Other Works *Man with a Cane; Regents of the Company of St Elisabeth*
Influences Van Noort, Van Mander
Frans Hals *Born c.* 1580 Antwerp, Holland. *Painted in* Antwerp and Haarlem
Died 1666 Haarlem

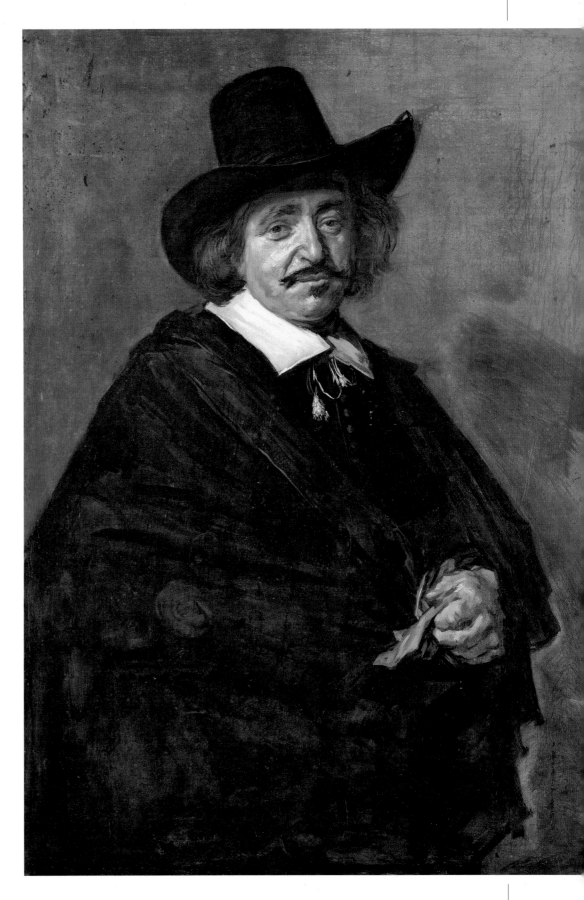

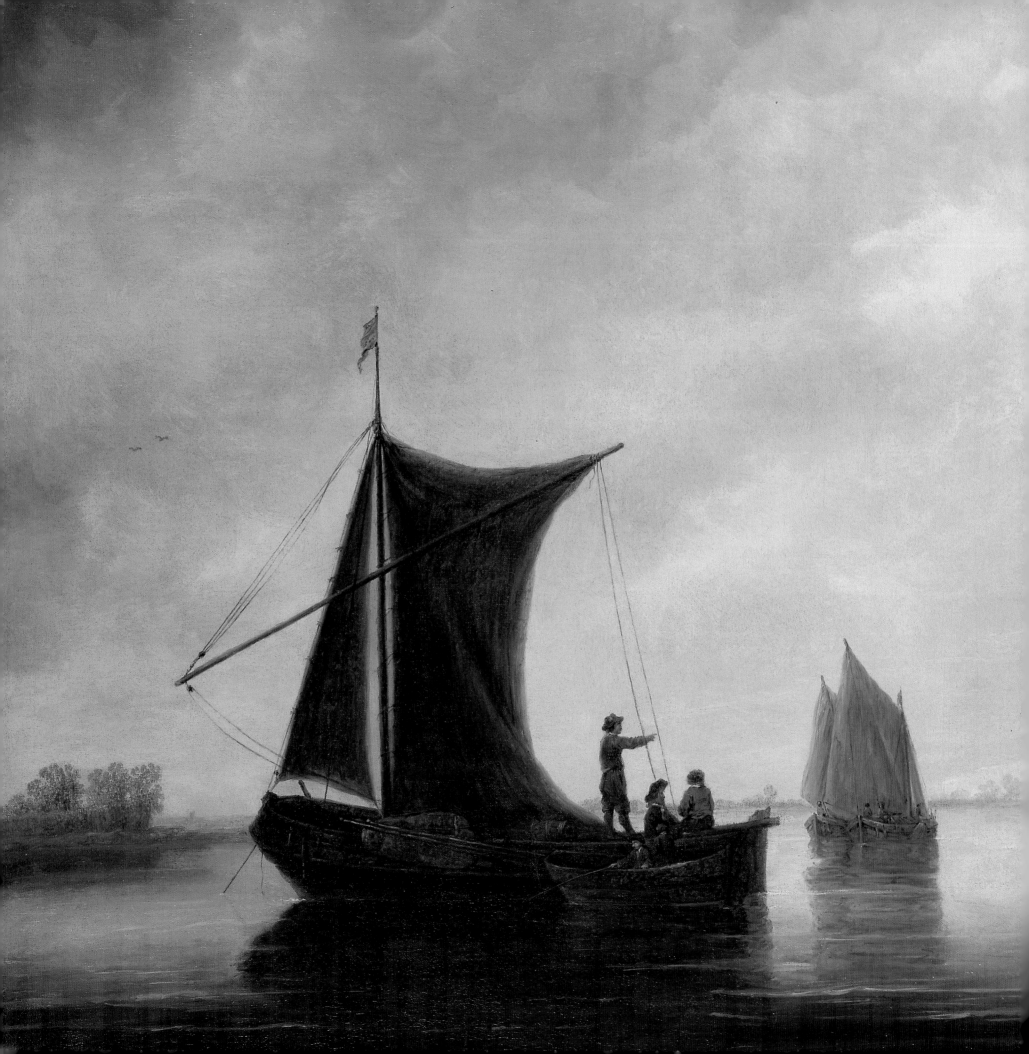

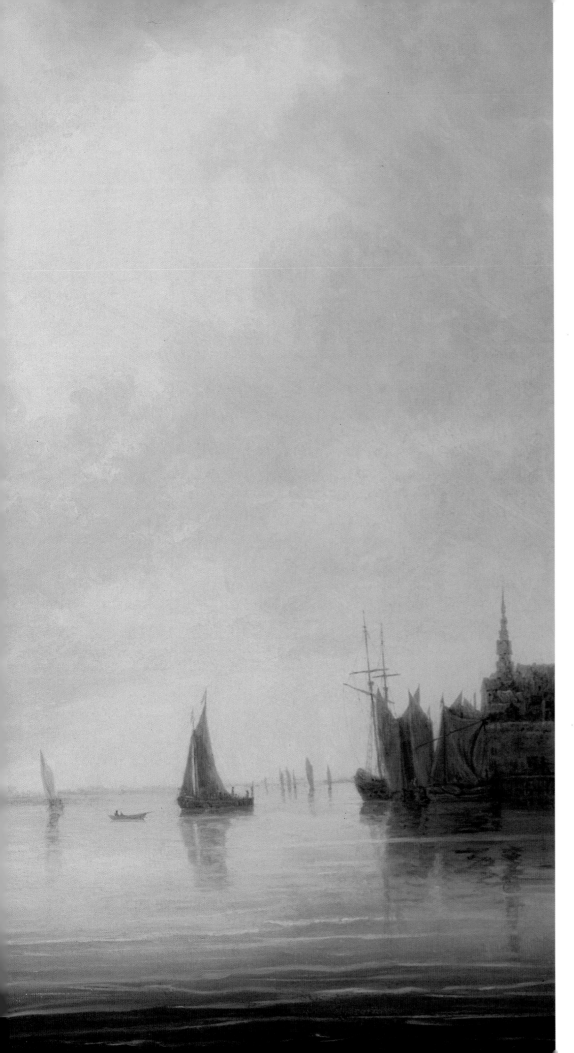

Albert Cuyp
The Maas at Dordrecht
with Fishing Boats

Courtesy of Private Collection/Christie's Images

Albert Cuyp, or Cuijp, was the son of the painter Jacob
Gerritsz Cuyp (1594–*c*. 1652), scion of a well-to-do
family. Controversy continues to rage over the extent of
his work, many paintings, particularly of still life, being
merely signed with the initials AC. On the other hand,
those paintings signed 'A Cuyp' are generally landscapes,
whose startling lighting effects are very characteristic of
his work. As the signed canvasses belong to his later
period, it has been argued that the AC paintings are
from his earliest years as a painter. He never strayed
beyond the Netherlands and his landscapes are bounded
by the Maas and the Rhine, but what the flatness of the
scenery lacks in variety is more than compensated for by
Cuyp's mastery of conveying the different seasons and
even different times of day, at their best suffusing the
figures of humans and animals with brilliant sunshine.

Movement Dutch School
Other Works *Dordrecht Evening;*
Cattle with Horseman and Peasants
Influences Van Goyen and Jan Both
Albert Cuyp *Born* 1620 Dordrecht, Holland
Painted in Dordrecht
Died 1691 Dordrecht

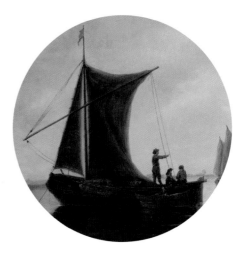

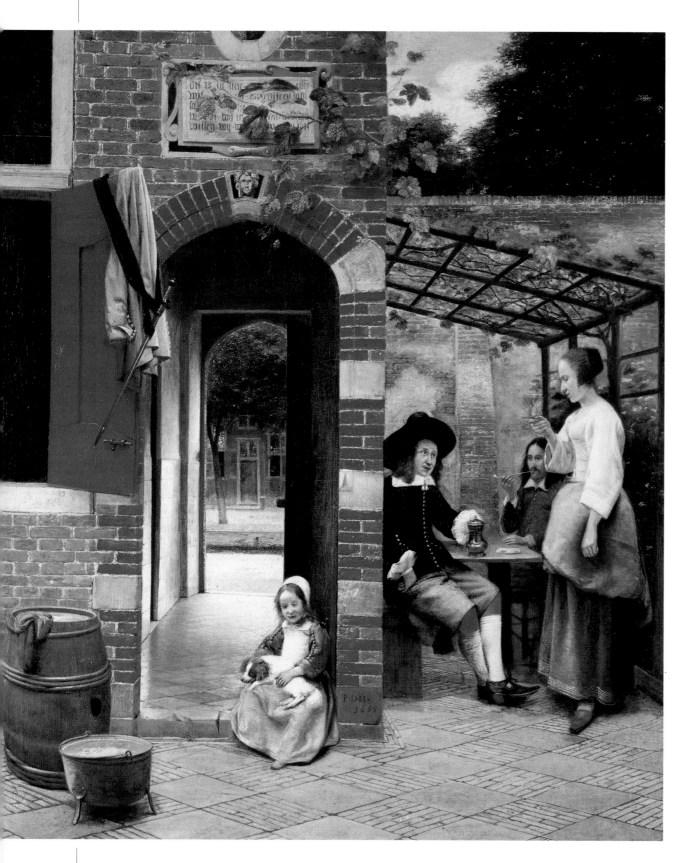

Pieter de Hooch
The Courtyard of a House in Delft, 1658

Courtesy of Noortman, Maastricht, Netherlands/Bridgeman Art Library

Pieter de Hooch spent his early life in Rotterdam but when he married in 1654 he settled in Delft. Here he came under the influence of Carel Fabritius shortly before the latter's untimely death in the explosion of the Delft Arsenal. De Hooch was subsequently influenced by the late artist's gifted pupil Jan Vermeer. De Hooch himself became one of the leading masters of paintings showing domestic interiors or courtyard scenes, with the emphasis on order, domestic virtue, cleanliness to the point of asceticism and benign tranquillity, shown through the careful arrangement of furniture and figures. His pictures are characterized by a dark foreground, often a doorway or gateway, leading to a bright interior suffused with light and colour. He was an accomplished technician, noted for his complete mastery of perspective which enabled him to create an almost three-dimensional effect.

Movement Dutch School
Other Works *Woman and a Maid with a Pail in a Courtyard*
Influences Carel Fabritius, Vermeer
Pieter de Hooch *Born* 1629 Rotterdam, Holland
Painted in Rotterdam and Delft, Holland
Died 1684 Amsterdam

Harmensz van Rijn Rembrandt

Self Portrait, 1658

Courtesy of Prado, Madrid/Bridgeman Art Library/Christie's Images

One of Holland's greatest and most versatile artists, Rembrandt trained under several painters, the most influential of these being Pieter Lastman. For a time he shared a studio with Jan Lievens, but by the early 1630s he had moved to Amsterdam, where he established a formidable reputation as a portraitist. Rembrandt's approach to group portraiture, in particular, was extremely ambitious. He showed the anatomist, Dr Tulp actually performing a dissection, while his most famous canvas, The Night Watch, is a stunningly complex composition portraying a local militia group.

As the 1640s progressed, Rembrandt's art entered a more reflective phase. He painted fewer fashionable portraits, preferring instead to depict the inner life. This can be seen in his magnificent religious paintings, in his intimate, unidealized portrayals of his two wives, Saskia and Hendrickje, and in a penetrating series of self-portraits – perhaps the finest ever produced by any artist. Rembrandt's later work was less commercially successful and, although this led to insolvency, the popular image of him as a reclusive pauper is entirely fictitious.

Movement Baroque
Other Works *The Night Watch; The Anatomy Lesson of Dr. Tulp; The Jewish Bride*
Influences Pieter Lastman, Jan Lievens, Rubens
Rembrandt *Born* 1606 Leiden, Holland
Painted in Holland
Died 1669

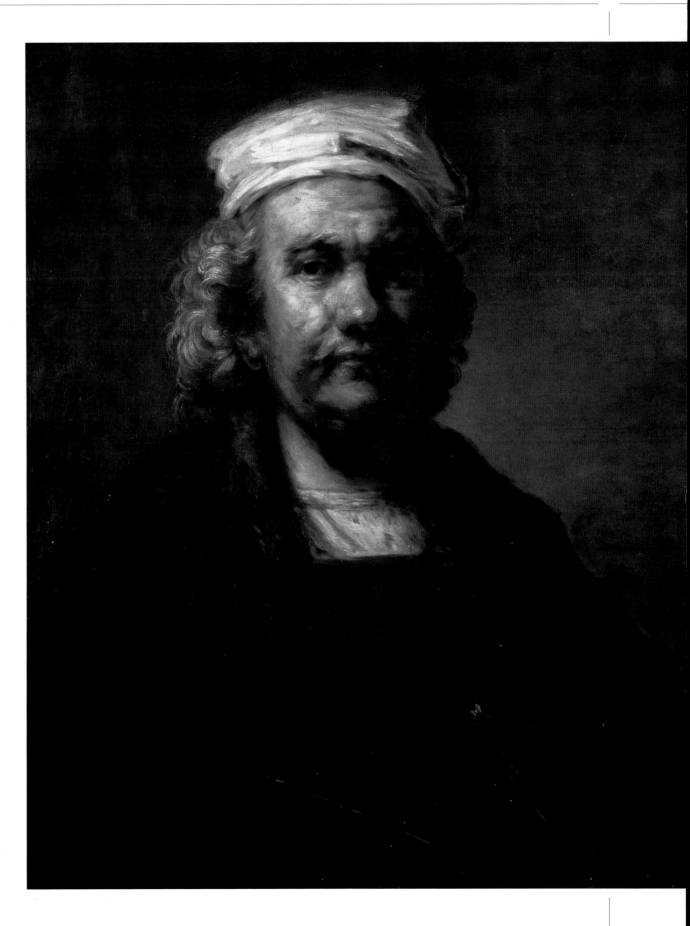

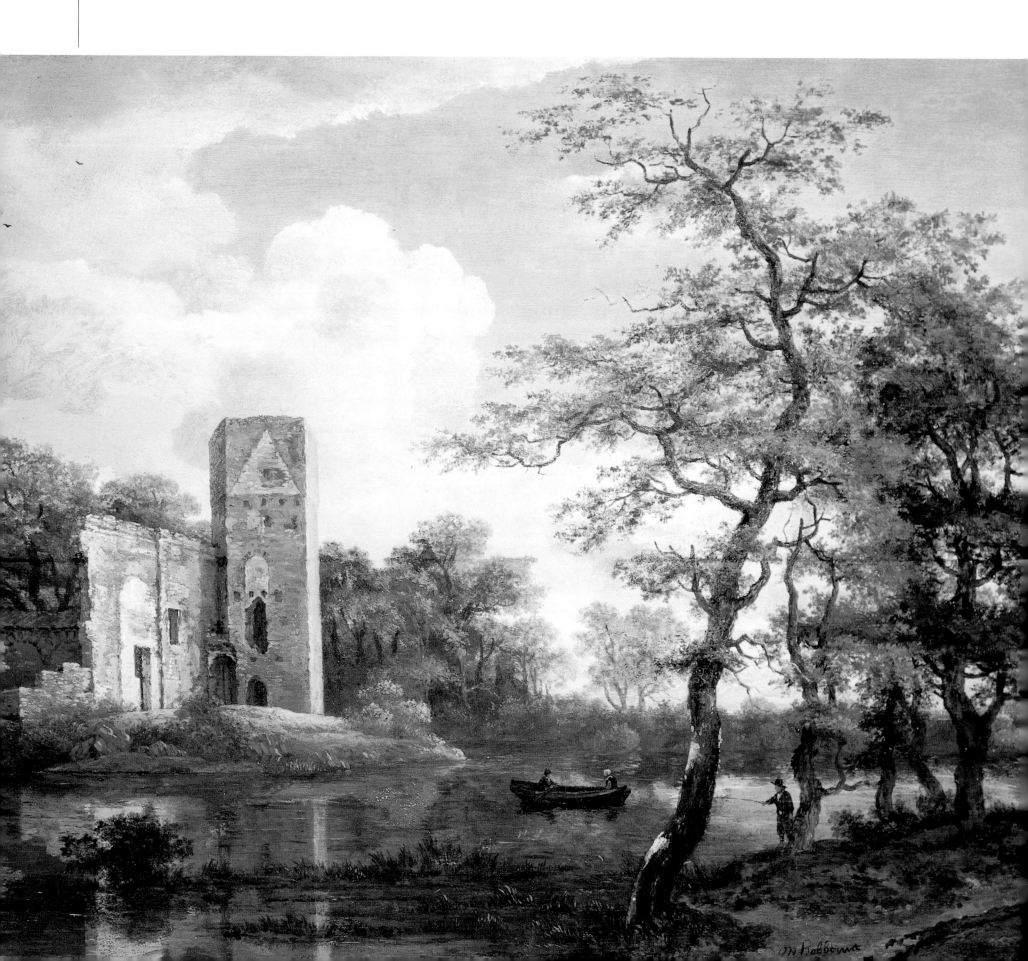

Meindert Hobbema
A River Landscape with a Ruined Building and Figures, *c.* 1660s

Courtesy of Private Collection/Christie's Images

Originally named Meindert Lubbertszoon, Hobbema studied under Jacob van Ruysdael in his native city. They were close friends and often painted the same subjects; as Hobbema lacked his master's genius in raising the dramatic temperature in his landscapes, Hobbema languished in his shadow. This must also have been the attitude of the picture-buying public at the time, for eventually Hobbema was obliged to forsake painting and work as an excise man, an arduous occupation that left him little time or inclination for art. While it is true that many of his paintings are not particularly distinguished, Hobbema at his best could be sublime and in recent times his painting has been the subject of considerable re-appraisal. It is generally recognized that his greatest achievement was *The Avenue, Middelharnis* – deceptively simple, yet a painting of immense subtlety and complex detail.

Movement Dutch School
Other Works *Stormy Landscape; Road on a Dyke; Watermill with a Red Roof*
Influences Jacob and Salomon van Ruysdael
Meindert Hobbema *Born* 1638 Amsterdam, Holland
Painted in Amsterdam. *Died* 1709 Amsterdam

Samuel Cooper
Miniature of James II as the Duke of York, 1661

Courtesy of Victoria & Albert Museum, London, UK/Bridgeman Art Library

Samuel Cooper is often regarded as the greatest painter of miniatures who ever lived; certainly he was instrumental in raising the status of miniature painting to new heights. He learned his skills from his uncle, John Hoskins. Pepys mentions Cooper frequently in his diaries and noted that he was a fine musician and a good linguist in addition to his artistic talents. He lived through turbulent times and had the distinction of holding official appointments both under the Commonwealth and later the Crown following the Restoration of 1660. He painted several portraits of both Oliver Cromwell and King Charles II, including the effigy of the King used for the coinage. As well as miniatures, painted on ivory or fine parchment, he was also a prolific draughtsman, his collection of chalk drawings being preserved in the University Gallery, Oxford.

Movement English Miniaturists
Other Works *John Aubrey; Mrs Pepys; Self Portrait*
Influences John Hoskins
Samuel Cooper *Born* 1609 London, England
Painted in London. *Died* 1672 London

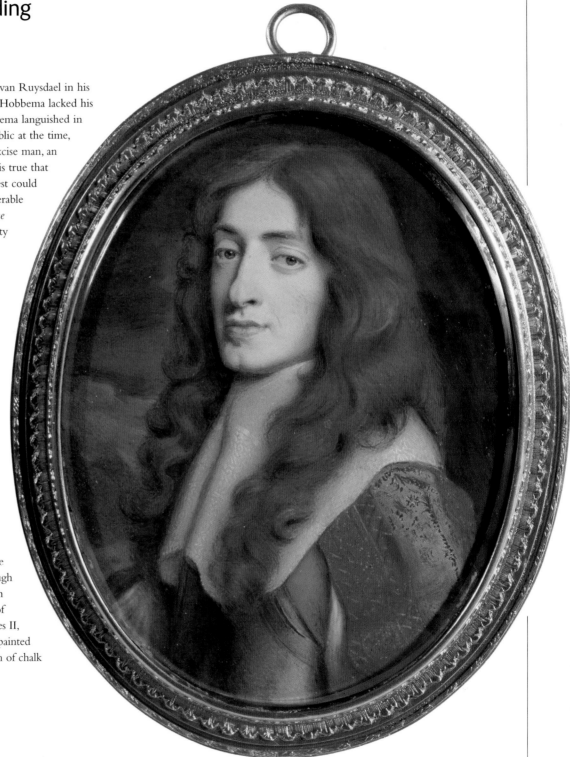

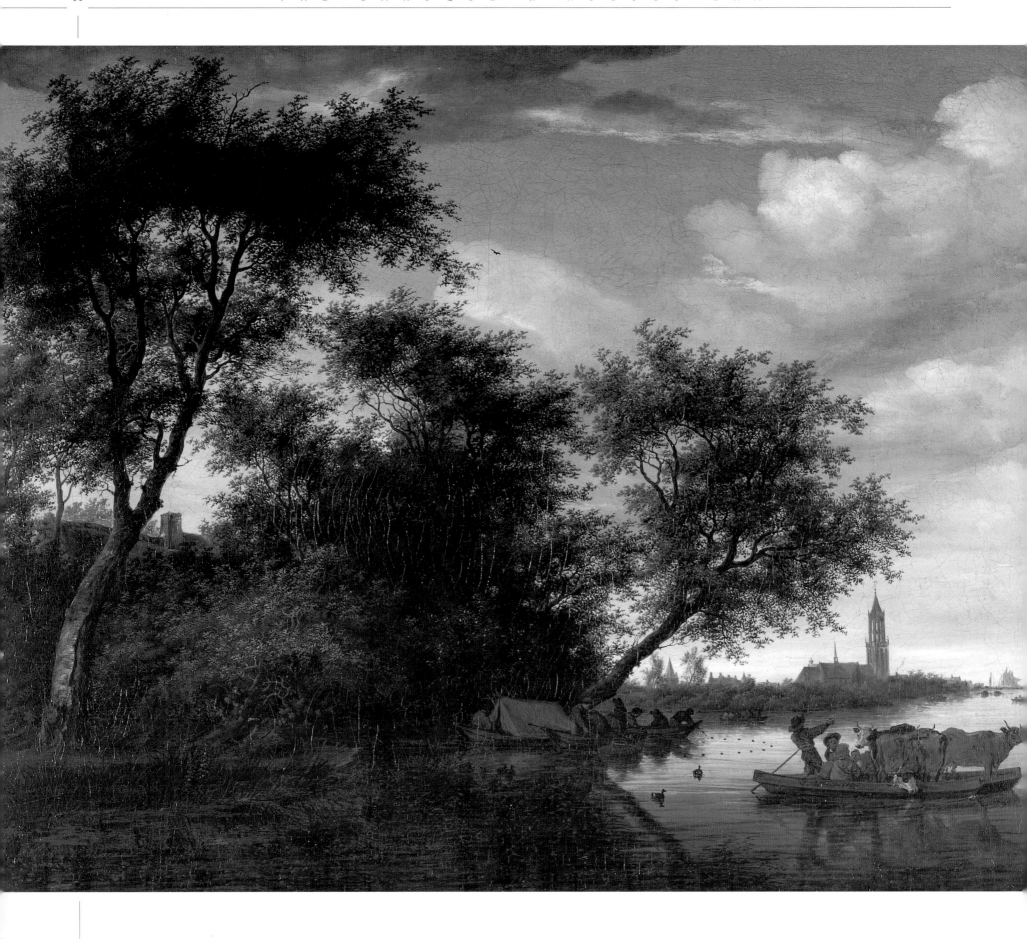

Salomon van Ruysdael
A Wooded Landscape with Cattle and Drovers on a Ferry, 1663

Courtesy of Private Collection/Christie's Images

Born at Naarden in Gooiland, Salomon Jacobsz van Ruysdael was originally Salomon de Gooyer, but he and his brother Isaack (1599–77) adopted the name 'Ruysdael' from a castle near their father's home. Salomon joined the Painters' Guild at Haarlem in 1623, becoming Dean in 1648. From 1651 he also had a business supplying blue dyes to the Haarlem bleachworks. His earliest dated works belong to 1626 and within two years of this his reputation as a landscape painter was assured. Although he remained in Haarlem all his life, he made occasional forays to other parts of the Netherlands in search of landscape subjects, noted for their fine tonal qualities, and laying the foundations for the great paintings of his much more famous nephew Jacob van Ruysdael. As well as his tranquil landscapes and river scenes, he produced a number of still-life paintings towards the end of his career.

Movement Dutch School
Other Works *Utrecht; Still Life*
Influences Esaias van de Velde, Jan van Goyen
Salomon van Ruysdael *Born c.* 1600 Holland
Painted in Haarlem, Holland. *Died* 1670 Haarlem

Jan Vermeer
Girl with a Pearl Earring, *c.* 1665–6

Courtesy of Mauritshuis, The Hague, Netherlands/Bridgeman Art Library

Jan Vermeer studied painting under Carel Fabritius. In 1653 he entered the Guild of St Luke taking the role of head there in 1662 and 1670. Diffident and a poor businessman, he died young, leaving a widow and eight children destitute. He was almost entirely forgotten until 1860, when he was rediscovered and works which had previously been attributed to other artists were properly identified as coming from his brush. He specialized in small paintings of domestic scenes, distinguished by their perspective and clever use of light to create subtle tones, as well as the fact that, unusual for the time, the figures in them are self-absorbed. Only about 40 paintings have definitely been credited to him, but they are sufficient to establish him as one of the more original and innovative painters of his time – second only to Rembrandt.

Movement Dutch School
Other Works *Lady Seated at a Virginal; The Painter in his Studio; View of Delft*
Influences Carel Fabritius
Jan Vermeer *Born* 1632 Delft, Holland
Painted in Delft. *Died* 1675 Delft

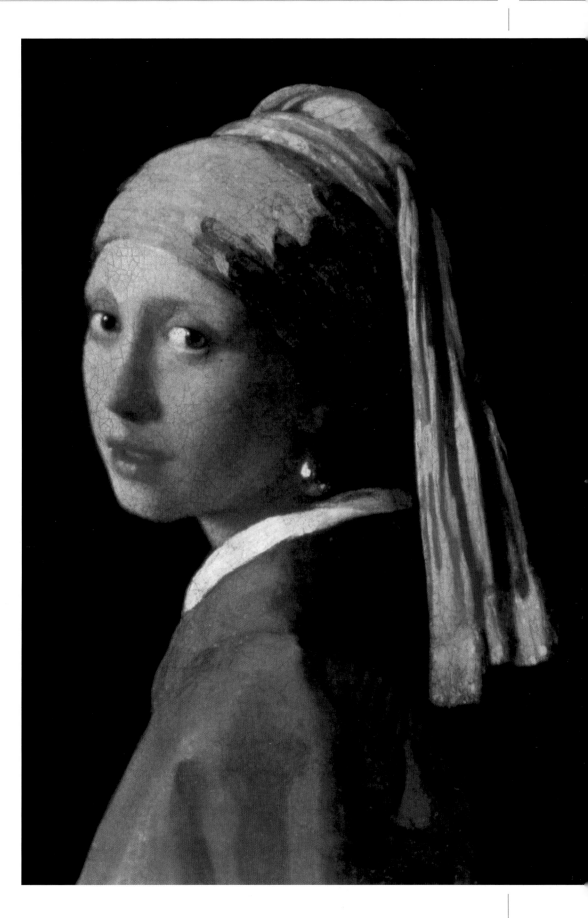

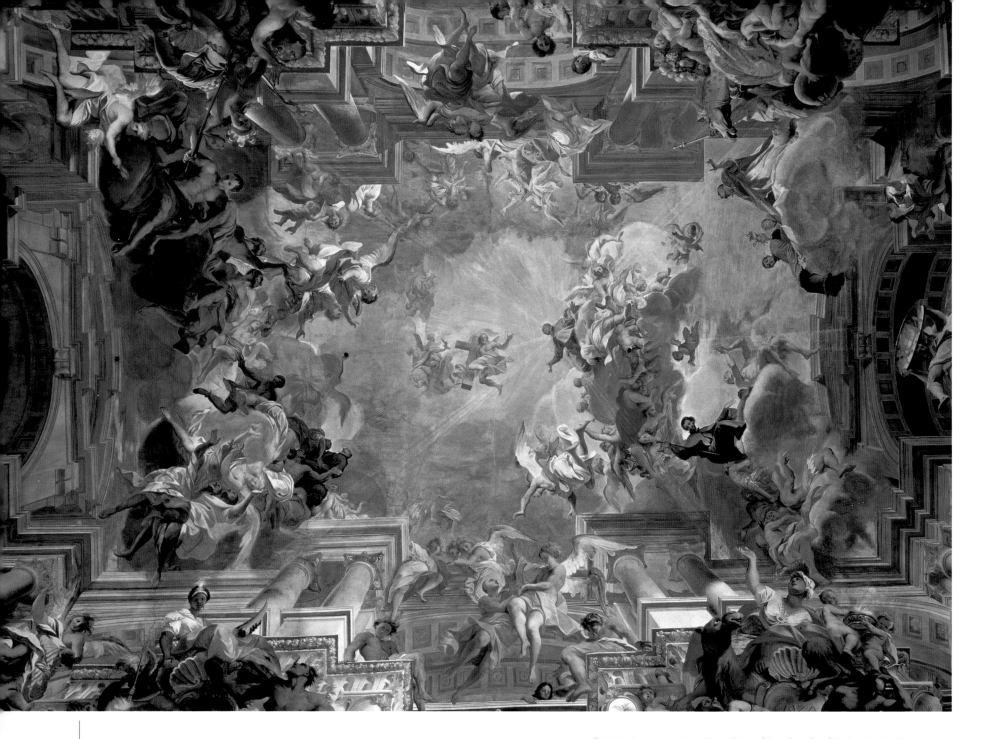

Andrea Pozzo

The Entry of Saint Ignatius
Into Paradise, c. 1707

Courtesy of Church of St Ignatius, Rome, Italy/Bridgeman Art Library

One of the most brilliant painters and architects of his generation, Andrea Pozzo was the pupil of an unknown master whom he accompanied to Milan, where he became a Jesuit lay brother. In this connection he was responsible for the decorations of religious festivals and from this graduated to theatrical sets. In 1676 he painted the frescoes for the church of San Francisco Saverio in Modovi, a masterpiece of trompe l'oeil. This was a foretaste of his greatest illusionistic masterpiece, the ceiling of the church of St Ignatius in Rome which, by an ingenious use of perspective, appears to expand the interior by hundreds of feet. In this immense achievement he united his talents as painter, architect and sculptor to great effect. In 1695 he designed the elaborate tomb of Ignatius Loyola, founder of the Society of Jesus. He worked on the decoration of many other churches in Italy and from 1703 onwards was similarly employed in Vienna.

Movement Italian Baroque
Other Works *St Francis Xavier Preaching; Investiture of St Francesco Borgia*
Influences Andrea Sacchi, Pietro da Cortona, Bernini
Andrea Pozzo *Born* 1642 Trento, Italy
Painted in Mondovi, Rome and Vienna, Austria
Died 1709 Vienna

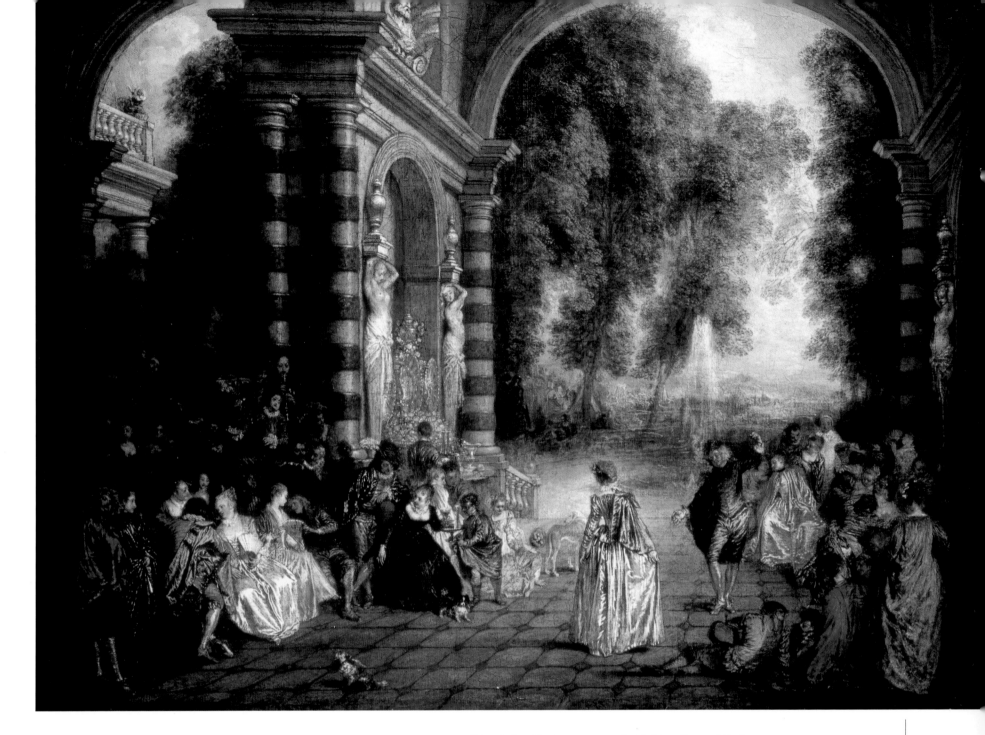

Jean-Antoine Watteau

Les Plaisir du Bal, c. 1714

Courtesy of Dulwich Picture Gallery, London, UK/Bridgeman Art Library

Jean-Antoine Watteau studied under Gérin but learned more from the paintings of Ostade and Teniers. On his master's death, Watteau went to Paris, where he worked for the scene-painter Métayer and then in a factory where he turned out cheap religious pictures by the dozen. He was rescued from this drudgery by Claude Gillot and later worked under Claude Audran. The turning point came when he won second prize in a Prix de Rome competition in 1709. He became an associate of the Academy in 1712 and a full member in 1717. He led the revolt against the pompous classicism of the Louis XIV period and broke new ground with his realism and lively imagination. His early works were mainly military subjects, but later he concentrated on rustic idylls which were very fashionable in the early eighteenth century.

Movement French School
Other Works *The Music Party; Embarkation for the Isle of Cythera*
Influences Claude Audran, David Teniers
Jean-Antoine Watteau *Born* 1684 France
Painted in Valenciennes and Paris
Died 1721 Nogent-sur-Marne, France

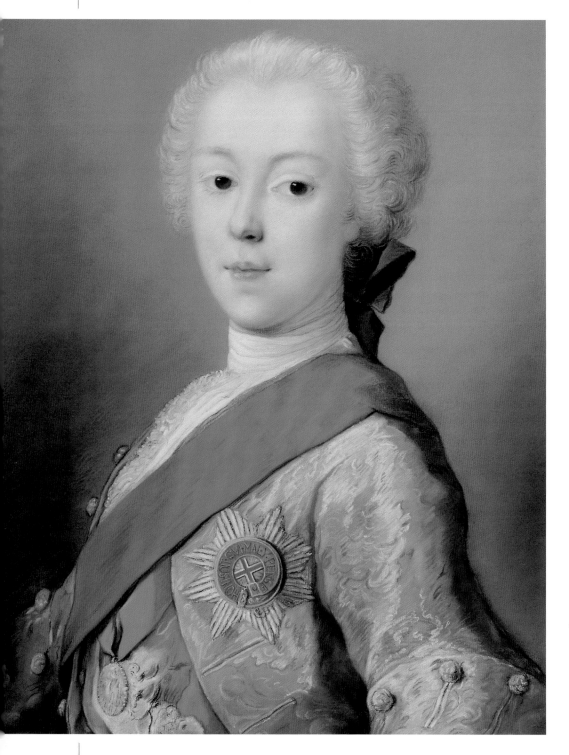

Rosalba Carriera
Portrait of Prince Charles Edward Stuart

Courtesy of Private Collection/Christie's Images

The daughter of the painter Andrea Carriera, Rosalba was taught by her father and worked in pastels and oils. She painted mostly miniature portraits in oils on ivory both for framing and mounting in snuff-boxes, but by the beginning of the eighteenth century she had diversified into larger portraits mainly executed in pastels. Soon gaining a high reputation in this medium, she was admitted to the Academy of St Luke at Rome in 1705. As well as formal portraits she painted genre subjects, mainly dealing with the everyday lives of women, latterly she also painted allegorical scenes and figures from classical mythology. Her style matured significantly from about 1711, and her portraits became much more expressive of the sitter's character. In 1720–22 she worked in Paris and was admitted to membership of the Académie Royale. From 1723 onwards she was much in demand at the courts of Europe to paint royal portraits.

Movement Venetian School
Other Works *Antoine Watteau; Empress Amalia; Lady Cutting her Hair*
Influences Andrea Carriera, Federico Bencovich, Giovanni Pellegrini
Rosalba Carriera *Born* 1675 Venice, Italy
Painted in Italy, France, Germany and Austria. *Died* 1757 Venice

William Hogarth
Beggars' Opera, 1728–31

Courtesy of Private Collection/Christie's Images

William Hogarth became the greatest English satirical artist of his generation. He was apprenticed to a silver-plate engraver, Ellis Gamble, and established his own business in 1720. Seeking to diversify into the more lucrative business of copper-plate engraving, however he took lessons in draughtsmanship under Sir James Thornhill. His early work consisted mainly of ornamental bill-heads and business cards, but by 1724 he was designing plates for booksellers and from this he progressed to individual prints, before turning to portrait painting by 1730. Within a few years he had begun to concentrate on the great satirical works on which his reputation now rests. His canvasses are absolutely crammed with figures and minute detail, sub-plots and side issues to the main theme. Following a visit to Paris in 1743 he produced several prints of low life and moral subjects. He also executed a number of portraits and oils of genre subjects.

Movement English School
Other Works *Marriage à la Mode; Industry and Idleness; Garrick as Richard III*
Influences Sir James Thornhill
William Hogarth *Born* 1697 London, England
Painted in London. *Died* 1764 London

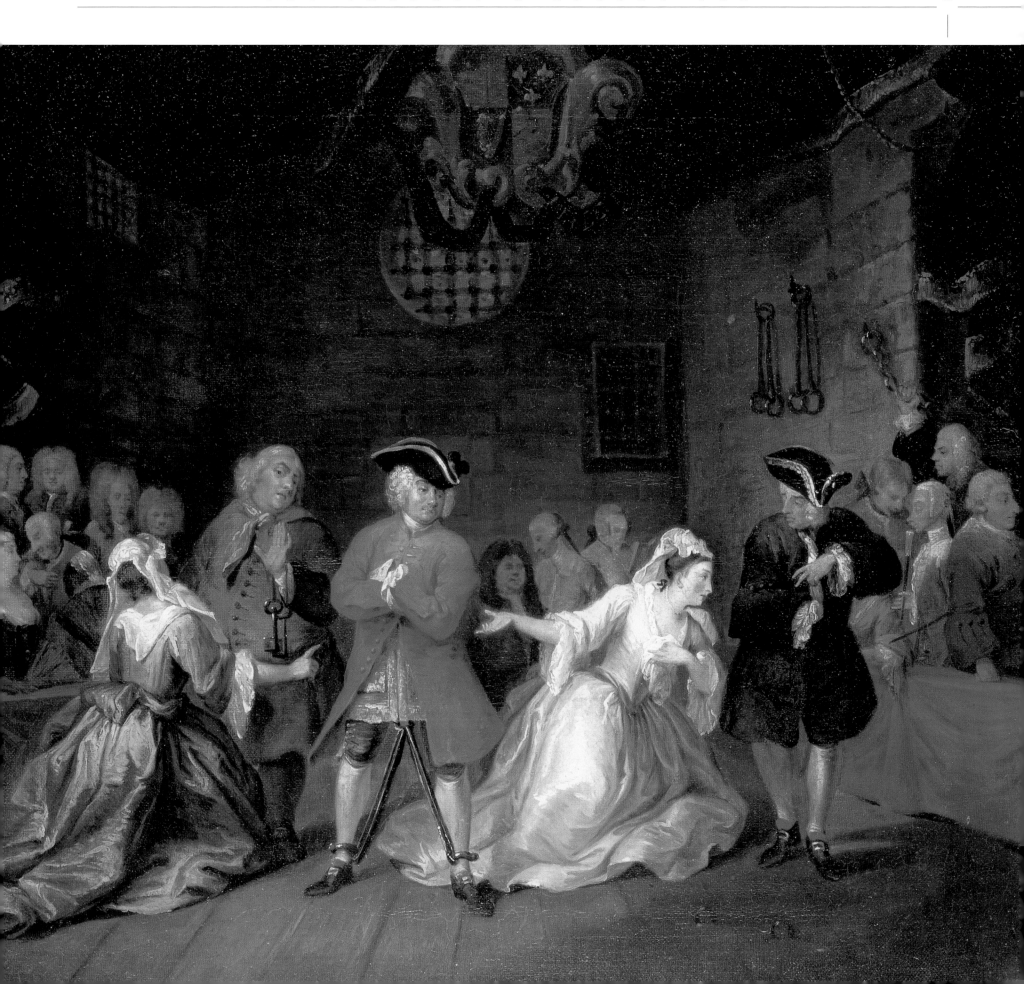

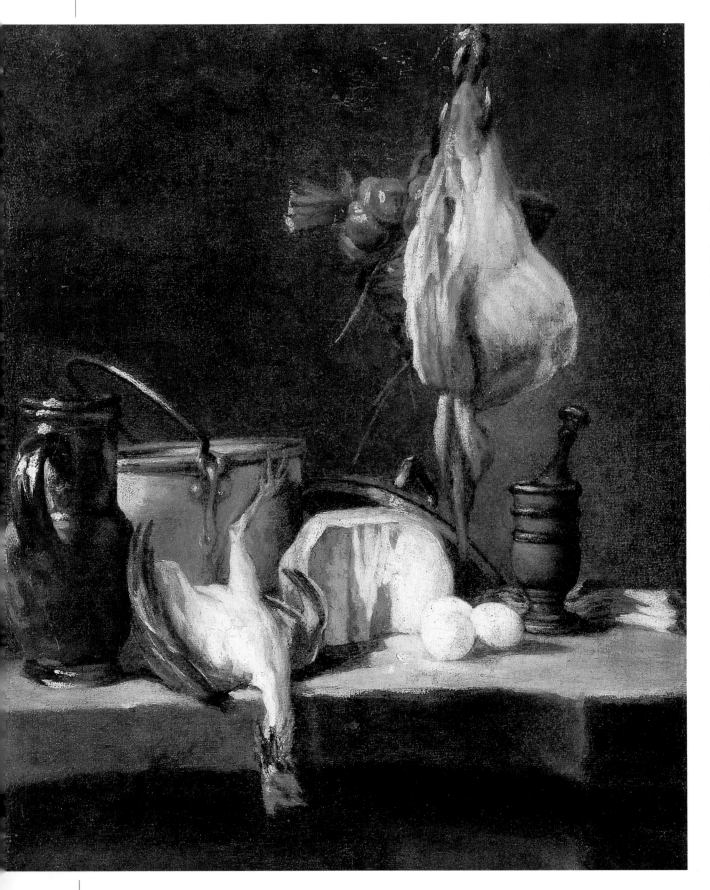

Jean-Baptiste-Siméon Chardin
Still Life with Ray and Basket of Onions, 1731

Courtesy of Private Collection/Christie's Images

A French painter specializing in still life and genre scenes, Chardin was born in Paris where he spent most of his life. His father was a carpenter and, initially, he seemed destined to follow this trade, until his aptitude for painting became apparent. As a youth, Chardin trained under two very minor history painters, Pierre Cazes and Noel-Nicolas Coypel, but this real education came from copying Dutch and Flemish paintings in private art collections. These prompted him to concentrate on still-life pictures – a brave decision, since this type of painting had a low reputation and was very poorly paid.

Despite these drawbacks, Chardin's career flourished. In 1728, *The Skate* won such acclaim at a Paris exhibition that he was invited to become a full member of the Academy, an unprecedented honour for a still life artist. Chardin was delighted and became a stalwart of the institution, holding the post of Treasurer for 20 years. Even so, he found it hard to make a living and, accordingly, extended his repertoire to include simple domestic scenes. These wonderful vignettes of everyday life displayed none of the affectation of the prevailing Rococo style and proved enormously popular with the public.

Movement Still life and genre
Other Works *Saying Grace, The Brioche*
Influences Nicolaes Maes; Jean-Baptiste Oudry
Jean-Baptiste-Siméon Chardin
Born 1699 Paris, France
Painted in France
Died 1779 Paris

Canaletto

Grand Canal, *c.* 1740

Courtesy of Private Collection/Christie's Images

Originally named Giovanni Antonio Canale, Canaletto was the son of a scene-painter in whose footsteps he at first followed. In 1719 he went to Rome to study architecture and on his return to Venice he began painting those great architectural masterpieces with which he has been associated ever since. Although most of his paintings illustrate the buildings and canals of his native city – executed as souvenirs for wealthy patrons from England making the Grand Tour – he lived mainly in London from 1746 to 1753. This is reflected in his paintings of the Thames and the City, and other views in the Home Counties. He then returned to Venice where he became a member of the Academy in 1763. He established a style of architectural painting that was widely imitated by the next generation of Italian artists, notably Francesco Guardi and his own nephew Bernardo Bellotto, who slavishly imitated him and even signed his works 'Canaletto'.

Movement Venetian School
Other Works *Piazza San Marco; Regatta on the Grand Canal*
Influences Tiepolo
Canaletto *Born* 1697 Venice, Italy
Painted in Venice and London
Died 1768 Venice

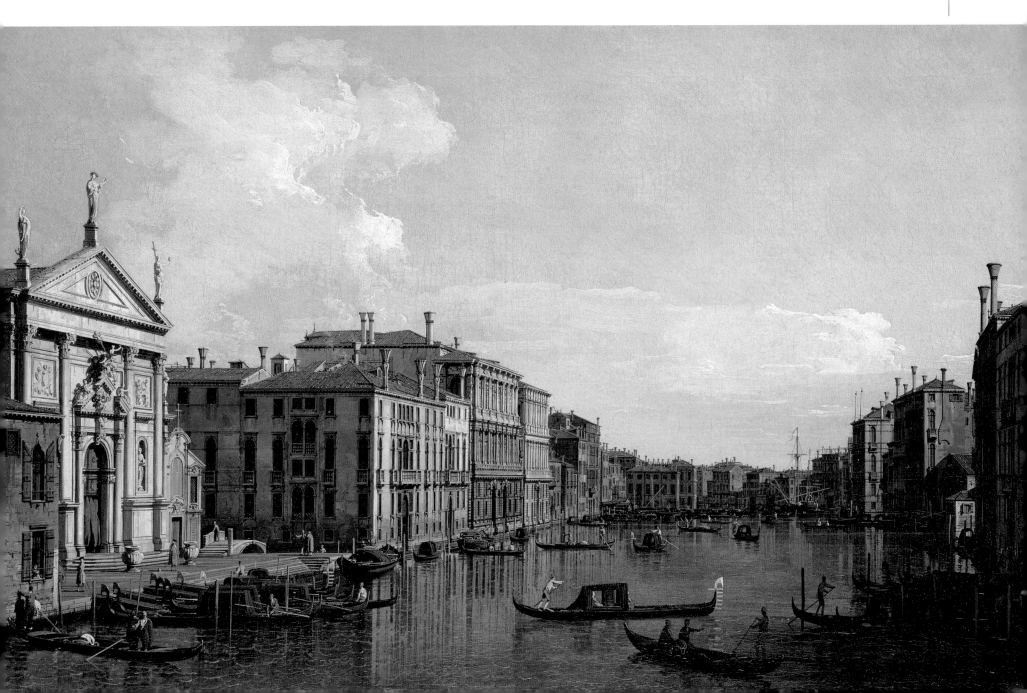

François Boucher

(attr. to) La Cible d'Amour ('The Target of Love'), 1758

Courtesy of Private Collection/Christie's Images

A French painter and designer, François Boucher was one of the greatest masters of the Rococo style. Born in Paris, Boucher was the son of a versatile, not particularly successful, artist and craftsman. As a result, he learned a wide variety of artistic techniques in his father's workshop before training more formally under François Lemoyne. Boucher's first significant job was to produce a set of engravings after Watteau's drawings, but he also found time to paint, winning the Prix de Rome in 1723. After making the traditional study-tour of Italy (1727–31), he began to gain official plaudits for his work. In 1735 he was granted his first royal commission and this secured his position as a court artist. This role governed the nature of Boucher's art. There were no grand, intellectual themes or moral dramas in his pictures. Instead, he painted light-hearted mythologies and pastoral idylls, which could serve equally well as paintings, tapestry designs or porcelain decoration. This is also evident in Boucher's work for his most distinguished patron, Madame de Pompadour. He immortalized her in a series of dazzling portraits, but also decorated her palace and designed sets for her private theatre.

Movement Rococo
Other Works *The Triumph of Venus; Mademoiselle O'Murphy*
Influences Watteau, Abraham Bloemaert, François Lemoyne
François Boucher *Born* 1703, Paris
Painted in France and Italy
Died 1770

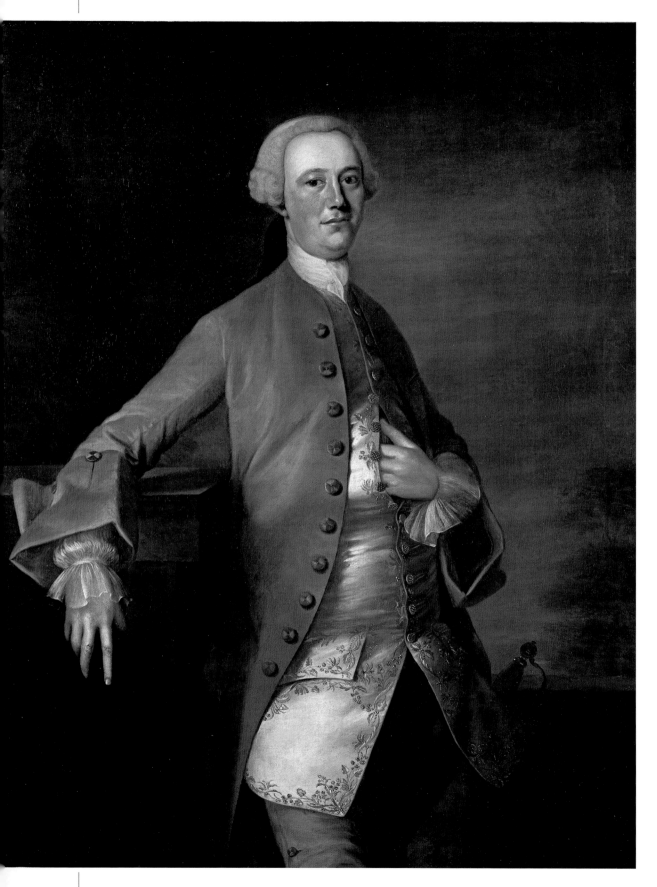

Thomas Gainsborough

Portrait of David Garrick, exhibited 1770

Courtesy of Private Collection/Christie's Images

Born in Sudbury, Suffolk Gainsborough displayed precocious artistic skills. According to family legend, he helped catch a pear thief in a neighbour's orchard by accurately sketching the culprit. Recognizing his obvious talent, his family sent him to London at the age of 13, where he was trained by the French Rococo artist Hubert Gravelot. In 1745, Gainsborough set up in business hoping to make a living selling landscapes, but the venture failed and he returned to Suffolk. Gainsborough preferred landscapes to 'face-painting', but found that portraiture was far more profitable. With this in mind, he eventually moved from Suffolk to the fashionable resort of Bath, where he was employed by a rich and illustrious clientele. Here, Gainsborough honed his skills to perfection, often painting by candlelight, in order to give his brushwork its distinctive, flickering appearance. By 1768, he was so famous that he was invited to become one of the founder members of the Royal Academy. Gainsborough accepted, and spent the final years of his career in London vying with Reynolds for supremacy in the field of portraiture.

Movement Rococo
Other Works *The Morning Walk; The Painter's Daughters Chasing a Butterfly*
Influences Hubert Gravelot, Van Dyck, Francis Hayman
Thomas Gainsborough *Born* 1727 England
Painted in England
Died 1788

Jean-Honoré Fragonard

Les Hazards heureux de l'escarpolette ('The Swing'), 1767

Courtesy of Wallace Collection, London, UK/Bridgeman Art Library

A leading exponent of the light-hearted Rococo style, Fragonard trained under Boucher (Madame de Pompadour's favourite artist) and won the Prix de Rome, both of which seemed to mark him out for a conventional career as a history painter. But he was too ill-disciplined to enjoy the business of copying old masters and his studies in Rome (1756–60) did not progress well. Instead, the Italian countryside awakened Fragonard's interest in landscape painting while, on his return to France, the success of *The Swing* led his art in a different direction.

The Swing demonstrated Fragonard's undoubted gift for playful eroticism, and it brought him a series of commissions for similar 'boudoir' pictures. Patrons were attracted by his dazzling, vivacious style and by his innate sense of taste, which strayed close to the margins of decency, but never crossed them. In this sense, Fragonard became the archetypal painter of the Ancien Régime and ultimately shared its fate. By the 1780s, Neoclassicism had all but supplanted the Rococo style and, although he received help from David after the Revolution in 1789, Fragonard's later years were marred by poverty and neglect.

Movement Rococo
Other Works *The Progress of Love; The Bolt; The Love Letter*
Influences François Boucher, Hubert Robert, Tiepolo
Jean-Honoré Fragonard *Born* 1732 France
Painted in France and Italy
Died 1806

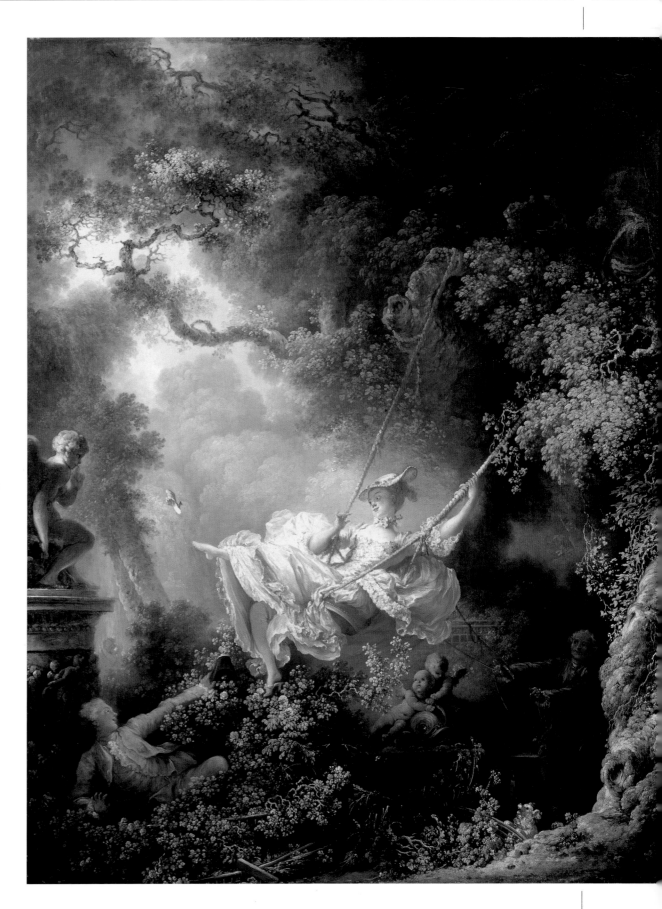

The Neoclassic
& Romantic Era

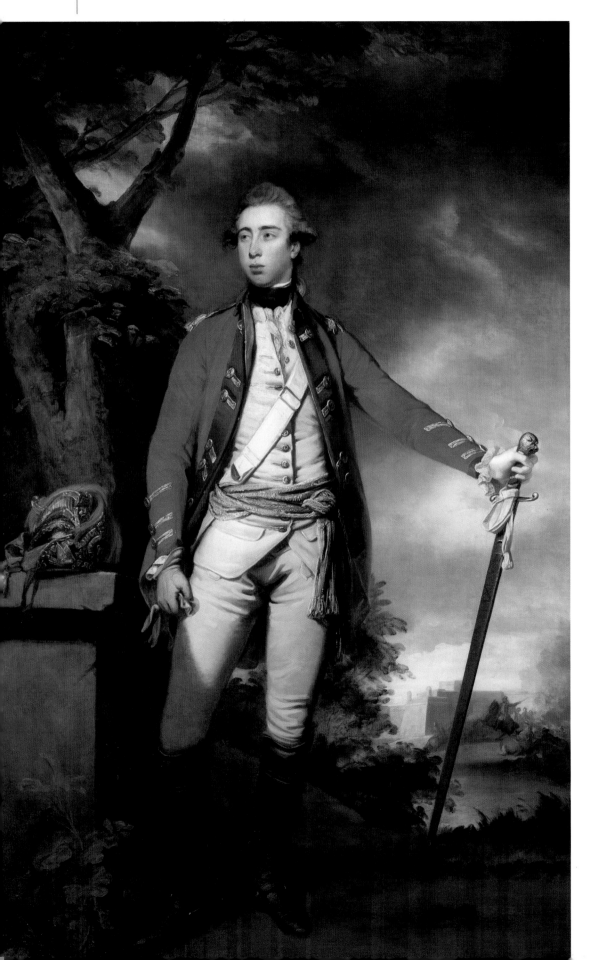

Sir Joshua Reynolds
George Townshend

Courtesy of Private Collection/Christie's Images

Born in Plympton, Devon, Joshua Reynolds was apprenticed in London to Thomas Hudson, a second-rate portrait painter, from whom he learned the rudiments of his craft. In 1743 Reynolds settled in Plymouth, but in 1744 he returned to London where his portrait of Captain John Hamilton, brought him recognition. Reynolds spent two years in Rome perfecting his technique, then visited other Italian art centres, before returning to England in 1752. By 1760 he was the most fashionable portrait painter in London, becoming the first President of the Royal Academy in 1768 and knighted a year later. A prolific artist, he produced over 2,000 portraits, many of which were subsequently published as engravings that further enhanced his reputation.

Movement English School
Other Works *Nelly O'Brien; Samuel Johnson*
Influences Thomas Hudson, Sir Peter Lely
Sir Joshua Reynolds *Born* 1723 England
Painted in London, England. *Died* 1792 London

Henry Fuseli
(Johann Heinrich Füssli)
The Birth of Sin

Courtesy of Private Collection/Christie's Images

A painter and graphic artist, Fuseli was a key figure in the English Romantic movement. Born in Zurich, the son of a town clerk and amateur painter, Fuseli trained as a minister in the Swiss Reformed Church. He was ordained in 1761, but turned to art in 1768, after receiving encouragement from Sir Joshua Reynolds. Pursuing this ambition, he spent several years in Italy (1770–78), where he was impressed, above all, by Michelangelo's vision of the Sublime – a mood which he tried to capture in many of his own paintings.

In 1778, Fuseli moved to London, making this his principal artistic base. He cemented his reputation with *The Nightmare*, which was exhibited at the Royal Academy in 1782. Fuseli made several versions of this haunting image, which is undoubtedly his most famous work. Although the picture may have had a purely personal meaning for him – the expression of his unrequited passion for a Swiss girl – it has become one of the landmarks of Romanticism. In it, as in his other works, the artist focused on the darker side of the imagination, weaving together elements of horror, fantasy and eroticism.

Movement Romanticism
Other Works *Titania's Awakening; The Ladies of Hastings*
Influences Michelangelo, William Blake, Sir Joshua Reynolds
Henry Fuseli *Born* 1741 Switzerland.
Painted in England, Italy, Switzerland and Germany. *Died* 1825

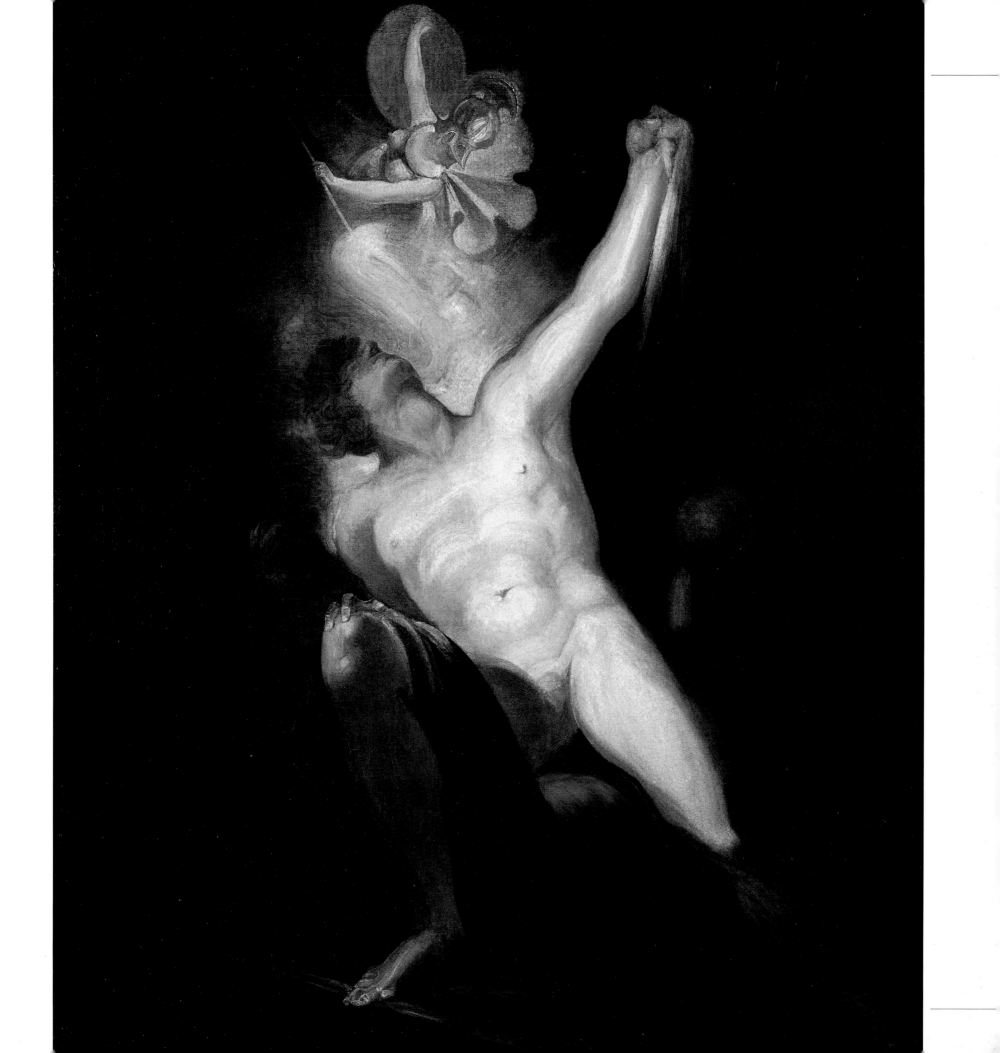

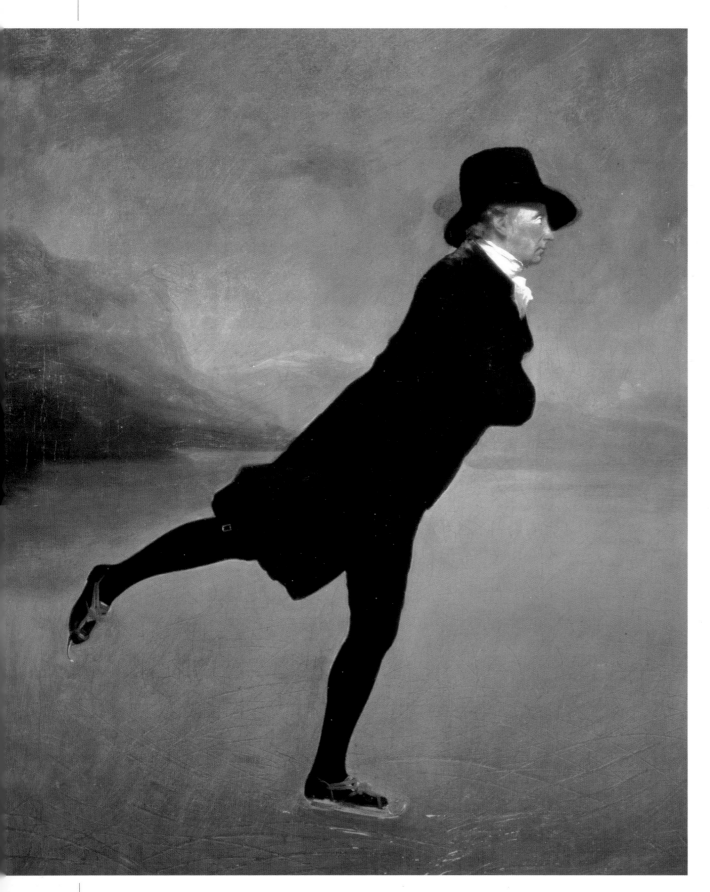

Sir Henry Raeburn

The Reverend Robert Walker Skating on Duddington Loch, 1784

Courtesy of National Gallery of Scotland, Edinburgh, Scotland/Bridgeman Art Library

Henry Raeburn was originally apprenticed to a goldsmith but began painting portrait miniatures and soon expanded to full-scale oil paintings, though entirely self-taught. After marrying one of his sitters, a wealthy widow, he was enabled to travel to Italy to study for two years, mainly under Pompeo Batoni. He returned to Edinburgh in 1787 and established himself as the most fashionable portraitist of his generation. Unlike Ramsay, he spent most of his life in Edinburgh and seldom visited London. He became a full member of the Royal Academy in 1815. In 1823 he was appointed His Majesty's Limner for Scotland and was knighted the same year. Although his contemporaries judged him less successful in his female subjects, his portraits of both men and women are full of vigour and liveliness and had a profound influence on the development of Scottish art in the nineteenth century.

Movement British School of Portraiture
Other Works *Self Portrait; Sir Walter Scott; Mrs Robert Bell*
Influences Allan Ramsay, Pompeo Batoni, Sir Joshua Reynolds
Sir Henry Raeburn *Born* 1756 Scotland
Painted in Edinburgh and Rome
Died 1823 Edinburgh

George Romney

Portrait of Emma, Lady Hamilton, 1786

Courtesy of Philip Mould, Historical Portraits Ltd, London, UK/Bridgeman Art Library

An English painter specializing in portraits, Romney was born in Lancashire, the son of a cabinet maker, and trained under an itinerant portraitist named Christopher Steele. For a time, he picked up commissions by travelling from town to town, before making his base in Kendal. Moving to London in 1762, he established a reputation as a fashionable portrait painter, although his style did not really mature until after his tour of Italy (1773–75). There, his study of Classical and Renaissance art paid huge dividends and most of his best paintings were produced in the decade after his return to England.

Romney, like Gainsborough, was deeply dissatisfied with portraiture. His ambition of becoming a history painter was never fulfilled, perhaps partly because of his nervous, introspective character and partly because of his reluctance to exhibit. His later career was marred by his obsession with Emma Hart, later to become Lady Hamilton and Nelson's mistress. Romney met her in 1781, and in the years that followed produced dozens of pictures of her, usually masquerading as a character from mythology. As his reputation began to wane, the artist returned to Kendal, where he suffered a serious mental decline.

Movements Neoclassicism, Romanticism
Other Works *The Parson's Daughter; The Beaumont Family; Lady Rodbard*
Influences Sir Joshua Reynolds, Henry Fuseli, Joseph Highmore
George Romney *Born* 1734 England
Painted in England and Italy
Died 1802

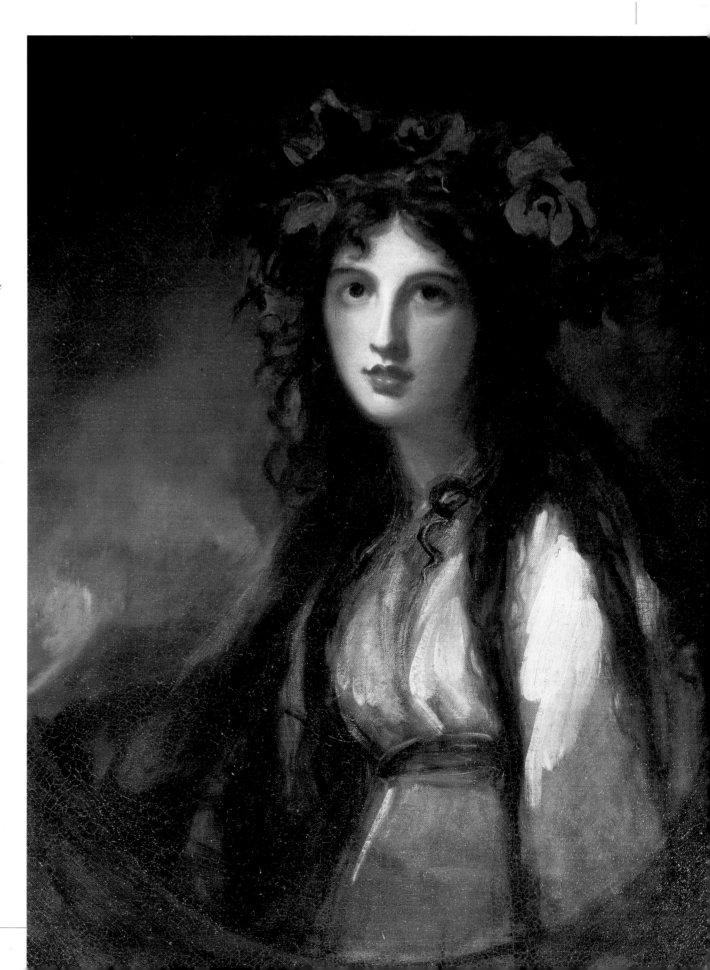

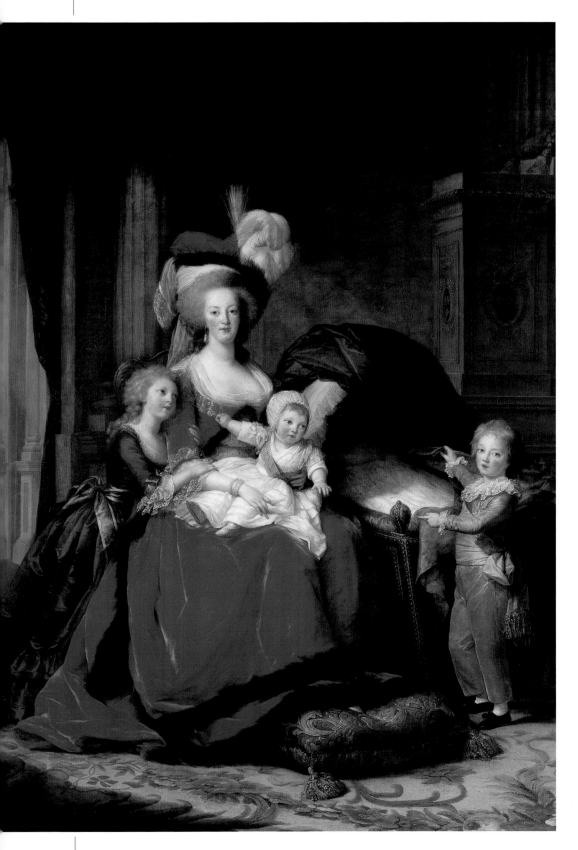

(Marie Louise) Elisabeth Vigée-Lebrun

Marie Antoinette and her Four Children, 1787

Courtesy of Chateau de Versailles, France/Bridgeman Art Library

Marie Louise Elisabeth Vigée-Lebrun was the daughter of an artist from whom she received her early training, but later benefited from the help of several fellow-painters. By the age of 20 she had already made her mark with portraits of Count Orloff and the Duchess of Orleans. In 1783 she was admitted to the Academy on the strength of her allegorical masterpiece *Peace Bringing Back Abundance*. Following the outbreak of the Revolution she fled to Italy and worked in Rome and Naples, later visiting Vienna, Berlin and St Petersburg. She returned briefly to Paris in 1802 but went to London the same year, where she painted the Prince of Wales and Lord Byron. She was a prolific portraitist and a score of her paintings portray Marie Antoinette alone.

Movement French School
Other Works *Portrait of the Artist and her Daughter*
Influences Joseph Vernet, Jean Baptiste Grueze, Charles Lebrun
Elisabeth Vigée-Lebrun *Born* 1755 France
Painted in France, England and Europe. *Died* 1842 Paris

Thomas Girtin

Dunstanborough Castle, *c.* 1797

Courtesy of Private Collection/Christie's Images

Thomas Girtin served his apprenticeship in London as a mezzotint engraver under Edward Dayes, through whom he made the acquaintance of J. M. W. Turner who, being shown Girtin's architectural and topographical sketches, encouraged him to develop his talents as a landscape painter. His early death in 1802 from tuberculosis brought a very promising career to an untimely end, but even by then he had established a high reputation as an etcher. Hitherto, watercolours had been used almost entirely for tinting engravings, but to Girtin goes the credit for establishing watercolour painting as a major art form in its own right. From 1794 onwards he exhibited his great watercolour landscapes at the annual Royal Academy exhibitions and this helped to develop the fashion for this medium from the beginning of the nineteenth century. Girtin collaborated with Turner in making a series of copies of architectural paintings for Dr Monro, notably works by Canaletto.

Movement English School
Other Works *A Winding Estuary; Porte St Denis*
Influences Turner
Thomas Girtin *Born* 1775 London, England
Painted in London. *Died* 1802 London

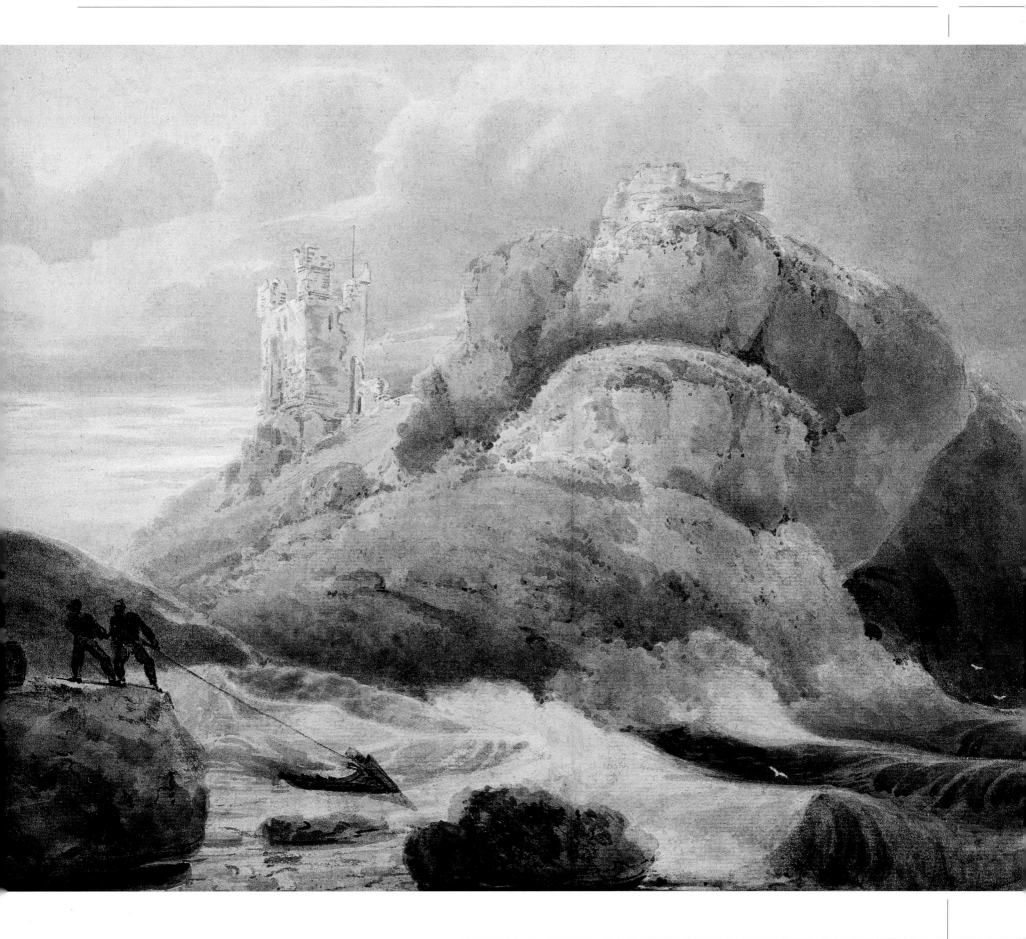

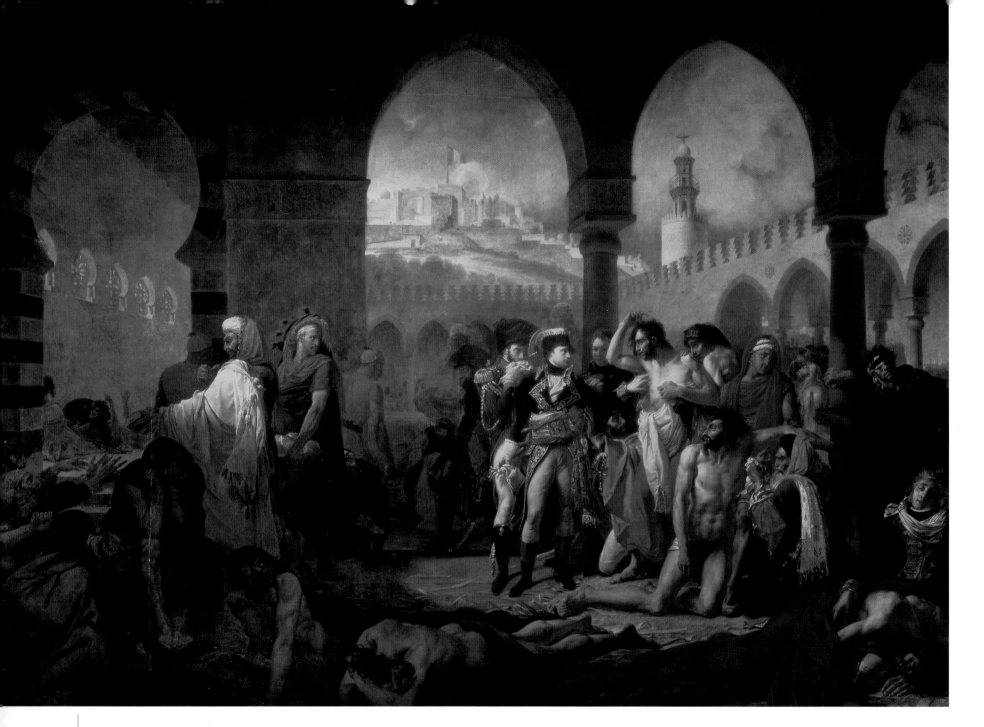

Antoine-Jean Gros

Napoleon Bonaparte Visiting the
Plague Stricken of Jaffa, 1799

The son of a miniature painter, Antoine-Jean Gros studied under Jacques-Louis David. Following the death of his father in 1791 he went to Italy and it was there that he met Josephine Beauharnais, who introduced him to Napoleon, whom he accompanied on his Italian campaign. He was an eye-witness of the dramatic scene when Bonaparte planted the Tricolour on the bridge at Arcole in November 1796 and the dramatic painting that recorded this incident gave Gros a sense of purpose. Thereafter, as a war artist, he chronicled on canvas the exploits of the Napoleonic army down to the campaign of 1811, and it is on these heroic paintings that his reputation is largely based, earning him the Napoleonic title of Baron in the process. The downfall of Napoleon robbed Gros of his true vocation. In the aftermath of Waterloo he returned to his classicist roots and concentrated on such works as *Hercules and Diomedes*, but by now he was fighting a losing battle against the rising tide of Romanticism.

Movement French Classicism
Other Works *The Departure of Louis XVIII*
Influences Jacques-Louis David
Antoine-Jean Gros *Born* 1771 Paris, France
Painted in France and Italy
Died 1835 Bas-Meudon, France

Francisco Goya
The Clothed Maja, *c.* 1800–05

Courtesy of Prado, Madrid, Bridgeman Art Library/Christie's Images

Francisco José de Goya y Lucientes was raised in the small town of Fuendetodos near Saragossa, Spain. Frequently involved in parochial gang fights, he fled to Madrid in 1765 after a brawl in which three youths were killed. As a result of continued sparring he left Madrid precipitately, joining a troupe of itinerant bull-fighters and eventually reaching Rome, where he resumed his studies in art. In 1798 he returned to Spain as a designer for the royal tapestry factory and executed a number of frescoes drawn from contemporary life, as well as a series of satirical etchings. In 1799 he was appointed court painter to Charles IV, which resulted in some of his most notable portraits. After the French invasion in 1808 he sided at first with the invaders, but secretly sketched their atrocities, which resulted in both full-scale canvasses and numerous etchings. In 1824 he moved to Bordeaux where, in old age, he produced some of his finest genre paintings.

Movement Spanish School
Other Works *Execution of the Defenders of Madrid; The Naked Maja*
Influences Anton Raphael Mengs, Tiepolo
Francisco Goya *Born* 1746 Fuendetodos, Spain
Painted in Madrid and Bordeaux
Died 1828 Bordeaux

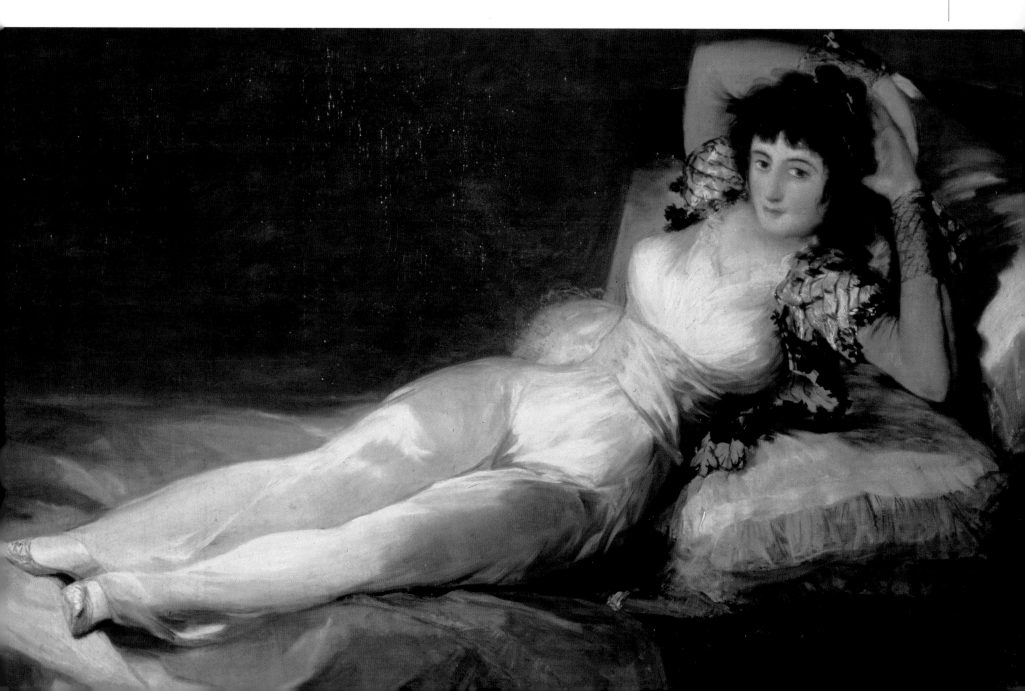

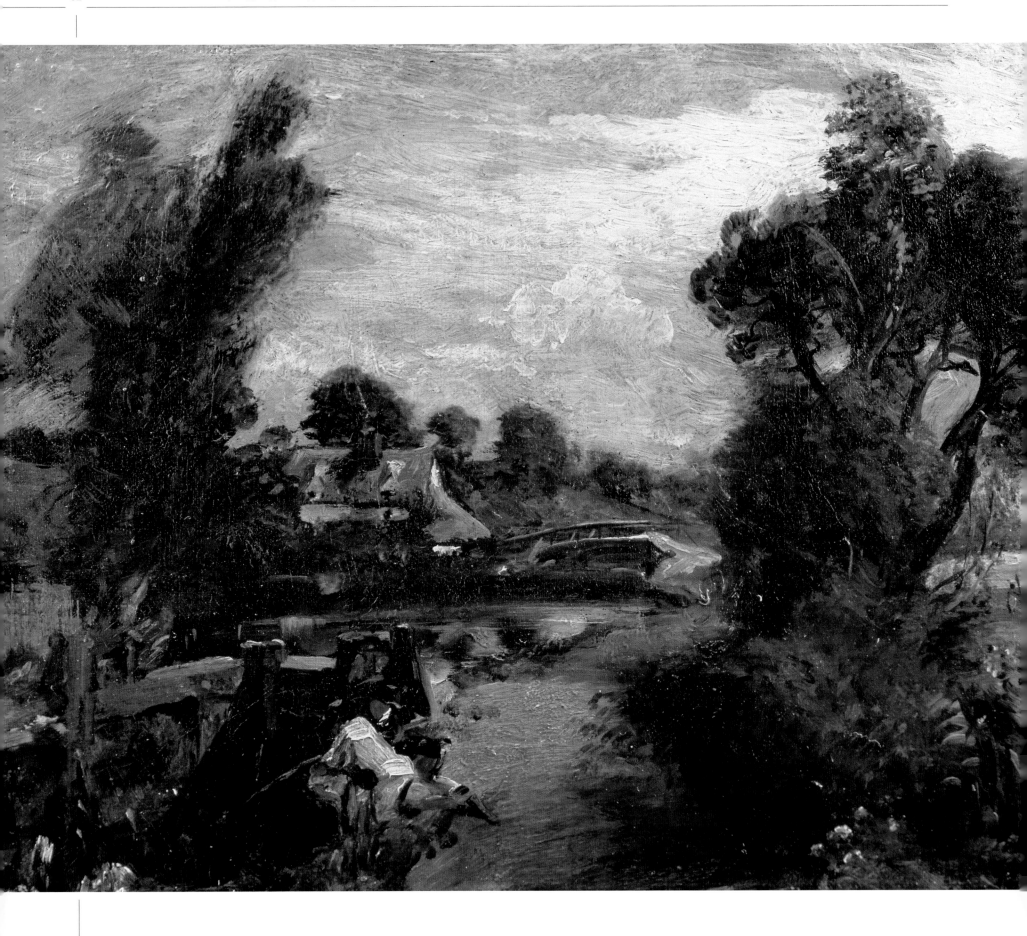

John Constable
Lock on the Stour

Courtesy of Private Collection/Christie's Images

A pioneering British artist, Constable, together with Turner, raised the status of landscape painting in England. Constable enjoyed a happy childhood in his native Suffolk and this region became the focus for most of his paintings. In Constable's day, however, landscape painting was a poorly paid profession and both his family and that of his lover, Maria Bicknell, were appalled by his choice of career. For many years, the couple were forced to meet in secret, until they eventually married in 1816. Constable's struggle for success was as difficult as his father had feared and, for a time, he was obliged to paint portraits for a living. In part, this was because he did not seek out romantic or picturesque views, but preferred to paint his local area, even though many regarded it as dull, agricultural land. He also paid unprecedented attention to atmospheric conditions, making copious sketches of individual clouds. These were so realistic that one critic joked that Constable's paintings always made him want to reach for his umbrella. Eventually, he found success with his 'six-footers' (i.e. six feet wide), gaining membership of the Royal Academy and winning a gold medal at the Paris Salon.

Movement Romanticism
Other Works *The Hay Wain; Flatford Mill; Salisbury Cathedral*
Influences Thomas Gainsborough, Jacob van Ruisdael, Claude Lorrain
John Constable *Born* 1776, Suffolk, England. *Painted in* England. *Died* 1837

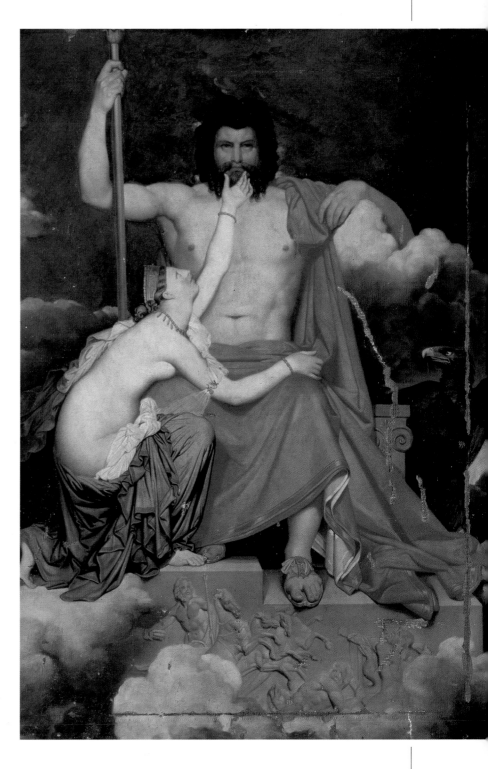

Jean-Auguste-Dominique Ingres
Jupiter and Thetis, 1811

Courtesy of Private Collection/Christie's Images

French painter and draughtsman, a champion of academic art. Ingres' father was a minor painter and sculptor and, with parental encouragement, he displayed a talent for both drawing and music at a very early age. Opting for the former, he moved to Paris in 1797 and entered David's studio. There, inspired by his teacher and by Flaxman's engravings of antique vases, Ingres developed a meticulous Neo-classical style, notable for impeccable draughtsmanship and a smooth, enamel-like finish. This helped him to win the Prix de Rome in 1801 and brought him a succession of lucrative portrait commissions.

Ingres worked extensively in Italy after 1806, although he continued to exhibit at the Salon and rapidly became the epitome of the academic establishment. This was most obvious in the 1820s, when his pictures were contrasted with those of Delacroix, in the 'battle' between Classicism and Romanticism. While his style was a model of classical correctness, however, Ingres' subject matter was often distinctly Romantic. This is particularly evident in the exotic eroticism of Oriental scenes, such as *La Grande Odalisque* and *The Turkish Bath*.

Movement Neoclassicism, Romanticism
Other Works *Madame Moitessier; The Apotheosis of Homer*
Influences David, Raphael, John Flaxman
Jean-Auguste-Dominique Ingres *Born* 1780. *Painted in* France and Italy. *Died* 1867

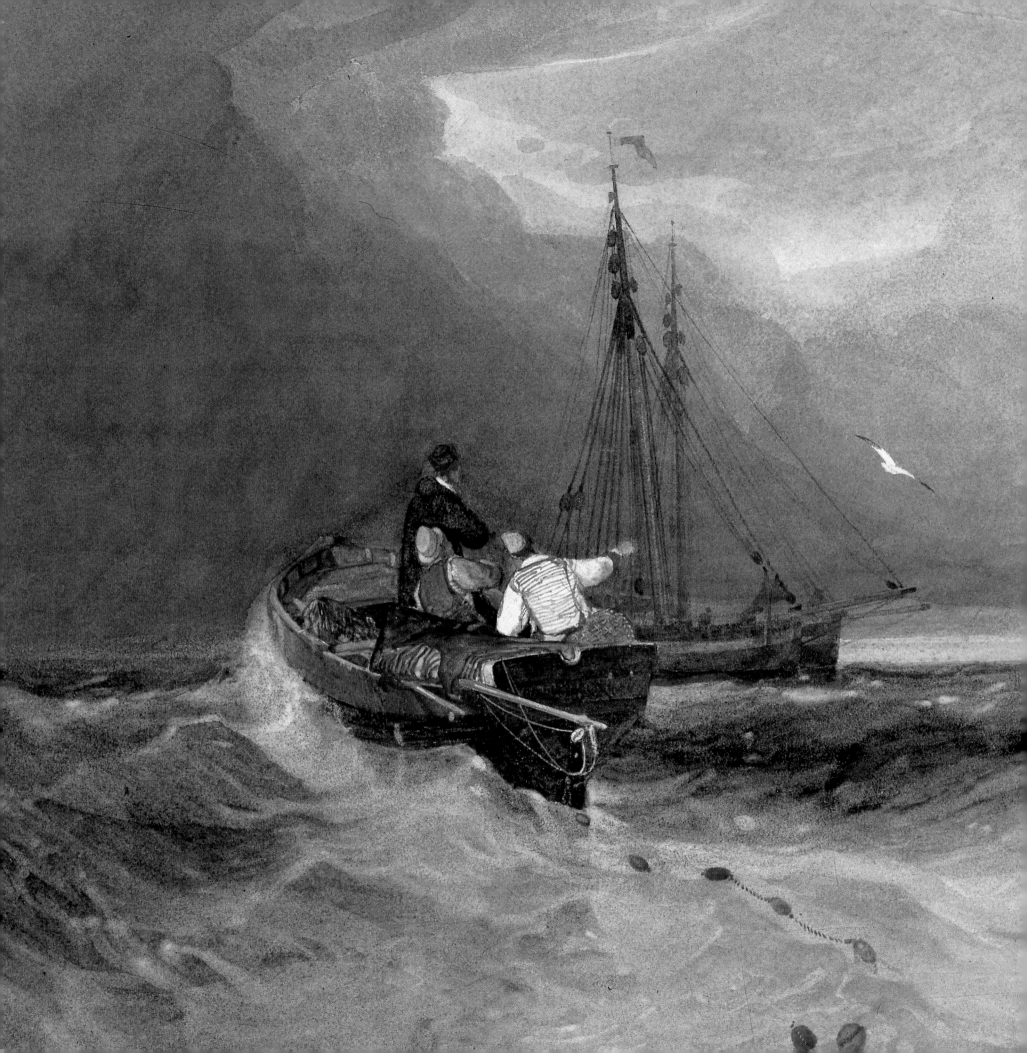

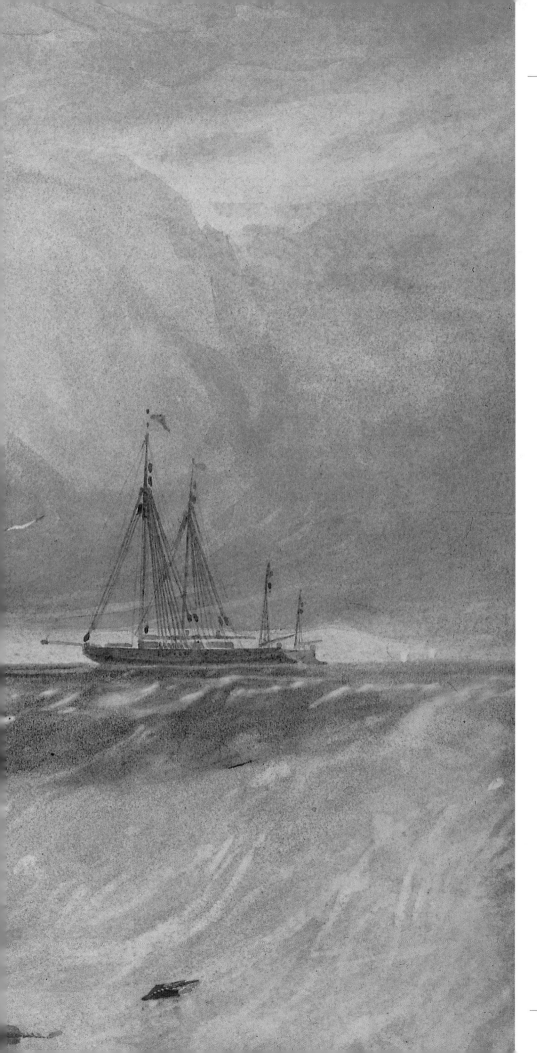

John Sell Cotman
Fishing Boats off Yarmouth

Courtesy of Christie's Images/Bridgeman Art Library

John Sell Cotman received his art training in London before returning to his native Norwich in 1806, where he became the foremost watercolourist among the group of East Anglian artists who came to be known as the Norwich School. In the early years of the nineteenth century he travelled extensively in England and Wales and his best work belongs to this period. Although chiefly remembered for his work in this medium he also executed a number of fine oil paintings during the time he resided at Great Yarmouth from 1811–23. Failing in business, however, he was forced to sell all his paintings and etchings and return to London, where he obtained a position as drawing master at King's College. There is an uncompromisingly austere character to his landscapes, very much ahead of his time and not at all in step with the fashions prevailing in Regency England, but his handling of light and shade was to have a profound influence on his followers.

Movement English Landscape School
Other Works *Greta Bridge; Chirk Aqueduct; Duncombe Park*
Influences Thomas Girtin, Turner
John Sell Cotman *Born* 1782, Norfolk, England
Painted in Norwich and London
Died 1842 London

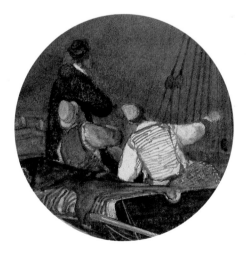

J. M. W. Turner
Farnley Hall from above Otley

Courtesy of Private Collection/Christie's Images

Joseph Mallord William Turner entered the Royal Academy School in 1789 and began exhibiting the following year. He travelled all over England, filling sketch-books with drawings of scenery and landmarks which would later provide the raw material for his oils and watercolours. He collaborated with Girtin on a three-year watercolour project but later turned to oils. After his first trip to Italy in 1819 his paintings showed a marked Classical influence, and following his second trip in 1829 his art entered its greatest phase with paintings such as *Rain and Steam and Speed* (1844), which were the precursors of Impressionism. A solitary, rather reclusive man who never married, Turner bequeathed over 300 oils and some 20,000 watercolours and drawings to the nation. A prolific artist, he ranks with Constable as one of the greatest British landscape painters of all time and his career marks a turning-point in the development of modern British art.

Movement English School
Other Works *The Fighting Téméraire; Norham Castle; Sunrise with Sea Monsters*
Influences Claude Lorraine
J. M. W. Turner *Born* 1775 London, England
Painted in England
Died 1851 London

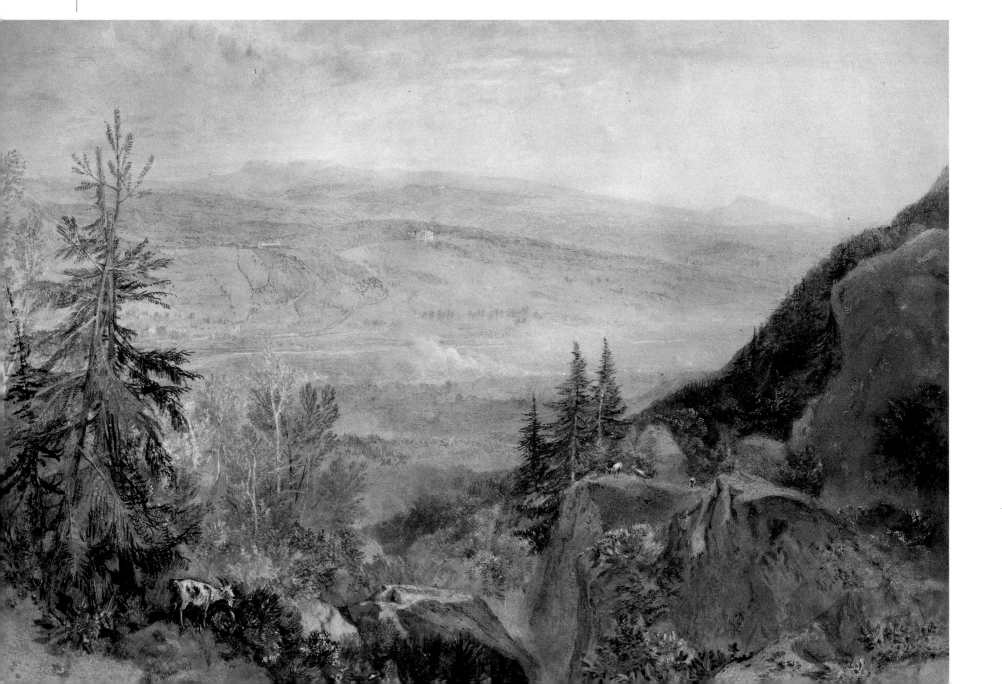

Caspar David Friedrich

The Wanderer Above the Sea of Clouds, 1818

Courtesy of Hamburg Kunsthalle, Hamburg,

Germany/Bridgeman Art Library

Caspar David Friedrich studied drawing under J. G. Quistorp in Greifswald before going to the Copenhagen Academy between 1794–98. On his return to Germany he settled in Dresden, where he spent the rest of his life. His drawings in pen and ink were admired by Goethe and won him a Weimar Art Society prize in 1805. His first major commission came two years later in the form of an altarpiece for Count Thun's castle in Teschen, Silesia, entitled *Crucifixion in Mountain Scenery*. This set the tone of many later works, in which dramatic landscapes expressed moods, emotions and atmosphere. Appointed a professor of the Dresden Academy in 1824, he influenced many of the young German and Scandinavian artists of the mid-nineteenth century and as a result he ranks high among the formative figures of the Romantic movement. For many years his works were neglected, but in the early 1900s they were rediscovered and revived.

Movement Romanticism
Other Works *The Wreck of the Hope; The Stages of Life; Graveyard in Snow*
Influences Albrecht Altdorfer, Turner
Caspar David Friedrich *Born* 1774 Germany
Painted in Dresden, Germany
Died 1840 Dresden

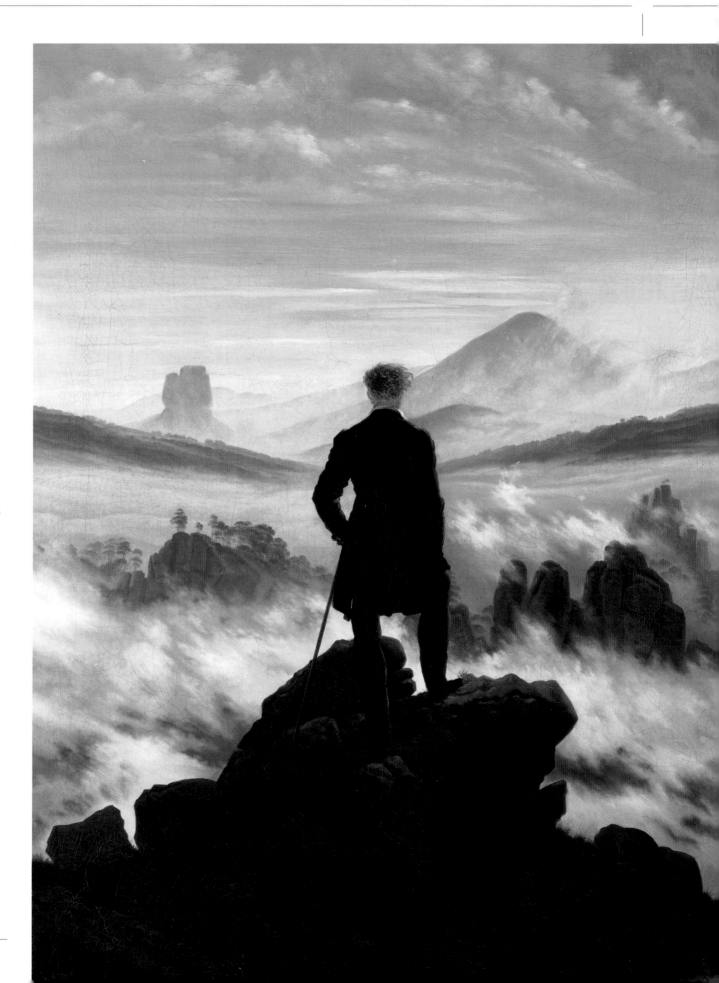

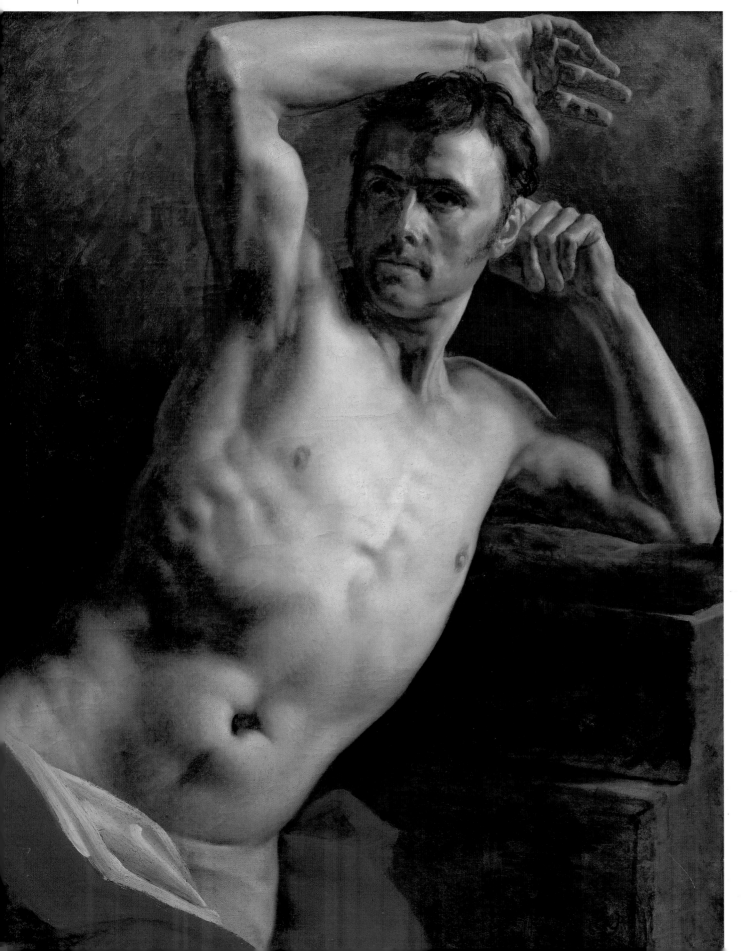

Théodore Géricault

Homme Nu a Mi-Corps ('Man Naked to the Waist')

Courtesy of Private Collection/Christie's Images

Jean Louis André Théodore Géricault studied under Carle Vernet and Pierre Narcisse Guérin, although he was frequently at odds with the latter because of his passion for Rubens and his unconventional approach in interpreting nature. He made his debut at the Salon of 1812 with his spirited portrait of a cavalry officer on horseback, and followed this with the *Wounded Cuirassier* in 1814, subjects which were immensely popular at the height of the Napoleonic Empire. During the Hundred Days, he served as a volunteer in a Royalist regiment, witnessing soldiers and horses at close quarters. He travelled and studied in Italy from 1816–19, and on his return to Paris embarked on the large-scale works which established his reputation as one of the leading French Romantics. For an artist renowned for his equestrian subjects it is ironic that he died as the result of a fall from his horse.

Movement Romanticism
Other Works *Officer of the Hussars; Coirse des Chevaux Libres*
Influences Carle Vernet, Pierre Narcisse Guérin
Théodore Géricault
Born 1791 Rouen, France
Painted in Paris
Died 1824 Rouen

Thomas Cole
Mountain Sunrise, 1826

Courtesy of Private Collection/Christie's Images

Born in Lancashire, England, Thomas Cole served his apprenticeship as an engraver of textile designs for calico printing. He emigrated with his family in 1818 and worked briefly as an engraver in Philadelphia before settling in Steubenville, Ohio, where he took lessons from an unknown travelling artist. In 1823 he returned to Philadelphia and enrolled at the Pennsylvania Academy of Fine Arts, then moved to New York in 1825. He began sketching along the Hudson River and through the Catskill Mountains, and his paintings of the American wilderness brought him fame and fortune. In 1829–32 he travelled all over Europe painting landscapes and classical ruins. On his return to New York he embarked on a colossal project – a series of large paintings that would chronicle the rise and fall of civilization. He took immense pride in his allegories and deprecated the landscapes which made his fortune and on which his reputation still rests.

Movement Hudson River School
Other Works *Expulsion from the Garden of Eden; The Course of Empire*
Influences Washington Alliston
Thomas Cole *Born* 1801, Lancashire, England
Painted in North America and Europe
Died 1848 Catskill, New York, USA

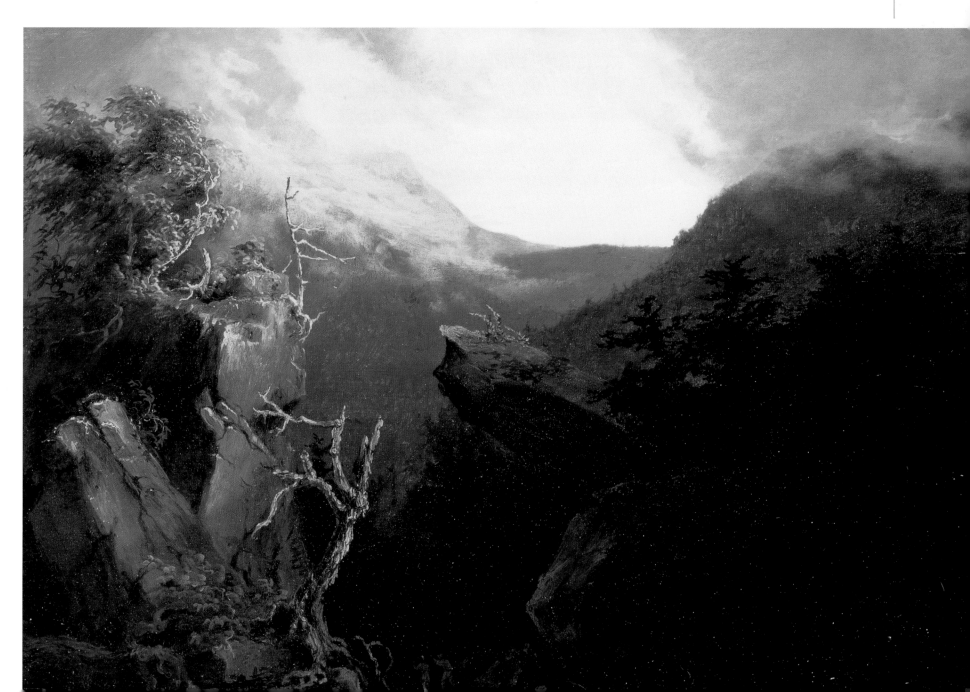

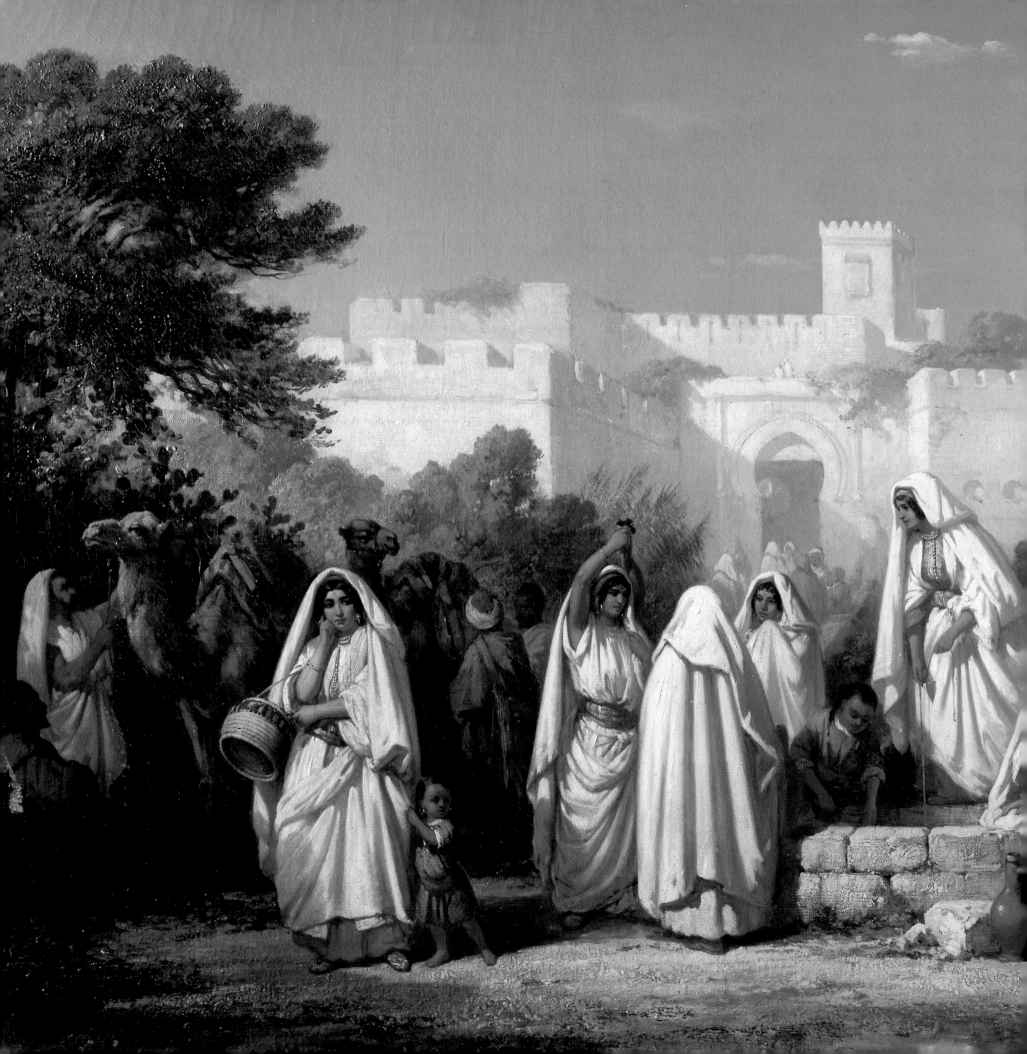

Eugène Delacroix
Le Puits de la Casbah Tanger

Courtesy of Private Collection/Christie's Images

A champion of the Romantic cause, Delacroix
was legally the son of a politician but in reality he
was probably the illegitimate child of Talleyrand,
a celebrated diplomat. He trained under Guérin,
a respected Neoclassical painter, but the dominant
influence on his style came from Géricault, a fellow
pupil. Delacroix watched the latter creating
The Raft of the Medusa, one of the seminal works
of the Romantic movement, and was overwhelmed by
its raw, emotional power. He swiftly began to emulate
this in his own canvasses, achieving his breakthrough
with *The Massacre of Chios*.

Critics attacked Delacroix for his apparent fixation
with violence and his lack of finish. They accused him
of wallowing in scenes of brutality, rather than acts of
heroism. In addition, they denounced his pictures as
'sketches', because he abandoned the smooth, linear
finish of the Neoclassical style, preferring to build up
his compositions with small dabs of colour. Like most
Romantics, Delacroix was fascinated with the exotic
but, unusually, he actually visited the Arab world. As a
result, his Orientalist paintings were more sober and
realistic than most European fantasies.

Movement Romanticism
Other Works *The Massacre at Chios; Women of Algiers;*
The Death of Sardanapalus
Influences Rubens, Géricault, Constable
Eugène Delacroix *Born* 1798
Painted in France, England, Morocco, Spain, Algeria
Died 1863

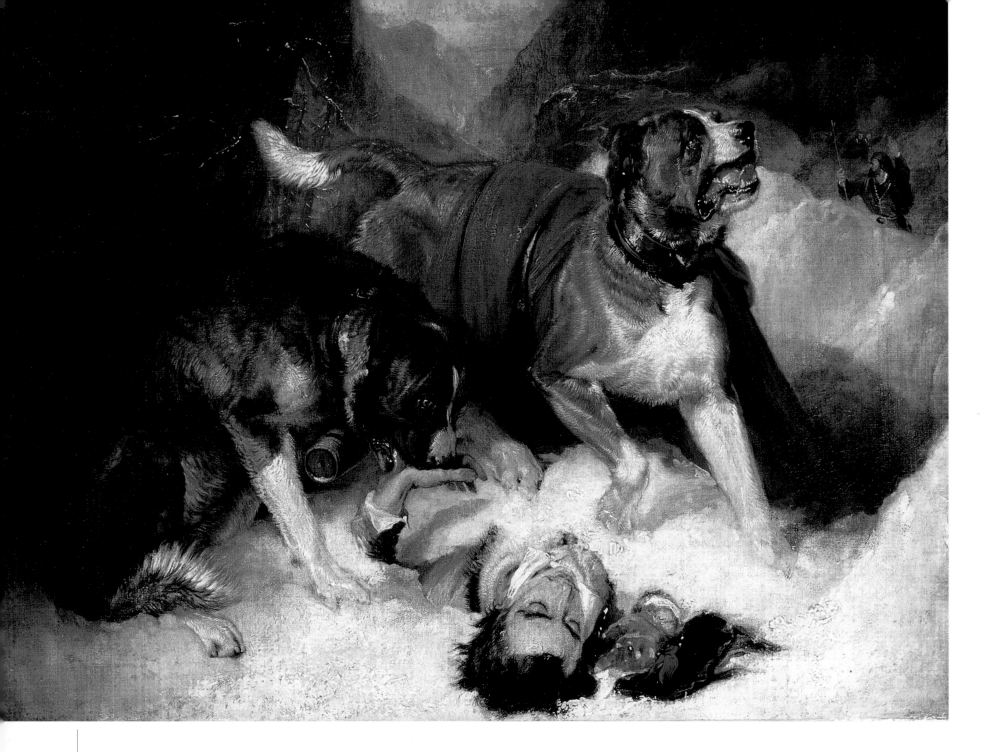

Sir Edwin Landseer

Saint Bernard Dogs

Courtesy of Private Collection, Christie's Images

Edwin Henry Landseer was taught by his father to sketch animals from life. From the age of 13 he exhibited at the Royal Academy and became one of the most fashionable painters of the mid-Victorian period, specializing in pictures of dogs with humanoid expressions and deer, usually set in misty, romantic Highland glens or moorland made popular by the novels of Sir Walter Scott and Queen Victoria's passion for Balmoral. Landseer's paintings attained even wider prominence as a result of the fine engravings of them produced by his brother Thomas. One of the Queen's favourite artists, he was knighted in 1850. He modelled the four lions, cast in bronze, which sit at the foot of Nelson's Column in Trafalgar Square, London, unveiled in 1867. Landseer's posthumous reputation was dented by accusations of sentimentalizing animals and, in more recent years, of political incorrectness in glorifying blood sports, but he wielded enormous influence on a later generation of British artists.

Movement English School
Other Works *Monarch of the Glen; The Old Shepherd's Chief Mourner*
Influences George Stubbs
Sir Edwin Landseer *Born* 1802 London
Painted in London
Died 1873 London

Théodore Rousseau
A Wooded Landscape at Sunset with a Faggot Gatherer

Courtesy of Christie's Images

A French landscape painter, Rousseau is hailed as the leader of the Barbizon School. The son of a clothier, Rousseau developed a deep love of the countryside at an early age. After working briefly in a sawmill, he decided to take up landscape painting and trained with Joseph Rémond. The latter produced classical landscapes, however, and Rousseau's naturalistic tendencies were better served by the study of foreign artists, such as Ruisdael and Constable. He adopted the practice of making sketches outdoor – a foretaste of Impressionism – although he still preferred to finish his paintings in the studio.

Rousseau's favourite location was the Barbizon region, at the edge of the Forest of Fontainebleau. By the late 1840s, this area had become the focus for a group of like-minded artists known as the Barbizon School. Headed by Rousseau, this circle included Corot, Daubigny, Diaz and Millet. In the 1850s, Rousseau's work achieved widespread recognition, fetching high prices, but he preferred to remain in Barbizon, campaigning to preserve the character of the forest. He died in his cottage, in the arms of fellow landscapist Jean-François Millet.

Movement Barbizon School
Other Works *Edge of a Forest – Sunset; Farm in the Landes*
Influences Jacob van Ruisdael, Constable
Théodore Rousseau *Born* 1812 Paris, France
Painted in France. *Died* 1867 Paris

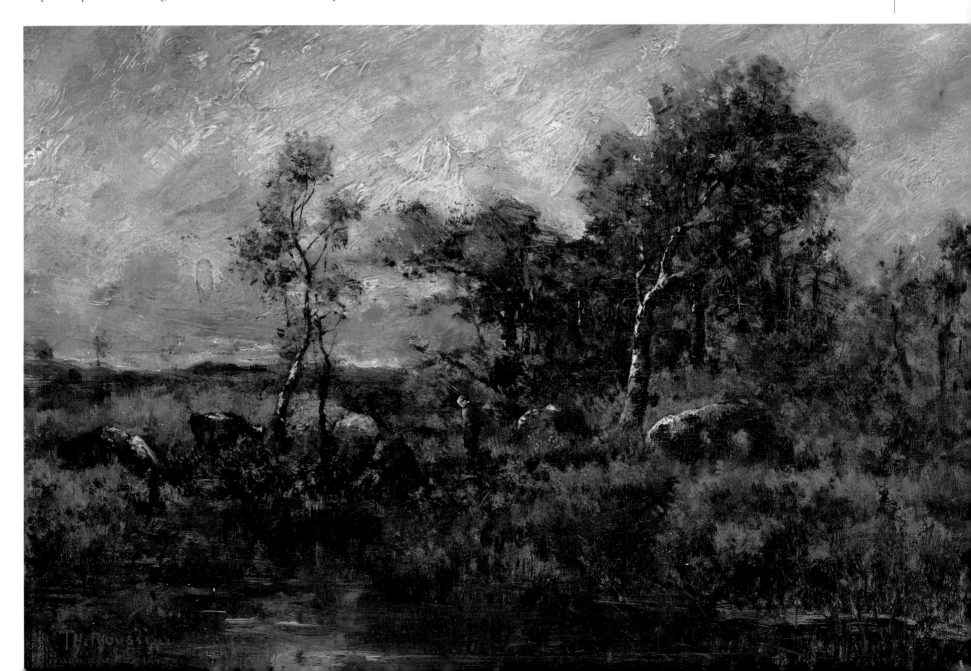

HISTORY OF ART

The Impressionist Era

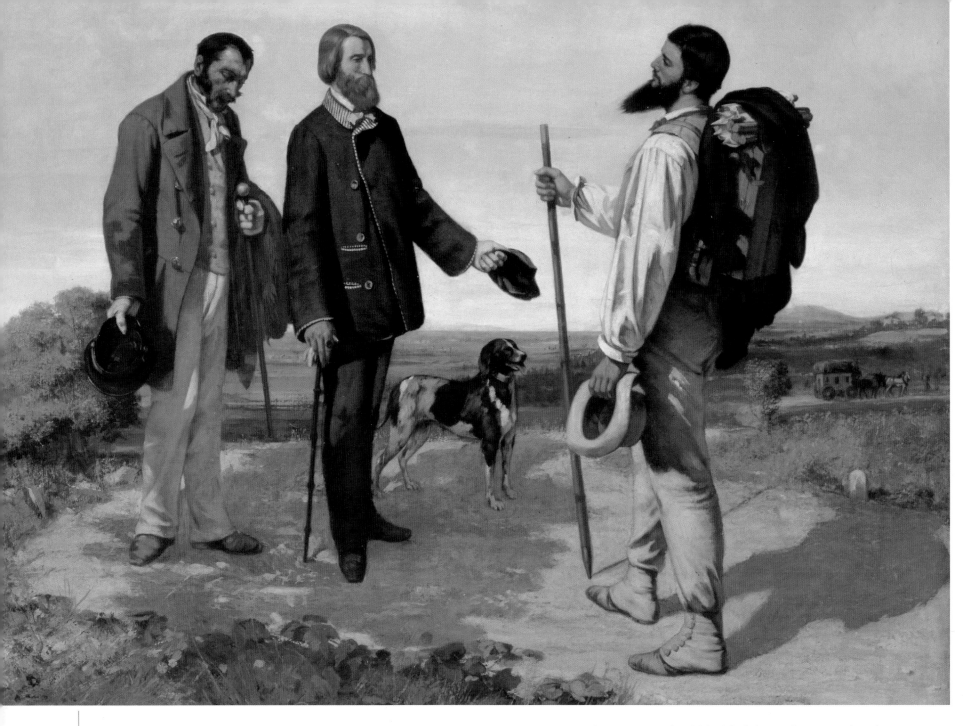

Gustave Courbet

Bonjour Monsieur Courbet, 1854

Courtesy of Musée Fabre, Montpelier, France/Bridgeman Art Library

A French painter, Courbet was the leader of the Realist movement. Born at Ornans in the Jura region, Courbet remained fiercely loyal to this area throughout his life, featuring it prominently in his paintings. Although he later claimed to be self-taught, he actually studied under a succession of minor artists, but learned more from copying old masters in the Louvre. Initially, Courbet aimed for conventional success by exhibiting at the Salon, even winning a gold medal for his 1849 entry. After he showed *The Burial at Ornans*, however, official approval evaporated. Instead, this landmark realist picture was savagely criticized for being too large, too ugly and too meaningless. Worse still, in the light of the recent 1848 Revolution, the artist was suspected of having a political agenda.

Courbet revelled in the furore. In the following years, he gained greater recognition abroad, but remained antagonistic towards the French Establishment. He refused to exhibit at the 1855 World Fair, turned down the offer of a Legion of Honour and served as a Councillor in the Paris Commune. The latter proved his undoing and he was forced to spend his final years exiled in Switzerland.

Movement Realism
Other Works *The Painter's Studio; The Bathers*
Influences The Le Nain brothers, Velázquez, Millet
Gustave Courbet *Born* 1819 France
Painted in France, Switzerland and Germany. *Died* 1877

Jean-Baptiste-Camille Corot

Etretat un Moulin à Vent, 1855

Courtesy of Private Collection/Christie's Images

Corot, a French painter, specialized in landscapes in the classical tradition. Born in Paris, Corot was the son of a cloth merchant and initially followed his father's trade. For a time, he worked at The Caliph of Bagdad, a luxury fabric shop. Turning to art, he trained under Michallon and Bertin, both of whom were renowned for their classical landscapes. Indeed, Michallon was the first winner of the Historical Landscape category in the Prix de Rome, when it was introduced in 1817. This genre, which Corot was to make his own, consisted of idealized views, set in the ancient, classical world, and was inspired by the 17th century paintings of Poussin and Claude Lorrain.

Corot's distinctive style stemmed from his unique blend of modern and traditional techniques. Each summer, he made lengthy sketching trips around Europe, working these studies up into paintings in the winter, in his Paris studio. He combined this traditional practice with a fascination for the latest developments in photography. The shimmering appearance of his foliage, for example, was inspired by the *halation* or blurring effects, which could be found in contemporary photographs.

Movement Romanticism, Barbizon School
Other Works *The Bridge at Narni; Gust of Wind; Recollection of Mortefontaine*
Influences Achille-Etna Michallon, Claude Lorrain, Constable
Jean-Baptiste-Camille Corot *Born* 1796
Painted in France, Italy, Switzerland, England and the Low Countries. *Died* 1875

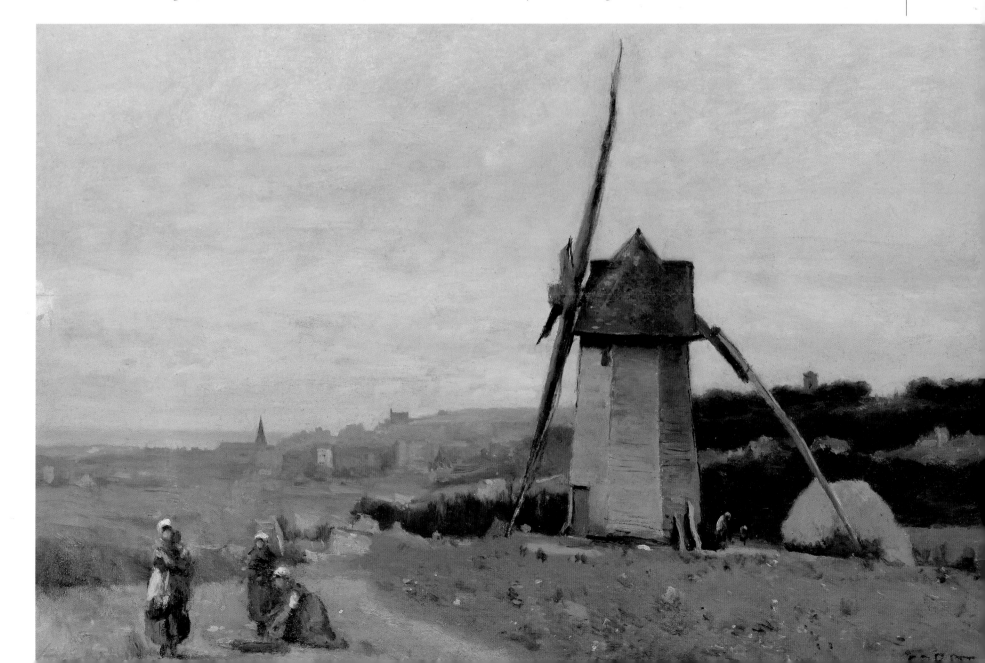

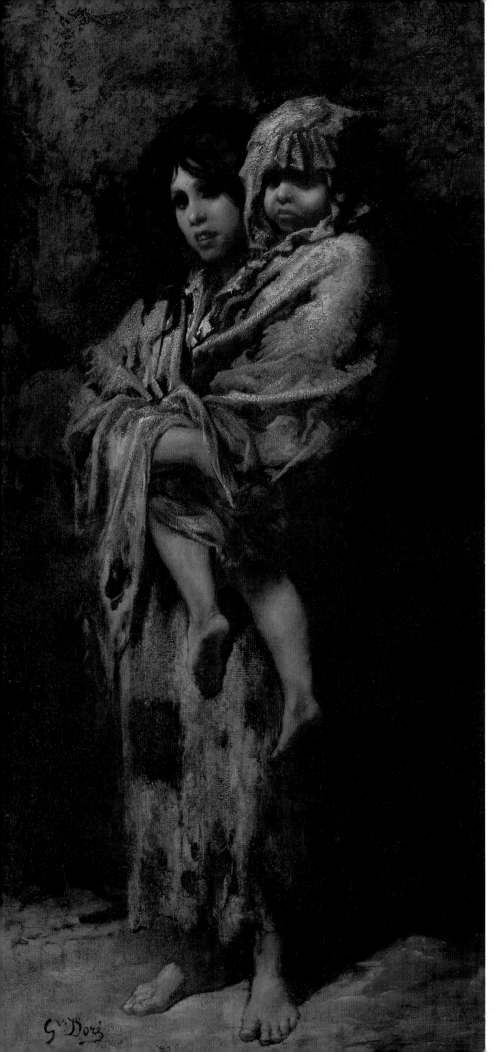

Gustave Doré
The Beggar Children

Courtesy of Private Collection/Christie's Images

Doré was the most prolific and successful French illustrator of his age. Initially, he was drawn to caricature, spurred on by the encouragement of Philipon. As a teenager, Doré visited the Paris shop of this noted cartoonist and was briefly employed by him. He also began producing humorous drawings for *Le Journal pour Rire*. These precocious skills proved invaluable, when, following the death of his father in 1849 he became the family's main breadwinner.

Doré soon progressed to book illustrations. During the 1860s, his wood engravings for Dante's *Inferno* and Cervantes' *Don Quixote* made him famous. Stylistically, he owed much to the Romantics, excelling at depictions of the exotic and the macabre. This is particularly evident from his strange, glacial landscapes in t*he Rime of the Ancient Mariner* and the grotesque beasts in the *Inferno*. Yet Doré could also be brutally realistic. His unflinching portrayal of the London slums attracted widespread praise and captured the imagination of the young Van Gogh. In later life, Doré produced some paintings and sculpture, but these are less highly regarded. His most successful venture in this field was the monument to his friend, the novelist Alexandre Dumas.

Movement Romanticism
Other Works *London: A Pilgrimage*
Influences Charles Meryon, Grandville, Charles Philipon
Gustave Doré *Born* 1832, France. *Worked in* France and England. *Died* 1883

Jean-François Millet
La Cardeuse, *c.* 1858

Courtesy of Private Collection/Christie's Images

Millet was born near the city of Cherbourg, which granted him a scholarship to train in Paris, under Delaroche. His early paintings were mainly portraits or pastoral idylls, but by the 1840s he was producing more naturalistic scenes of the countryside. These drew on his own experience, since he came from peasant stock, but the pictures disturbed some critics, because of their unglamorous view of rustic life.

In the 1850s Millet's work attracted genuine hostility. In part, this was due to fears that his paintings were political. Memories of the 1848 Revolution were still very fresh, and the authorities were nervous about any images with socialist overtones. Millet declined to express his political views, but *The Gleaners*, for example, was a compelling portrait of rural poverty. Some critics also linked his work with the Realist movement, launched by Courbet, which was widely seen as an attack on the academic establishment.

After 1849, Millet was mainly based at Barbizon, where he befriended Rousseau and other members of the Barbizon School. Under their influence, he devoted the latter part of his career to landscape painting.

Movements Naturalism, Barbizon School
Other Works *The Winnower; Man with a Hoe*
Influences Rousseau, the Le Nain brothers, Gustave Courbert
Jean-François Millet *Born* 1814 France. *Painted in* France. *Died* 1875 France

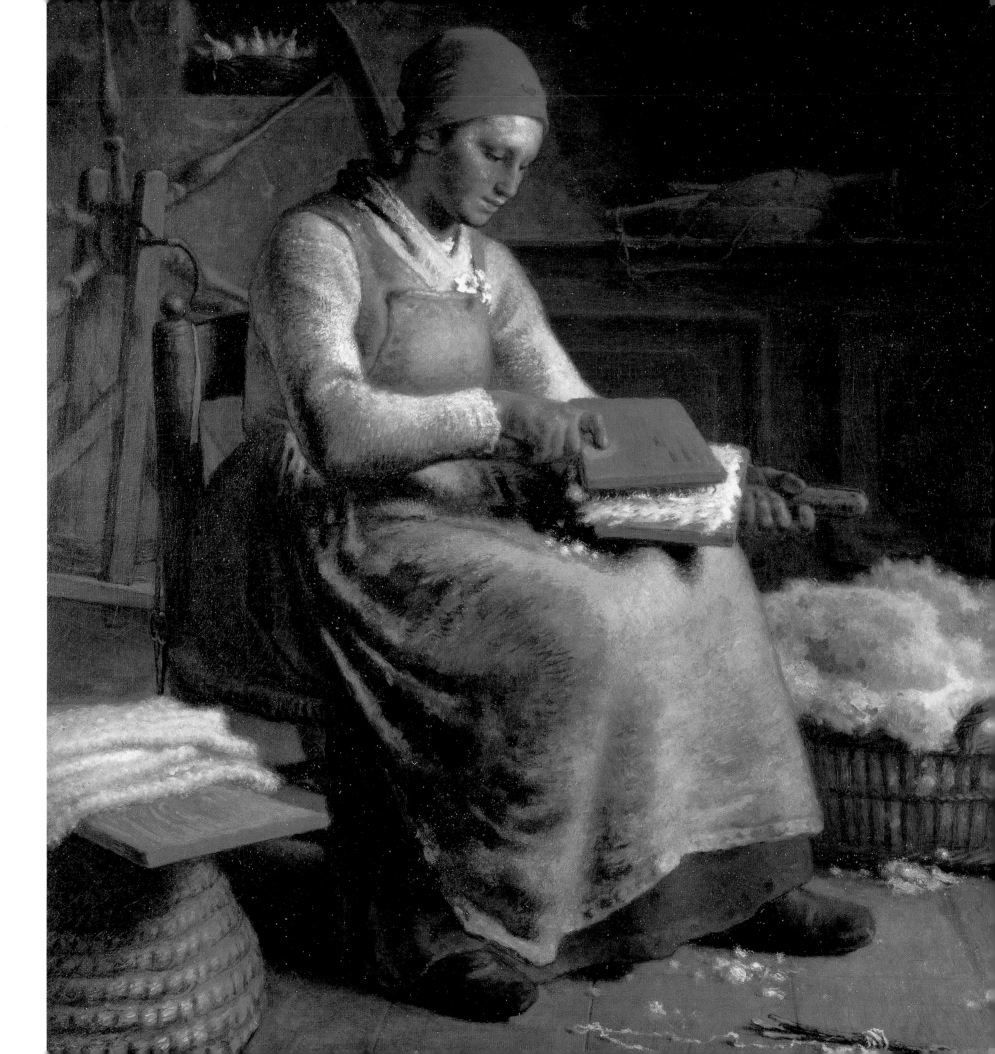

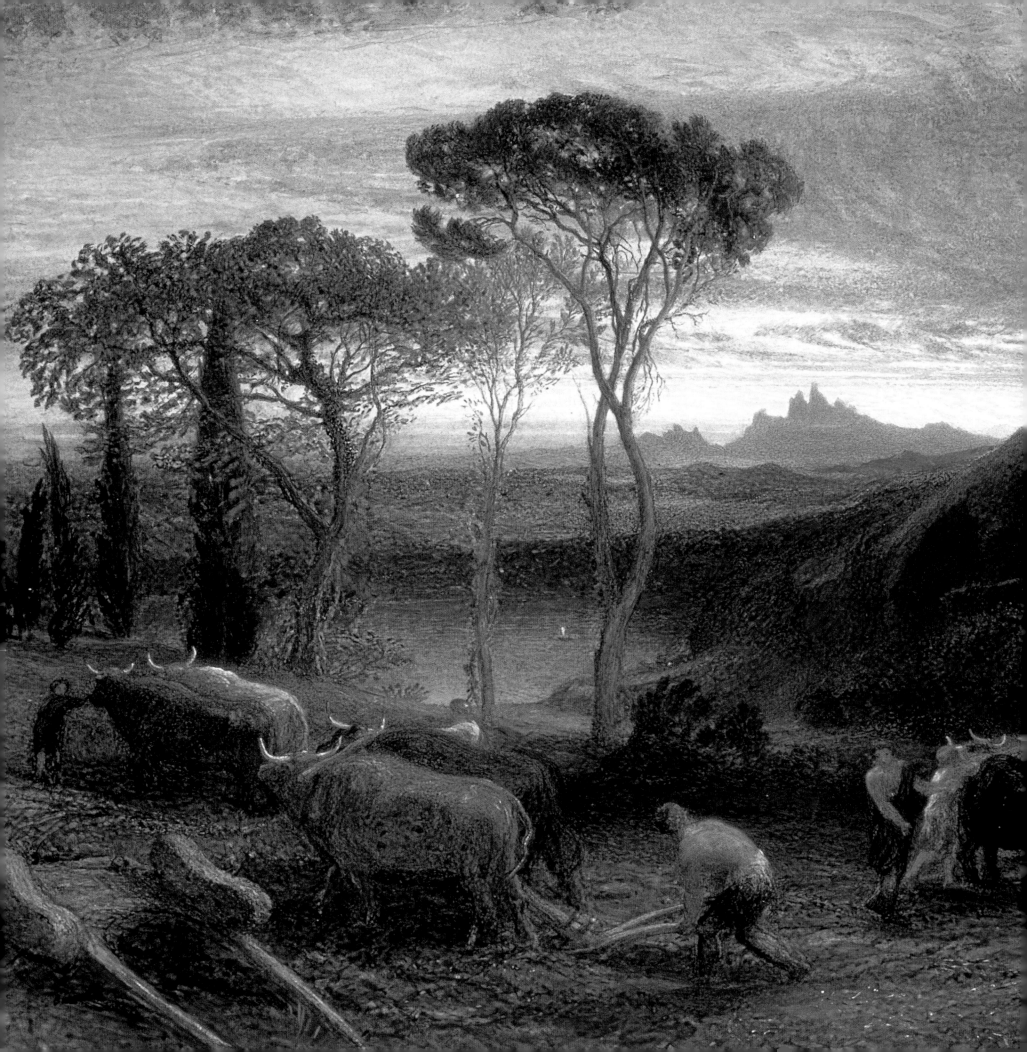

Samuel Palmer

Illustrations to Milton's Lycidas,
c. 1864

Courtesy of Private Collection/Christie's Images

Born in London, the son of an eccentric bookseller, Palmer revealed his artistic talent at a very early stage. In 1819, aged just 14, he exhibited at the Royal Academy and the British Institution, selling a painting at the latter. Three years later he met the painter John Linnell, who gave him some instruction. More importantly, perhaps, Linnell also introduced Palmer to William Blake – a meeting which only served to intensify the youngster's mystical outlook.

In 1824, the same year as his encounter with Blake, Palmer started painting at Shoreham in Kent. In this rural retreat, he began to produce the strange, pastoral idylls, which made his name. Using nothing more than ink and a sepia wash, he conjured up a worldly paradise, stocked with dozing shepherds, carefree animals and luxuriant foliage. In 1826, Palmer settled in Shoreham, where he was soon joined by a group of like-minded artists, who came to be known as the Ancients. Sadly, Palmer's period of poetic inspiration was short-lived. By the mid-1830s, his paintings had become disappointingly conventional, although his etchings retained some of his earlier, lyrical power.

Movements Romanticism, the Ancients
Other Works *The Sleeping Shepherd; Coming from Evening Church*
Influences William Blake, John Linnell, Edward Calvert
Samuel Palmer *Born* 1805 London, England
Painted in England and Italy
Died 1881

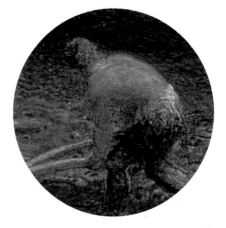

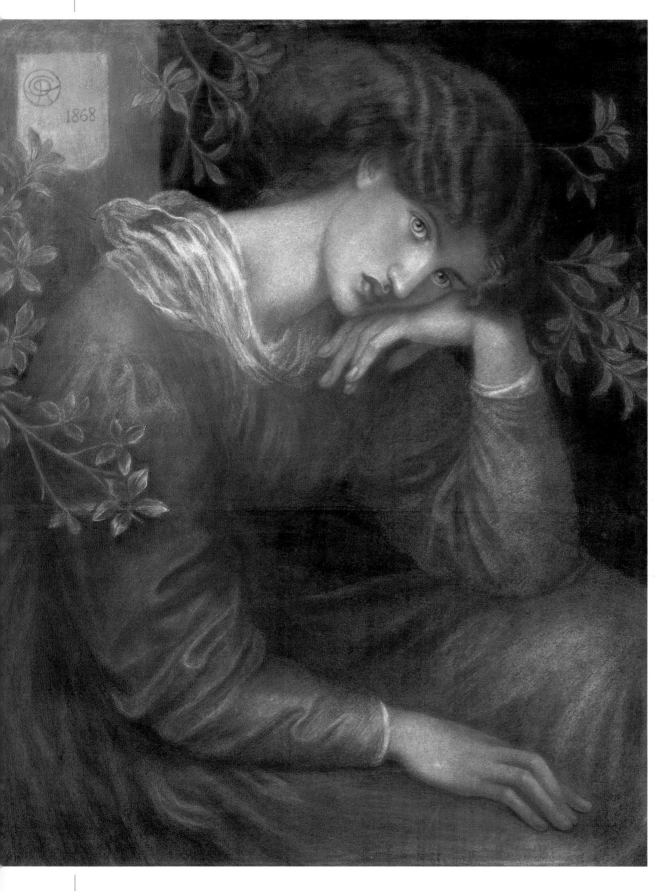

Dante Gabriel Rossetti
Reverie, 1868

Courtesy of Christie's Images

Rossetti came from a hugely talented family. His father was a noted scholar while his sister Christina became a celebrated poet. For years Dante wavered between a career in art or literature, before devoting himself to painting. While still only 20, he helped to found the Pre-Raphaelite Brotherhood, the radical group that shook the Victorian art world with their controversial exhibits at the Royal Academy in 1848. The Pre-Raphaelites were appalled by the dominant influence of sterile, academic art, which they linked with the teachings of Raphael – then regarded as the greatest Western painter. In its place, they called for a return to the purity and simplicity of medieval and early Renaissance art.

Although championed by the critic Ruskin the Pre-Raphaelites' efforts were greeted with derision and this discouraged Rossetti from exhibiting again. During the 1850s, he concentrated largely on watercolours, but in the following decade he began producing sensuous oils of women. These were given exotic and mysterious titles, such as *Monna Vanna* and were effectively the precursors of the *femmes fatales,* which were so admired by the Symbolists.

Movement Pre-Raphaelite Brotherhood
Other Works *Beata Beatrix; Proserpine*
Influences Ford Madox Brown, William Bell Scott
Dante Gabriel Rossetti *Born* 1828
Painted in England
Died 1882

Sir Edward Burne-Jones
The Prince Enters the Briar Wood, 1869

Courtesy of Private Collection/Christie's Images

Edward Coley Burne-Jones studied at Oxford where he met William Morris and Dante Gabriel Rossetti, who persuaded him to give up his original intention of entering holy orders and concentrate on painting instead. He was also heavily influenced by the art critic John Ruskin, who introduced him to the paintings of the Pre-Raphaelites and with whom he travelled to Italy in 1862. On his return to England he embarked on a series of canvasses that echoed the styles of Botticelli and Mantegna, adapted to his own brand of dreamy mysticism in subjects derived from Greek mythology, Arthurian legend and medieval romance. Burne-Jones, made a baronet in 1894, was closely associated with the Arts and Crafts movement, designing tapestries and stained glass for William Morris, as well as being a prolific book illustrator.

Movement Romanticism and Mannerism
Other Works *King Cophetua and the Beggar Maid; The Beguiling of Merlin*
Influences Botticelli, Mantegna, Pre-Raphaelites
Sir Edward Burne-Jones *Born* 1833 Birmingham, England
Painted in England
Died 1898 London, England

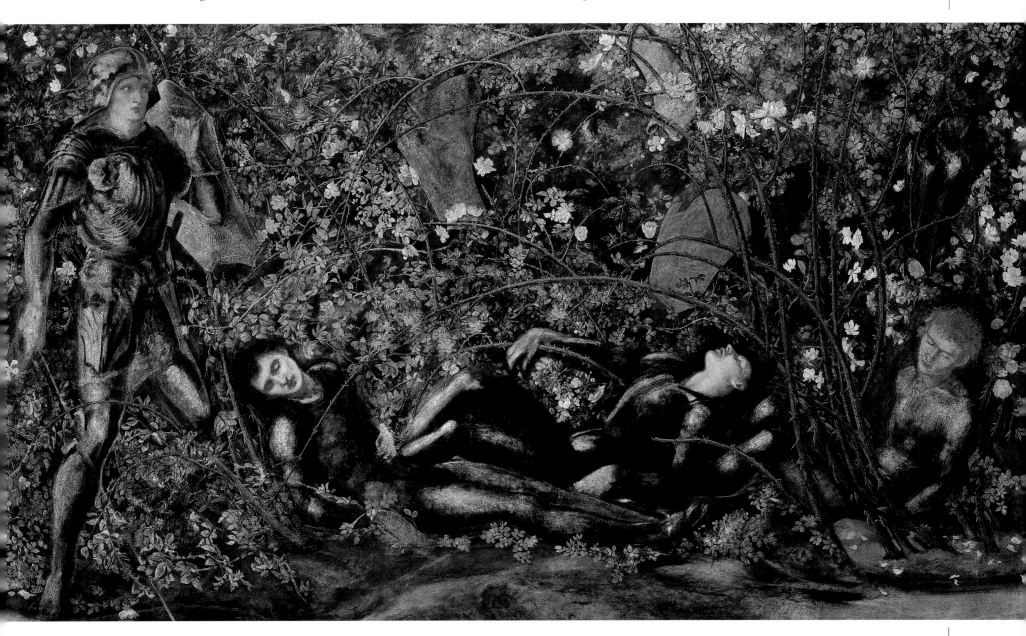

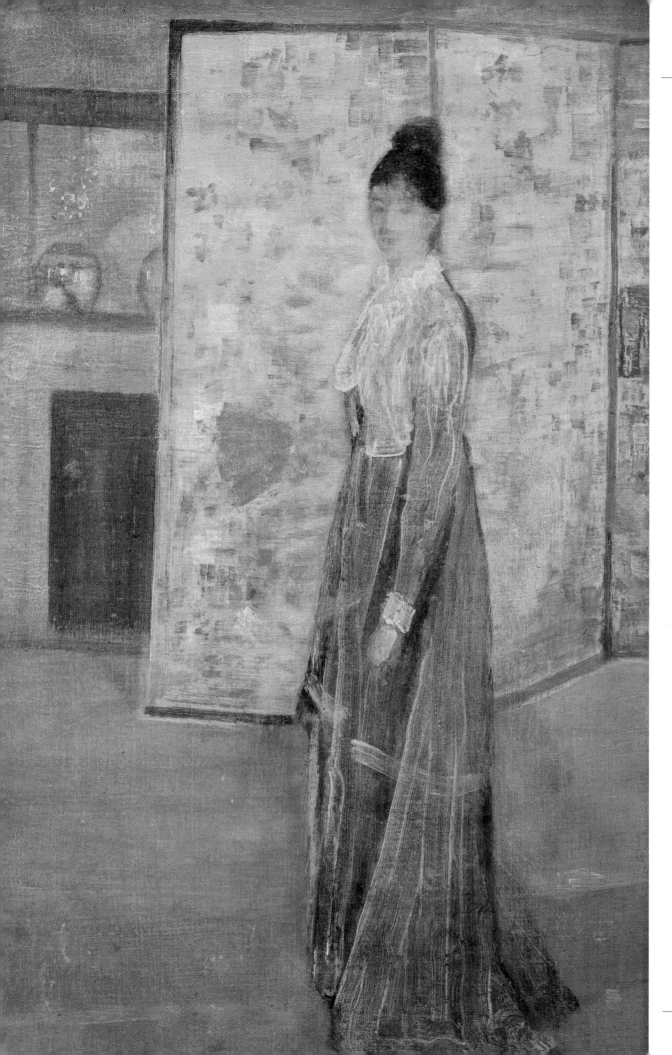

James Whistler
Arrangement in Flesh Colour and Grey

James Abbott McNeill Whistler was originally intended for a career in the army and studied at West Point from 1851 to 1854, then worked for a year as a Navy map-maker before going to Paris to take up art instead. He met Courbet and Fantin-Latour, and joined their group of Realist painters. He copied paintings in the Louvre and fell in love with Japanese art, which was then a novelty. In 1859 he settled in London, where he began painting in a style which combined these influences rather than following the English narrative convention. He strove to present a harmonious composition of tone and colour, doing in paint what a composer might do in music. This analogy was evident in the titles of these paintings, which Whistler called *Nocturnes*. Not surprisingly, his work got a very mixed reception, John Ruskin being his most vociferous critic and accusing him of "flinging a pot of paint in the public's face". Nevertheless his views gradually gained ground and influenced the next generation of British artists.

Movement Realism
Other Works *Nocturne in Blue and Gold; Old Battersea Bridge*
Influences Gustave Courbet, Henri Fantin-Latour
James Whistler *Born* 1834 Massachusetts, USA
Painted in Paris and London
Died 1903 London

Berthe Morisot
Enfant dans les Roses Trémières

Courtesy of Private Collection/Christie's Images

One of the leading female Impressionists, Berthe Morisot was the daughter of a high-ranking civil servant and received art lessons from Corot. Then in 1859, she met Fantin-Latour, who would later introduce her to future members of the Impressionist circle. Before this, she had already made her mark at the Salon, winning favourable reviews for two landscapes shown at the 1864 exhibition. Conventional success beckoned, but a meeting with Manet in 1868 altered the course of Morisot's career. She was strongly influenced by his radical style, and appeared as a model in several of his paintings. For her part, she also had an impact on Manet's art, by persuading him to experiment with *plein-air* painting. The close links between the two artists were further reinforced when Morisot married Manet's brother in 1874.

Morisot proved to be one of the most committed members of the Impressionist group, exhibiting in all but one of their shows. She concentrated principally on quiet, domestic scenes, typified by *The Cradle*, which depicts her sister Edma with her newborn child. These canvasses displayed Morisot's gift for spontaneous brushwork and her feeling for the different nuances of light.

Movement Impressionism
Other Works *Summer's Day; The Lake in the Bois de Boulogne*
Influences Manet, Renoir, Corot
Berthe Morisot *Born* 1841
Painted in France and England
Died 1895

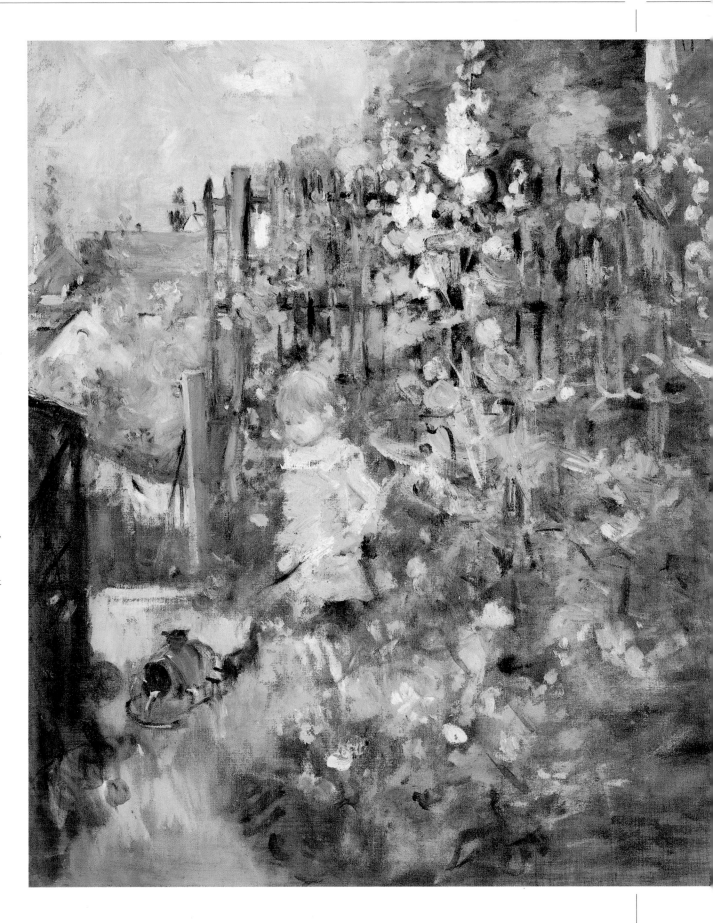

Henri Rousseau
Vue de l'Isle Saint-Louis, Prise du Port Saint-Nicolas le Soir

Courtesy of Private Collection/Christie's Images

French painter Rousseau was perhaps the most famous of all Naïve artists. Rousseau came from a poor background and he went through a succession of menial jobs, before turning to art late in life. Among other things he was a clerk, a soldier and a toll-collector. While working as the latter, he began painting as a hobby and, in 1893, he took early retirement, in order to pursue his artistic ambitions. Rousseau was entirely self-taught, although he did take advice from academic artists such as Clément and Gérôme. He copied many of the individual elements in his pictures from book illustrations, using a mechanical device called a pantograph. But it was his dreamlike combination of images and his intuitive sense of colour which gave his art its unique appeal. Rousseau began exhibiting his paintings from the mid-1880s, using avant-garde bodies such as the Salon des Indépendants, for the simple reason that they had no selection committee. He never achieved great success, but his guileless personality won him many friends in the art world, among them Picasso, Apollinaire and Delaunay. Posthumously, his work was an important influence on the Surrealists.

Movement Naive Art

Other Works *Surprised! (Tropical Storm with a Tiger);*
The Sleeping Gypsy

Influences Jean-Léon Gérôme, Félix Clément

Henri Rousseau *Born* 1844 France

Painted in France

Died 1910 Paris, France

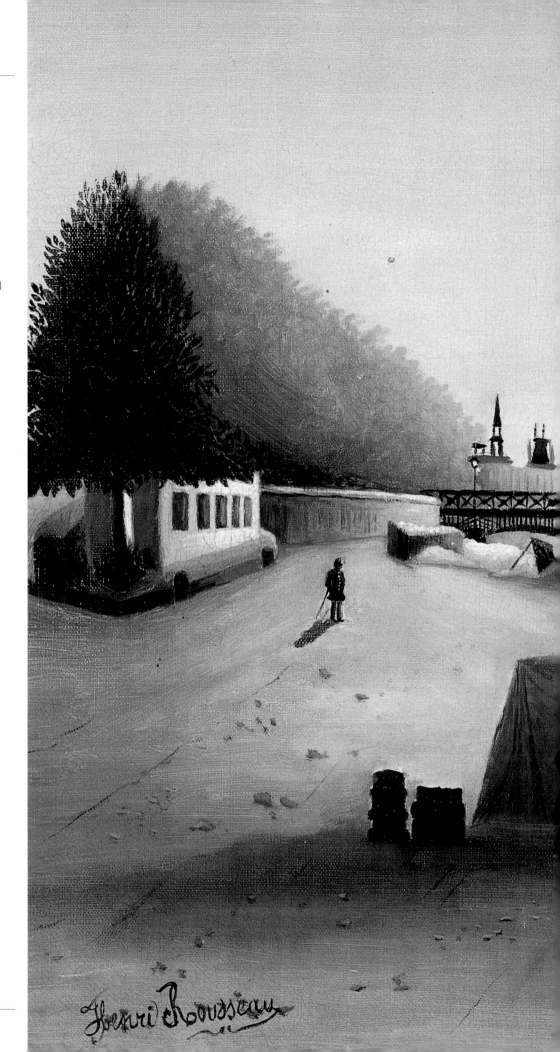

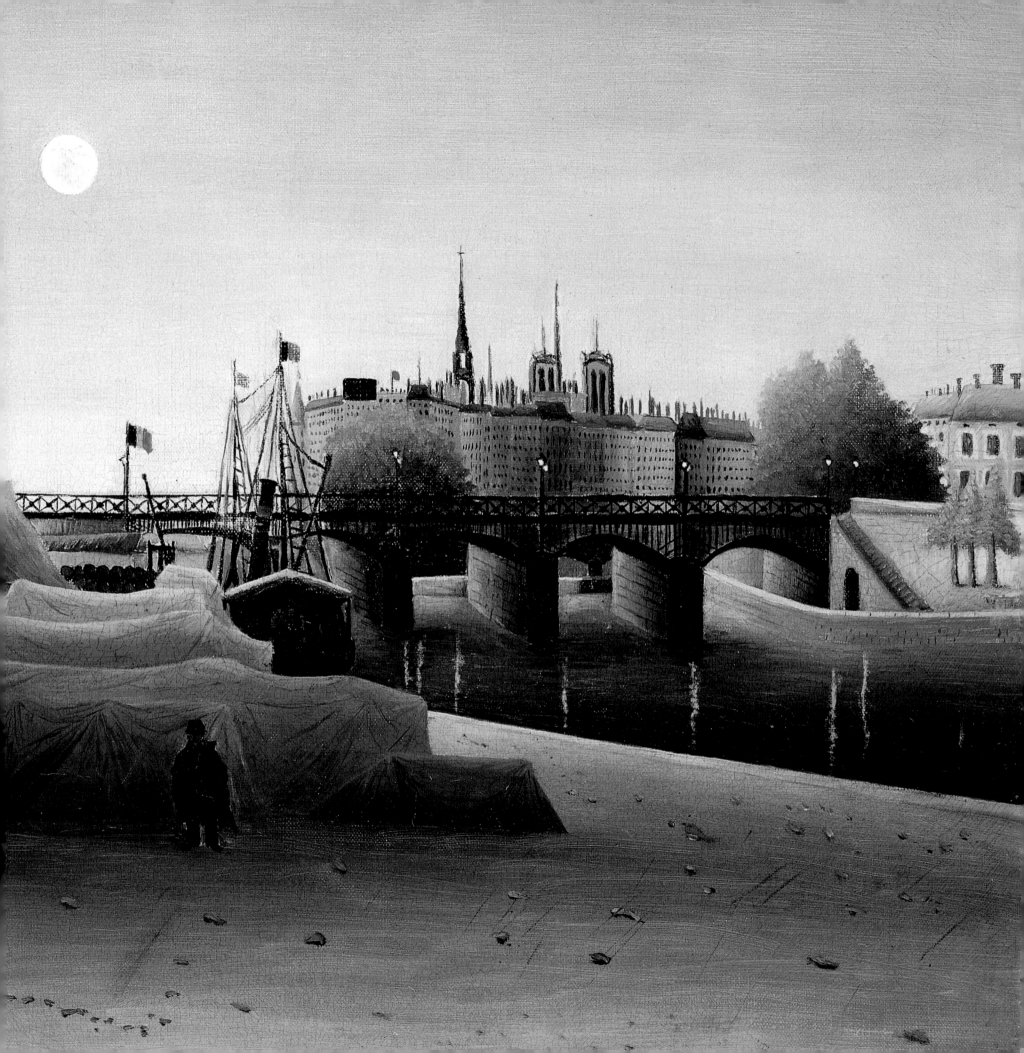

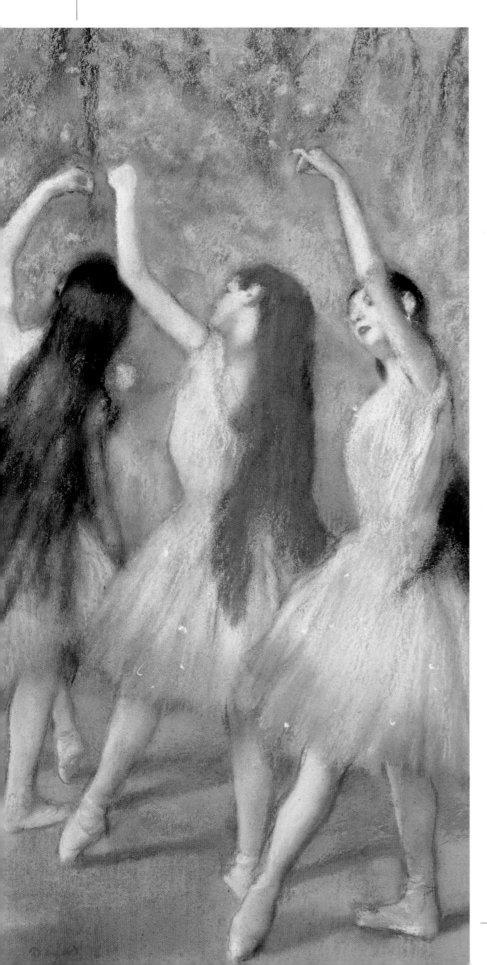

Edgar Degas
Danseuses Vertes, 1878

Courtesy of Private Collection/Christie's Images

A French painter and graphic artist, Degas was one of the leading members of the Impressionist circle. Originally destined for the law, Degas' early artistic inspiration came from the Neoclassical painter Ingres – who taught him the value of sound draughtsmanship – and from his study of the old masters. However, he changed direction dramatically after a chance meeting with Manet in 1861. Manet introduced him to the Impressionist circle and, in spite of his somewhat aloof manner, Degas was welcomed into the group, participating in most of their shows.

Degas was not a typical Impressionist, having little enthusiasm for either landscape or *plein-air* painting but he was, nevertheless, extremely interested in capturing the spontaneity of a momentary image. Where most artists sought to present a well-constructed composition, Degas wanted his pictures to look like an uncomposed snapshot; he often showed figures from behind or bisected by the picture frame. Similarly, when using models, he tried to avoid aesthetic, classical poses, preferring to show them yawning, stretching or carrying out mundane tasks. These techniques are seen to best effect in Degas' two favourite subjects: scenes from the ballet and horse-racing.

Movement Impressionism
Other Works *The Dancing Class; Carriage at the Races; Absinthe*
Influences Jean-Auguste-Dominique Ingres, Edouard Manet
Edgar Degas *Born* 1834 France
Painted in France, USA and Italy. *Died* 1917

Edouard Manet
La Rue Mosnier aux Drapeaux, 1878

Courtesy of Getty Museum/Christie's Images

An influential French painter, Manet was regarded by many as the inspirational force behind the Impressionist movement. Coming from a wealthy family, Manet trained under the history painter Couture, but was chiefly influenced by his study of the Old Masters, particularly Velázquez. His aim was to achieve conventional success through the Salon, but ironically two controversial pictures cast him in the role of artistic rebel. *Le Déjeuner sur l'Herbe* and *Olympia* were both updated versions of Renaissance masterpieces, but the combination of classical nudes and a modern context scandalized Parisian critics. This very modernity, however, appealed strongly to a group of younger artists, who were determined to paint scenes of modern life, rather than subjects from the past. This circle of friends who gathered around Manet at the Café Guerbois were to become the Impressionists.

Manet was equivocal about the new movement. He enjoyed the attention of his protégés, but still hoped for official success and, as a result, did not participate in the Impressionist exhibitions. Even so, he was eventually persuaded to try open-air painting, and his later pictures display a lighter palette and a freer touch.

Movements Realism, Impressionism
Other Works *A Bar at the Folies-Bergère*
Influences Velázquez, Gustave Courbet
Edouard Manet *Born* 1832 France
Painted in France. *Died* 1883 France

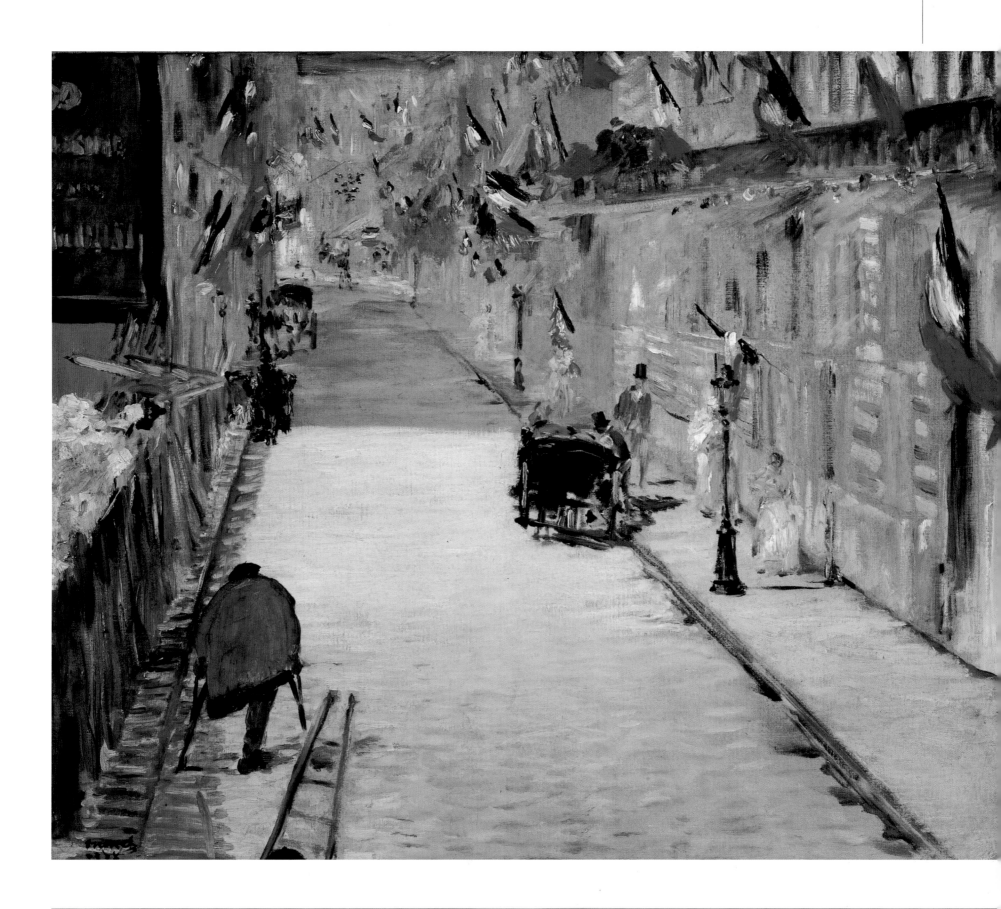

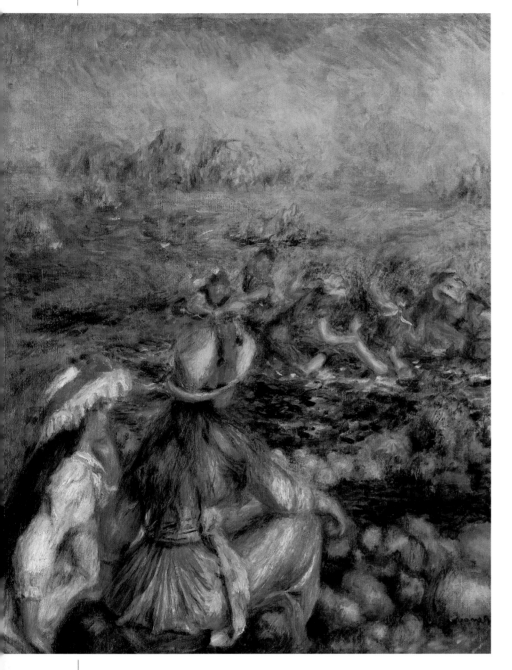

Pierre-Auguste Renoir
Les Baigneuses

Courtesy of Private Collection/Christie's Images

Born in Limoges, French Impressionist Renoir trained as a porcelain-painter before entering the studio of Gleyre in 1862. He learnt little from this master, but did meet future members of the Impressionist circle who were fellow-pupils. Together they attended the meetings at the Café Guerbois, where Manet held court. Initially, Renoir was particularly close to Monet and the pair often painted side by side on the River Seine. Although both were desperately poor, these early, apparently carefree pictures are often cited as the purest distillation of Impressionist principles.

Renoir participated at four of the Impressionist shows, but gradually distanced himself from the movement. This was partly because of his growing success as a portraitist, and partly because he had never lost his affection for Old Masters such as Rubens and Boucher. In the early 1880s, he reached a watershed in his career. He married Aline Charigot, one of his models, and travelled widely in Europe and North Africa, reaffirming his taste for the art of the past. In his subsequent work, he moved away from traditional Impressionist themes, concentrating instead on sumptuous nudes.

Movement Impressionism
Other Works *The Luncheon of the Boating Party; The Bathers; The Umbrellas,*
Influences Monet, François Boucher, Rubens
Pierre-Auguste Renoir *Born* 1841 France. *Painted in* France. *Died* 1919

Alfred Sisley
Le Barrage de Saint Mammes, 1885

Courtesy of Private Collection/Christie's Images

Born in Paris of English parents, Alfred Sisley had a conventional art education in Paris and at first was strongly influenced by Corot. In 1862 he entered the studio of Charles Gleyre, where he was a fellow pupil with Monet and Renoir, whom he joined on sketching and painting expeditions to Fontainebleau. The range of colours employed by Sisley lightened significantly under the influence of his companions. From 1874 onwards he exhibited regularly with the Impressionists and is regarded as the painter who remained most steadfast to the aims and ideals of that movement. The vast majority of his works are landscapes, drawing on the valleys of the Loire, Seine and Thames for most of his subjects. Sisley revelled in the subtleties of cloud formations and the effects of light, especially in the darting reflection of water. Hopeless at the business aspects of his art and largely dependent on his father for money, Sisley spent his last years in great poverty. Like Van Gogh, interest in his paintings only developed after his death.

Movement Impressionism
Other Works *Wooden Bridge at Argenteuil; Snow at Veneux-Nadon*
Influences Corot, Paul Renoir, Monet, Charles Gleyre
Alfred Sisley *Born* 1839 Paris, France
Painted in France and England. *Died* 1899 Moret-sur-Loing, France

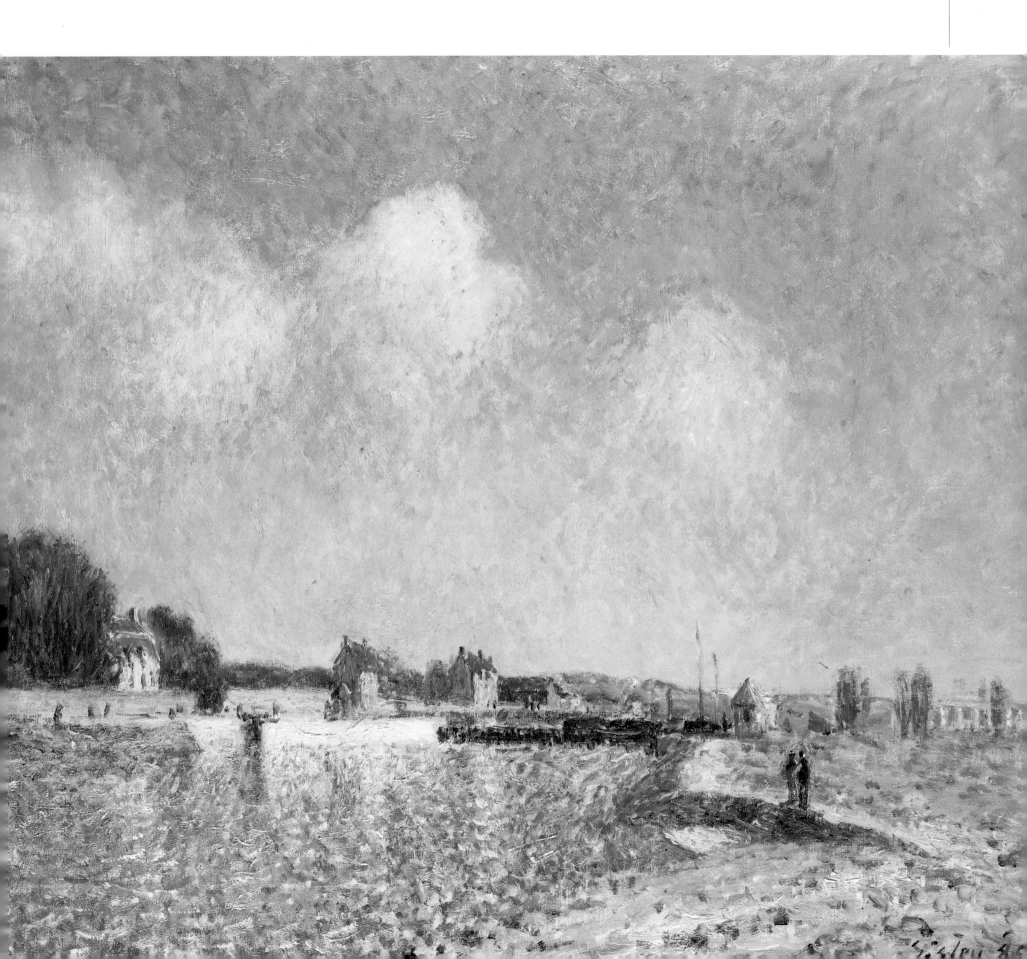

Sir Lawrence Alma-Tadema
Roses of Heliogabalus, 1888

Courtesy of Private Collection/Christie's Images

Lawrence Alma-Tadema trained at the Antwerp Academy of Art and later studied under Baron Hendryk Leys, an artist noted for his large historical paintings. In 1863 Alma-Tadema went to Italy, whose classical remains, notably at Pompeii, exerted a great influence on him. He moved to England in 1870, where he built up a reputation for narrative paintings in the Classical style. He was knighted in 1899. Three years later he visited Egypt and the impact of Pharaonic civilization had a major impact on the works of his last years. His large paintings brought everyday scenes of long-dead civilizations vividly to life through his extraordinary mastery of detail. He amassed a vast collection of ancient artefacts, photographs and sketches from his travels; the visual aids that enabled him to recreate the ancient world.

Movement Neoclassical
Other Works *The Finding of Moses; The Conversion of Paula*
Influences Baron Hendryk Leys
Sir Lawrence Alma-Tadema *Born* 1836 Dronrijp, Holland
Painted in Holland, England
Died 1912 Wiesbaden, Germany

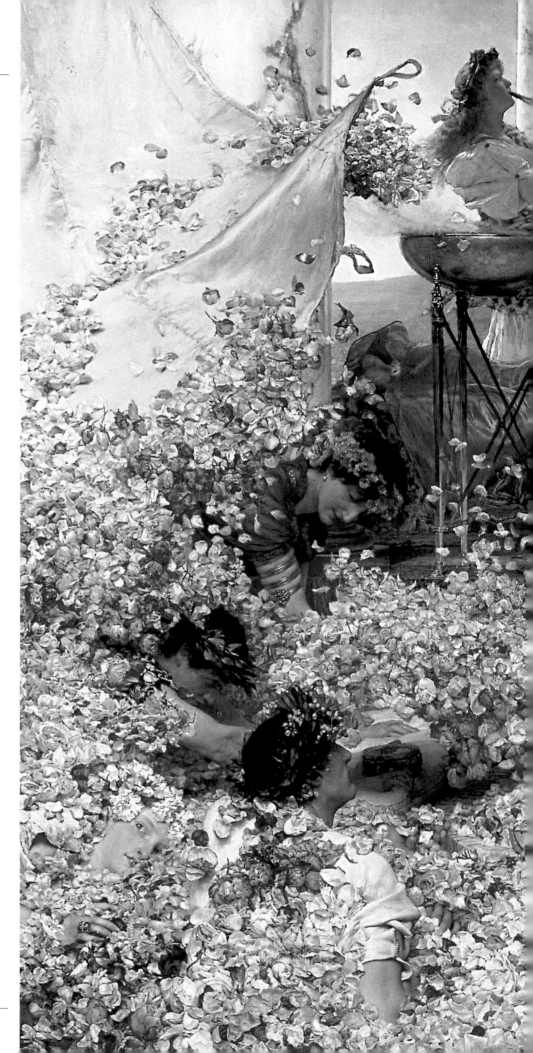

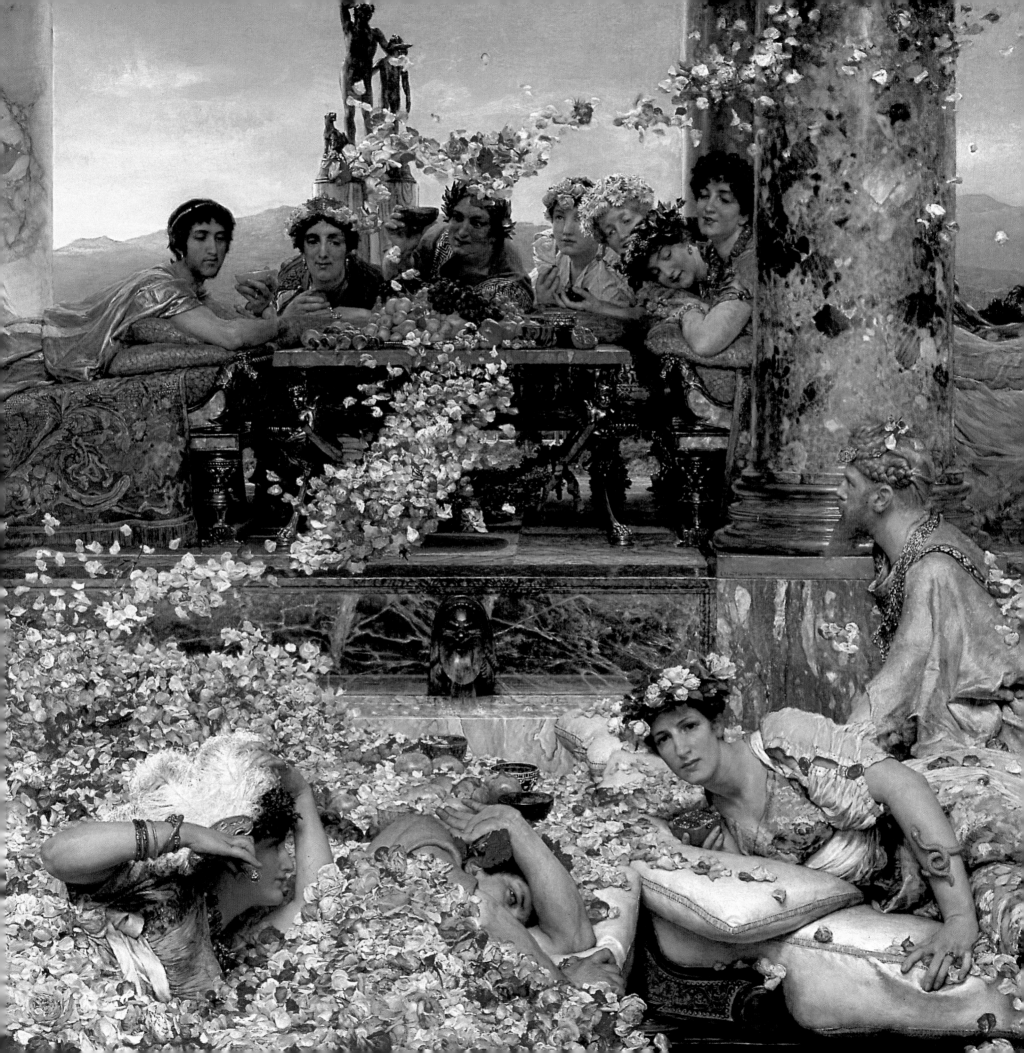

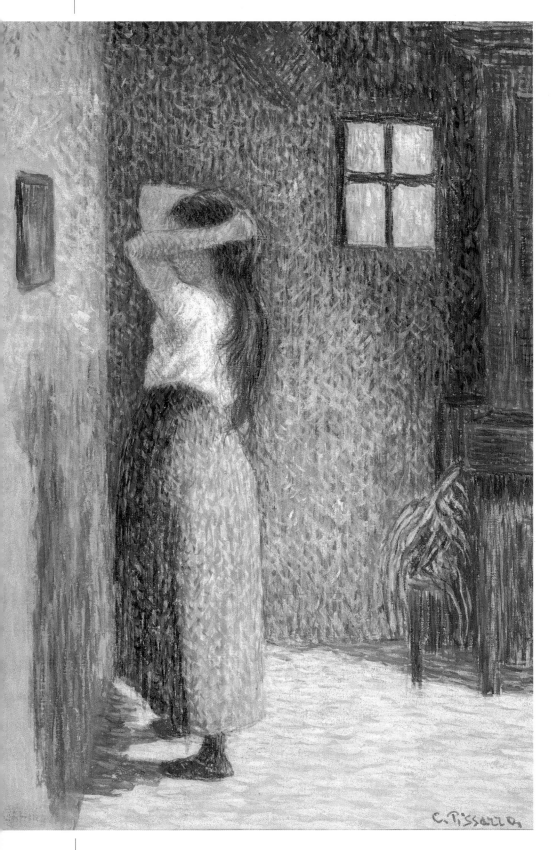

Camille Pissarro
Jeune Paysanne à sa Toilette, 1888

Courtesy of Private Collection/Christie's Images

One of the founding fathers of Impressionism, Camille Pissarro was born at St Thomas in the West Indies, schooled in Paris and enjoyed a brief interlude in Venezuela before eventually settling in France in 1855. There, he was initially influenced by Corot, whose landscapes he admired at the Universal Exhibition. He also studied at the Académie Suisse, where he met Monet, who introduced him to the future Impressionist circle at the Café Guerbois. Pissarro remained in close contact with Monet in 1870–71, when both men took refuge in London during the Franco-Prussian War.

Pissarro was slightly older than the other Impressionists and this, together with his ability as a teacher, enabled him to assume a guru-like authority within the group. In the mid-1880s, Pissarro flirted briefly with Seurat's Neo-Impressionist techniques, before reverting to his traditional style. In later years, he had increasing trouble with his eyesight and could no longer paint out of doors. Instead, he took to painting lively street scenes from rented hotel rooms. His son Lucien also became a successful artist.

Movement Impressionism
Other Works *View of Pontoise; A Road in Louveciennes; Red Roofs*
Influences Corot, Monet, Seurat
Camille Pissarro *Born* 1830. *Painted in* France, England and Venezuela. *Died* 1903

John Singer Sargent
Women at Work

Courtesy of Private Collection/Christie's Images

Born of American parents in Florence, Italy, John Singer Sargent was brought up in Nice, Rome and Dresden – giving him a rather sporadic education but a very cosmopolitan outlook. He studied painting and drawing in each of these cities, but his only formal schooling came at the Accademia in Florence, where he won a prize in 1873, and in the studio of Carolus-Duran in Paris (1874). In 1876 he paid the first of many trips to the USA, re-affirming his American citizenship in that Centennial year. He painted landscapes, but it was his early portraits that earned him acclaim. However, the scurrilous treatment of him by the French press over a décolleté portrait of Madame Gautreau induced him to leave France in 1885 and settle in London, where he spent most of his life. As well as portraits he produced large decorative works for public buildings from 1910 onwards. Some of his most evocative paintings were produced as a war artist in 1914–18.

Movement Anglo-American School
Other Works *The Lady of the Rose; Carmencita; Gassed*
Influences Carolus-Duran, Frans Hals, Velázquez
John Singer Sargent *Born* 1856 Florence, Italy
Painted in France, England and USA. *Died* 1925 London, England

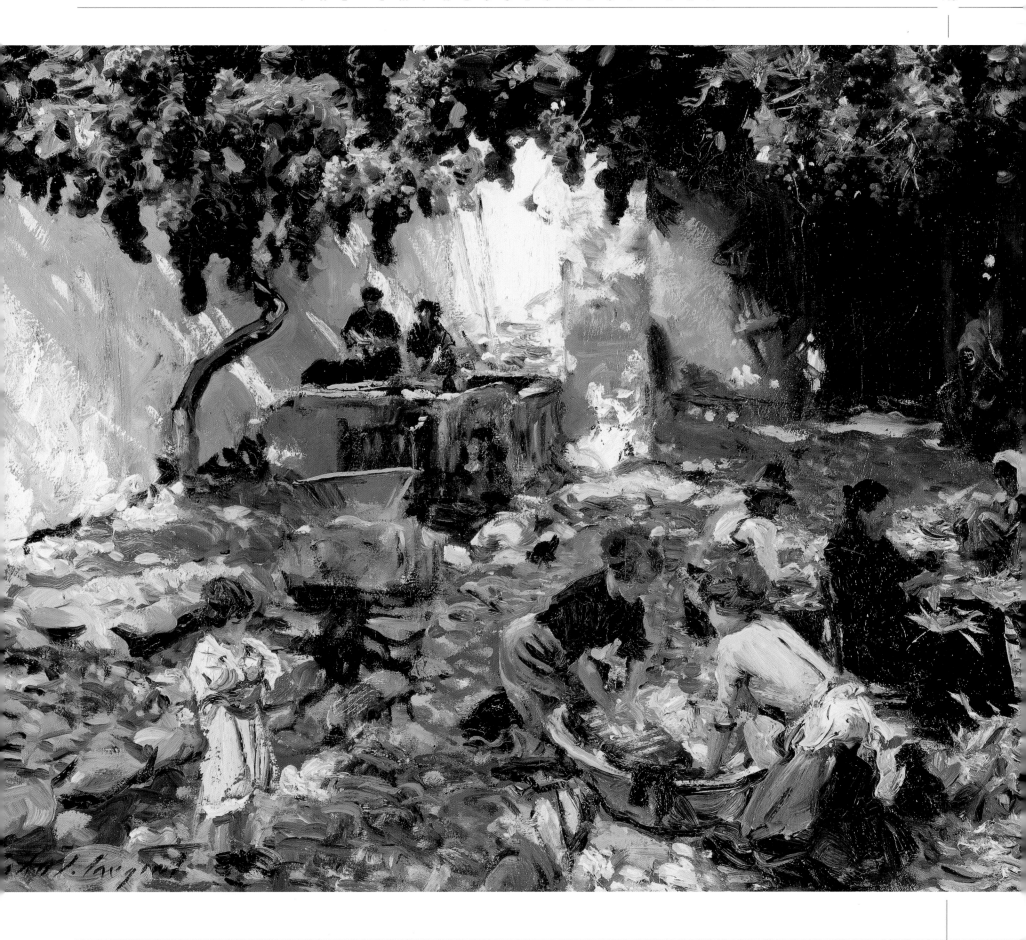

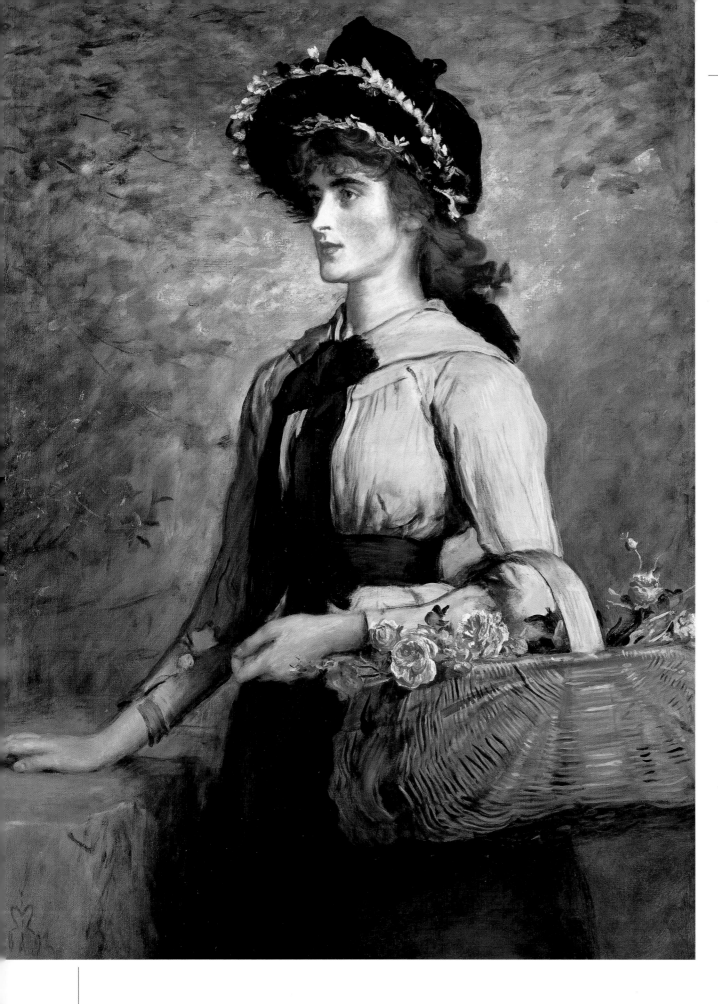

Sir John Everett Millais

Sweet Emma Morland, 1892

An English painter and illustrator, Millais was a founding member of the Pre-Raphaelite Brotherhood. Born in Southampton, Millais was a child prodigy and, at the age of 11 became the youngest-ever pupil at the Royal Academy Schools. With Rossetti and Hunt, he formed the nucleus of the Pre-Raphaelite Brotherhood. His *Christ in the Carpenter's Shop* was pilloried by the critics, although his work was vigorously defended by John Ruskin. Millais' relations with this influential critic were initially very cordial, until he fell in love with Ruskin's wife, Effie.

Millais' rift with the art establishment did not last long. He continued painting dreamy Pre-Raphaelite themes until around 1860, but found that they did not sell well and took too long to complete. So gradually he adopted a more commercial style and subject matter, specializing in imposing portraits, sentimental narrative pictures and mawkish studies of children. He also became a prolific book illustrator. This approach won Millais many honours – he was raised to the peerage and became President of the Royal Academy – but damaged his long-term artistic reputation.

Movement Pre-Raphaelite Brotherhood
Other Works *Ophelia; Sir Isumbras at the Ford; Bubbles*
Influences William Holman Hunt, Dante Gabriel Rossetti
Sir John Everett Millais *Born* 1829 England
Painted in England and Scotland
Died 1896 London, England

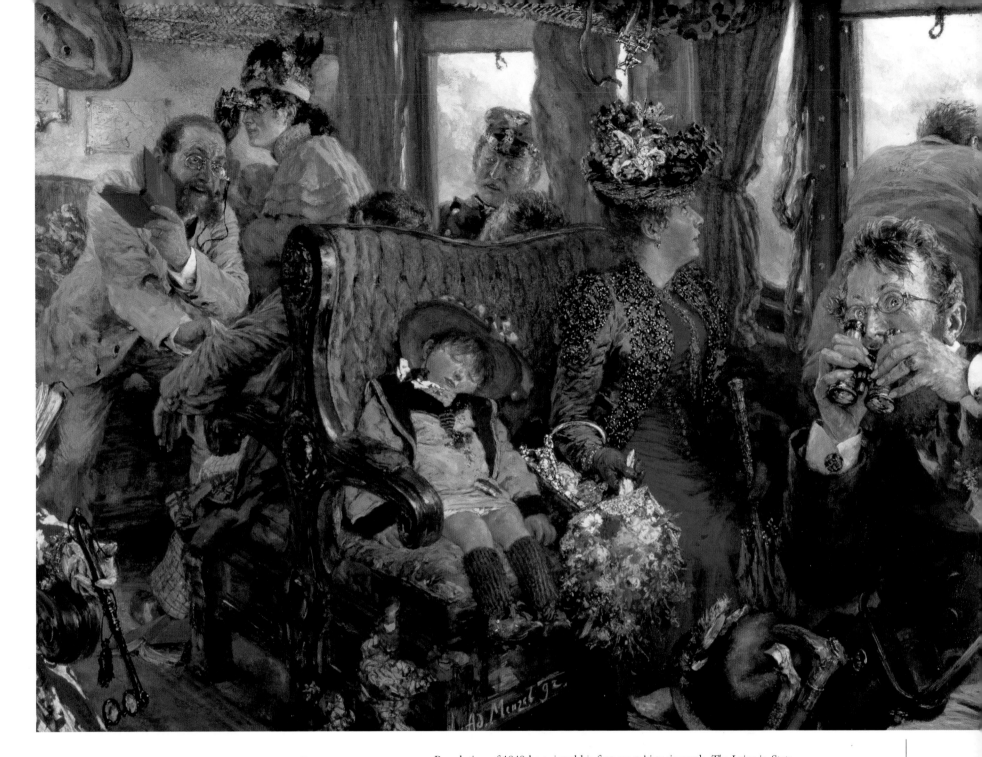

Adolph von Menzel
Auf der Fahrt durch Schone Natur, 1892

The son of a schoolmaster and lithographer, Adolph von Menzel was taught by his father and made his debut at an exhibition in Breslau in 1828 with a drawing of a tigress. The family moved to Berlin in 1830, where Adolph was employed in his father's business as a draughtsman and book illustrator. At the Berlin Academy show (1833) he exhibited illustrations for the works of Goethe. Later he produced a series showing the uniforms of the Prussian army and woodcut engravings of historical subjects. Inspired by the French Revolution of 1848 he painted his first great historic work, *The Lying in State of the March Fallen* – the first German political painting. Later he produced numerous portraits and historical scenes and was employed as a war artist during the Seven Weeks' War (1866) and the Franco-German War (1870–71), for which he was awarded the Ordre Pour le Mérite, Prussia's highest decoration. A pillar of the establishment, he influenced the heroic style of German painting in the late nineteenth century.

Movement German Romanticism
Other Works *Chess Players; Coronation of Wilhelm I in Königsberg*
Influences Claude Monet
Adolph von Menzel *Born* 1815 Breslau, Germany (now Wroclaw, Poland) *Painted in* Berlin. *Died* 1905 Berlin

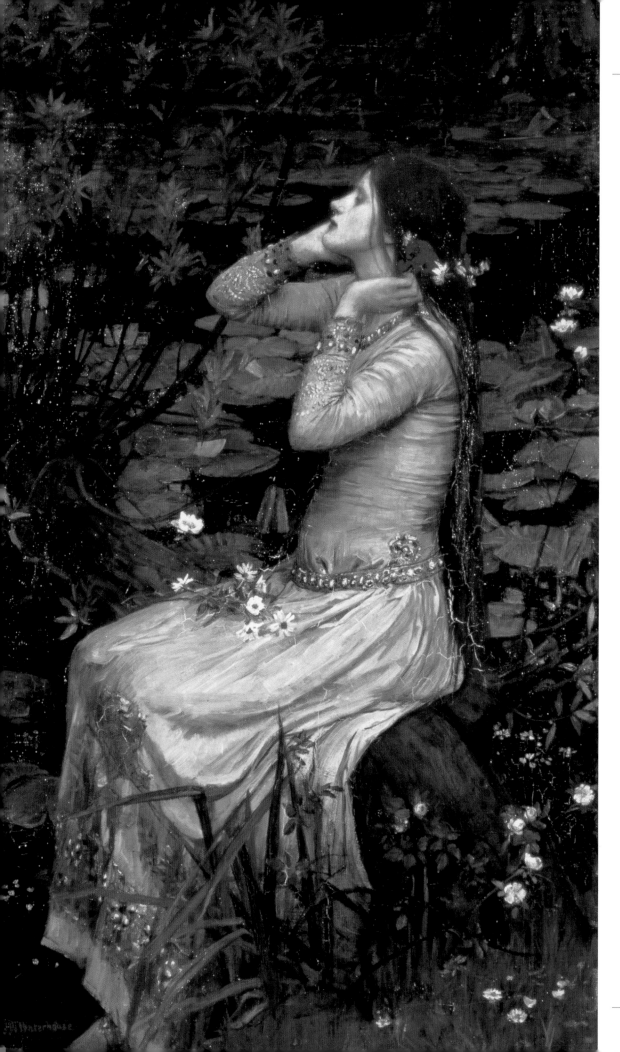

John William Waterhouse

Ophelia, *c.* 1894

An English painter, John Waterhouse's dreamy mythological paintings represent one of the last flowerings of Romanticism in Britain. Born in Rome, the son of a minor artist, Waterhouse moved to England with his family in 1854. He trained at the Royal Academy Schools and began exhibiting there in 1874. Initially, he painted in a traditional, academic vein, specializing in decorative, classical themes, which recall the work of Alma–Tadema and Leighton. By the late 1880s, however, elements of Symbolism and *plein-air* painting began to enter his work.

The pivotal work in Waterhouse's career was *The Lady of Shalott*. Painted in 1888, this was a typically Pre-Raphaelite subject – the kind of theme which he favoured increasingly, in his later years. The style, however, was more modern. The landscape background, in particular, displays a freshness and a robust handling, which underlines Waterhouse's links with the Newlyn School and his debt to continental, *plein-air* painting. During the same period, he also began to paint sirens, mermaids and other *femmes fatales*, drawing his inspiration from the French Symbolists.

Movements Late Romantic, Symbolism
Other Works *Hylas and the Nymphs; St Eulalia; Echo and Narcissus*
Influences Frederic Leighton, Alma-Tadema,
Sir Edward Burne-Jones
John William Waterhouse *Born* 1849
Painted in England and Italy
Died 1917

Max Liebermann
Bathers on the Beach at Scheveningen, *c.* 1897–98

Courtesy of Private Collection/Christie's Images/© DACS 2002

After his early training in Weimar, Germany, Max Liebermann continued his studies in Amsterdam and Paris, one of the first German artists of his generation to go abroad and come under the influence of foreign painters – in his case Courbet, Millet and the Barbizon School. Returning to Germany in 1878 Liebermann quickly established himself as the leading Impressionist, noted for his canvasses of mundane subjects in which elderly people and peasants predominate, although he also produced some noteworthy paintings of more sophisticated subjects, especially the outdoor cafés.

Liebermann played a major role in the establishment of the Berlin Secession in 1899. A major innovator in his heyday, he failed to move with the times and was later eclipsed by the younger avant-garde artists, led by Emil Nolde. Nevertheless, he remained a highly influential figure in German art, where the fashion for the heroic and romantic assured his works a substantial following.

Movement German Impressionism
Other Works *The Parrot Keeper; Haarlem Pig Market*
Influences Courbet, Millet
Max Liebermann *Born* 1847 Berlin, Germany
Painted in France, Holland and Germany
Died 1935 Berlin

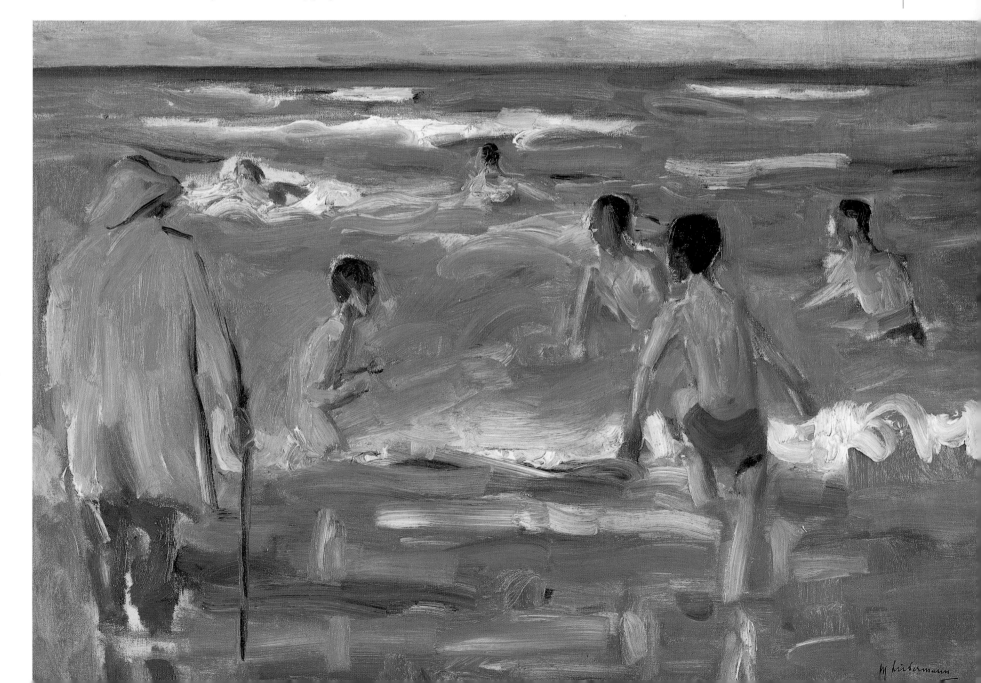

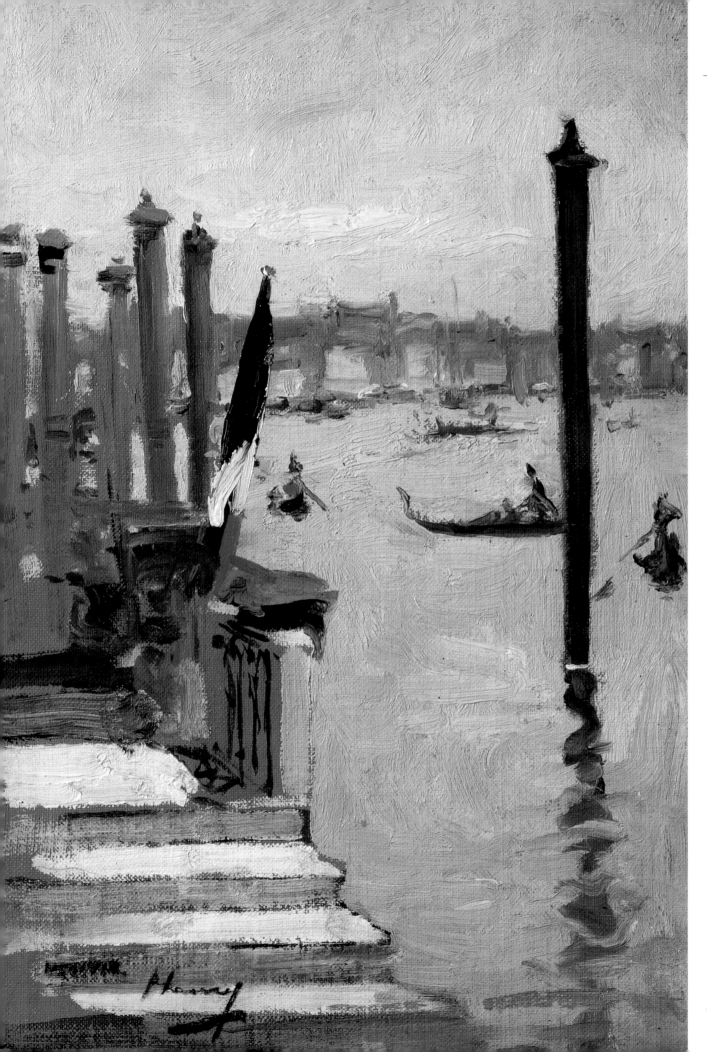

Sir John Lavery
The French Consulate,
The Grand Canal, Venice

Orphaned at the age of three, John Lavery, born in Belfast, was raised by relatives in Scotland and began his artistic career retouching photographs. When his studio burned down he used the insurance money to acquire an artistic education in London and Paris. Returning to Glasgow in 1885 he founded the group known as the Glasgow School, which promoted the techniques of French Impressionism in Britain. He excelled in landscapes and genre subjects but it was his skill as a portraitist that earned him his biggest commission, to paint the visit of Queen Victoria in 1888, a task that involved over 250 sitters and took two years to complete. The most cosmopolitan British artist of his generation, he spent much of his time in Brittany. He was knighted in 1918 but later devoted much of his energies to promoting better relations between Ireland and Britain. His portrait of his wife Hazel adorned Irish banknotes for many years.

Movement Modern British School
Other Works *The Unfinished Harmony;*
George Bernard Shaw
Influences Pre-Raphaelites,
French Impressionists
Sir John Lavery *Born* 1856 Belfast, Ireland
Painted in Britain, France, Ireland and USA
Died 1941 Kilkenny, Ireland

Mary Cassatt
The Young Mother, 1900

Courtesy of Private Collection/Christie's Images

Mary Cassatt studied art at the Pennsylvania Academy of Art in Philadelphia from 1861 to 1865, but after the American Civil War she travelled to Europe, continuing her studies in Spain, Italy and the Netherlands before settling in Paris, where she became a pupil of Edgar Degas. Her main work consisted of lithographs, etchings and drypoint studies of genre and domestic subjects which often reflect her interest in Japanese prints; but her reputation now rests on her larger works, executed in pastels or oils, which explore the tender relationship between mother and child, although her mastery of technique (which owed much to her original teacher, Thomas Eakins) prevented her from descending into the banal or mawkish. After her death in Paris in 1926 her work was neglected for some time, but in more recent years it has been the subject of re-appraisal and her realistic but sensitive portraiture of women, girls and young children is now more fully appreciated.

Movement Impressionism
Other Works *Mother and Child; Woman Sewing*
Influences Thomas Eakins, Degas
Mary Cassatt *Born* 1844 Pennsylvania, USA
Painted in USA and France
Died 1926 Paris, France

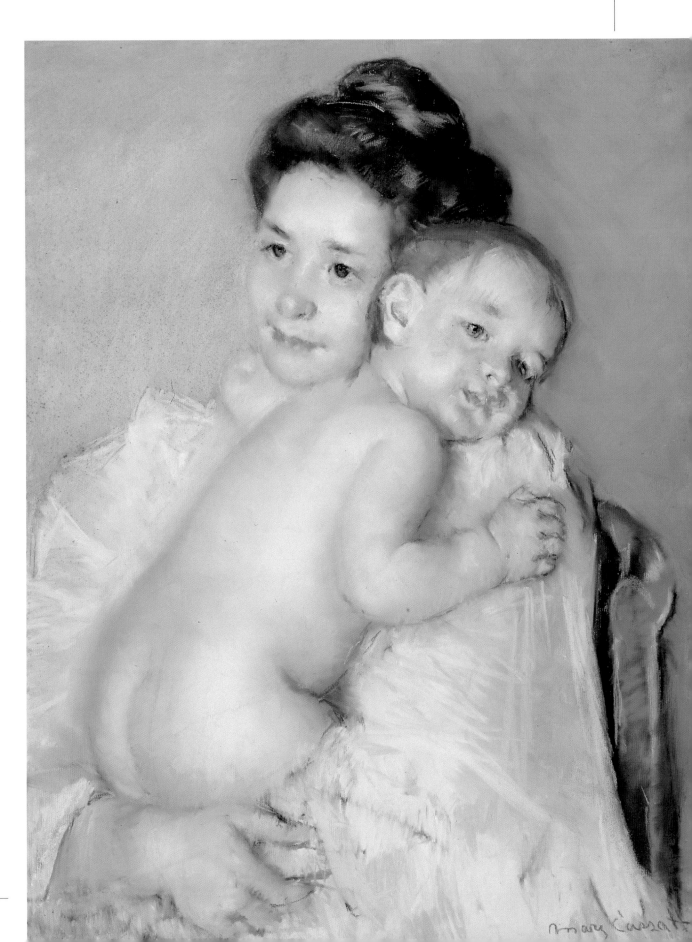

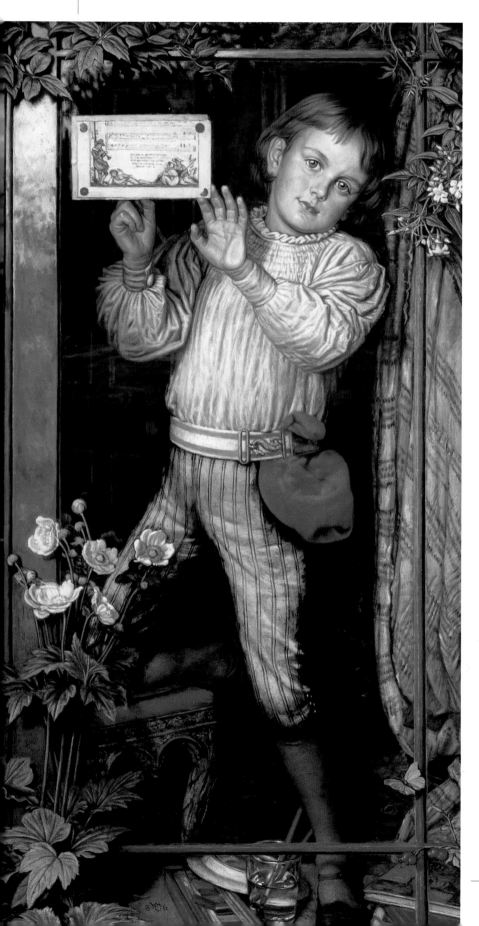

William Holman Hunt
Master Hilary – The Tracer, 1900

Courtesy of Private Collection/Christie's Images

One of the founders of the Pre-Raphaelite movement, William Holman Hunt was born in London. The son of a warehouse manager, Hunt worked as a clerk before entering the Royal Academy School in 1844. There, he met Millais and, together with Rossetti, they formed the core of the Pre-Raphaelite Brotherhood. Hunt's meticulous attention to detail and his fondness for symbolism accorded well with the aims of the group, but his deeply felt religious convictions led him away from the British art scene. In January 1854, he embarked on a two-year expedition to Egypt and the Holy Land, believing that this was the only way to produce realistic images of biblical themes.

The critical response to this enterprise was mixed. *The Scapegoat* was greeted with puzzlement, but *The Finding of the Saviour in the Temple* was received far more enthusiastically, securing Hunt's reputation as a religious painter. Further trips to the East followed, although these were not always happy affairs. In 1866, his wife died in Florence, shortly after giving birth to their son. Hunt later married her sister. In 1905, he wrote his memoirs, which have become a primary source document for the Pre-Raphaelite movement.

Movement Pre-Raphaelite Brotherhood
Other Works *The Hireling Shepherd; The Light of the World*
Influences Dante Gabriel Rossetti, Augustus Egg, John Everett Millais
William Holman Hunt *Born* 1827. *Painted in* England, Egypt and the Holy Land. *Died* 1910

Claude Monet
Le Palais Ducal vu de Saint George Majeur, 1908

Courtesy of Private Collection/Christie's Images

A founding member of the Impressionist circle, Monet was born in Paris but grew up on the Normandy coast, where he developed an early interest in landscape painting. His early mentors were Jongkind and Boudin, and the latter encouraged Claude to paint outdoors rather than in the studio. This was to be one of the key principles of Impressionism.

While a student in Paris he met Pissarro, Renoir and Sisley, and together they formulated the basic ideas of the movement. One of Monet's paintings, *Impression: Sunrise* gave the group its name.

The Impressionists staged their own shows, holding eight exhibitions between 1874 and 1886. Initially, these attracted savage criticism, causing genuine financial hardship to Monet and his friends. His most distinctive innovation was the 'series' painting. Here, Monet depicted the same subject again and again, at different times of the day or in different seasons. In these pictures, his real aim was not to portray a physical object – whether a row of poplars or the façade of Rouen cathedral – but to capture the changing light and atmospheric conditions.

Movement Impressionism
Other Works *Waterlilies; Wild Poppies; Rouen Cathedral*
Influences Eugène Boudin, Johan Barthold Jongkind, Pierre-Auguste Renoir
Claude Monet *Born* 1840 Paris, France
Painted in France, England and Italy. *Died* 1926 Givernay, France

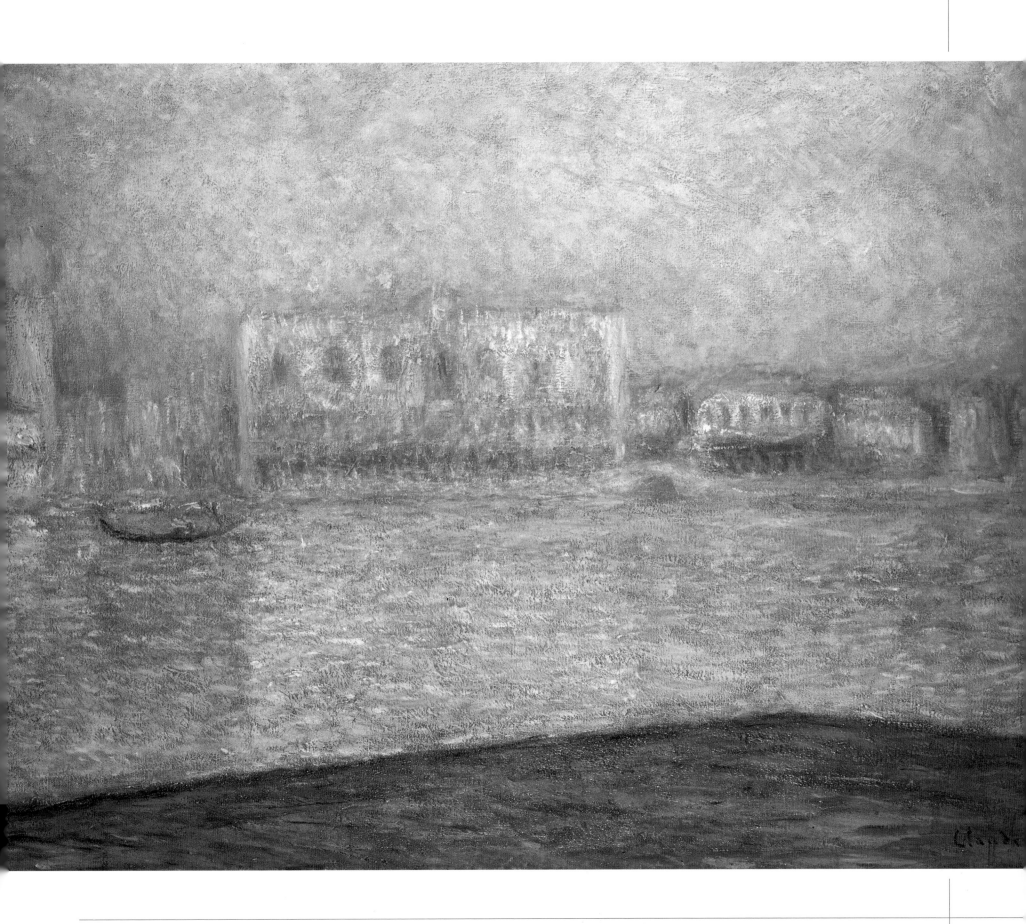

The
Post–Impressionist Era

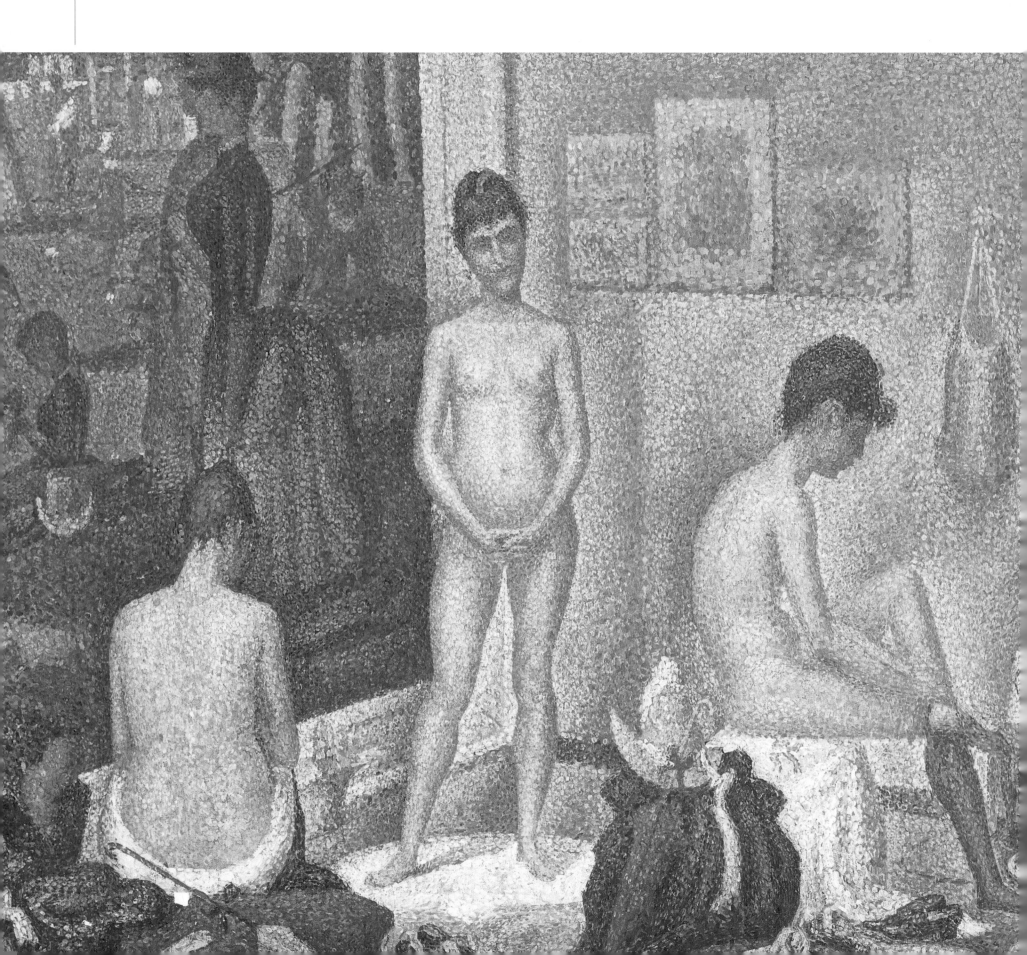

Georges Seurat
Les Poseuses, 1887–88

Courtesy of Private Collection/Christie's Images

Georges Pierre Seurat studied at the École des Beaux-Arts and was influenced by the precise draughtsmanship of Ingres, as well as with Chevreul's theories on colour. He combined the Classicist tradition with the newer ideas of the Impressionists. In particular, he painted in a very distinctive style using a multitude of different coloured dots to build up the impression of the subject, much as the half-tone process or multicolour photogravure use a screen of dots of varying intensity and depth to achieve the overall image. This extremely precise method he termed divisionism, and it was instrumental in the subsequent development of pointillism. There is not much evidence of this technique, however, in his first major work depicting bathers at Asnières (1884), but it became almost a trade mark in his later paintings. Always meticulous in the execution of his work, Seurat was also painstaking in the preparation, often spending months on preliminary sketches for each canvas.

Movement French Impressionism
Other Works *The Can-Can; Sunday Afternoon on the Island of the Grande Jatte*
Influences Ingres, Eugène Chevreul
Georges Seurat *Born* 1859 Paris, France. *Painted in* France. *Died* 1891 Paris

Vincent van Gogh
Portrait de l'Artiste sans Barbe, 1889

Courtesy of Private Collection/Christie's Images

A leading Post-Impressionist and forerunner of Expressionism. Vincent's first job was for a firm of art dealers, but he was sacked after a failed affair affected his ability to work. After a brief stint as a teacher, he became a lay preacher in a Belgian mining district. Here again he was fired when the Church became concerned at his over-zealous attempts to help the poor. Vincent had at least found his true vocation: illustrating the plight of the local peasantry.

Previously influenced by Millet, in 1886 Van Gogh went to Paris where his style changed dramatically. Under the combined impact of Impressionism and Japanese prints, his palette lightened and he began to employ bold simplifications of form. Like Gauguin, he also used colours symbolically, rather than naturalistically. With financial help from his brother, Theo, Vincent moved to the south of France. Gauguin joined him but the pair soon clashed, hastening Van Gogh's mental collapse. Despite his illness he continued working at a frenzied pace until his suicide in July 1890. Van Gogh sold only one painting in his lifetime, but his work has since become the most popular and sought-after of any modern artist.

Movement Post-Impressionism
Other Works *A Starry Night; Sunflowers; The Potato Eaters*
Influences Jean-François Millet, Louis Anquetin, Gauguin
Vincent van Gogh *Born* 1853
Painted in France, Holland and Belgium. *Died* 1890

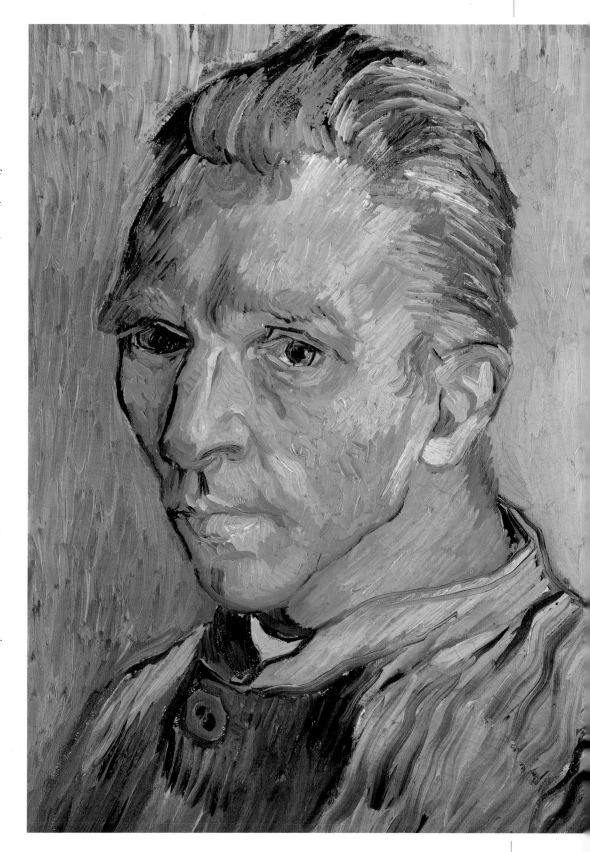

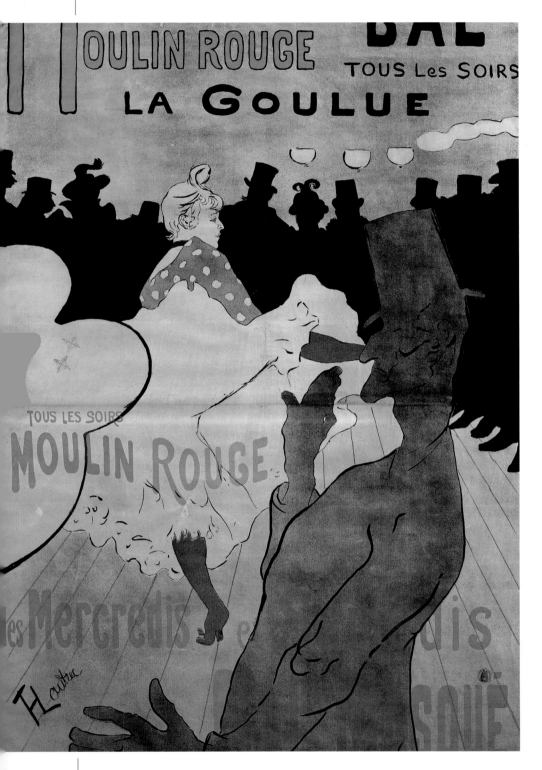

Henri de Toulouse-Lautrec
Moulin Rouge – La Goulue, 1891

Courtesy of Christie's Images

Henri Marie Raymond de Toulouse-Lautrec-Monfa was the scion of one of France's oldest noble families who had been rulers of Navarre in the Middle Ages. Henri was a chronically sick child whose legs, broken at the age of 14, stopped growing and left him physically deformed. In 1882 he went to Paris to study art and settled in Montmartre, where he sketched and painted the cabaret performers, can-can dancers, clowns, barmaids and prostitutes, although occasionally he painted more conventional subjects as well. He played a prominent part in raising the lithographic poster to a recognized art form. He worked rapidly and feverishly from life, seldom using posed models. He belonged to the artistic milieu in which Impressionists and Post-Impressionists mingled and both schools left their mark on his work. Alcoholism led to a complete breakdown and confinement in a sanatorium (1899) but he recovered sufficiently for a last frenzied bout of hard work.

Movement Post-Impressionism
Other Works *At the Moulin Rouge; The Bar; At the Races; Jane Avril*
Influences Degas
Henri de Toulouse-Lautrec *Born* 1864 France. *Painted in* Paris. *Died* 1901 Paris

Paul Cézanne
Still Life with Apples, 1893–94

Courtesy of Private Collection/Bridgeman Art Gallery/Christie's Images

French painter, a leading member of the Post-Impressionists. Born in Aix-en-Provence, the son of a banker, Cézanne's prosperous background enabled him to endure the long struggle for recognition. He studied in Paris, where he met the future members of the Impressionist circle, although his own work at this time was full of violent, Romantic imagery. Cézanne did not mix easily with the group; he was withdrawn, suspicious and prey to sudden rages. Gradually, with Pissarro's encouragement, he tried *plein-air* painting and participated at two of the Impressionist exhibitions. But, in art as in life, Cézanne was a solitary figure and he soon found the principles of the movement too restricting.

After his father's death in 1886, Cézanne returned to Aix, where he brought his style to maturity. His aim was to produce 'constructions after nature'. He followed the Impressionist practice of painting outdoors but, instead of the transient effects which they sought, he tried to capture the underlying geometry of the natural world. This was to make him a fertile source of inspiration for the Cubists.

Movement Post-Impressionism
Other Works *Mont Sainte-Victoire; Apples and Oranges; The Card Players*
Influences Delacroix, Courbet, Pissarro
Paul Cézanne *Born* 1839 France. *Painted in* France. *Died* 1906

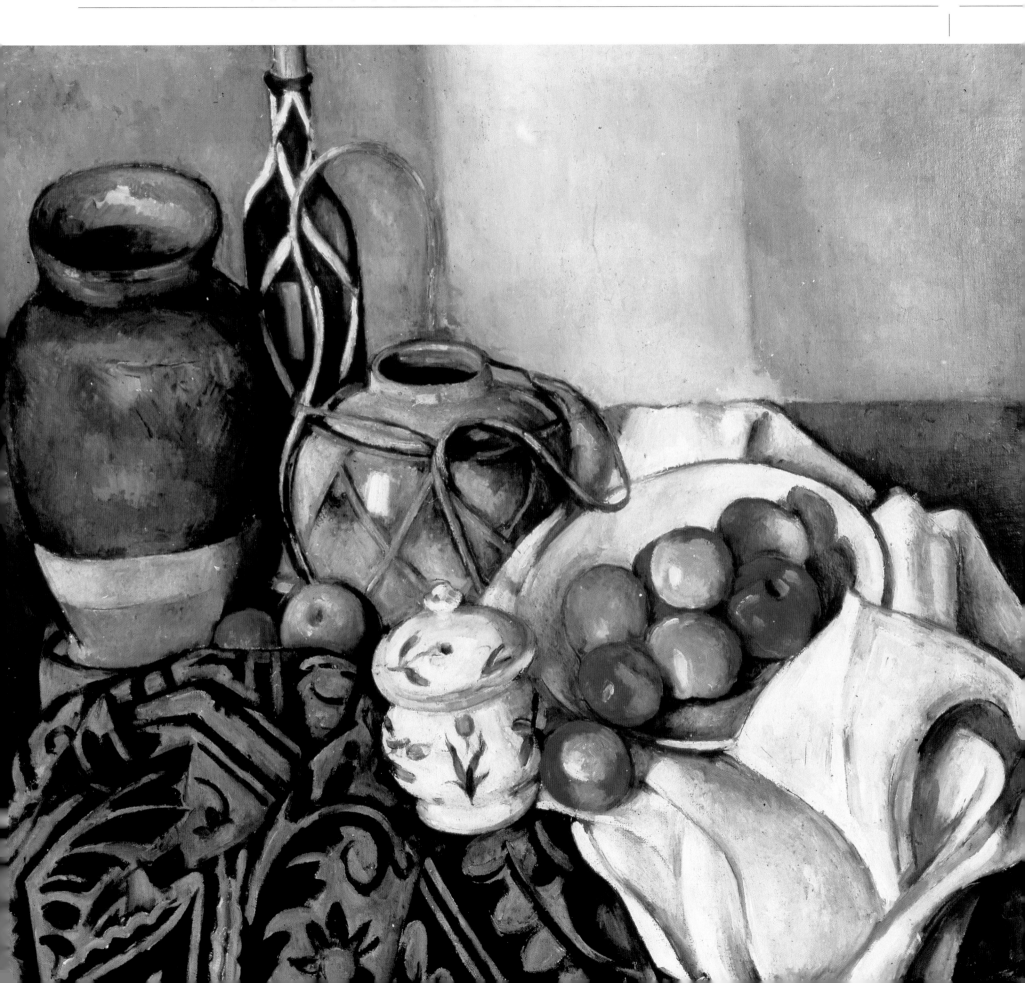

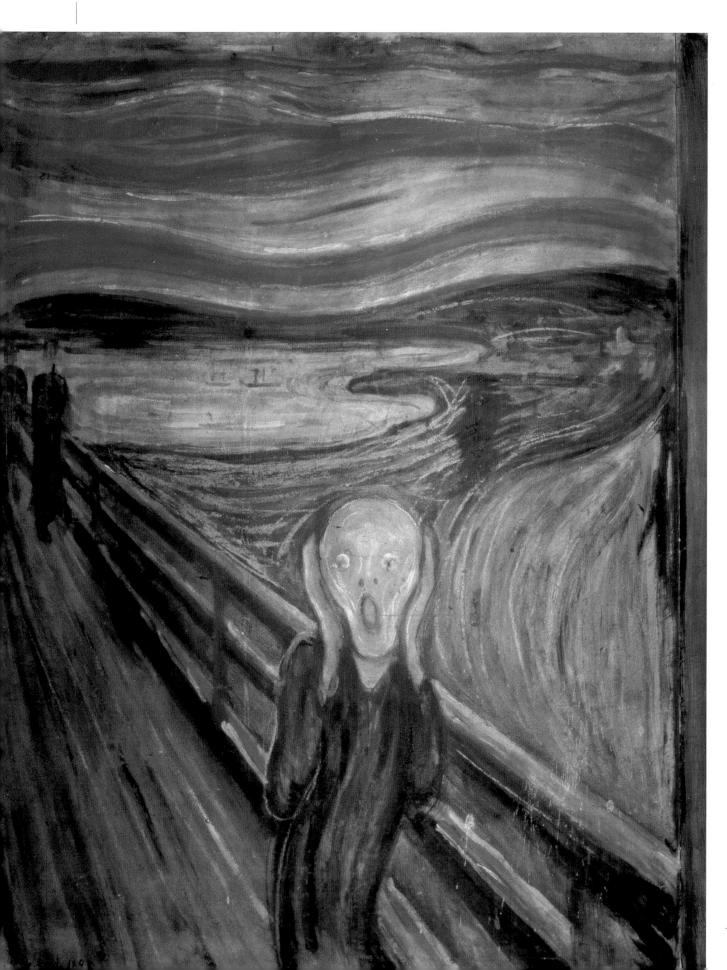

Edvard Munch
The Scream, 1893

Courtesy of Nasuonal Galleriet, Oslo/Bridgeman/
Christie's Images/© Munch Museum/Munch – Ellingsen
Group; BONO, Oslo and DACS, London 2002

Edvard Munch studied in Christiania (now
Oslo) and travelled in Germany, Italy and
France before settling in Oslo. During his
time in Paris (1908) he came under the
influence of Gauguin and had immense
sympathy for Van Gogh due to the bouts
of mental illness from which both suffered.
In fact, this would have a profound effect on
the development of Munch as an artist and
explains the extraordinary passion that
pervades his work. Life, love and death are
the themes that he endlessly explored in
his paintings, rendered in an Expressionist
symbolic style. His use of swirling lines and
strident colours emphasize the angst that lies
behind his paintings. He also produced
etchings, lithographs and woodcut engravings
which influenced the German artists of the
movement known as Die Brücke.

Movement Expressionism
Other Works *Puberty, The Dance of Life;
The Madonna; Ashes*
Influences Gauguin, Van Gogh
Edvard Munch *Born* 1863 Loten, Norway
Painted in Oslo, Norway
Died 1944 Oslo

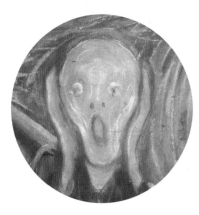

Aubrey Beardsley

The Peacock Skirt,
illustration for
Oscar Wilde's play
'Salome', 1894

Courtesy of Fogg Art Museum, Harvard University Art
Museums, USA/Bridgeman Art Library

English graphic artist, the epitome of *fin-de-siècle*
decadence. Born in Brighton, Beardsley was a
frail child and suffered his first attack of
tuberculosis in 1879. He left for London at the
age of 16, working initially in an insurance
office, while attending art classes in the evening.
In 1891 Edward Burne-Jones persuaded him to
become a professional artist and, two years later,
Beardsley received his first major commission,
when J. M. Dent engaged him to illustrate
Malory's *Morte d'Arthur*. The success of this
venture gave him the opportunity to work on an
even more prestigious project, the illustration of
Wilde's *Salome*, while also producing images for a
new journal, *The Yellow Book*.

Soon Beardsley developed a unique style,
combining the bold compositional devices used
in Japanese prints; the erotic, sometimes perverse
imagery of the Symbolists; and an effortless
mastery of sinuous, linear design, which prefigured
Art Nouveau. A glittering career seemed to
beckon, but in 1895 the scandal surrounding the
Wilde trial led to his sacking from *The Yellow
Book*. His tubercular condition flared up again
and within three years he was dead.

Movements Symbolism, Decadence,
Art Nouveau
Other Works *The Toilet of Salome;
How King Arthur saw the Questing Beast*
Influences Sir Edward Burne-Jones, Kitagawa
Utamaro, Toulouse-Lautrec
Aubrey Beardsley *Born* 1872 Brighton,
England. *Worked in* England and France
Died 1898

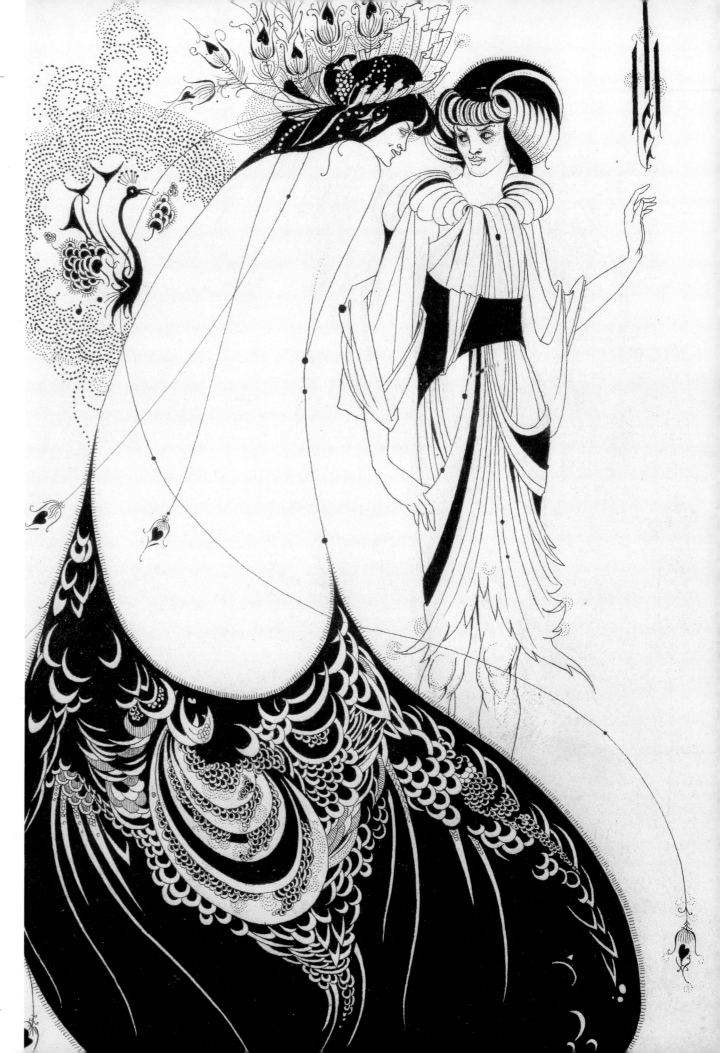

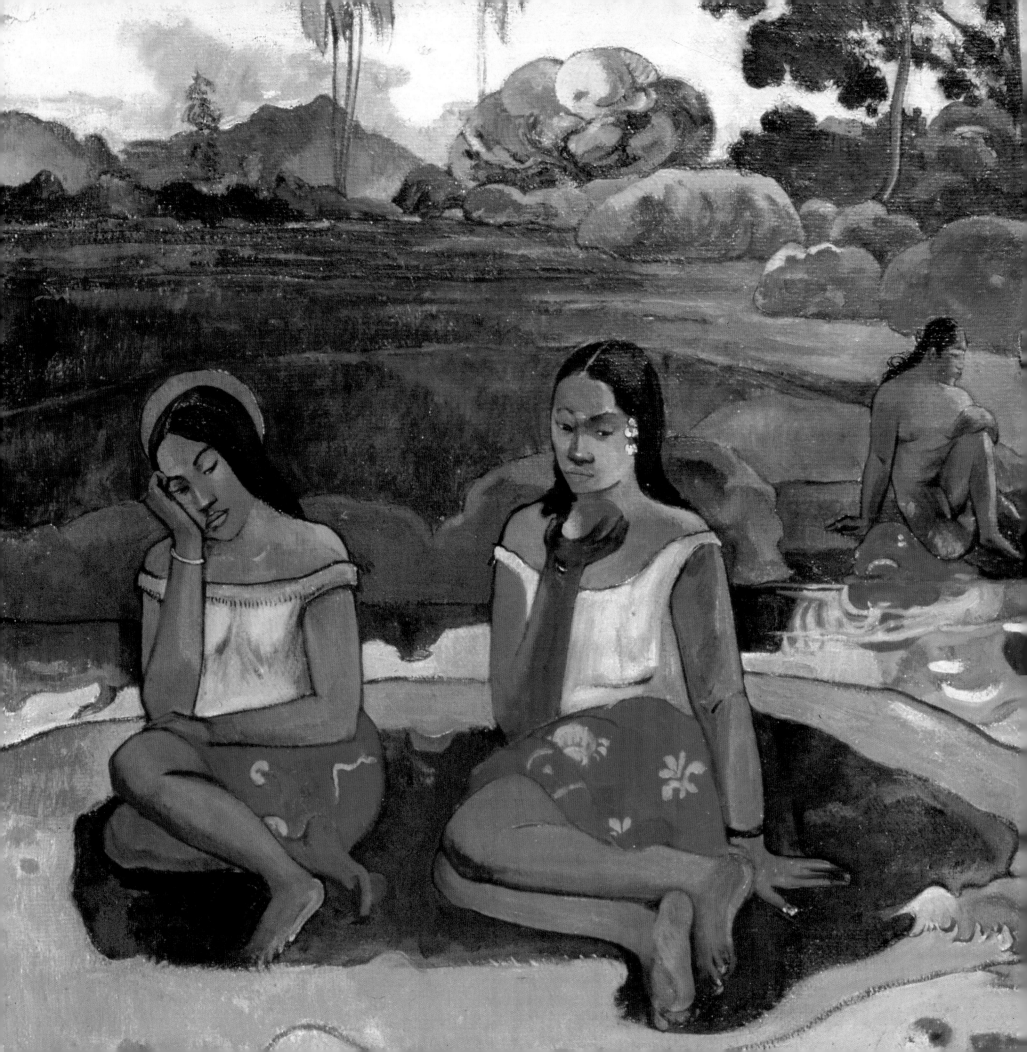

Paul Gauguin
Nave Nave Moe, 1894

Courtesy of Hermitage, St Petersburg/Bridgeman/Christie's Images

Although he was born in Paris, Gauguin spent his early childhood in Peru, returning to France in 1855. He worked for a time as a stockbroker, painting only as a hobby, until the stock market crash of 1882 prompted a dramatic change of career. His first pictures were in the Impressionist style, influenced in particular by his friend, Camille Pissarro. Increasingly, though, Gauguin became dissatisfied with the purely visual emphasis of the movement, and tried to introduce a greater degree of symbolism and spirituality into his work. Inspired by Japanese prints, he also developed a new style, coupling bold splashes of bright, unmixed colour with simplified, linear designs. At the same time, haunted by memories of his Peruvian childhood, Gauguin developed a growing fascination for exotic and primitive cultures. Initially, he was able to satisfy this need in Brittany where, inspired by the region's distinctive Celtic traditions, he produced *The Vision after the Sermon,* his first great masterpiece. Then in 1891, he moved to the French colony of Tahiti. Dogged by poverty and ill health, he spent most of his later life in this area producing the paintings for which he is best known today.

Movements Post-Impressionism, Impressionism, Symbolism
Other Works *Where Do We Come From? What Are We? Where Are We Going To?*
Influences Camille Pissarro, Emile Bernard, Vincent Van Gogh
Paul Gauguin *Born* 1848 Paris, France
Painted in France, Denmark, Martinique Tahiti
Died 1903

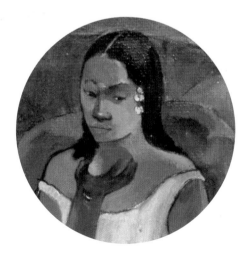

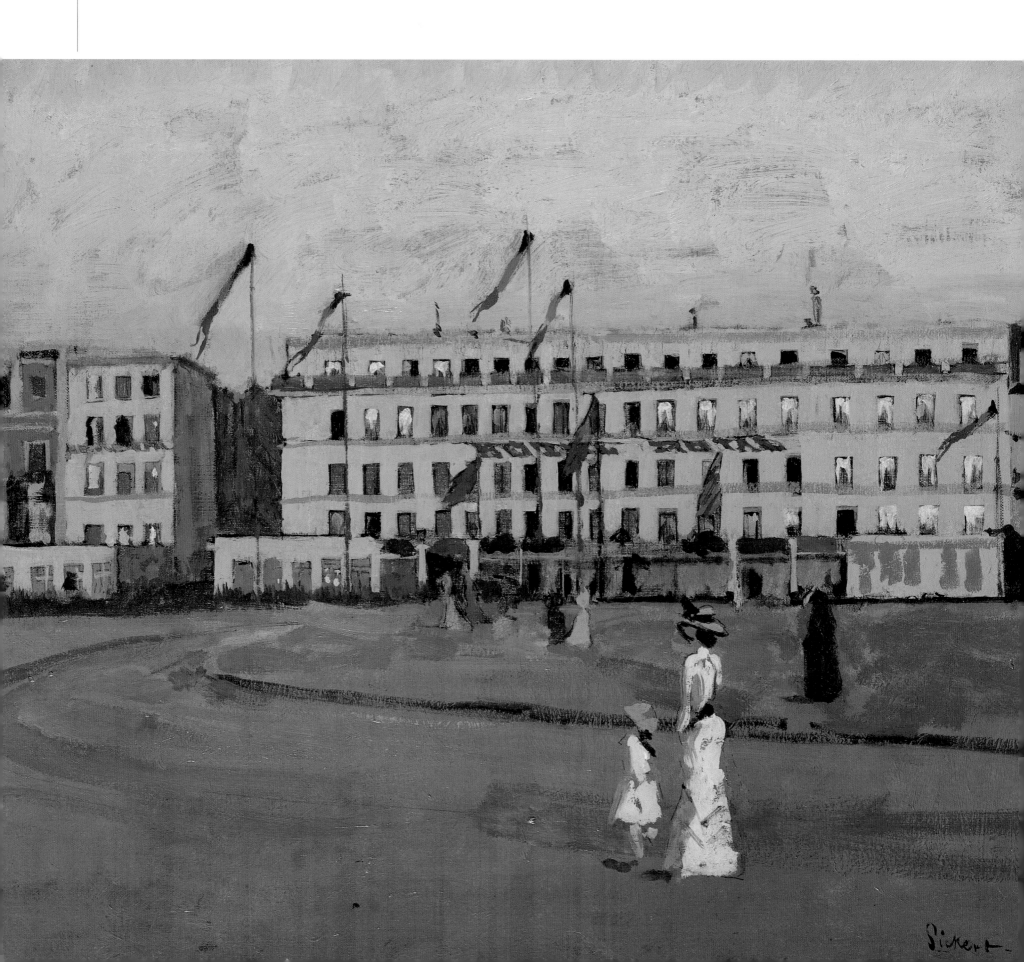

Walter Sickert
L'Hotel Royal Dieppe, c. 1894

Born in Munich, Bavaria, Walter Richard Sickert was the son of the painter Oswald Adalbert Sickert and grandson of the painter and lithographer Johannes Sickert. With such an artistic pedigree it was almost inevitable that he should follow the family tradition. In 1868 his parents moved to London, where he later studied at the Slade School of Art and took lessons from Whistler, whose limited tonal range is reflected in much of Sickert's work. On the advice of Degas – whom he met while studying in Paris – he made detailed preliminary drawings for his paintings rather than paint from life. As a youth, Sickert had been an actor and he had a lifelong interest in the theater, reflected in many of his paintings. He was a competent all-rounder, painting portraits, rather seedy genre subjects and murky landscapes, and as a teacher he wielded enormous influence on the British artists of the early twentieth century.

Movement British Impressionism
Other Works *Mornington Crescent Nude; La Hollandaise Nude*
Influences James McNeill Whistler, Degas
Walter Sickert *Born* 1860 Munich, Germany. *Painted in* London, Dieppe, and Venice. *Died* 1942 Bathampton, Avon, England

Edouard Vuillard
Causerie chez les Fontaines

Jean Edouard Vuillard studied at the Académie Julien in Paris and shared a studio with Pierre Bonnard. Both artists were inspired by Sérusier's theories derived from the works of Gauguin and became founder members of Les Nabis in 1889. Vuillard was also influenced by the fashion for Japanese prints and this was reflected in his paintings of flowers and domestic interiors, executed with a keen sense of tone, colour and light. He was also a prolific designer of textiles, wallpaper and decorative features for public buildings. His paintings of cozy domestic subjects show a tremendous feeling for texture and patterning, a skill he picked up from his mother who was a dressmaker. The bolts of brightly coloured cloth that surrounded him as a child found an echo in his own textile designs. His later paintings were more naturalistic, aided by photography, which he employed to capture the fleeting moment.

Movement Les Nabis
Other Works *Femme Lisant; Le Soir; Two Schoolboys; Mother and Child*
Influences Paul Sérusier, Gauguin
Edouard Vuillard *Born* 1868 Cuiseaux, France. *Painted in* France
Died 1940 La Baule, France

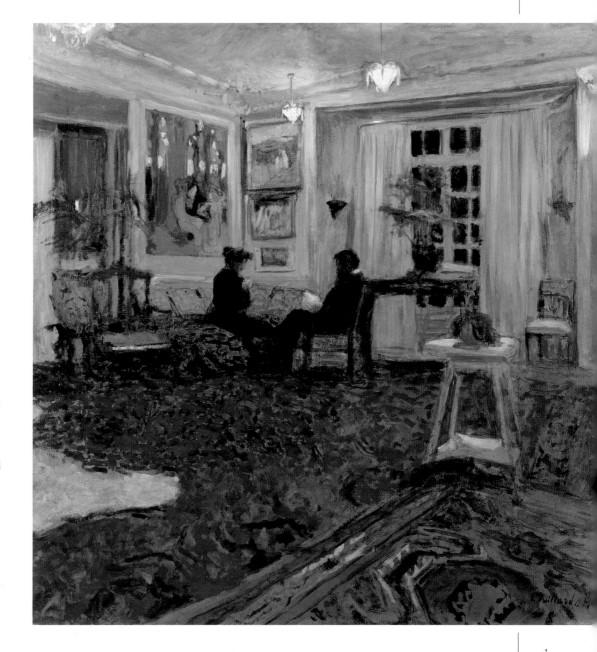

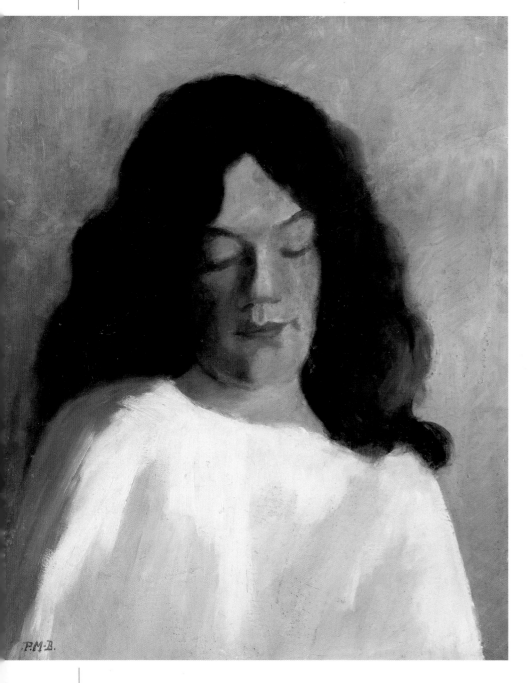

Paula Modersohn-Becker
Brustbild einer Jungen Frau mit Offenem Haar

Courtesy of Private Collection/Christie's Images

Born Paula Becker, she was largely self-taught although she was encouraged by her parents to develop her art by sending her to Paris on several occasions, during which she became familiar with the works of Cézanne, Gauguin and Van Gogh. What formal training she had she received at the classes held by the Association of Berlin Women Artists in 1893–95, but three years later she joined the artists' colony at Worpswede, where she spent most of the last nine years of her short life. Her early paintings concentrated largely on landscapes and peasant genre subjects. In 1901 she married Otto Modersohn, a widower 11 years her senior, and the more mature style of her later paintings may owe something to his advice and example. To her last years belong a number of portraits which reflect the influence of the Expressionists. Unable to cope with her domineering husband she fled to Paris in 1906 and died early the following year while giving birth to her daughter Mathilde.

Movement German Expressionism
Other Works *Old Poorhouse Woman with a Glass Bottle*
Influences Cézanne, Gauguin, Van Gogh
Paula Modersohn-Becker *Born* 1876 Germany
Painted in Dresden, Berlin and Worpswede. *Died* 1907 Worpswede, Germany

Gustav Klimt
The Kiss, 1907–08

Courtesy of Osterreichische Galerie, Vienna, Austria/Bridgeman Art Library

Klimt was born in Vienna and became one of the leading lights in the city's most dazzling, artistic period. The son of a goldsmith, he trained at the School of Applied Arts and started work as a decorative painter. He achieved early success with the schemes at the Burgtheater and the Kunsthistorisches Museum, but future commissions were threatened by his growing fascination with avant-garde art. Faced with official opposition, Klimt resigned from the Viennese Artists' Association in 1897 and founded the Vienna Sezession, becoming its first president. This coincided with protracted disputes about his decorations for the university, a project that he abandoned in 1905.

Klimt's style was a compelling blend of Art Nouveau and Symbolist elements. From the former, he derived his taste for sinuous, decorative lines, while from the latter he borrowed his erotic subject matter and, in particular, his interest in the theme of the *femme fatale*. It was this blatant eroticism which troubled the authorities, though it did not seriously damage Klimt's career. He was always in great demand as a portraitist, and he continued to receive private commissions for decorative schemes.

Movement Vienna Sezession
Other Works *Judith I; The Beethoven Frieze*
Influences Hans Makart, Edvard Munch, Franz von Stuck
Gustav Klimt *Born* 1862 Vienna, Austria. *Painted in* Austria-Hungary, Belgium. *Died* 1918

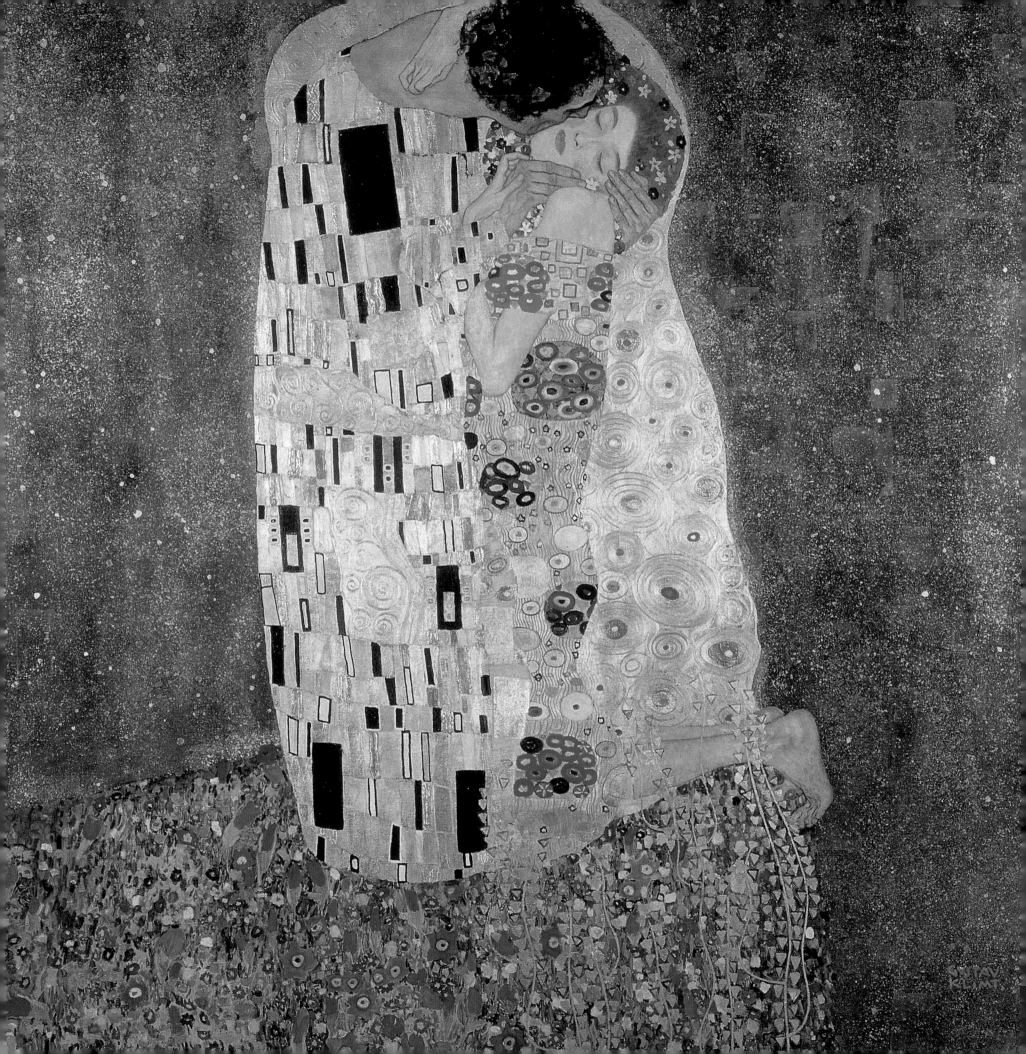

HISTORY OF ART

The Modern Era

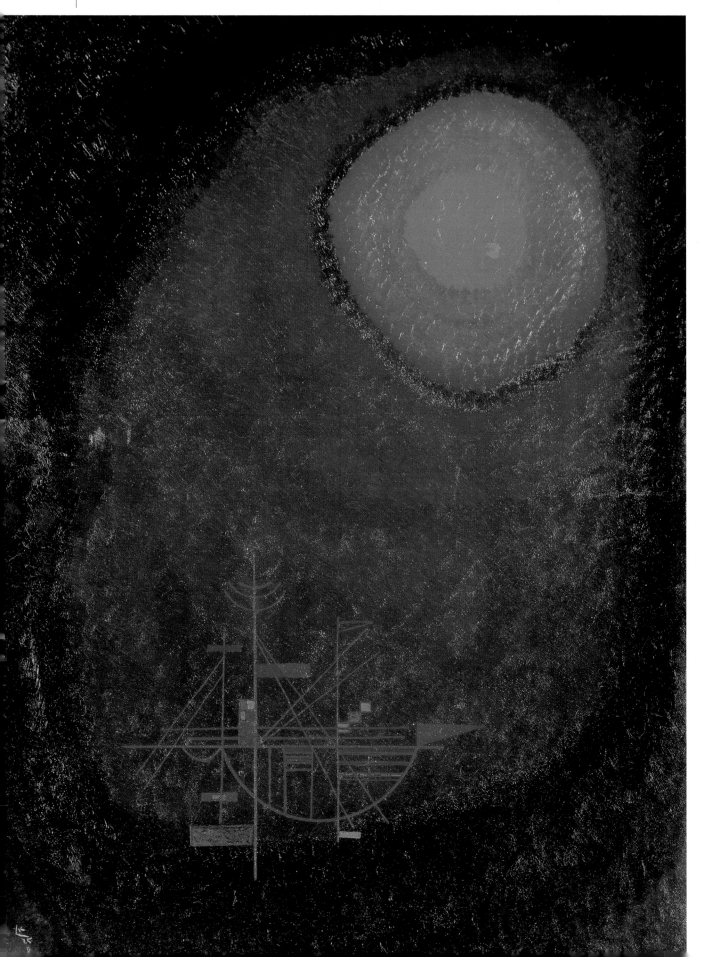

Wassily Kandinsky
Ship and Red Sun, 1925

Courtesy of Private Collection/Bridgeman Art Library/
© ADAGP, Paris and DACS, London 2002

Born in Moscow, Kandinsky trained as a lawyer but
turned to art after visiting an exhibition of Monet's
work. He moved to Munich, where he studied
under Franz von Stuck. Here, he demonstrated his
talent for organizing groups of artists when he
founded influential Der Blaue Reiter ('The Blue
Rider'), an association of Expressionist artists that
included Franz Marc and Paul Klee. Kandinsky's
personal style went through many phases, ranging
from Jugenstil (the German equivalent of Art
Nouveau) to Fauvism and Expressionism. He is
most celebrated, however, for his advances towards
abstraction. This came about after he returned to his
studio one evening and was enchanted by a picture
he did not recognise. It turned out to be one of his
own paintings lying on its side. Kandinsky
immediately realized that subject matter lessened
the impact of his pictures and he strove to remove
this from future compositions. In later life
Kandinsky taught at the Bauhaus, until it was closed
down by the Nazis in 1933. He spent his final years
in France, becoming a French citizen in 1939.

Movements Expressionism, Abstract Art
Other Works *Swinging; Composition IV (Battle)*
Influences Claude Monet, Paul Klee, Franz Marc
Wassily Kandinsky *Born* 1866 Moscow, Russia
Painted in Russia, Germany, France and Holland
Died 1944 Neuilly-sur-Seine, France

André Derain
La Tamise et Tower Bridge, 1906

Courtesy of Private Collection/Christie's Images © ADAGP, Paris and DACS, London 2002

While studying art in Paris, André Derain teamed up with fellow student Maurice de Vlaminck with whom he shared a studio. Although very different in temperament they sparked radical ideas off each other regarding the use of colour and, encouraged by Matisse whom they met in 1899, they gradually evolved the style known as Fauvism, distinguished by its often violent and savage use of contrasting colours. In 1905 Ambroise Vollard, a prominent art dealer, encouraged Derain to travel to England and try to capture the strange lighting effects in the Pool of London. The results were startling but considered to be some of his greatest masterpieces. Later he toned down the adventurous use of colour and, under the influence of Cézanne, painted landscapes in a more Impressionist style. He also designed theatre sets, notably for Diaghilev, as well as working as a book illustrator.

Movement Fauvism
Other Works *Houses of Parliament; Barges on the Thames; The Pool of London*
Influences Maurice de Vlaminck, Henri Matisse, Paul Cézanne
André Derain *Born* 1880 Chatou, France
Painted in France and England. *Died* 1954

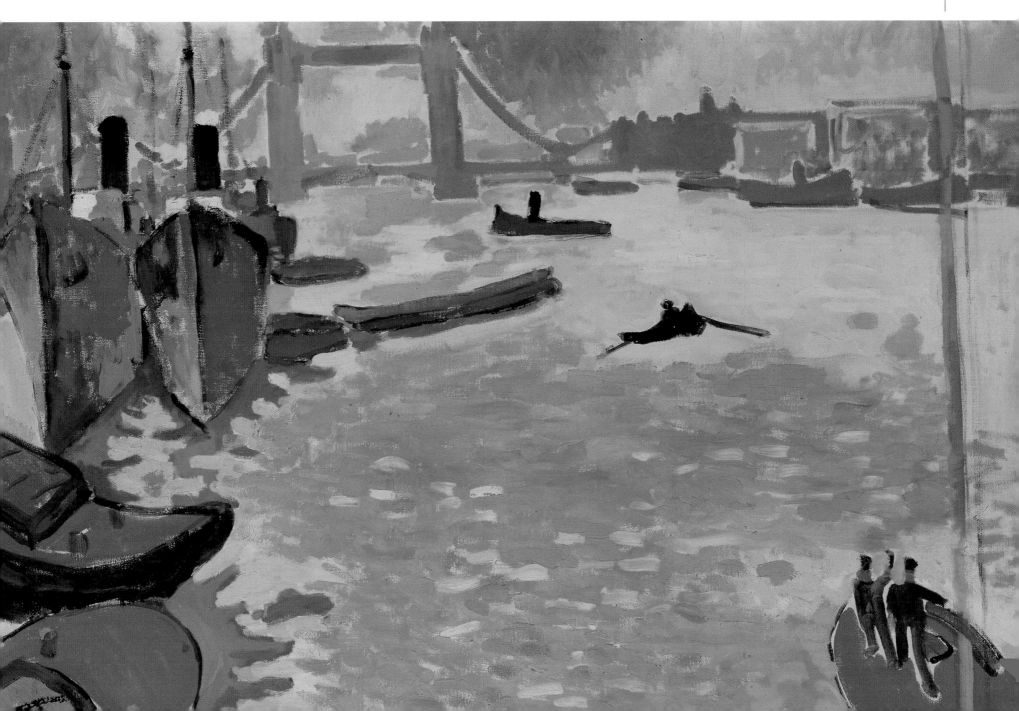

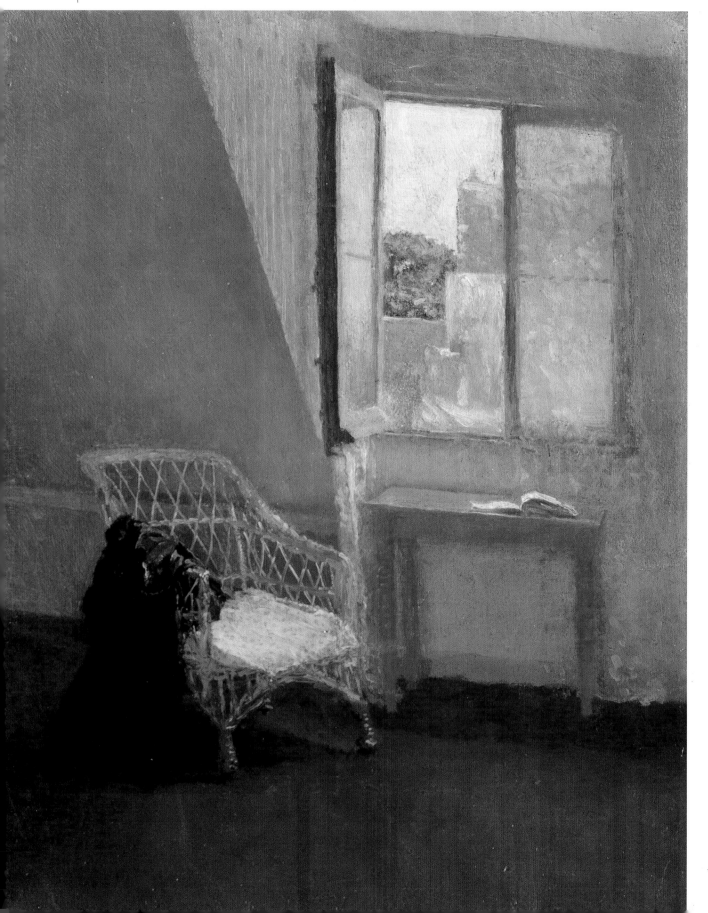

Gwen John
A Corner of the Artist's Room in Paris, c. 1907

A Welsh painter and the greatest female artist of her age, John trained at the Slade School in London together with her brother Augustus, who also went on to become a famous artist. She then moved to Paris to study under Whistler, from whom she derived her delicate sense of tonality. In 1903, John planned to walk to Rome with a friend, but they only got as far as France, where she decided to settle. For a time she worked as a model in Paris and, through this, met the sculptor Rodin, who became her lover. He urged her to paint more, but John's output was small and it was only through the generosity of her chief patron, an American lawyer named John Quinn, that she was able to give up modelling and devote herself to her art.

Quiet and retiring, John lived alone and rarely exhibited her work. In her solitude, she developed a unique style, painting intimate, small-scale subjects – usually female portraits or corners of her studio – in thin layers of exquisitely muted colours. At first glance, these often appear frail and insubstantial but, like the artist herself, they also exude an inner calm and strength.

Movement Intimism
Other Works *The Convalescent; Girl Reading at the Window; Nude Girl*
Influences James Whistler, Henry Tonks
Gwen John *Born* 1876 Wales
Painted in England and France
Died 1939 Dieppe, France

Egon Schiele
Liegender Halbakt mit Rolem, 1910

Courtesy of Private Collection/Christie's Images

Egon Schiele studied at the Vienna Academy of Fine Arts in 1906 and the following year he met Gustave Klimt, whose Vienna Sezession movement he joined in 1908. A disciple of Sigmund Freud, Schiele sought to explore the deeper recesses of the human psyche, especially the sexual aspects. He developed a particularly stark style of Expressionism – distinguished by figures, often naked and usually emaciated – with harsh outlines, filling the canvas with contorted limbs and anguished features. Long before the Nazis were denouncing his paintings as degenerate art, the Austrian authorities were confiscating and destroying his works. In 1912 he was actually arrested, convicted of offences against public morals and briefly imprisoned. After his marriage in 1915 his art mellowed, taking on a brighter and more sensuous form, and it is interesting to conjecture how this trend might have developed had he not died in the influenza pandemic of 1918.

Movement Austrian Expressionism
Other Works *The Embrace; Recumbent Female Nude with Legs Apart*
Influences Gustav Klimt
Egon Schiele *Born* 1890 Tulln, Austria.
Painted in Vienna, Austria
Died 1918 Vienna

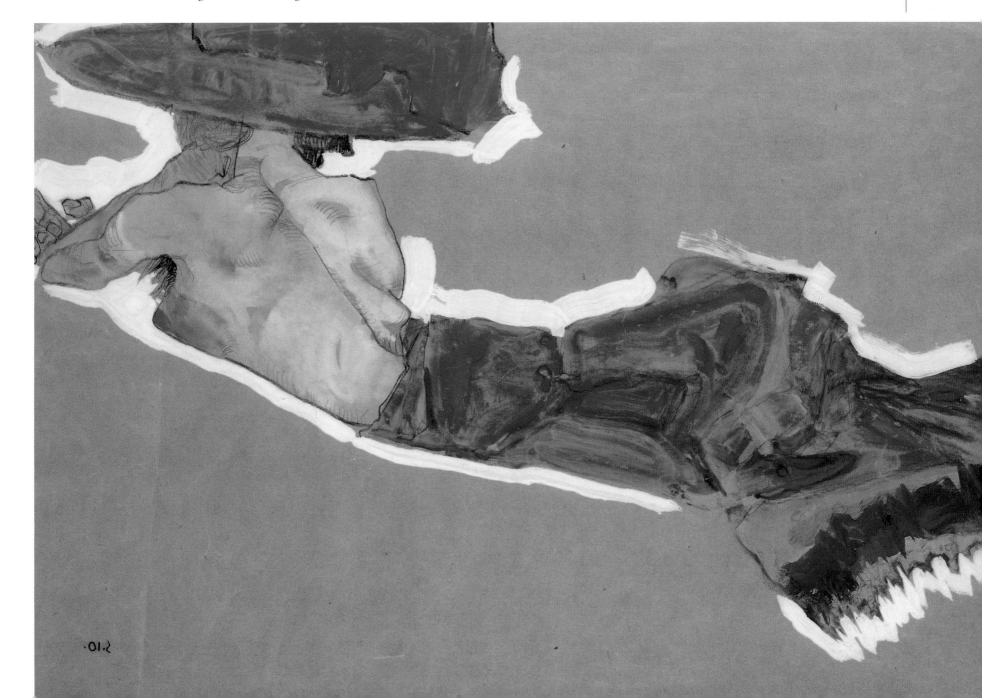

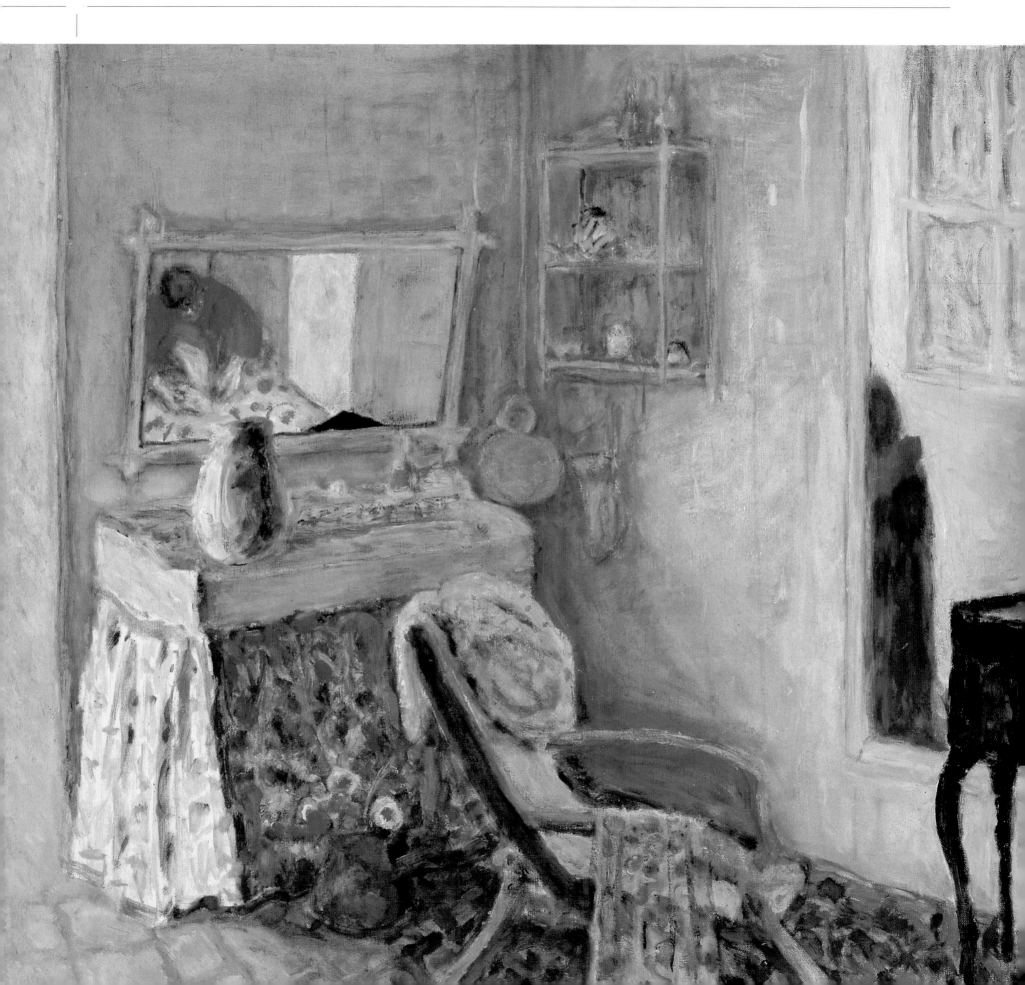

Pierre Bonnard
Intérieur, 1913

Courtesy of Private Collection/Christie's Images © ADAGP,
Paris and DACS, London 2002

Pierre Bonnard settled in Paris in 1888, where he
studied at the Académie Julien and the École des
Beaux-Arts. With Maurice Denis and Edouard Vuillard,
with whom he shared a studio, he was influenced by
Paul Gauguin's expressive use of colour and formed the
group known as Les Nabis (from the Hebrew word for
prophet) and later the Intimists. While other artists at
the end of the nineteenth century were tending
towards abstraction, Bonnard was influenced by
Japanese prints and concentrated on landscapes and
interiors which strove after subtle effects in light and
colour at the expense of perspective. At the turn of the
century he was moved by the intensity and passion in
the paintings of Van Gogh and this led him to become a
founder member of the Salon d'Automne in 1903.
Thereafter he was influenced by Les Fauves (literally
'the wild beasts'), whose strident colours and distorted
images he tamed and harnessed to his own style.

Movements Les Nabis, Intimism, Fauvism
Other Works *Mirror on the Washstand;*
The Open Window; The Table
Influences Paul Gauguin, Vincent Van Gogh
Pierre Bonnard *Born* 1867 Fontena-aux-Roses, France
Painted in Paris, France
Died 1947 Le Cannet, France

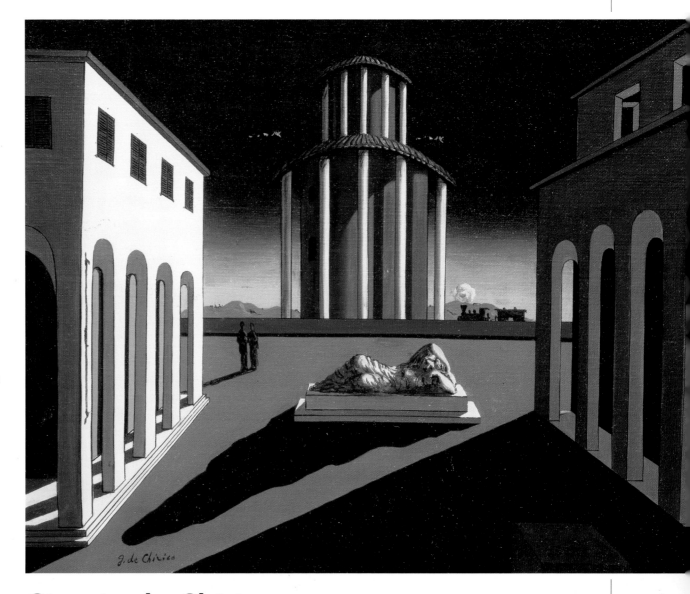

Giorgio de Chirico Piazza d'Italia, c. 1915

Courtesy of Private Collection/Christie's Images/© DACS 2002

Born in north-western Greece of Venetian descent, Giorgio de Chirico studied in Athens and Munich,
then worked in Paris and finally collaborated with Carrà in Italy, founding Pittura Metaphisica. About
1910 he began painting a series of pictures of deserted town squares, imbued with a dreamlike quality,
characterized by incongruous figures and strange shadows which anticipated the style of the Surrealists,
on whom he exerted tremendous influence. After suffering a breakdown during World War I he
developed his metaphysical style of painting, which conveyed an intensely claustrophobic impression. In
the 1920s, however, his paintings often verged on the abstract before he returned to a more traditional
style shortly before World War II – the complete antithesis of all he had done up to that time. He
continued to embrace academic naturalism in the postwar period.

Movement Metaphysical painting, Surrealism
Other Works *The Uncertainty of the Poet; The Archaeologists*
Influences Carlo Carrà
Giorgio de Chirico *Born* 1888 Volo, Greece. *Painted in* France and Italy. *Died* 1978 Rome

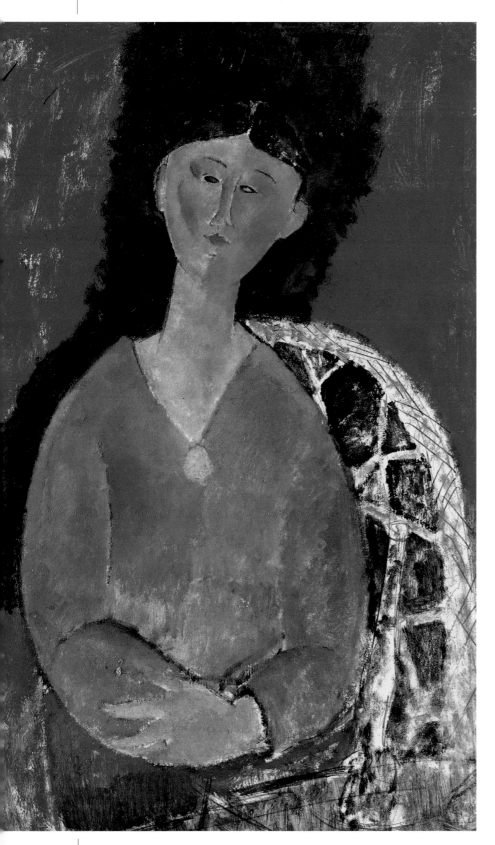

Amedeo Modigliani
Beatrice Hastings Assise, 1915

Courtesy of Private Collection/Christie's Images

Modigliani was born into a Jewish family in Livorno, Italy. Although educated in Florence and Venice he spent most of his career in France. His highly individual style combined the linear elegance of Botticelli, whose work he had studied in Italy, with the avant-garde ideas that were circulating in pre-war Paris. His key influence was the Romanian sculptor Brancusi, whom he met in 1909. Under his guidance, Modigliani produced an impressive series of African-influenced stone figures.

After the outbreak of war, the raw materials for sculpture became scarce, so Modigliani turned to painting. Most of his subjects were sensual nudes or portraits, featuring slender, elongated figures. These received little attention from the critics; he was better known for his self-destructive, bohemian lifestyle, a lifestyle which caused the breakdown of his health – he died of tuberculosis at the age of 35. Tragically, Jeanne Hébuterne, his mistress and favourite model, committed suicide on the following day while pregnant with the artist's child. Modigliani's reputation was only secured posthumously, through a retrospective exhibition in Paris in 1922.

Movement School of Paris
Other Works *Seated Nude; The Little Peasant; Portrait of Jeanne Hébuterne*
Influences Sandro Botticelli, Paul Cézanne, Constantin Brancusi
Amedeo Modigliani *Born* 1884, Livorno, Italy
Painted in Italy and France. *Died* 1920 Paris, France

Georges Braque
Verre et as de Trefle, 1917

Courtesy of Private Collection/Christie's Images © ADAGP, Paris and DACS, London 2002

Born in Argenteuil, the son of a house-painter, Braque was initially trained to carry on the family business. In 1902 he switched to art, but retained a profound respect for craftsmanship and always ground his own pigments. Initially, he joined the Fauvist group, but his style altered radically after two key events in 1907. Firstly he was overwhelmed by an exhibition of Cézanne's work, then, later in the year, he saw *Les Demoiselles d'Avignon* in Picasso's studio and embarked on a unique collaboration with the Spaniard. Working, in Braque's words, 'like two mountaineers roped together', they created Cubism. This artistic partnership was halted by the war, when Braque was called to the Front. He was decorated for bravery before being discharged with serious wounds in 1916. Unlike Picasso, who changed direction completely, Braque spent the remainder of his career refining his experiments with Cubism. These culminated in a magnificent cycle of paintings on *The Studio*, which he began in 1947. Braque also diversified into design work, producing ballet décors, stained-glass windows, book illustrations and, most notable of all, a ceiling for the Etruscan Gallery in the Louvre.

Movement Cubism
Other Works *The Round Table; Guitar and Fruit Dish; Still Life with Violin*
Influences Pablo Picasso, Paul Cézanne, Juan Gris
Georges Braque *Born* 1882, Argeuteille-sur-Seine, France
Painted in France. *Died* 1963 Paris, France

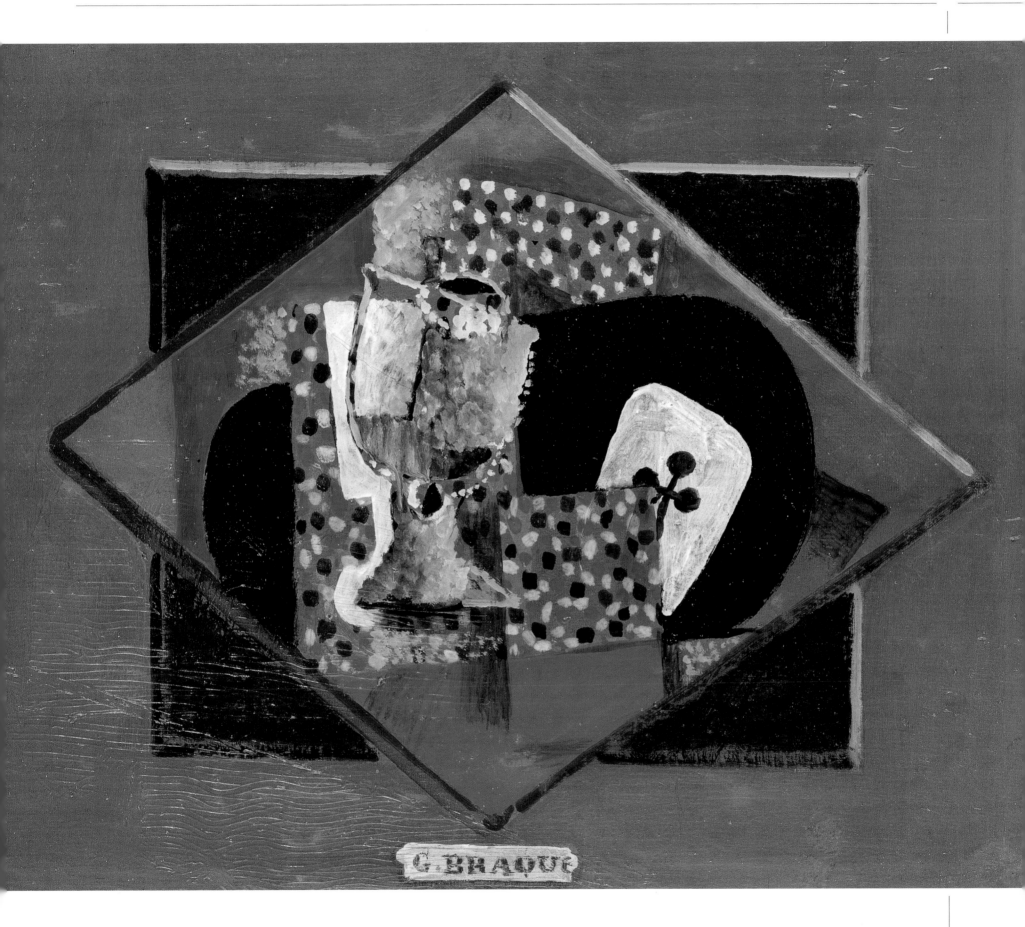

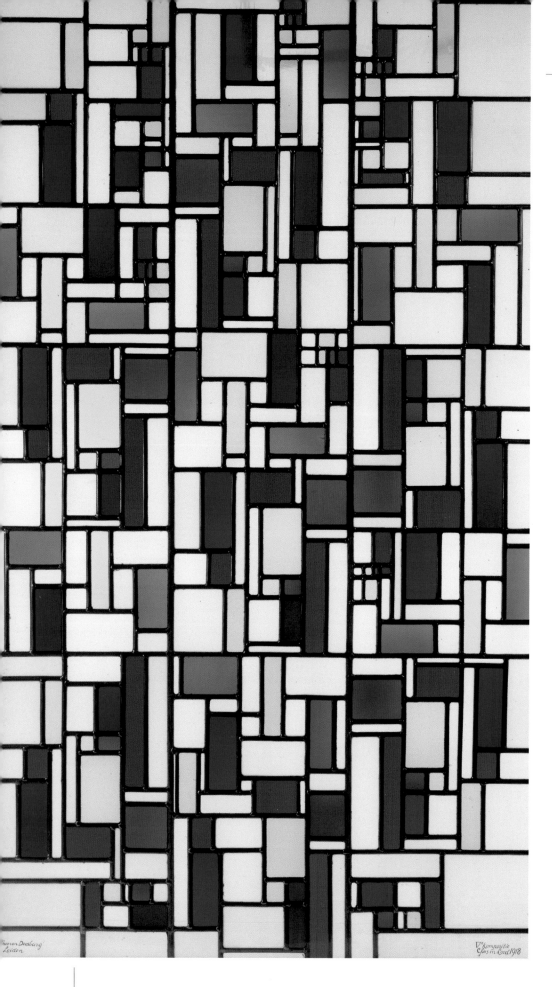

Theo van Doesburg
Vetrata Kompositie V in Lood, 1918

Courtesy of Private Collection/Christie's Images

De Stijl, Dutch for 'the Style' denoted a group of artists and designers that was formed in the Netherlands in 1917 and took its name from a magazine edited by Theo van Doesburg. The other founder members included the painters Piet Mondrian and Bart van der Leck, the architect J. J. P. Oud and the furniture designer Gerrit Rietveld. It was a reaction against Art Nouveau (which had run its course by that time) and the excessively florid styles of the late nineteenth century, and sought to create a pure aesthetic based on straight lines and primary colours plus black and white. It was a conscious reminder of the austere qualities of seventeenth century Dutch Protestantism and the flat, regimented character of the Dutch landscape. Van Doesburg was the driving force of the movement, creating paintings that were strongly influenced by Constructivism and, in turn, making a major contribution to the development of modern typography.

Movement De Stijl
Other Works *Composition in Grey*
Influences J. J. P. Oud, Jan Wils
Theo van Doesburg *Born* 1883 Utrecht, the Netherlands
Painted in the Ntherlands and Germany. *Died* 1931 Davos, Switzerland

Paul Klee
Moonshine, 1919

Courtesy of Private Collection/Christie's Images © DACS 2002

Paul Klee studied in Munich and worked there as an etcher. In 1911 he joined with Feininger, Kandinsky and Jawlensky in the Blaue Reiter group founded by August Macke; up to that time he had worked mainly in watercolours, painting in an Expressionist manner with overtones of Blake and Beardsley, but subsequently he veered towards Cubism under the influence of Robert Delaunay and from 1919 onwards painted mostly in oils. In 1920 he became a teacher at the Bauhaus and in the ensuing period his paintings mingled the figural with the abstract as he explored subtle combinations of colours and shapes, often deriving elements from folk art and even children's drawings. He severed his connections with the Bauhaus and returned to Switzerland when the Nazis came to power in 1933 and condemned his works as degenerate art.

Movements Expressionism, Cubism
Other Works *The Castle in a Garden; At the Sign of the Hunter's Tree*
Influences August Macke, Robert Delaunay
Paul Klee *Born* 1879 Münchenbuschsee, Switzerland
Painted in Berne and Munich. *Died* 1940 Muralto-Locarno, Switzerland

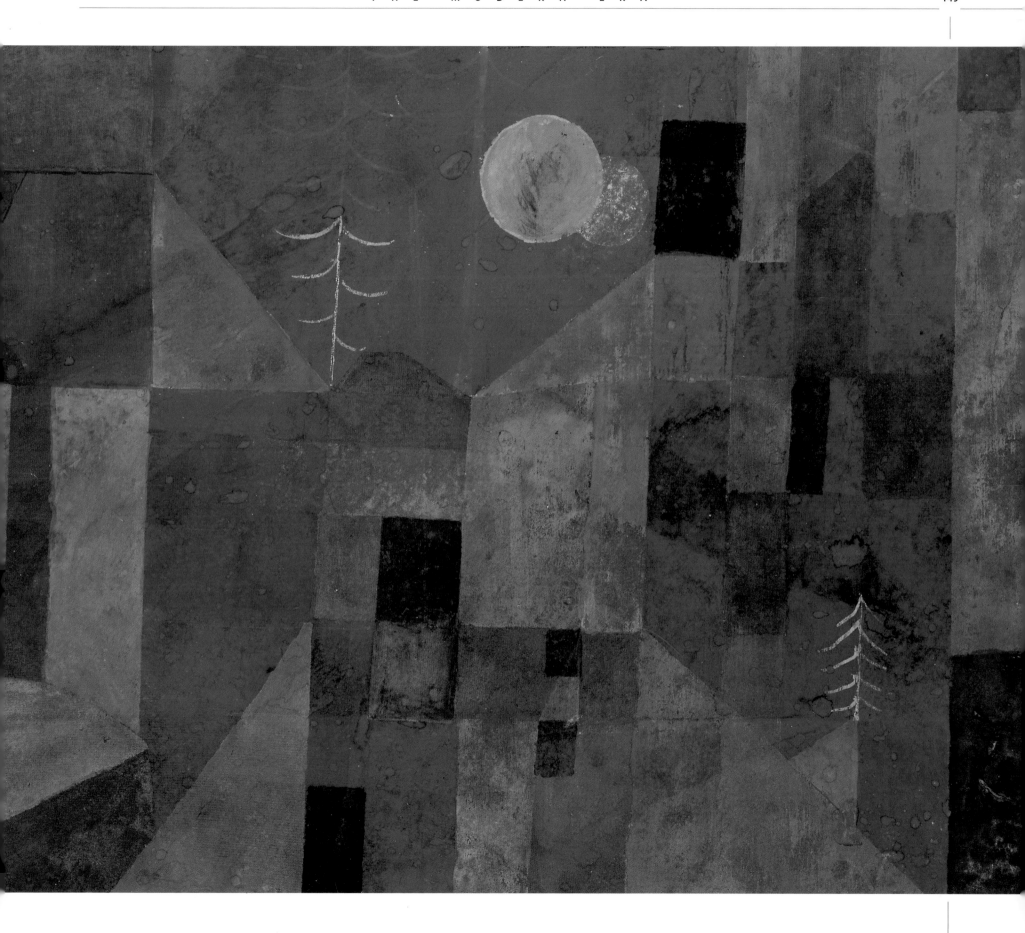

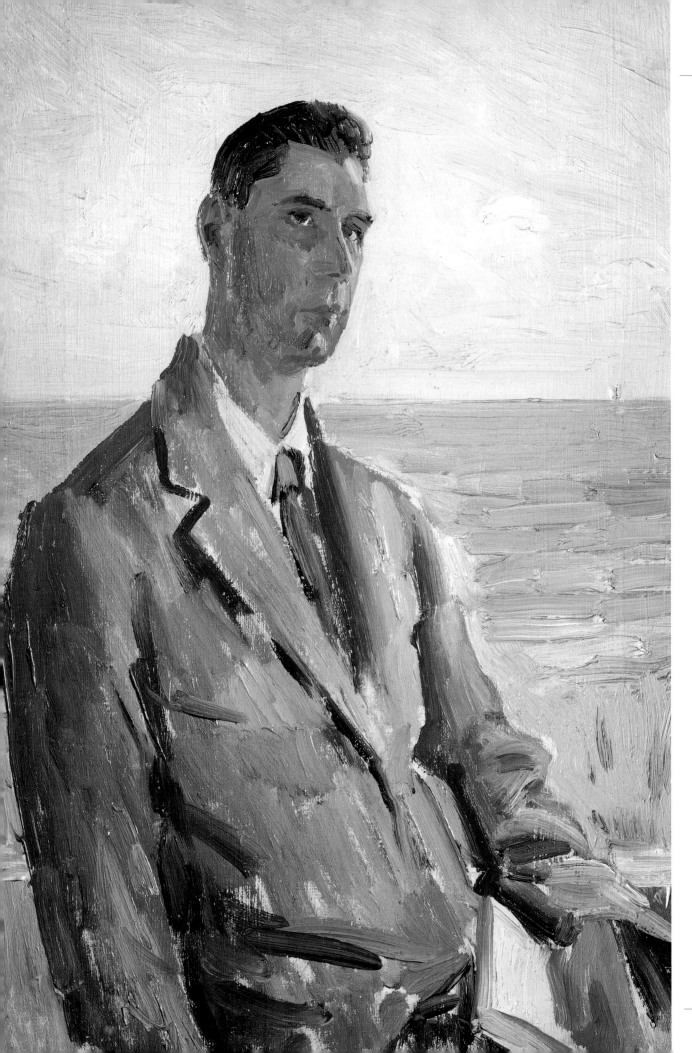

Augustus John
Meditation at Ischia, Portrait of Thomas Earp

Courtesy of The Artists' Estate/Bridgeman Art Library/
Christie's Images

Augustus Edwin John studied at the Slade School of
Art and the University of London under Fred Brown
and Henry Tonks, winning a scholarship with his
Moses and the Brazen Serpent (1896). He went to Paris
in 1900 and later travelled in the Netherlands,
Belgium and Provence. His early work was
influenced by Rembrandt, El Greco and the Post-
Impressionists. A colourful, larger-than-life character,
John hit the headlines when he roamed around
England in a horse and cart, painting gypsy scenes.
His later style was marked by the use of bold, bright
colours, his first major oil being *The Smiling Woman*
(1908) the first of many paintings in which his wife
Dorelia was the model. During World War I he served
as a war artist with the Canadians. From the 1920s
onwards he painted numerous portraits. He became a
member of the Royal Academy in 1928, resigned in
protest in 1938, was re-elected in 1940 and in 1942
was awarded the Order of Merit. His genre scenes are
full of wry humour.

Movement English School
Other Works *Canadians Opposite Lens;*
The Smiling Woman
Influences Rembrandt, El Greco
Augustus John *Born* 1878 Tenby, Wales
Painted in England
Died 1961 Hampshire, England

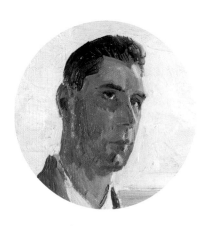

László Moholy-Nagy
CH Beata 2

Courtesy of Christie's Images/© DACS 2002

László Moholy-Nagy studied law in Budapest, but never practiced. Instead, he dabbled in photography and turned to painting after World War I, associating with Dadaists and Constructivists in Vienna and Berlin and constructing what he termed 'photograms': non-representational photographic images made directly from the subject without a camera. In 1925 he joined the Bauhaus under Gropius and established his reputation in the ensuing decade as the foremost exponent of the New Photographers' movement. In 1935 he moved to London, where he designed the futuristic sets for fellow-Hungarian Alexander Korda's film, *Things to Come*. In 1937 he went to the USA where he was appointed head of the Bauhaus School in Chicago, later renamed the Institute of Design. He became an American citizen at the end of World War II. Although primarily associated with photography, he also worked as a sculptor, designer and painter, often using collage and photo-montage.

Movement Constructivism
Other Works *CHX; Composition A II; Jealousy*
Influences Naum Gabo, Kasimir Malevich
László Moholy-Nagy *Born* 1895 Hungary
Painted in Vienna, Berlin, Weimar,
London and Chicago
Died 1946 Chicago, USA

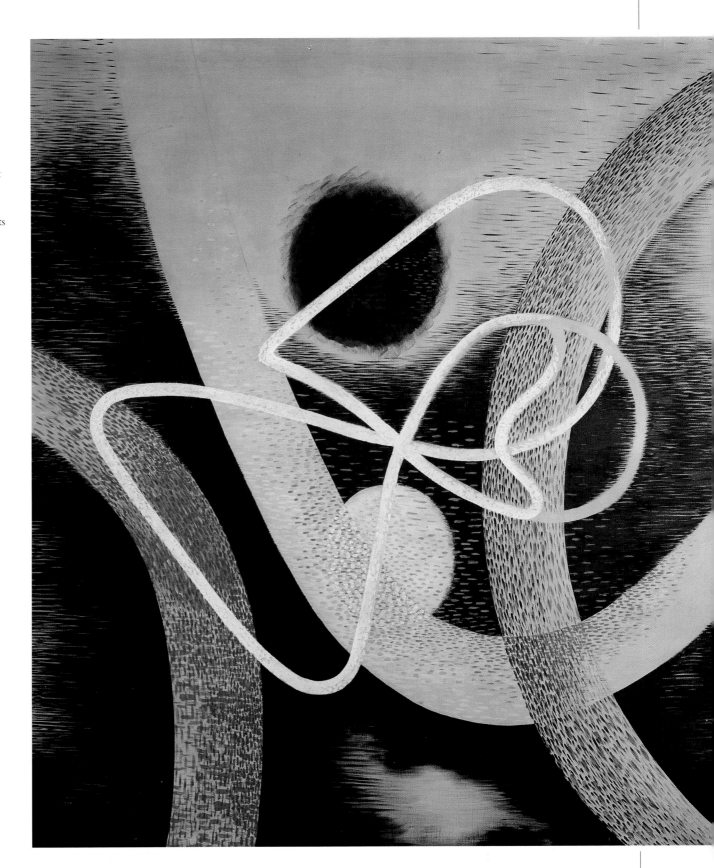

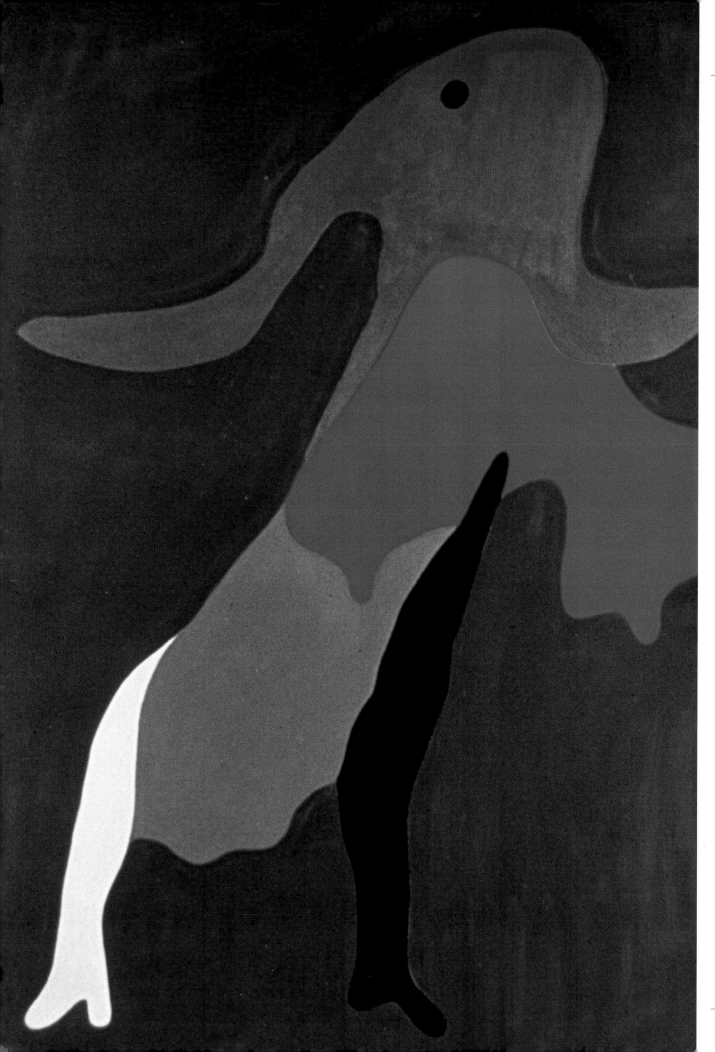

Jean Arp
The Great Dancer, 1926

Courtesy of Musee National d'Art Moderne,
Paris/Bridgeman Art Library/© DACS 2002

The Dada movement began in neutral Switzerland in 1915, when most of the surrounding countries were embroiled in a conflict that threatened to destroy civilization. It arose as a form of protest by violently and shockingly rejecting all previously accepted artistic values. The term itself, one of the first sounds made by babies, symbolized its deliberate irrationality. At first it consisted of recitals of obscene or nonsensical verse, or performances that involved the destruction of sculpture or paintings. These activities were purely transient, but the thinking behind them found expression in various periodicals and manifestos, deliberately crudely printed on coarse paper. Out of this developed the artistic medium, as avant-garde painters saw the possibilities of its anarchic nihilism. Jean Arp was the first to translate Dada into art, using pieces of paper torn up and haphazardly dropped on the floor. Marcel Duchamp took Dada across the Atlantic, exhibiting a urinal in New York and asserting that it was a work of art because he said so. Dada was short-lived, but it paved the way for Surrealism in 1924.

Movement Dada
Other Works *Overturned Blue Shoe with Two Heels Under a Black Vault*
Influences Wassily Kandinsky
Jean Arp *Born* 1886 Strasbourg, Alsace-Lorraine
Painted in Paris, Switzerland and Germany
Died 1966 Basel, Germany

Robert Delaunay
Helice, 1923

Courtesy of Private Collection/Christie's Images/
© L&M Services B.V. Amsterdam 20020512

After a conventional art training in Paris, Robert
Delaunay worked as a designer of sets for the
theatre and did not take up painting seriously until
1905–06, when he came under the influence of
the Neo-Impressionists. Over the ensuing decade
he was also closely associated in turn with the
Fauves, the Cubists and especially Der Blaue
Reiter in 1911–12. In the latter years, however, his
experimentation with contrasting colour patterns
resulted in the development of a distinctive style
which his friend, the poet Guillaume Apollinaire,
dubbed Orphism because of its lyrical, almost
musical, harmony. In his initial period, Delaunay
painted numerous landscapes in and around Paris –
the Eiffel Tower being a favourite subject – but
gradually he moved towards a more non-figurative
style. In his organization of contrasting colours he
had a profound influence on the development of
Abstract art in the 1920s. He collaborated with his
wife Sonia, especially from 1918 onwards when he
returned mainly to stage design.

Movement Orphism
Other Works *Eiffel Tower; Sainte Severin;*
Political Drama
Influences Pablo Picasso, Otto Freundlich,
Franz Marc, Wassily Kandinsky
Robert Delaunay *Born* 1885 Paris, France
Painted in Paris
Died 1941 Montpellier, France

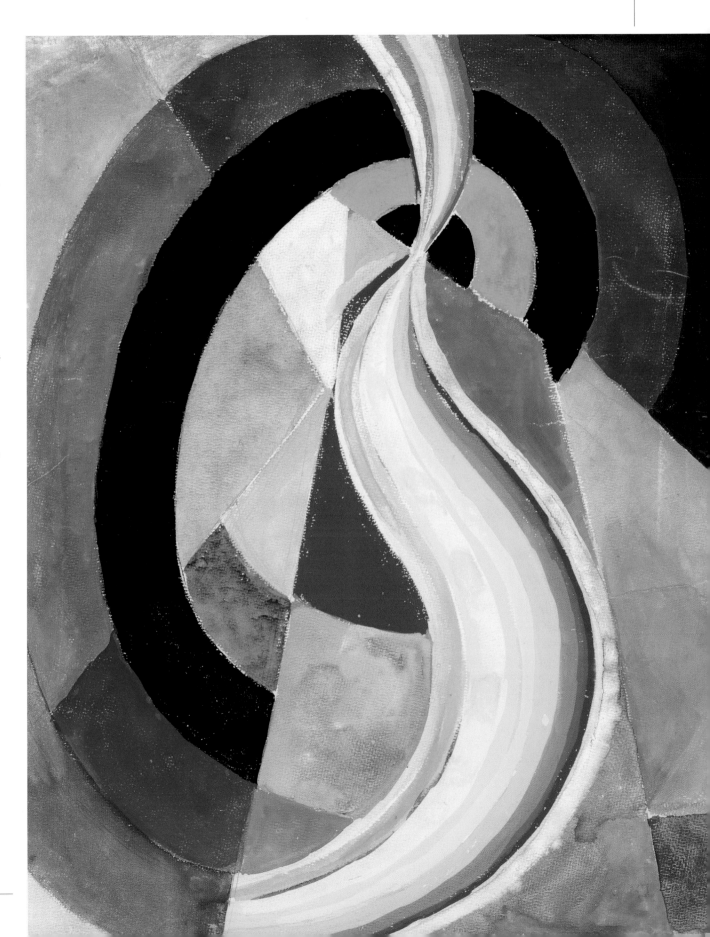

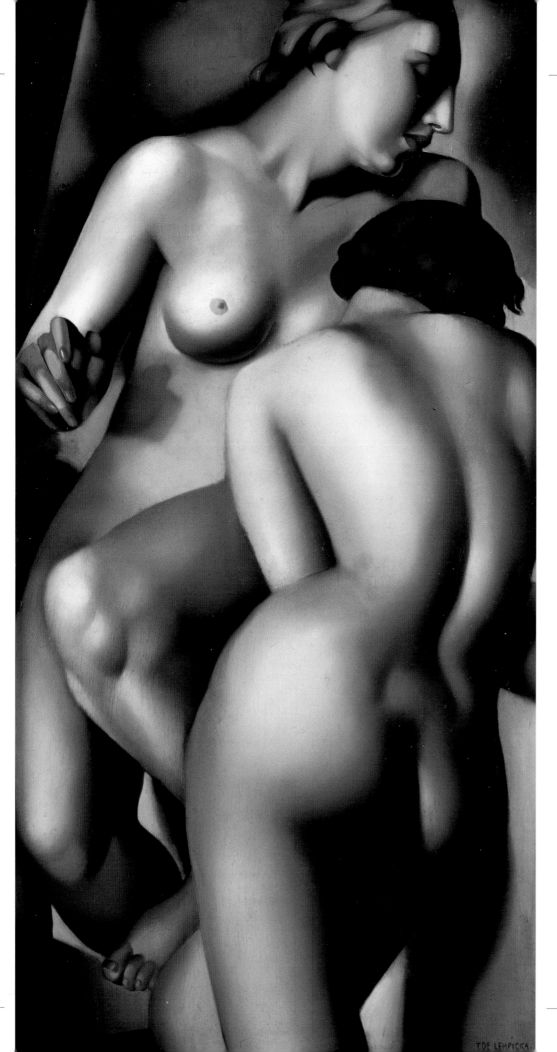

Tamara de Lempicka
Les Deux Amies, *c.* 1928

Courtesy of Private Collection/Christie's Images/© ADAGP,
Paris and DACS, London 2002

Tamara de Lempicka came from a Polish upper-class family, which gave her an excellent all-round international education. In 1918 she and her Russian husband fled the Russian Revolution to Paris. Here Lempicka came under the influence of the avant-garde artists, notably Fernand Léger. However, the painter whose work most impressed her and whose style is reflected in her own female nudes was Paul Cézanne, then near the end of his long career. Lempicka became one of the most fashionable portrait painters in Paris in the interwar period, her work emphasizing the glamour and ostentatious wealth of her patrons, idealizing their beauty and elegance. The other side of Lempicka, however, was her homosexuality – which was reflected in her extraordinary studies of female nudes, always fully representational (and often devastatingly so) yet with overtones of Cubism in the use of simplified anatomy and the geometric patterns of the background. The result was electrifying and highly distinctive.

Movement Cubism
Other Works *Kizette en Rose; St Moritz*
Influences Paul Cézanne, Fernand Léger
Tamara de Lempicka *Born* 1898 Warsaw, Poland
Painted in Paris and Mexico
Died 1980 Cuernavaca, Mexico

Georgia O'Keeffe

Red Gladiola in White Vase, 1928

Georgia O'Keeffe studied at the Art Institute of Chicago in 1905–06 and then the Art Students' League in New York City (1907–08), where she met her future husband Alfred Stieglitz, the founder of the avant-garde circle that bears his name. She was an early convert to Abstract Art and, with Stieglitz, did much to spread the gospel among American artists from 1915 onwards. In the 1920s, however, she developed a more figurative style, concentrating on architectural or floral motifs but injecting a note of Surrealism into her paintings. Her work was characterized by sharply defined images that explored geometric patterns and earned for her work the epithet of Precisionism. She travelled all over the world, drawing on her experiences in many of her later works. In her last years she resided in New Mexico, whose monumental scenery found expression in a number of her landscapes.

Movement Modern American School
Other Works *Radiator Building;*
Cow's Skull with Calico Roses
Influences Alfred Stieglitz
Georgia O'Keeffe
Born 1887 Wisconsin, USA
Painted in USA
Died 1986 Santa Fé, New Mexico, USA

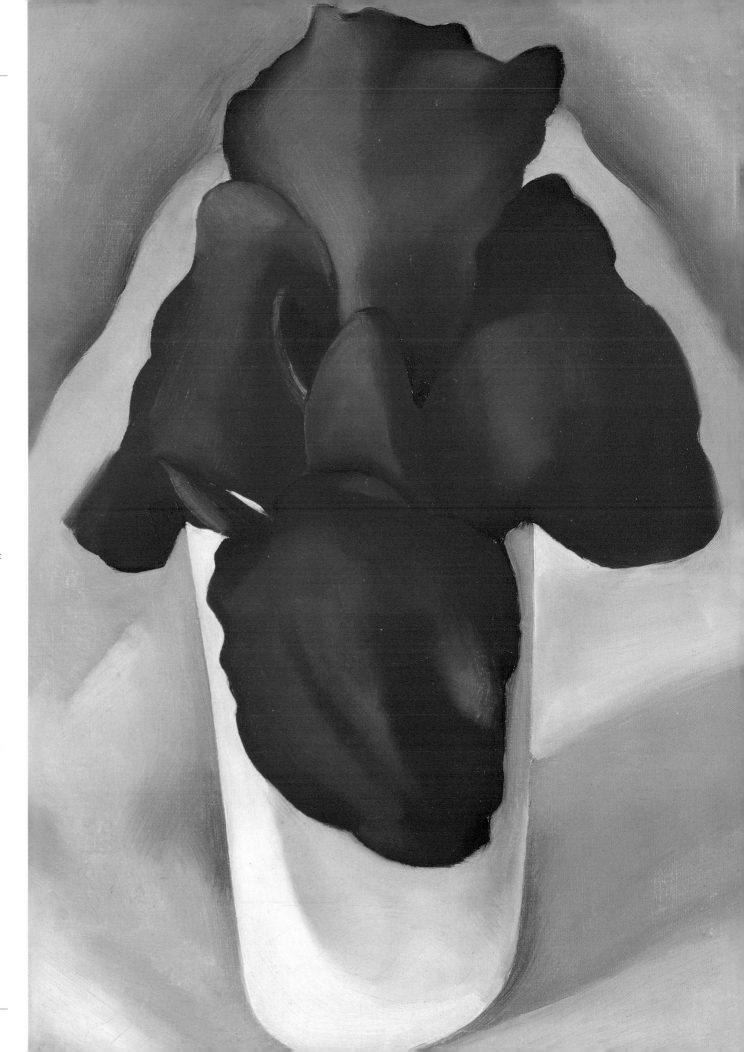

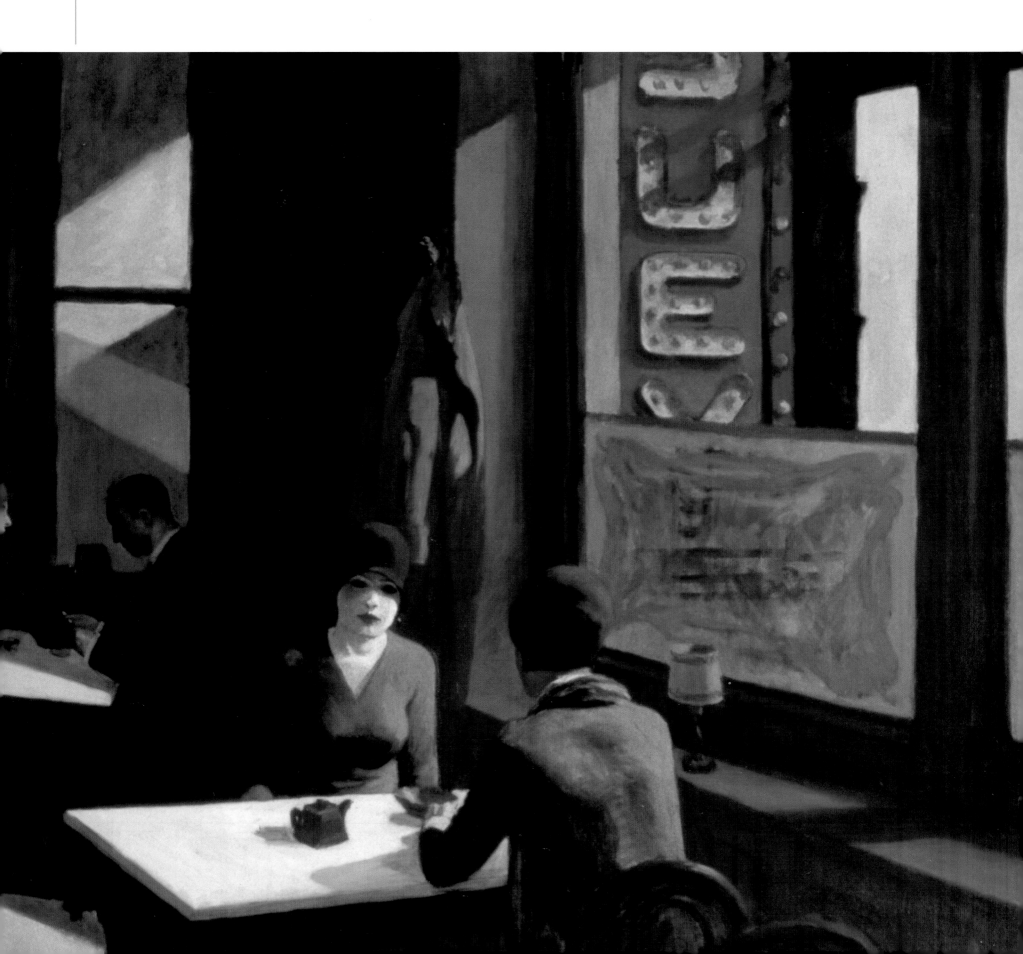

Edward Hopper
Chop Suey, 1929

Courtesy of Whitney Museum of American Art, New York,
USA/Bridgeman Art Library

Edward Hopper studied in New York City under Robert Henri between 1900
and 1906 and then travelled in Europe over the ensuing four years. The artistic
atmosphere in Paris (1909–10) had a major impact on him and his paintings up to
the mid-1920s reflect the influence of the French Impressionists. In this period he
worked mainly as an illustrator, but from 1924 he concentrated on large-scale
works which drew upon contemporary American life for their inspiration, from
diners and gas stations to hotel lobbies and late-night bars. This emphasis on
scenes which were instantly recognizable, coupled with the strong interplay of
light and shadow, left an indelible impression – so much so that Hopper's art has
come to represent urban America of the interwar years and had a major impact on
the Pop Art of more recent years.

Movement American School
Other Works *Room in New York; People in the Sun*
Influences Robert Henri
Edward Hopper *Born* 1882 New York, USA
Painted in New York. *Died* 1967 New York

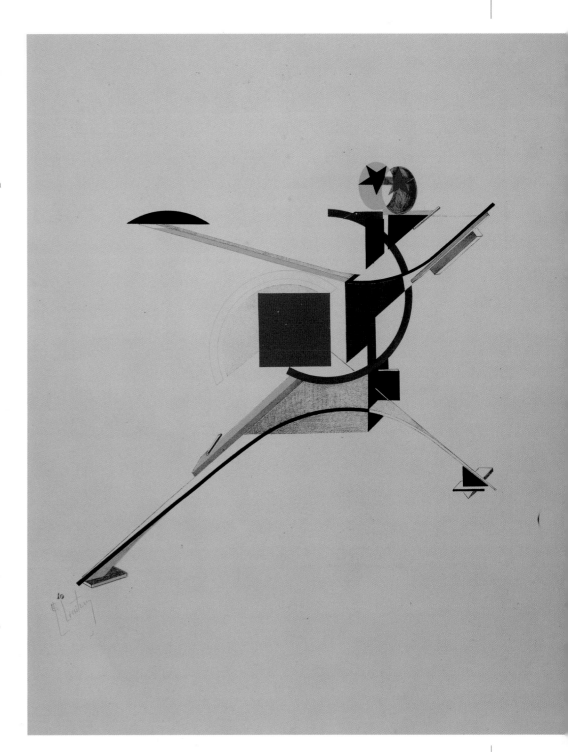

El Lissitzky
Neuer Plate 10 from Die Plastiche Gestaltung Der Elektro

Courtesy of Private Collection/Christie's Images/© DACS 2002

Lazar Markovich Lissitzky, better known as El Lissitzky, was a Russian artist, designer,
photographer, teacher, typographer, and architect. He was one of the most important
figures of the Russian avant garde, helping develop suprematism with his friend and
mentor, Kazimir Malevich. His work greatly influenced the Bauhaus, Constructivist,
and De Stijl movements and he experimented with production techniques and
stylistic devices that would go on to dominate 20th century graphic design. Lissitzky
firmly believed that the artist could be an agent for change. He began teaching at the
age of 15 and, over the years, taught in a variety of positions, schools, and artistic
mediums, spreading and exchanging ideas at a rapid pace. He took this ethic with
him when he worked with Malevich in heading the suprematist art group UNOVIS,
when he developed a variant suprematist series of his own known as Proun.

Movement Constructivism
Other Works *Proun 12E; Die Kunstismen*
Influences Kazimir Malevich
El Lissitzky *Born* 1890 Pochinok, Smolensk, Russia
Painted in Germany, Russia and Switzerland. *Died* 1941 Moscow, Russia

Raoul Dufy
Large Blue Nude, 1930

Courtesy of Galerie Daniel Malingue, Paris, France/Bridgeman Art Library/© ADAGP,
Paris and DACS, London 2002

Although he had a conventional training at the École des Beaux Arts in Paris,
Raoul Dufy was attracted to the radical ideas of Matisse and Derain and for
some time flirted with Impressionism, Cubism and Fauvism. In 1907 he
turned away from painting to concentrate on textile patterns, graphic design
and book illustrations, but in 1919 he took up painting again and settled on
the French Riviera. There he was encouraged by his friend, the couturier Paul
Poiret, to embark on a prolific series of paintings executed swiftly,
characterized by large areas of flat colour and sharply incised black lines after
the manner of the Chinese calligraphic artists. He created a kind of *ukiyo-e*,
pictures of transient scenes, on promenades and beaches, at regattas and race
meetings. His greatest masterpiece was the vast mural for the Exposition
Universelle in Paris, 1938, one of the largest works ever painted.

Movement Modern French School
Other Works *The Paddock; The Pier and Promenade at Nice*
Influences Henri Matisse, André Derain, Maurice de Vlaminck
Raoul Dufy *Born* 1877 Le Havre, France
Painted in Paris and the French Riviera. *Died* 1953 Forcalquier, France

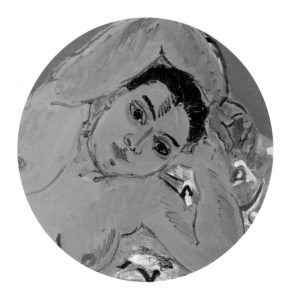

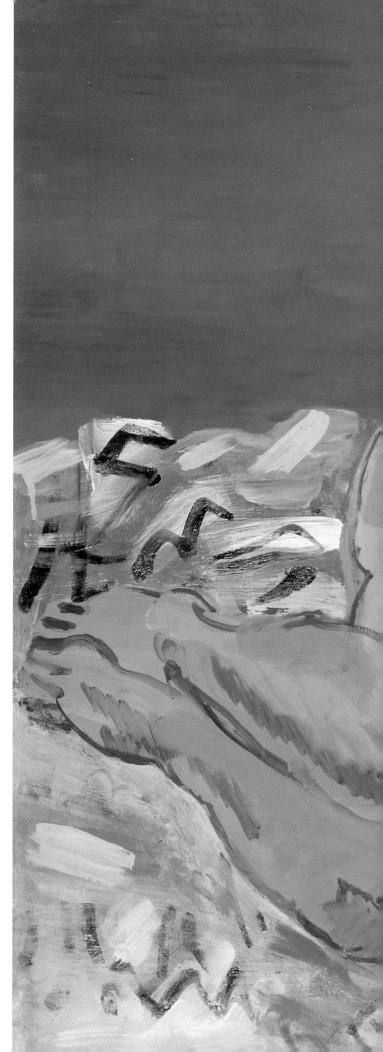

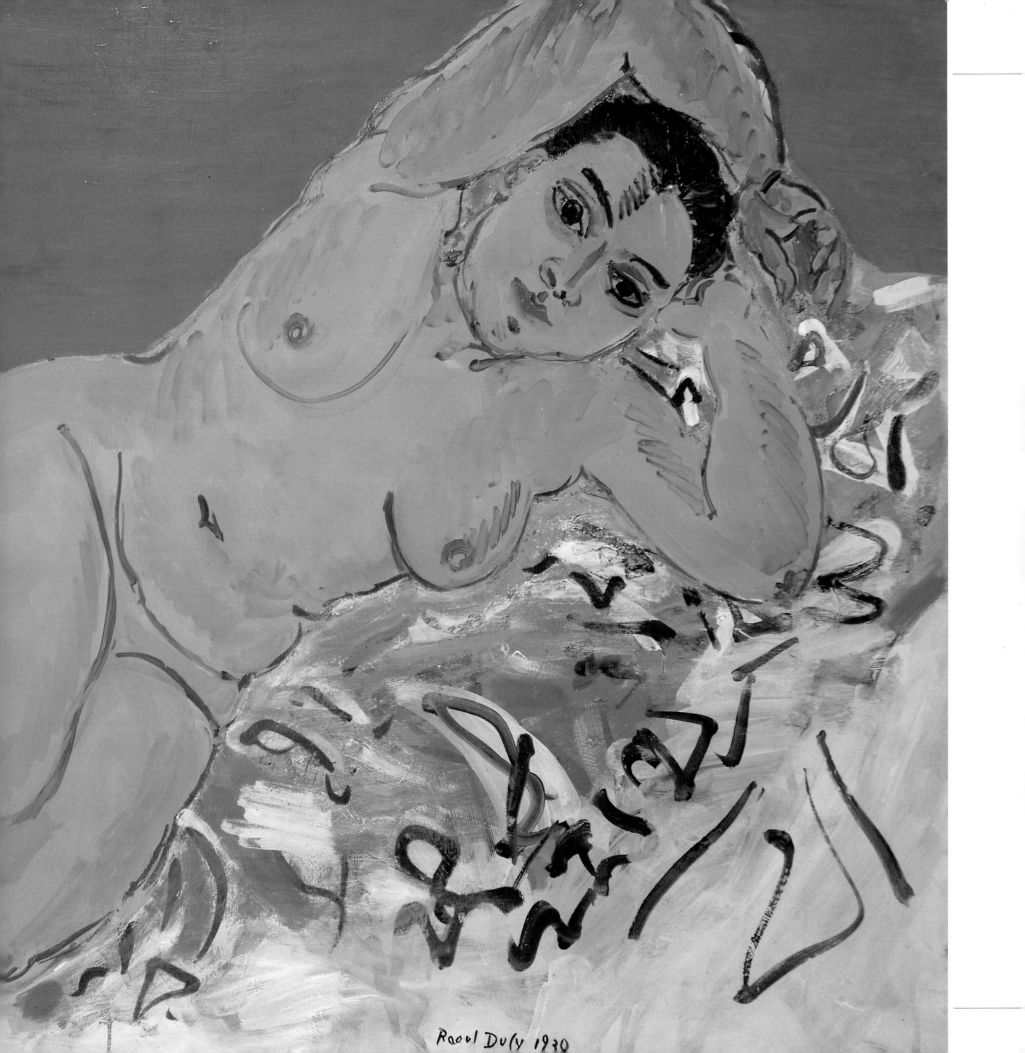

Raoul Dufy 1930

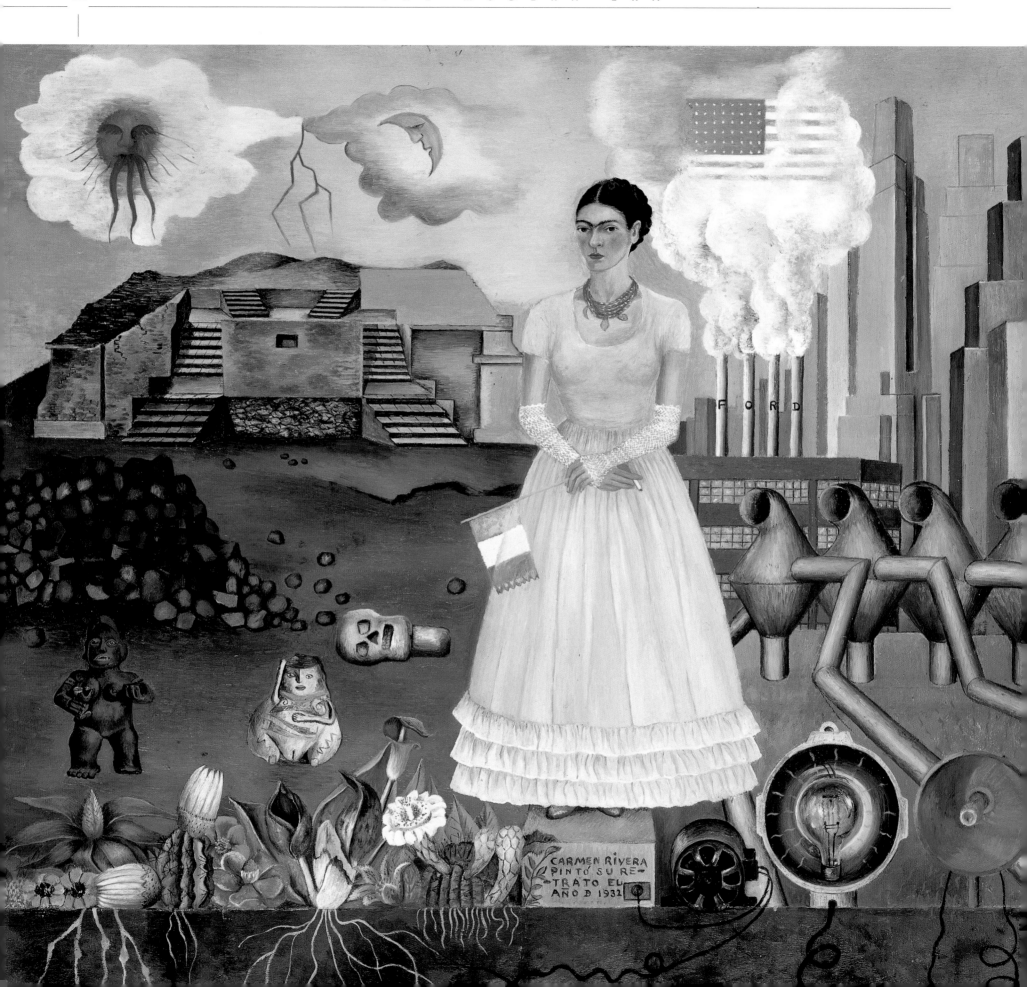

Frida Kahlo

Autoretrato en la Frontera entre Mexico y los Estados, 1932

Courtesy of Private Collection/Christie's Images/© Banco de Mexico Diego Rivera and Frida Kahlo Museums Trust Av. Cinco de Mayo No. 2, Col. Centro, Del. Cuauhtemoc 06059, Mexico, D.F.

Born at Coyoicoan near Mexico City, Frida Kahlo had the misfortune to be in a streetcar crash at the age of 15. During the long convalescence from her terrible injuries she took up painting and submitted samples of her work to Diego Rivera, whom she married in 1928. Artistic temperament resulted in a stormy relationship that ended in divorce in 1939; many of Kahlo's self-portraits in this period are wracked with the pain she suffered all her adult life, as well as reflecting anger at her husband's numerous infidelities. Indeed, pain and the suffering of women in general were dominant features of her paintings, endlessly explored and revisited in canvasses that verge on the surreal and often shock with their savage intensity. André Breton, the arch-apostle of Surrealism, neatly described her art as "like a ribbon tied around a bomb".

Movement Surrealism
Other Works *Self Portrait with Cropped Hair; Self Portrait with Monkey*
Influences Diego Rivera
Frida Kahlo *Born* 1907 Coyoicoan, Mexico. *Painted in* Mexico City *Died* 1954 Mexico City

Pablo Picasso

Violon, Bouteille et Verre, 1913

Courtesy of Private Collection/Christie's Images/© Succession Picasso/DACS 2002

In 1907 Pablo Picasso and Georges Braque wrestled with the problem of representing three-dimensional figures and objects in the two-dimensional medium of painting. Their solution was to create an abstract form that could display two or more sides of an object simultaneously. The artists collaborated closely and worked without any predetermined concepts in their attempts to create recognizable images liberated from all the previous artistic conventions. Picasso's *Demoiselles d'Avignon* (1907) is regarded as the first Cubist painting, although his ideas were not fully developed until 1911 when both he and Braque exhibited at the Salon des Indépendants in Paris. Their example was rapidly followed by artists such as Léger and Delaunay and their ideas propagated in the writings of Apollinaire. Although many of the Cubist painters later moved on to more completely abstract work, the movement had an enormous impact on the development of twentieth century art.

Movements Cubism, Surrealism, Classical Revival
Other Works *Three Musicians*
Influences Paul Cézanne, Georges Braque, Toulouse-Lautrec
Pablo Picasso *Born* 1881 Malaga, Spain. *Painted in* Spain, France and Italy *Died* 1973 Aix-en-Provence, France

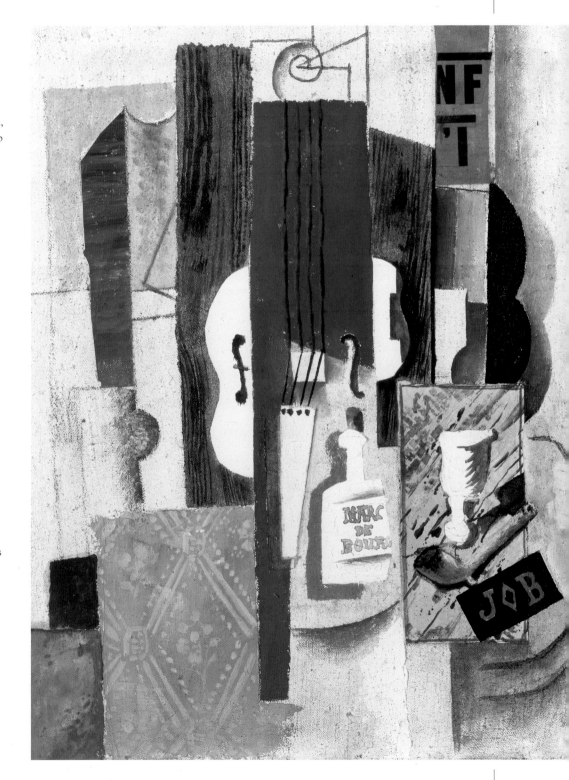

René Magritte
Le Chef d'Oeuvre ou les Mystères de l'Horizon

Courtesy of Christie's Images © ADAGP, Paris and DACS, London 2002

The great Surrealist master René François Ghislain Magritte studied at the Académie Royale des Beaux-Arts in Brussels (1916–18) and became a commercial artist for fashion magazines and a designer of wallpaper. His paintings were initially influenced by Futurism and Cubism, but later he was attracted to the work of Giorgio de Chirico. In 1924 he became a founder member of the Belgian Surrealist group, which provided an escape from the dull routine of his everyday work. From 1927 to 1930 he lived in Paris to better continue his study of the Surrealists, then returned to Brussels where he built his reputation for paintings of dreamlike incongruity, in which themes and objects are jumbled in bizarre, nonsensical situations, often showing paintings within paintings. He is regarded in the United States as a forerunner of Pop Art.

Movement Surrealism
Other Works *Rape; The Reckless Sleeper; The Treachery of Images*
Influences Giorgio de Chirico
René Magritte *Born* 1898 Lessines, Belgium
Painted in Belgium
Died 1967 Brussels, Belgium

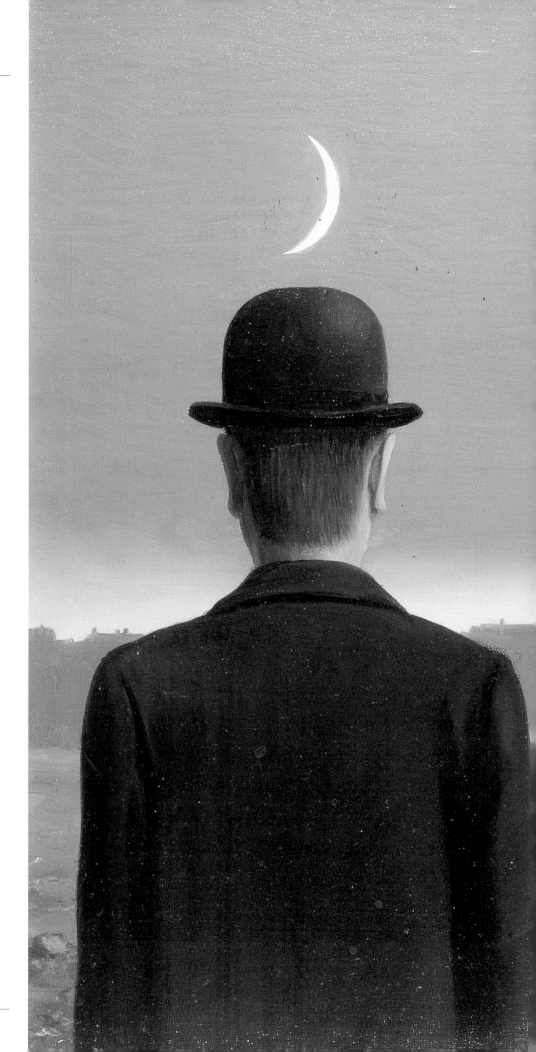

Grant Wood
Adolescence, 1933

Born at Anamosa, Iowa, Grant Wood spent his entire life in this small town in the American Midwest, and his paintings are a chronicle of the people and the scenery of the district. In the 1920s, however, he travelled to France and the Netherlands where he studied the works of the old masters, especially the Gothic, Romanesque, Renaissance and Flemish School, all of which had a strong influence on his own paintings. His best-known painting, *American Gothic*, is aptly named, for in it Wood depicts a cottage in his home town whose Gothic window appealed to him. In the foreground stands a typical Midwestern farmer and his wife, actually Wood's sister and his dentist, who served as his models. He was severely criticized at the time for lampooning the values of Middle America but he defended himself, insisting that the painting was intended as a sincere tribute to the simple dignity of rural communities. Wood was the foremost of the Regionalists, a group of American artists who rejected the abstract in favour of the realism of ordinary people and their locale.

Movement Regionalism
Other Works *Haying*
Influences Jan Van Eyck, Rogier van der Weyden
Grant Wood *Born* 1892 Anamosa, Iowa, USA
Painted in Iowa
Died 1942 Anamosa

David Alfaro Siqueiros

El Botero

Courtesy of Private Collection/Christie's Images © DACS 2002

A Mexican painter and political activist best known for his murals, Siqueiros was born in Chihuahua, the son of a lawyer. In his youth, he became involved in the Mexican Revolution and, as a reward, was given a scholarship to study in Europe (1919–22). There he met Rivera, a fellow muralist and future rival. The revival of mural painting was a deliberate government policy, aimed at bringing art to the people. Siqueiros received a commission to decorate the Preparatoria, but work was halted by student riots and, in fact, he did not complete a mural in his homeland until 1939.

Although a late developer, Siqueiros proved hugely influential as a teacher. In 1936, he ran an experimental workshop in New York, which did much to shape the Abstract Expressionism of Jackson Pollock. The latter was particularly impressed by Siqueiros's theories about the potential of 'pictorial accidents' and his use of industrial materials. These included spray-guns, blow-torches and the pyroxylin paints used in car manufacture. In the artist's own work, these were seen to best effect in the massive *March of Humanity in Latin America* and his extraordinary, multimedia creation the *Polyforum Siqueiros*.

Movement Mexican Muralists
Other Works *Portrait of the Bourgeoisie; The Victory of Science over Cancer*
Influences Diego Rivera, Amado de la Cueva
David Alfaro Siqueiros *Born* 1896 Mexico
Painted in Mexico, USA, Uruguay and Chile
Died 1974 Mexico City

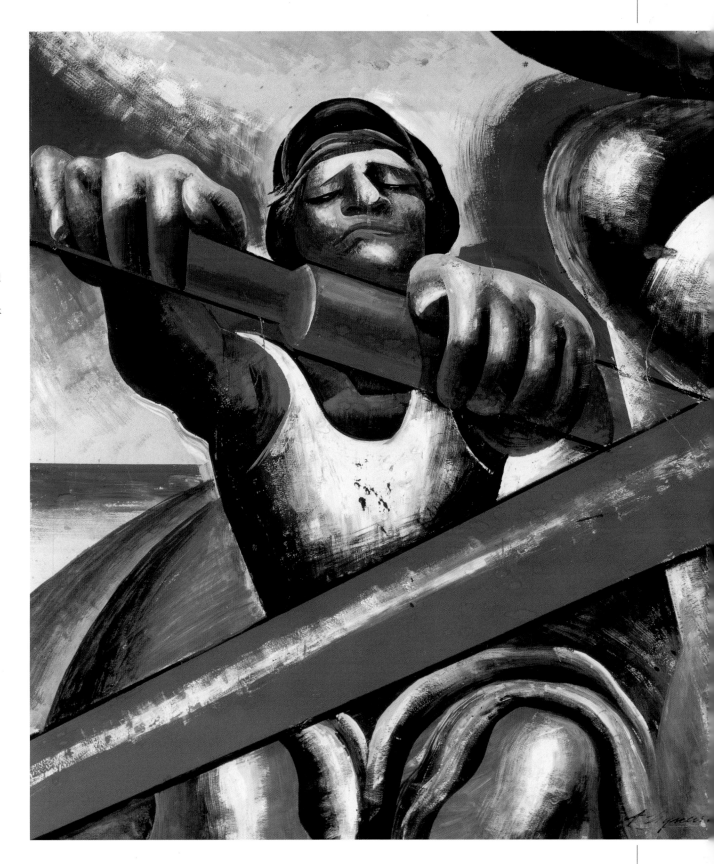

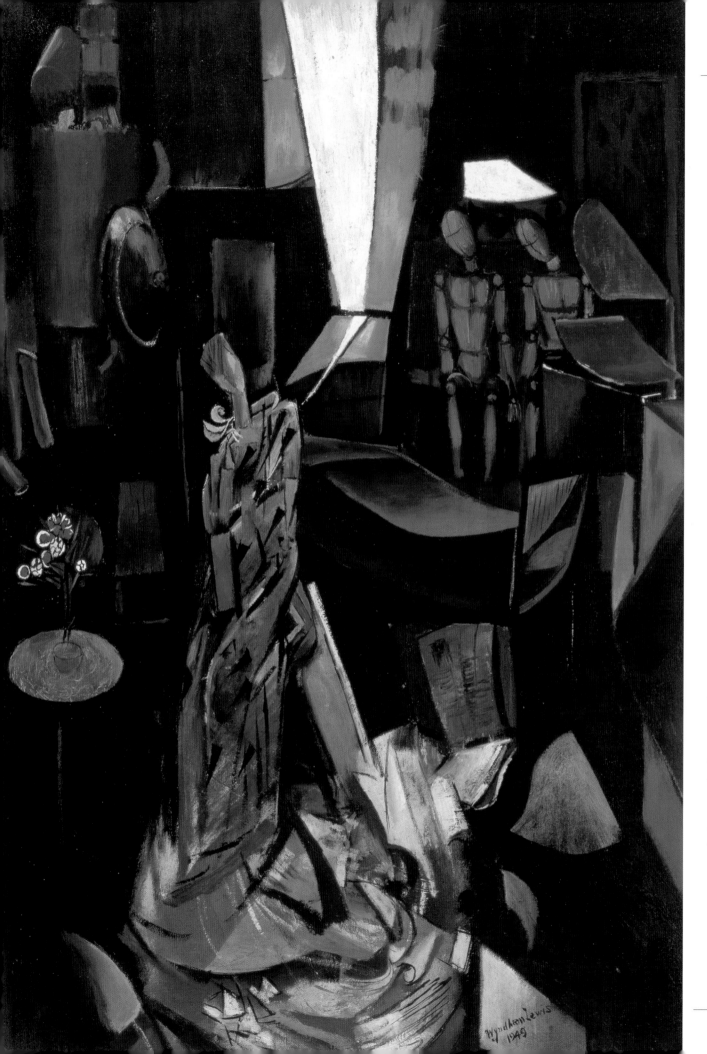

Percy Wyndham Lewis

The Room That Mary Lives In, 1949

Percy Wyndham Lewis was born in Canada, but following the break-up of his parents' marriage when he was 10 years old he moved with his mother to England, where he enrolled at the Slade School of Art (1898–1901). For six years he travelled extensively in Europe, painting and continuing his studies before settling in London, where he joined the Camden Group of avant-garde artists in 1911 and the Omega Workshops in 1913. One of the most articulate and intellectual painters of his group, he edited their magazine *Blast*, in which he published his Vorticist Manifesto in 1914. This, the only distinctively British art movement to emerge in the early twentieth century, was short-lived. Lewis volunteered for active service on the outbreak of World War I and subsequently became an official war artist. Nevertheless, there are echoes of Vorticism in his powerful war paintings as well as in the great series of canvasses in the postwar period inspired by characters from classical mythology. In 1939 he returned to Canada and also worked for a time in the USA before going back to England in the last years of his life. Although blind in his old age he continued to teach and write.

Movement Vorticism
Other Works *The Dancers; A Battery Shelled; A Reading of Ovid*
Influences Albert Gleizes, George Grosz
Percy Wyndham Lewis *Born* 1882 Canada
Painted in England, Canada and USA
Died 1957 London, England

Yves Tanguy
Paysage Surréaliste, 1937

Courtesy of Private Collection/Christie's Images/© ARS,
New York and DACS, London, 2002

Going to sea as a teenager and later serving in the
French army, Yves Tanguy did not take up painting
until his return to Paris in 1922. Without any
formal training, he was influenced by the work of
Giorgio de Chirico and joined the Surrealists in
1925, subsequently concentrating on that style
known as Biomorphism because its images were
derived from living organisms. Inevitably, Tanguy's
paintings in the ensuing period drew heavily on
memories of naval and military service. In 1939 he
immigrated to the United States, where he
married fellow-artist Kay Sage and settled in
Woodbury, Connecticut. In his last years his work
took on a darker character, suggestive of dream
sequences which reflected his fascination with the
Freudian theories of psychoanalysis. His paintings
were non-figurative, inhabited by small objects,
often boney-like but defying description and
suggestive of some other world.

Movements Biomorphism, Surrealism
Other Works *Dehors; The Invisible;*
The Rapidity of Sleep
Influences Giorgio de Chirico, Salvador Dalí
Yves Tanguy *Born* 1900, Paris, France
Painted in Paris, France and Woodbury,
Connecticut, USA
Died 1955, Woodbury

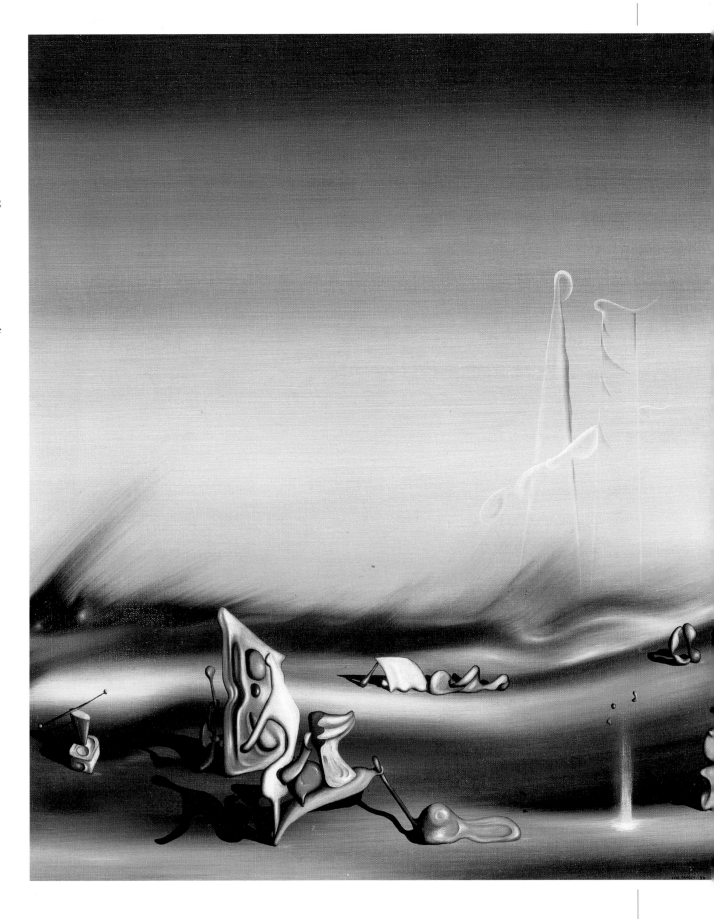

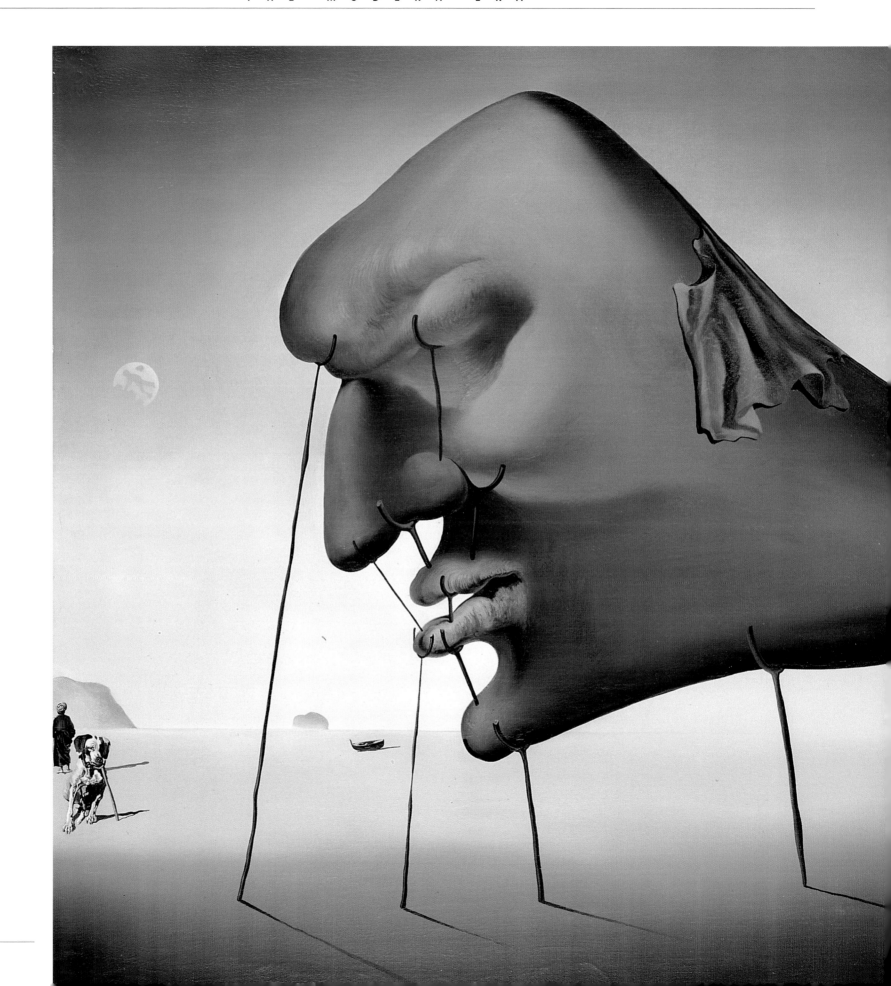

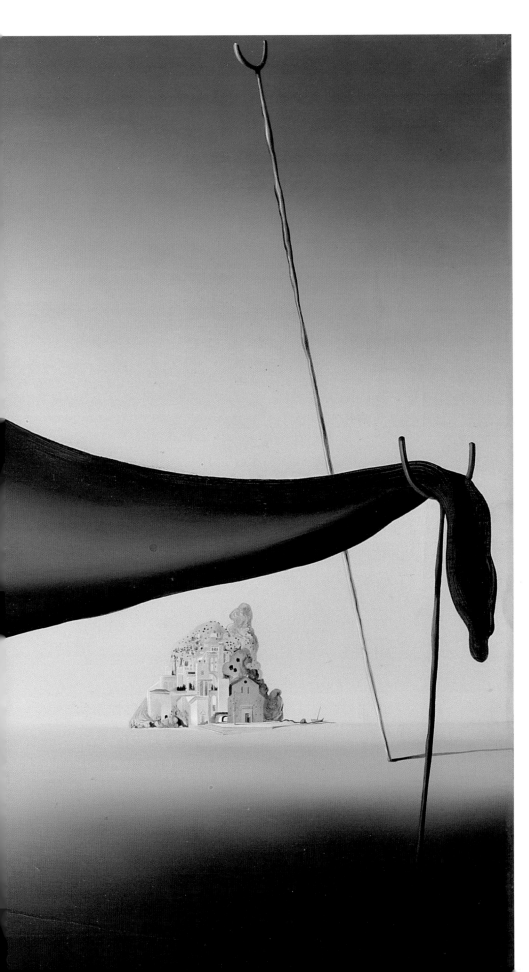

Salvador Dalí
Le Sommeil, 1937

Courtesy of Private Collection/Christie's Images/© Salvador Dalí;
Gala-Salvador Dalí Foundation,;DACS, London 2002

Salvador Dalí – Spanish painter, graphic artist and film-maker –
was the most controversial member of the Surrealists. Dalí was
born in Catalonia and studied at the Academy of Fine Arts in
Madrid, until his outrageous behaviour caused his expulsion.
Before this, he had already made contact with the poet Lorca and
the film-director Buñuel. In the early 1920s, he dabbled in a
variety of styles, including Futurism and Cubism, although it
was the metaphysical paintings of de Chirico which made the
deepest impact on him.

The key stage in Dalí's career came in 1929, when he made
Un Chien Andalou with Buñuel, met his future wife Gala and
allied himself with the Surrealists. His relationship with the latter
was rarely smooth and, after several clashes with Breton, he was
forced out of the group in 1939. In the interim, he produced
some of the most memorable and hallucinatory images
associated with the movement, describing them as 'hand-painted
dream photographs'. Dalí remained very much in the public eye
in later years, gaining great celebrity and wealth in the US, but
for many critics his showmanship overshadowed his art.

Movement Surrealism
Other Works *The Metamorphosis of Narcissus;*
The Persistence of Memory
Influences Pablo Picasso, Giorgio de Chirico, Yves Tanguy
Salvador Dalí *Born* 1904 Catalonia, Spain
Painted in Spain, France, USA and Italy
Died 1989

Max Ernst
Forêt et Soleil, 1938

A leading Surrealist, Max Ernst was born near Cologne. Ernst studied psychology at Bonn University, taking a particular interest in the art of the insane. Before the war he befriended Arp and Macke and mixed with the Blaue Reiter (Blue Rider) group. Then, in 1919, he staged the first Dada exhibition in Cologne. Typically for this movement, visitors had to enter the show through a public urinal and were handed axes, in case they wished to destroy any of the exhibits. In 1922, Ernst moved to Paris and joined the Surrealist circle. His work in this style was incredibly varied. He made considerable use of the chance images, which were suggested by automatic techniques, such as *frottage* (rubbings of textured surfaces). At the same time, he exploited the 'poetic sparks', which were created by the juxtaposition of totally unrelated objects. These sometimes took the form of paintings, but were also produced as collages, drawn from popular magazines. Ernst was interned during World War II and spent much of his later career in America.

Movements Surrealism, Dada
Other Works *The Robing of the Bride; Europe after the Rain*
Influences August Macke, Hans Arp, Giorgio de Chirico
Max Ernst *Born* 1891, Cologne, Germany
Painted in Germany, France and the USA. *Died* 1976

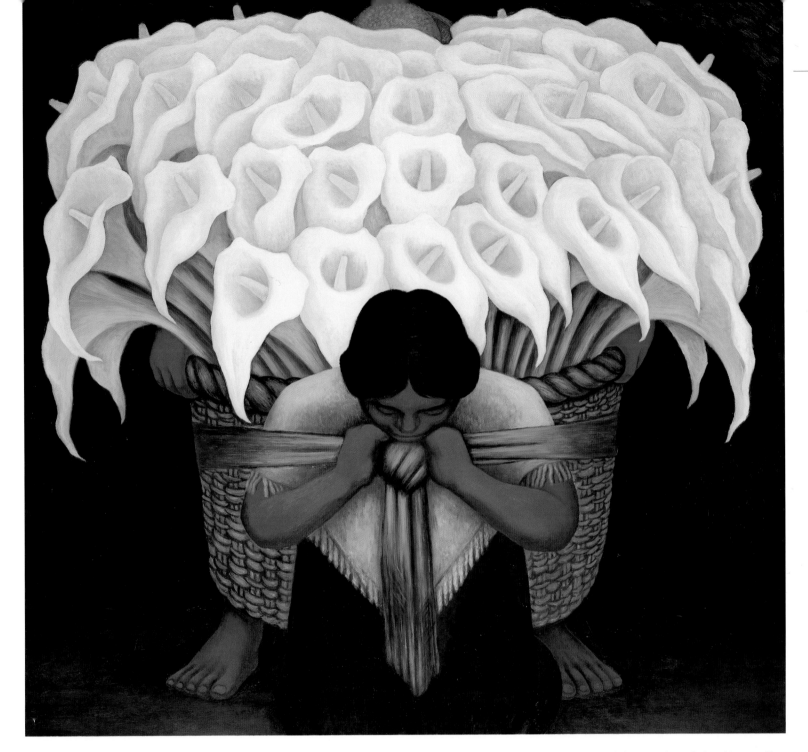

Diego Rivera
Vendedora de Flores, 1942

Courtesy of Private Collection/Christie's Images/2002 Banco de Mexico Diego Rivera & Frida
Kahlo Museums Trust, Av. Cinco de Mayo No. 2, Col. Centro, Del. Cuauhtemoc 06059, Mexico, D.F.

The outstanding muralist of Latin America, Diego Rivera studied art in Mexico
City and Madrid; he went to Paris in 1911, where he met Picasso and began
painting Cubist works, which were strongly influenced by Gris and Braque. By
contrast, a sojourn in Italy studying the frescoes of the Renaissance masters
made such an impact on him that, on his return to Mexico in 1921, he
concentrated on large murals decorating the walls of public buildings. These
depicted every aspect of life in Mexico and drew on the turbulent history of its
people. Rivera's best work was carried out during a period when Mexico was
dominated by left-wing, anti-clerical governments, which regarded Rivera as
the leading revolutionary artist. He also worked in the USA where he painted
murals extolling the industrial proletariat and preaching social messages. He
evolved his own brand of folk art with overtones of such disparate elements as
Aztec symbolism and Byzantine icons.

Movement Mexican Modernism
Other Works *Court of the Inquisition; Workers of the Revolution*
Influences Juan Gris, Georges Braque
Diego Rivera *Born* 1886 Guanajuato, Mexico
Painted in Mexico and USA. *Died* 1957 Mexico City

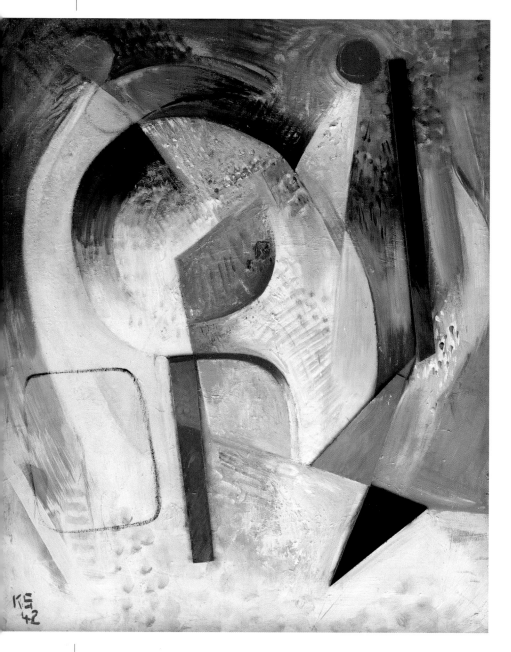

Kurt Schwitters
Roter Kreis, 1942

Courtesy of Private Collection/Christie's Images/© DACS 2002

Kurt Schwitters studied at the Dresden Academy and worked as a painter, designer, architect, typographer, writer and publisher, disparate occupations and disciplines which he combined with remarkable flair. He was intrigued by Cubism very early on and produced a number of abstract paintings in this style, but was then attracted to Dadaism and strongly influenced by Hausmann, Arp and other leading exponents. During this phase he produced montages of totally unrelated objects and incongruous fragments of junk and ephemera, such as discarded leaflets, bus tickets and used stamps torn off envelopes. After 1920 he took this notion a step further, incorporating street rubbish in enormous three-dimensional collages which he termed Merzbau ('cast-off construction'). This led to the Dadaist magazine *Merz*, which he ran from 1923 until 1932. When the Nazis came to power he fled to Norway and from there moved in 1940 to England, where he died in 1948.

Movement Dada
Other Works *Chocolate; Spring Picture; Circle*
Influences Jean Arp, Marcel Duchamp, Raoul Hausmann
Kurt Schwitters *Born* 1887 Hanover, Germany.
Painted in Germany, Norway and England. *Died* 1948 Ambleside, Cumbria, England

L. S. Lowry
Industrial Landscape, 1944

Courtesy of Private Collection/Christie's Images/Reproduced by kind permission of Carol Lowry, copyright proprietor

A distinctive British painter famous for his pictures of 'matchstick men', Laurence Stephen Lowry was born in Old Trafford, Manchester, and lived in or near the city all his life. He failed to gain entry to the local art school and, instead, took on office work and painted in the evenings. Initially, he was employed by an insurance company and, after 1910, as a rent collector for a property firm. In later years, much of his time was also devoted to the care of his invalid mother. They were very close and Lowry was devastated when she died in 1939.

The childlike qualities of Lowry art have often been classified as naïve, but technically this is untrue, since he had a succession of teachers at evening school. The most significant of these was Adolphe Valette, who also painted urban townscapes. From an early stage, Lowry began producing unglamorous views of the local, industrial scene, focusing in particular on details of everyday life. These ranged from the grotesque to the humorous. Lowry's style baffled the art establishment – he was conspicuously omitted from the Royal Academy's survey of twentieth century British art – but his paintings sold well and he has remained unfailingly popular with the public.

Movement Naïve Art
Other Works *Our Town; Man Lying on a Wall; Sudden Illness; The Pond*
Influences Adolphe Valette, Camden Town School
L. S. Lowry *Born* 1887 Manchester, England
Painted in England. *Died* 1976 Glossop, England

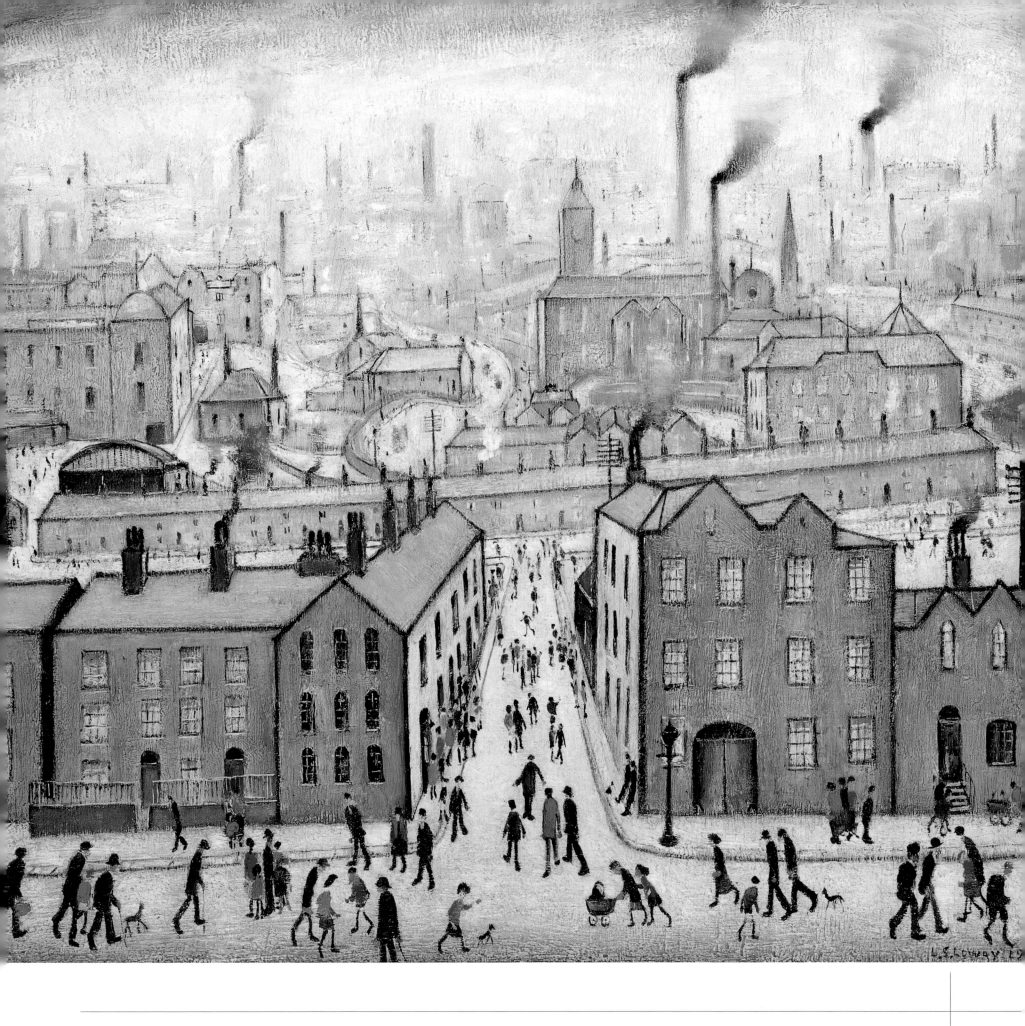

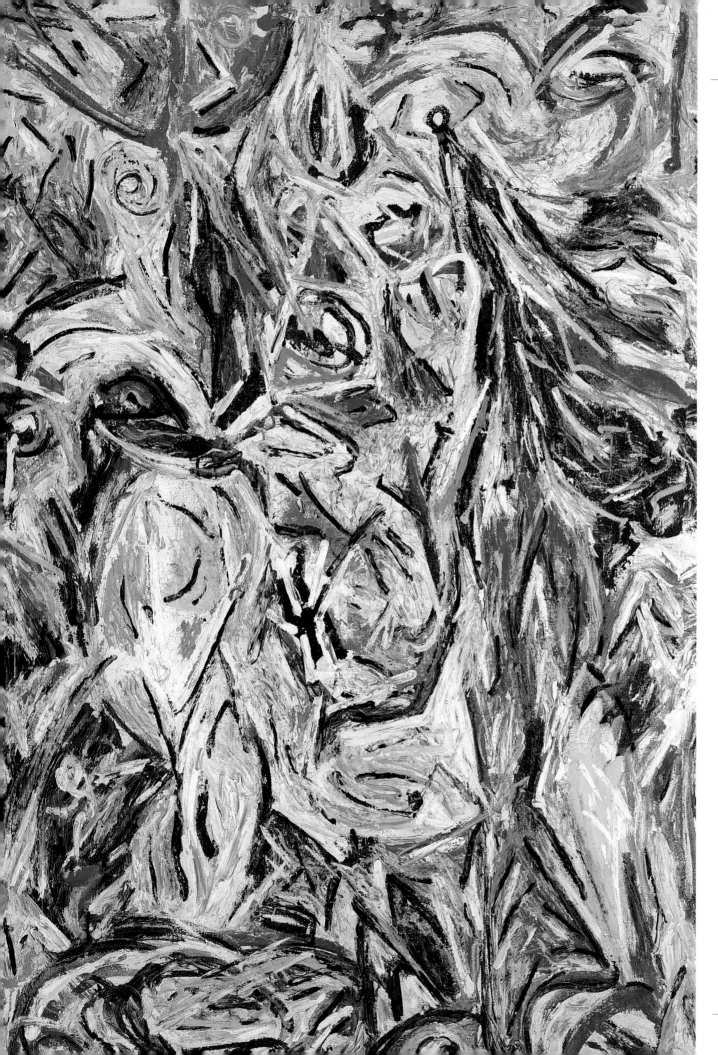

Jackson Pollock

Something of the Past, 1946

Courtesy of Private Collection/Christie's Images/© ARS, New York and DACS, London 2002

Pollock grew up in the American West, becoming familiar with Native American art at an early age. He was briefly influenced by Benton and the Regionalists, but learned more from Siqueiros and the Mexican muralists. He was impressed by their expressive, almost violent use of paint. Pollock also began to explore the possibilities of Jungian psychology. This started as an aspect of his private life – psychotherapy was one of the many treatments he tried for his long-term alcoholism – but it also fuelled his art. For, like the Surrealists, he adopted the idea of automatic painting, as a mirror of the subconscious.

After years of isolation and critical neglect, Pollock's experiments bore fruit in the late 1940s. By 1947, he had perfected the 'drip' technique which made him famous. He placed his canvas on the floor and covered it in trails of paint, poured directly from the can. This process was carried out in an artistic frenzy, comparable with the Indian ritual dances which he had witnessed as a boy. Pollock's output slowed in the 1950s and he was killed in a car crash in 1956.

Movement Abstract Expressionism
Other Works *Convergence; Autumn Rhythm; Lavender Mist*
Influences André Masson, Thomas Hart Benton, David Siqueiros
Jackson Pollock
Born 1912 USA
Painted in USA
Died 1956

Arshile Gorky
Year After Year, 1947

Courtesy of Private Collection/Christie's Images
© ADAGP, Paris and DACS, London 2002

Originally named Vosdanig Manoog Adoian,
Gorky was born at Khorkom Vari in Turkish
Armenia. He survived the genocide
perpetrated on the Armenians by the Turks
during World War I and escaped to the West,
settling in the USA in 1920. The death of his
mother during one of the Turkish atrocities
had a profound influence on his art. It was at
this time that he adopted his new name,
taking the surname from the celebrated
Russian writer Maxim Gorky. In America he
trained at the Rhode Island School of Design
and continued his studies in Boston. For
several years his style was a heady but eclectic
mixture of elements drawn from Miró,
Cezanne, Picasso, Motta and André Breton,
and it was from the latter that he was attracted
to Surrealism, concentrating on biomorphism
(the creation of organic abstracts), but later he
developed his own distinctive style which
promoted Abstract Expressionism.

Movement Abstract Expressionism
Other Works *Agony; Waterfall*
Influences Joan Miró, Pablo Picasso,
Paul Cézanne
Arshile Gorky
Born 1904 Khorkom Vari, Turkey
Painted in USA
Died 1948 Sherman, Connecticut, USA

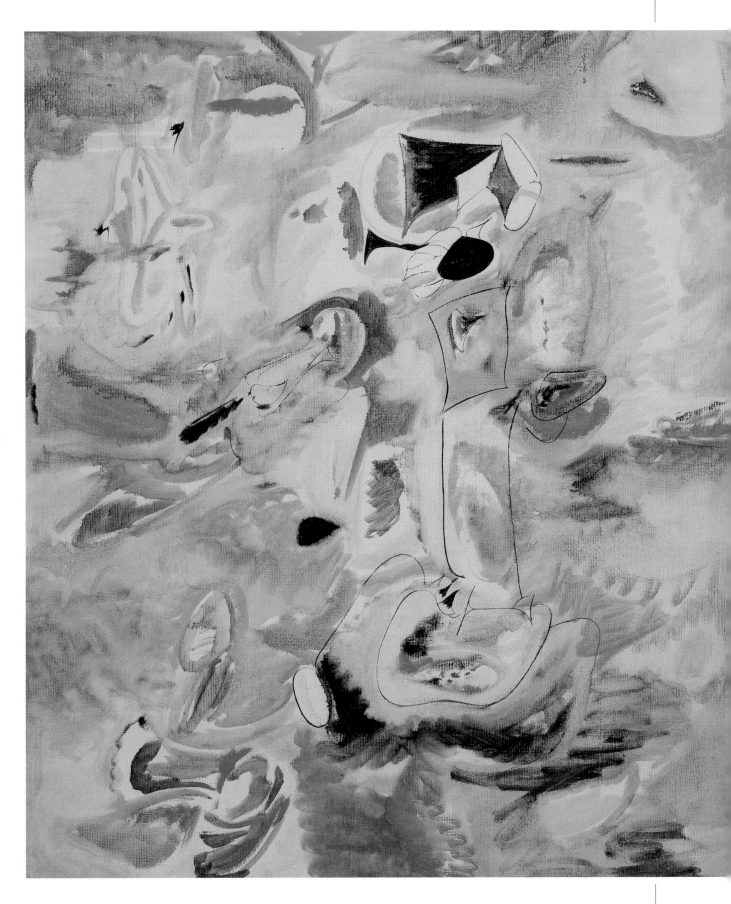

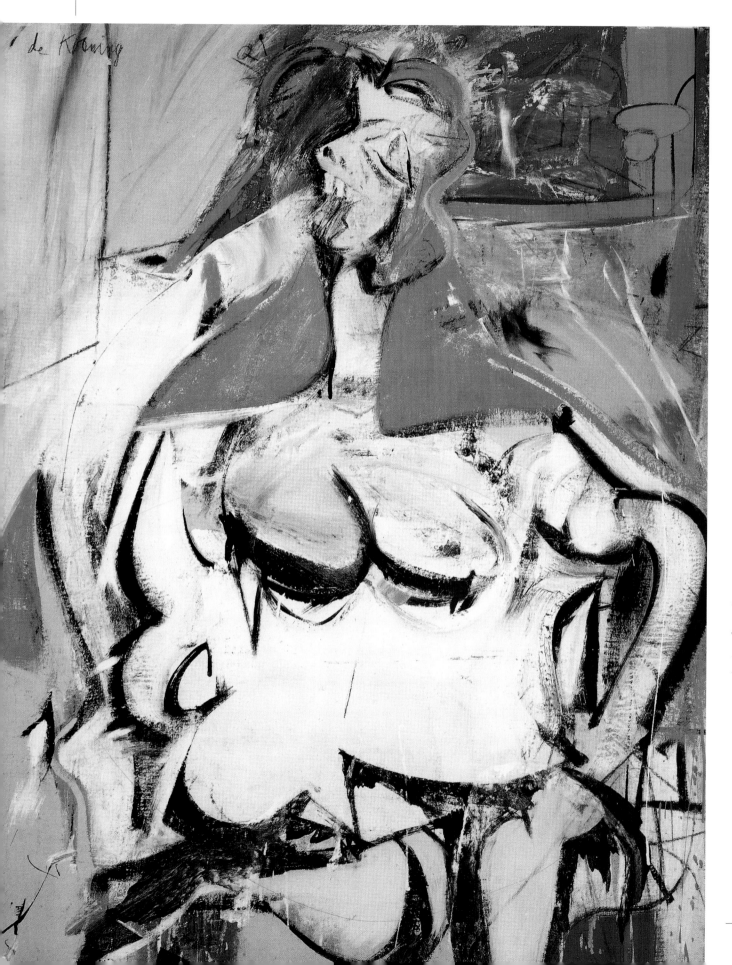

Willem de Kooning
Woman, 1950

Courtesy of Private Collection/Christie's Images/
© Willem de Kooning Revocable Trust/ARS,
New York and DACS, London 2002

Born in the Netherlands, Willem de Kooning
was apprenticed to a firm of commercial
artists at the tender age of 12 but shortly after
receiving his diploma from the Rotterdam
Academy of Fine Arts in 1925 he emigrated
to the United States and settled in New York,
where he worked as a house painter and
commercial artist. From the early 1930s he
shared a studio with Arshile Gorky and made
painting a full-time career from about 1936.
Through Gorky he was introduced to
Surrealism, reflected in the predominantly
black and white paintings of his early period.
In the immediate postwar period, under the
influence of Adolph Gottlieb, he turned to
colour and painted female figures, tending
towards Abstract Expressionism. He became
one of the foremost exponents of this
movement, especially as expressed in his
action paintings. In the last years of his
long life, however, he turned to modelling
figures in clay.

Movement Abstract Expressionism
Other Works *The Visit; Marilyn Monroe*
Influences Arshile Gorky, Adolph Gottlieb
Willem de Kooning *Born* 1904 Holland
Painted in New York, USA
Died 1997 New York

Henri Matisse

The Snail, 1953

A French painter, printmaker and designer, Henri Matisse was the dominant figure in the Fauvist movement. Initially a lawyer's clerk, Matisse turned to art in 1890. His first teacher, Bouguereau, was a disappointment, but he learned a great deal from his second master, Gustave Moreau, a Symbolist painter with a taste for exotic colouring. Matisse's early works were mainly Impressionist or Neo-Impressionist in character but, after painting trips to the Mediterranean, he began to employ more vivid colours, using them to create an emotional impact rather than simply to transcribe nature. After years of failure, Matisse and his friends made their breakthrough at the Salon d'Automne of 1905. Critics were overwhelmed by the dazzling canvasses on display and dubbed the group *Les Fauves* ('The wild beasts'). Matisse continued to find his greatest inspiration from painting on the Riviera, but he also travelled widely, visiting Morocco, America and Spain. He decorated a chapel in Vence in southern France and experimented with 'cut-outs' (pictures formed from coloured paper shapes, rather than paint).

Movement Fauvism
Other Works *The Dance; Luxe; Calme et Volupte; The Blue Window*
Influences Paul Signac, Henri Edmond Cross, Gustave Moreau, Paul Cézanne
Henri Matisse *Born* 1869 France *Painted in* France and Morocco *Died* 1954

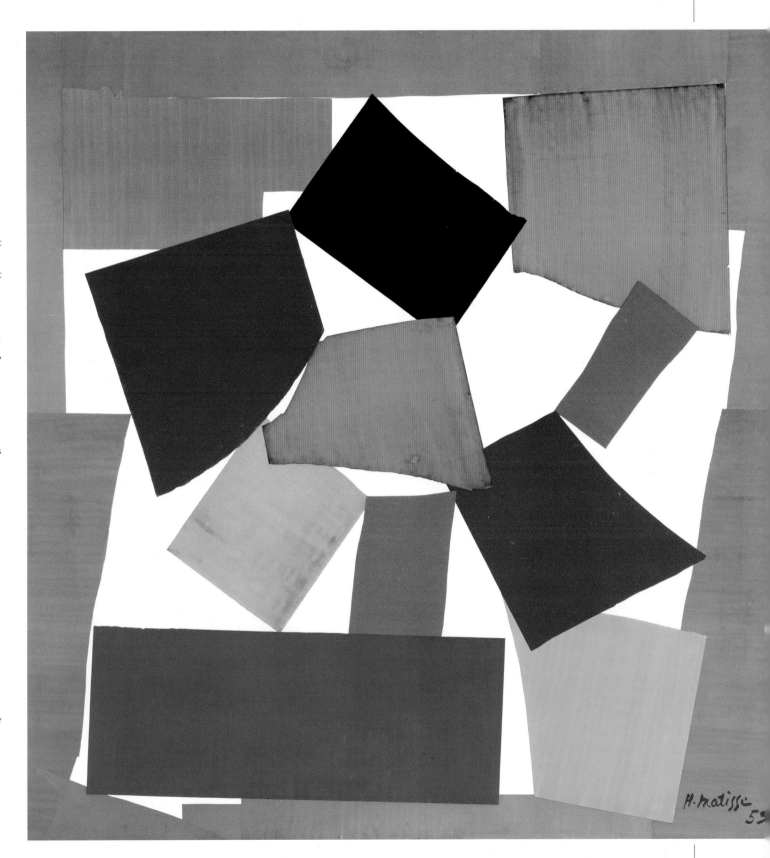

H. Matisse 53

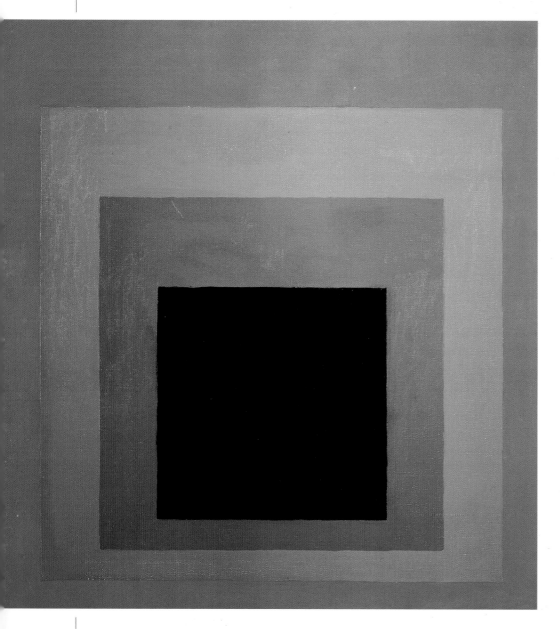

Josef Albers
Homage, 1954

Courtesy of Private Collection/Christie's Images © DACS 2002

Albers trained in the prevailing German academic tradition, at the art schools of Berlin, Essen and Munich. He combined their discipline in draughtsmanship with his own imaginative flair and innovative approach when he continued his studies at the Bauhaus in Weimar, subsequently working as an abstract painter and furniture designer. The advent of the Nazi regime forced him to leave Germany and settle in the United States, where he developed a style that gave free rein to the exploration of colours and their relationship to each other. He held a series of important academic appointments, at the avant-garde Black Mountain College, North Carolina (1933–49) and at Yale University (1950–60). His work became increasingly non-figurative and in the 1950s culminated in purely geometric canvasses, notably in his series entitled *Homage to the Square*. He was also one of the foremost colour theorists of the immediate post-war period, publishing a seminal work on the subject in 1963 which was influential in the subsequent rise of geometric abstract painting.

Movement Abstract Expressionism
Other Works *Skyscrapers; Homage to the Square: Blue Climate; Apparition*
Influences Walter Gropius, Wassily Kandinsky
Josef Albers *Born* 1888 Bottrup, Germany
Painted in Germany, USA. *Died* 1976 New Haven, Connecticut, USA

Francis Bacon
Seated Figure (Red Cardinal), 1960

Courtesy of Private Collection/Christie's Images/© Estate of Francis Bacon 2002. All rights reserved, DACS

Born in Dublin of English parents, Bacon left home at the age of 15, travelling to London, Berlin and Paris. In Paris he visited a Picasso exhibition, which inspired him to paint. In 1929, Bacon settled in London, where he designed Bauhaus-style furnishings and later, during wartime, joined the Civil Defence. His breakthrough as an artist came in 1945, when his *Three Studies for Figures at the Base of a Crucifixion* caused a sensation at the Lefevre Gallery. In this, as in many of his future works, elements of mutilation, pain and claustrophobia combined to create a highly disturbing effect.

From 1946 to 1950, Bacon resided in Monte Carlo, partly to satisfy his passion for gambling. His international reputation growing, he returned to London. His source material was very diverse, ranging from the work of other artists (Velázquez, Van Gogh) to films and photographs (Muybridge, Eisenstein) and autobiographical details. His studies of caged, screaming figures, for example, are often viewed as a reference to his asthma. Bacon's prevailing theme, however, is the vulnerability and solitude of the human condition.

Movement School of London
Other Works *Sleeping Figure; Man with Dog*
Influences Pablo Picasso, Diego Velázquez, Mathis Grünewald, Eadweard Muybridge
Francis Bacon . *Born* 1909 Dublin
Painted in Britain, France and South Africa. *Died* 1992

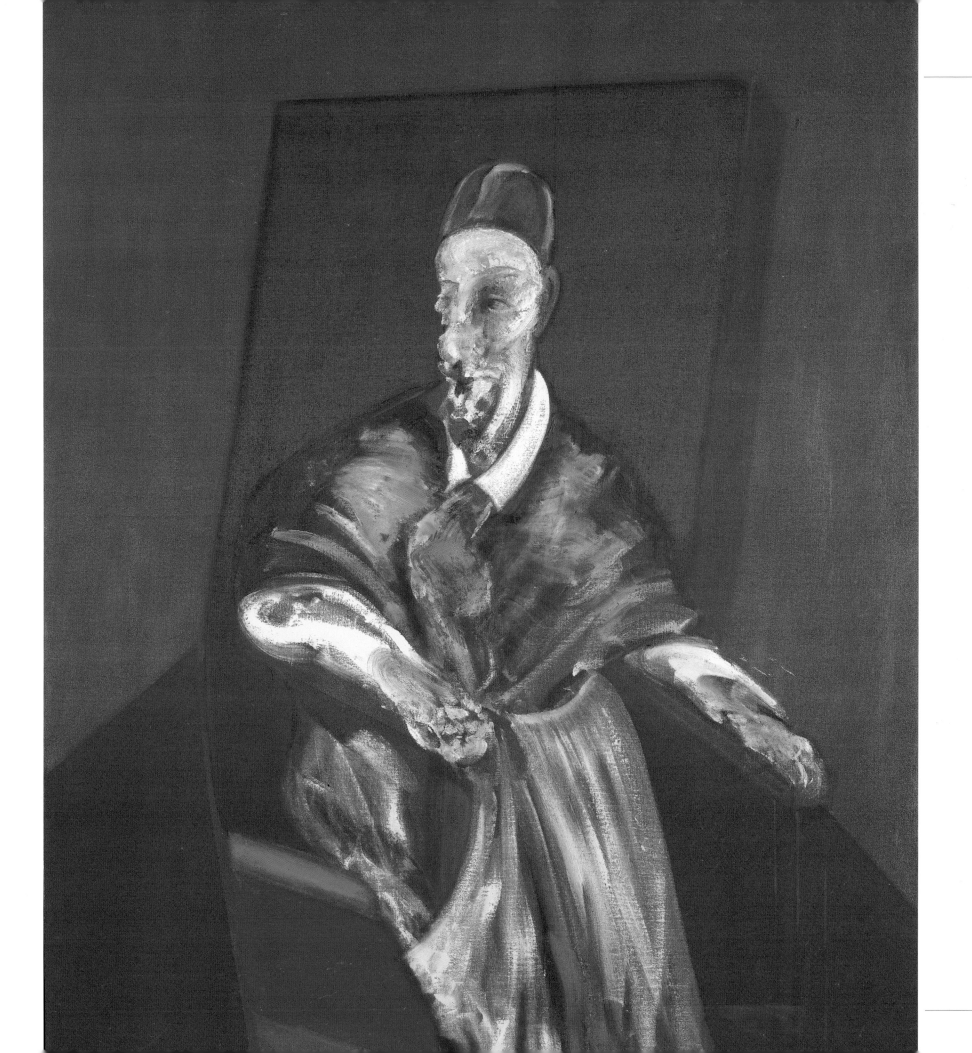

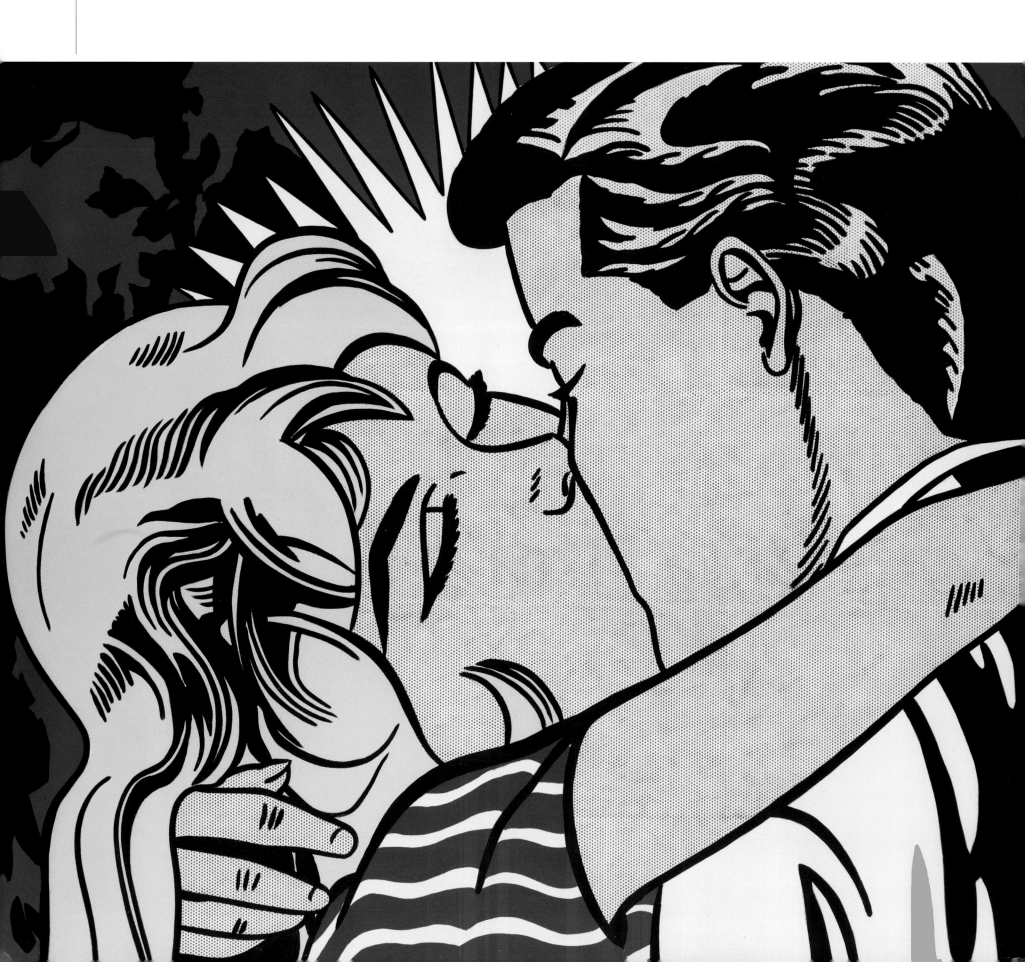

Roy Lichtenstein
Kiss II

Courtesy of Private Collection/Christie's Images/© The Estate of Roy Lichtenstein/DACS 2002

Roy Lichtenstein enrolled at the Art Students' League (1939) and later studied at Ohio State College. After military service (1943–46) he returned to Ohio State as a teacher, and later taught at New York State and Rutgers Universities. He began exhibiting in 1949, his early works inspired by aspects of American history, strongly influenced by Cubism, though later he tended towards Abstract Expressionism. While teaching at Rutgers he met Allan Kaprow, who opened his eyes to the artistic possibilities inherent in consumerism and from about 1960 he developed what later came to be known as Pop Art, in which images are painted in the style of the comic strip. Even the dots of the screening process used in the production of comic books is meticulously reproduced in Lichtenstein's highly stylized paintings.

Movement Pop Art
Other Works *In the Car; M-Maybe; Whaam!*
Influences Allan Kaprow
Roy Lichtenstein *Born* 1923 New York, USA
Painted in USA. *Died* 1997 New York

Sonia Delaunay
Rythme Couleur, 1961

Courtesy of Private Collection/Christie's Images/DACS 2002
© L & M Services B.V. Amsterdam 20020512

Born Sonia Terk Stern at Gradizhsk in the Ukraine, she was raised in St Petersburg and studied art in Karlsruhe, Germany and then, in 1905, attended the Académie de la Palette in Paris. In order to remain in France, in 1909 she contracted a marriage of convenience with the art critic Wilhelm Uhde but it was dissolved after a few months. In 1910 she married the French painter Robert Delaunay (1885–1941) with whom she founded the movement known as Orphism. Together they designed and painted sets and costumes for Diaghilev's Ballets Russes. Robert is chiefly remembered for his endless experiments in colour orchestration, which had a profound effect on abstract art, while Sonia concentrated on Art Deco textile designs. In the interwar period she also evolved a purity of expression using brightly contrasting colours in her paintings, mainly in watercolours, that influenced her textile designs and vice versa.

Movements Orphism, Cubism
Other Works *Girls in Swimming Costumes*
Influences Robert Delaunay, Wassily Kandinsky
Sonia Delaunay *Born* 1885 Gradizhsk, Ukraine
Painted in France. *Died* 1979 Paris, France

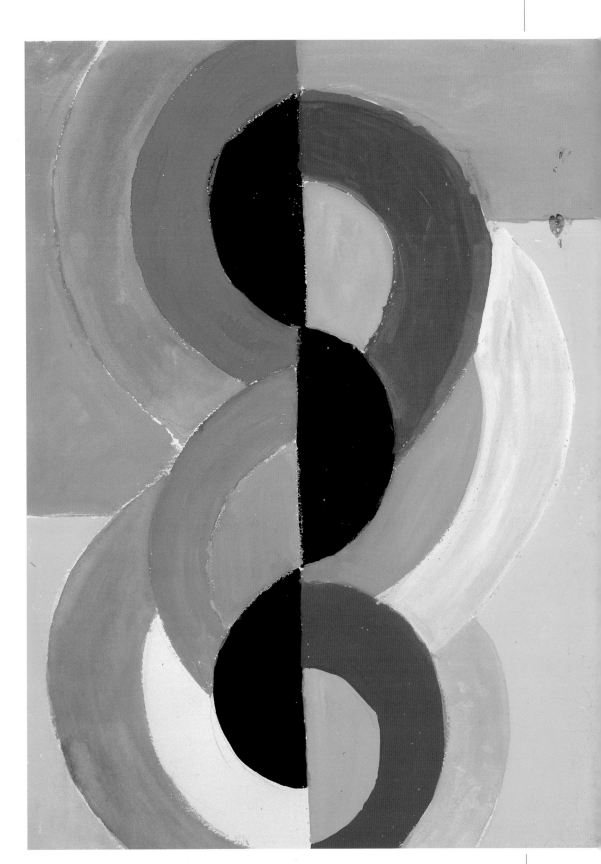

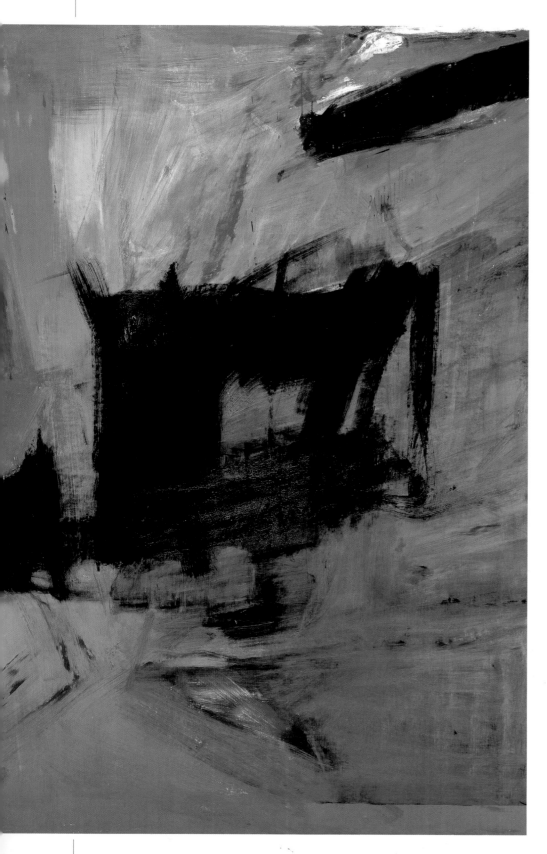

Franz Kline
Scudera, 1961

Courtesy of Private Collection/Christie's Images/© ARS, NY and DACS, London 2002

Until 1939 the centre of the avant-garde art world was Paris, but with the outbreak of World War II this shifted to New York, where many European painters fled from Nazi-occupied Europe. This influx of new ideas coincided with the project under Roosevelt's New Deal program of commissioning otherwise unemployed artists in the Depression period to paint large murals. Out of these factors emerged Abstract Expressionism, which may be defined as a style of painting in which the artist strove to express feelings and attitudes through non-representational means. Whether as refugees from persecution or as a result of hardship or social injustice, there was also a strong social message. The movement was divided between the Gesture Painters, such as Jackson Pollock and Franz Kline, and the Colour Field Painters led by Clyfford Still and Mark Rothko.

Movement Abstract Expressionism
Other Works *Woton; Le Gros*
Influences Jackson Pollock, Willem de Kooning
Franz Kline *Born* 1910 Pennsylvania, USA
Painted in New York, USA. *Died* 1962 New York, USA

Andy Warhol
Shot Red Marilyn, 1964

Courtesy of Christie's Images/© The Andy Warhol Foundation for the Visual Arts, Inc./ARS, New York and DACS, London 2002

American artist specializing in printmaking and films. Warhol was born in Pittsburgh, the son of Czech immigrants. In 1949 he moved to New York, where he became a successful commercial artist. This gave him a solid grounding in silkscreen printing techniques and taught him the value of self-promotion – both of which were to feature heavily in his art. Warhol's breakthrough came when he began to make paintings of familiar, everyday objects, such as soup cans, dollar bills and Brillo pads. Early examples were hand-painted, but Warhol soon decided to use mechanical processes as far as possible. His aim, in this respect, was to free the image from any connotations of craftsmanship, aesthetics or individuality. He further emphasized this by describing his studio as 'The Factory'.

Warhol rapidly extended his references to popular culture by portraying celebrities (Marilyn Monroe, Marlon Brando), as well as more sinister items, such as news clippings with car crashes or the electric chair. He also associated himself with other branches of the mass media, notably through his links with the rock band The Velvet Underground, and through his controversial films.

Movement Pop Art
Other Works *Campbell's Soup Can; Marilyn Monroe; Brillo*
Influences Roy Lichtenstein, Jasper Johns
Andy Warhol *Born* 1928 Pittsburgh, USA
Painted in USA. *Died* 1987 New York, USA

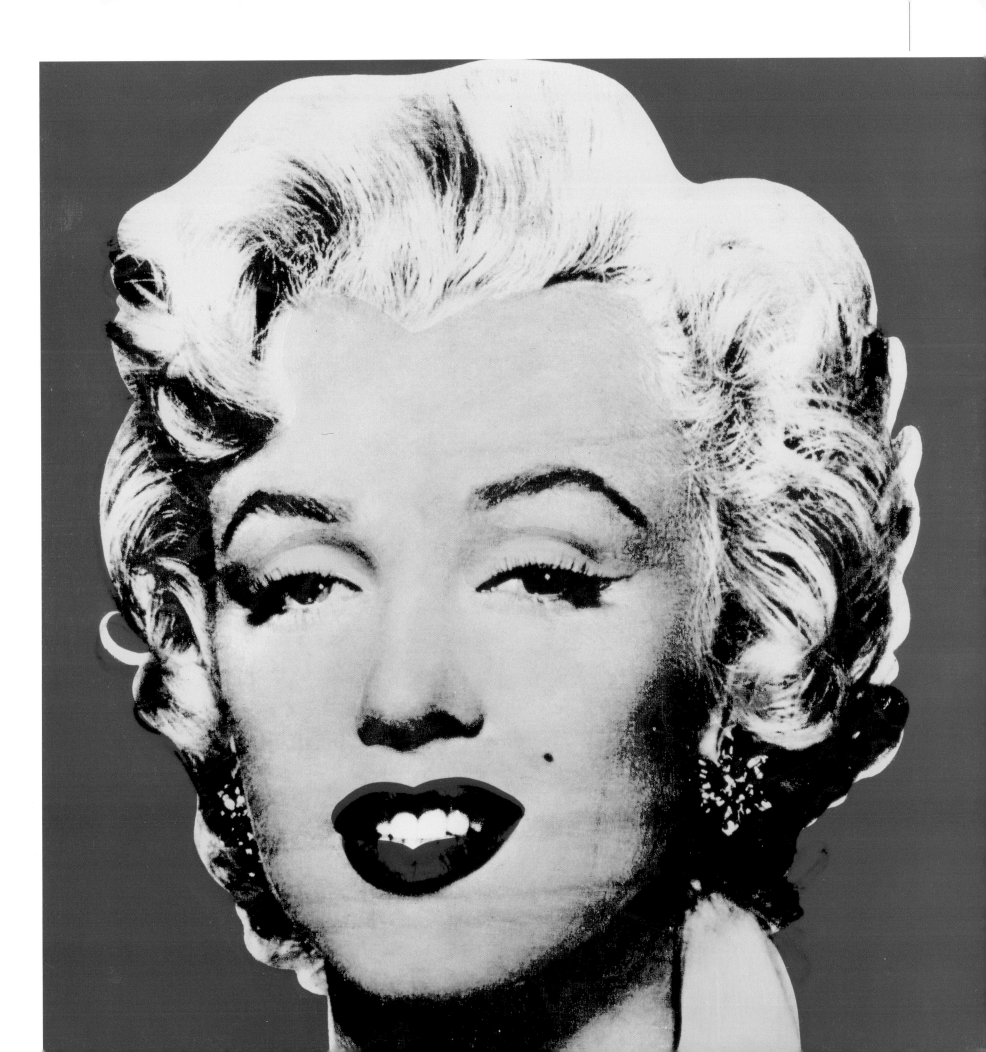

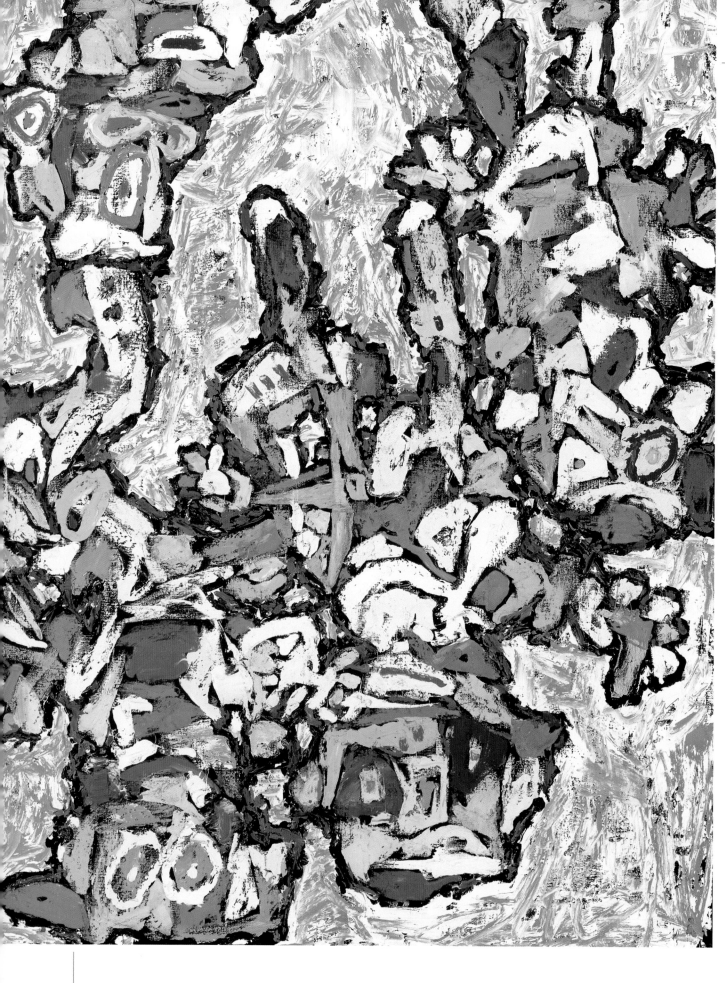

Jean Dubuffet
Cortège, 1965

Jean Dubuffet studied at the Académie
Julien in Paris but, dissatisfied with the styles
in 'new art' then being taught, branched out
on his own and began exploring unusual
materials and the deliberate use of coarse
canvas and paint applied roughly. He
believed that there was more truth in the art
produced by the untrained, the childish or
the psychotic and strove to recreate such
effects. The synthesis of rough materials
with discarded rubbish such as pieces of old
newspapers and broken glass resulted in
what he termed Art Brut (raw art), which
was the antithesis of painterly perfection
and aesthetic sensitivity. By this means
Dubuffet confronted the spectator with the
seamier side of life and nature in the raw.
Though often derided, he exerted a
tremendous influence on the next
generation of artists and anticipated the
Pop Art and neo-Dadaism of the 1960s.

Movement Abstract Expressionism
Other Works *Man with a Hod;
Villa sur la Route; Jazz Band*
Influences Antoni Tapiès, Alberto
Giacometti
Jean Dubuffet
Born 1901 Le Havre, France
Painted in France
Died 1985 Paris, France

Marc Chagall

Le Repos, 1967–8

Courtesy of Private Collection/Christie's Images/
© ADAGP, Paris and DACS, London 2002

Born into an Orthodox Jewish family in
what was then known as Russian Poland,
Marc Chagall studied in St Petersburg and
Paris and returned to his native city on the
eve of World War I. Initially he worked as a
sign-writer but on his return to Russia he
joined the Knave of Diamonds group and
participated in their 1917 exhibition, which
was intended as an attack on the stuffy
classicism of the Moscow School of Art.
The Revolution broke out shortly
afterwards and Chagall was appointed
Director of the Vitebsk Art School before
being summoned to Moscow to design sets
for the Jewish Theatre. He left Russia in
1922 and settled near Paris. On the
outbreak of World War II he moved to the
USA where he designed sets and costumes
for the ballet, as well as illustrating books
and producing stained-glass windows,
notably for the UN Building in New York
and the Hadassah Hospital in Jerusalem.
He also painted the murals for the Knesset
(Israeli parliament). His paintings combine
fantasy, folklore and biblical themes with
an intensely surreal quality. Indeed, it is
claimed that Guillaume Apollinaire
originally coined the term 'Surrealist' to
describe Chagall's paintings.

Movement Surrealism
Other Works *Above the Town;*
I and the Village
Influences Gauguin, The Fauves
Marc Chagall *Born* 1887 Vitebsk, Russia
Painted in Russia, France and USA
Died 1985 Saint Paul-de-Vence, France

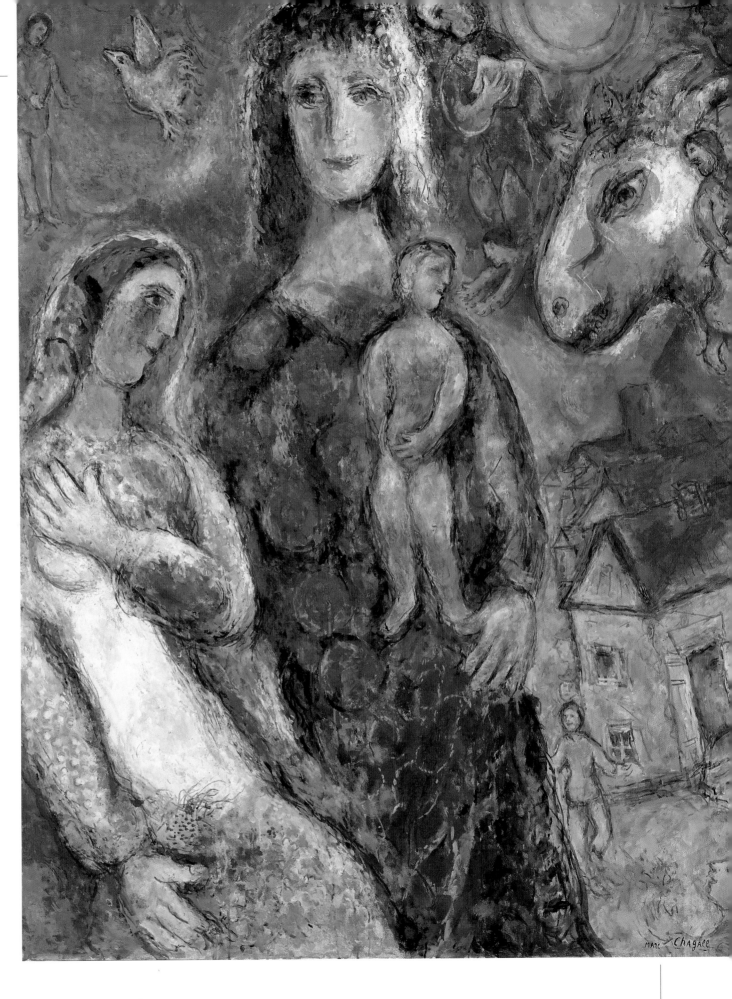

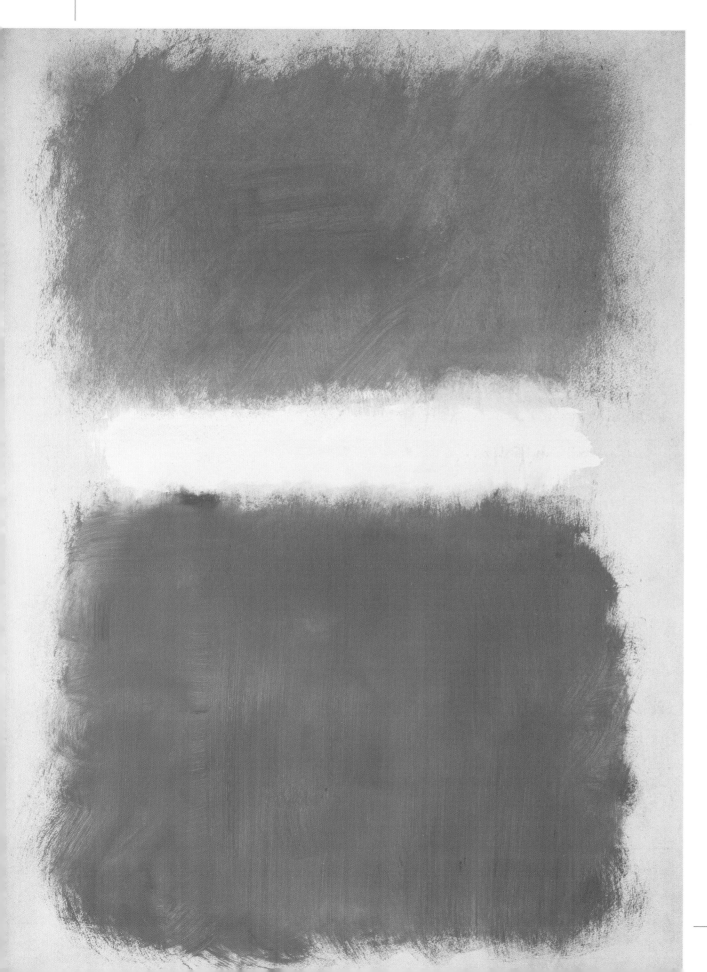

Mark Rothko
Untitled, 1968

Courtesy of Private Collection/Christie's Images/
© Kate Rothko Prizel and Christopher Rothko/DACS 2002

Born Marcus Rothkovitch in Dvinsk, Russia,
Rothko emigrated to the US in 1913. He studied
briefly at Yale and in New York, although he
considered this to have had little influence on his
painting. Rothko's style took many years to evolve.
His early figurative works included portraits and
psychologically-infused urban scenes, which he
exhibited with the American expressionist group,
The Ten. Rothko embraced ancient myth as he
moved into a surrealist phase in the late 1930s,
drawing on them as subjects for his increasingly
abstract works. By 1946, he moved into pure
abstraction, painting amorphous shapes, or
'Multiforms', that would coalesce into his familiar
rectangles on fields of colour by 1949. Although
the works were formally quite simple, Rothko
executed them with a meticulous eye for colour,
balance and brushwork that give them a dramatic
presence beyond their initial appearance. He was
pleased that viewers often found looking at his
paintings a deeply emotional experience. While he
maintained the essential elements of his signature
style, Rothko's paintings became generally larger,
darker and more meditative in the last dozen
years of his life.

Movements Abstract Expressionism,
Colour Field Painting
Other Works *Central Green; Blue; Orange;
Red; Number 118*
Influences Henri Matisse, Arshile Gorky,
Clyfford Still
Mark Rothko *Born* 1903 Drinsk, Russia
Painted in New York, USA
Died 1970 New York

David Hockney

Sun from The Weather Series, 1973

Courtesy of Christie's Images © David Hockney/Gemini G. E. L

British painter, photographer and designer Hockney was born in Bradford, Yorkshire and trained at the Royal College of Art. There, his fellow students included Allen Jones, Derek Boshier and R. B. Kitaj, and together they all exhibited at the Young Contemporaries exhibition of 1961, a landmark show which marked the arrival of British Pop Art. Hockney himself denies belonging to this movement, even though his early work contained many references to popular culture. Instead, his style may be better defined as New Figuration – a blanket term, relating to the revival of figurative art in the 1960s.

Hockney has travelled widely in Europe, but his main passion has been for the United States, especially Los Angeles where he settled in 1976. Throughout his career, autobiographical subjects have featured heavily in his paintings, ranging from friends, such as the Clarks and lovers sunbathing by swimming pools, to an entire book of pictures devoted to his dogs. Hockney has also been a prolific stage designer, creating sets and costumes for *The Rake's Progress, The Magic Flute* and *Parade*. In recent years, he has also experimented with photo-work, producing elaborate 'photocollages' from hundreds of photographic prints.

Movement Pop Art, New Figuration
Other Works *A Bigger Splash;*
Mr and Mrs Clark and Percy; Influences
influences Pablo Picasso, Henri Matisse,
Jean Dubuffet
David Hockney *Born* 1937 Bradford,
Yorkshire, England
Painted in Britain, USA and France

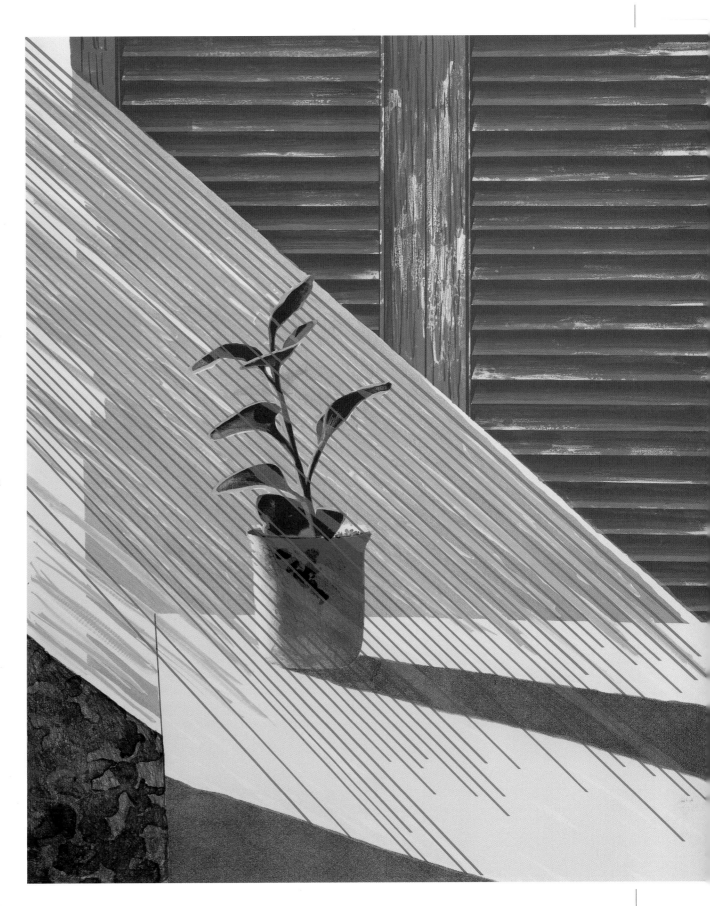

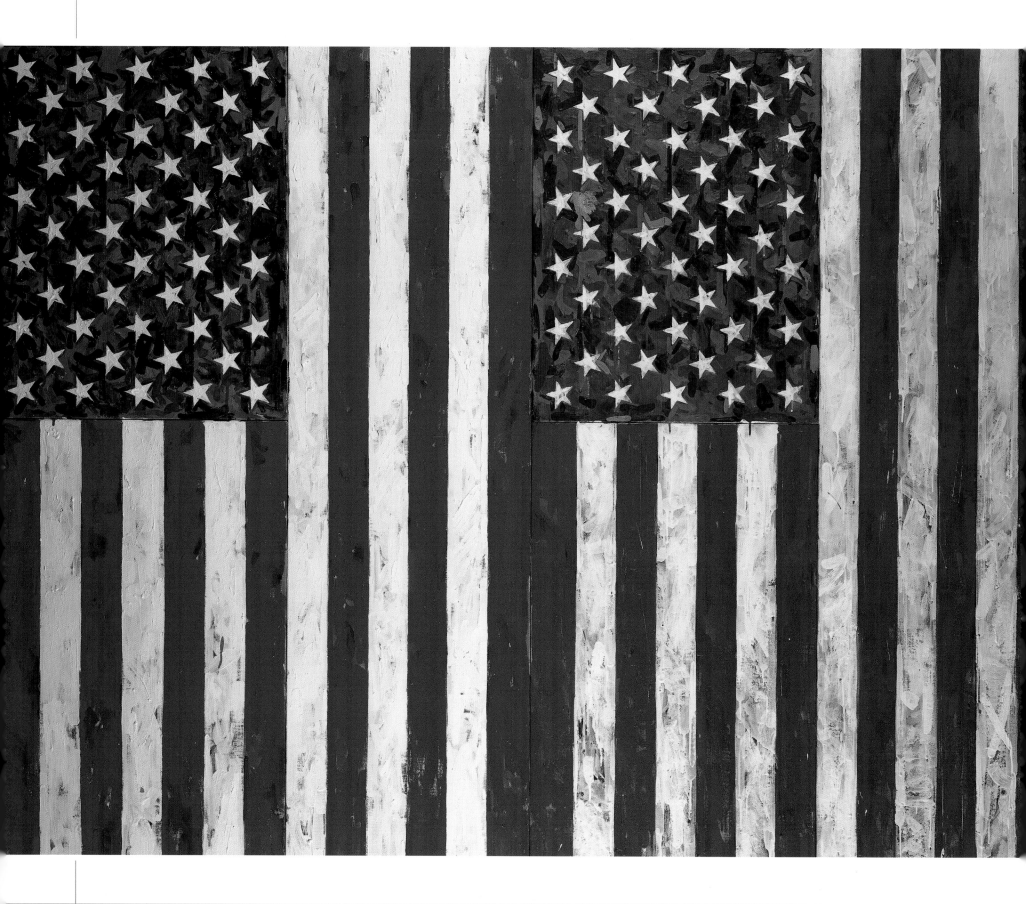

Jasper Johns
Flags, 1973

Courtesy of Private Collection/Christie's Images © Jasper Johns/VAGA, New York/DACS, London 2002

Jasper Johns studied at the University of South Carolina, Columbia. In 1952 he settled in New York City and there he met Robert Rauschenberg, who shared his views on the brash banality of contemporary culture, which they exploited in the development of Pop Art. By taking the familiar, the mundane and everyday icons such as the Stars and Stripes and the numerals on football jerseys he created works of art that put them in an entirely new light. The influence of Dada is evident as he deliberately set himself against the tenets of conventional art. Thus, originality is eschewed by taking previously existing and immediately recognizable objects and emphasizing their very ordinariness. Johns is a versatile artist, working in oils, encaustic, plaster and other materials in various media.

Movement Pop Art
Other Works *Device; Zero Through Nine; Zone*
Influences Marcel Duchamp
Jasper Johns *Born* 1930 Augusta, Georgia, USA. *Paints in* New York

Joan Miró
Personnages, Oiseaux, Étoiles, 1974–6

Courtesy of Private Collection/Christie's Images © ADAGP, Paris and DACS, London 2002

A Spanish painter, ceramist and graphic artist; Joan Miró was a key member of the Surrealists and trained under Francisco Galì. His early work showed traces of Fauvism and Cubism, but his first one-man show was a disaster. Undeterred, Miró decided to travel to Paris, the acknowledged home of the avant-garde. There, he contacted Picasso, who introduced him to the most radical artists and poets of the day. These included the blossoming Surrealist group, which Miró joined in 1924.

Miró was fascinated by the challenge of using art as a channel to the subconscious and, from the mid-1920s, he began to fill his canvasses with biomorphic, semi-abstract forms. Nevertheless, he felt suspicious of some of the more outlandish, Surrealist doctrines and remained at the fringes of the group. He moved to France during the Spanish Civil War, producing patriotic material for the struggle against Franco, but was obliged to return south in 1940 after the Nazi invasion. By this stage, Miró's work was much in demand, particularly in the US, where he received commissions for large-scale murals. Increasingly, these featured ceramic elements, which played a growing part in the artist's later style.

Movement Surrealism
Other Works *Dog Barking at the Moon; Aidez l'Espagne*
Influences Pablo Picasso, Hans Arp, Paul Klee
Joan Miró *Born* 1893 Barcelona, Spain
Painted in Spain, France, USA and Holland
Died 1983 Palma de Mallorca, Spain

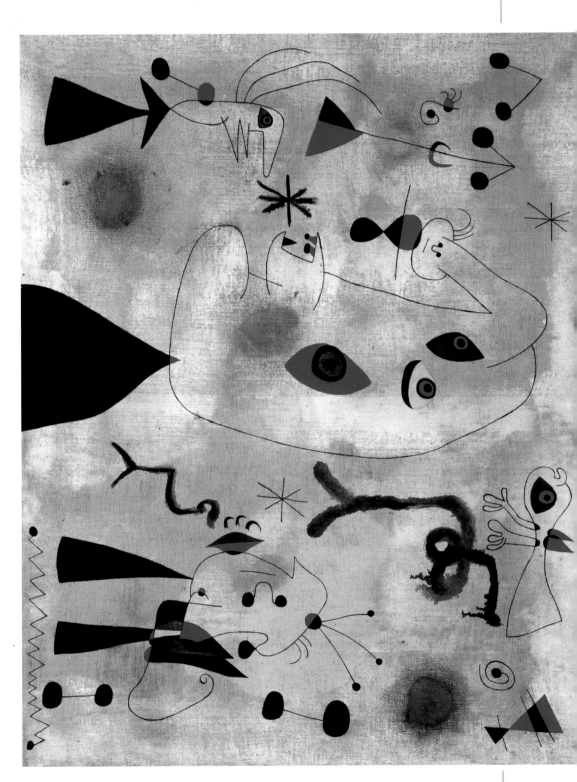

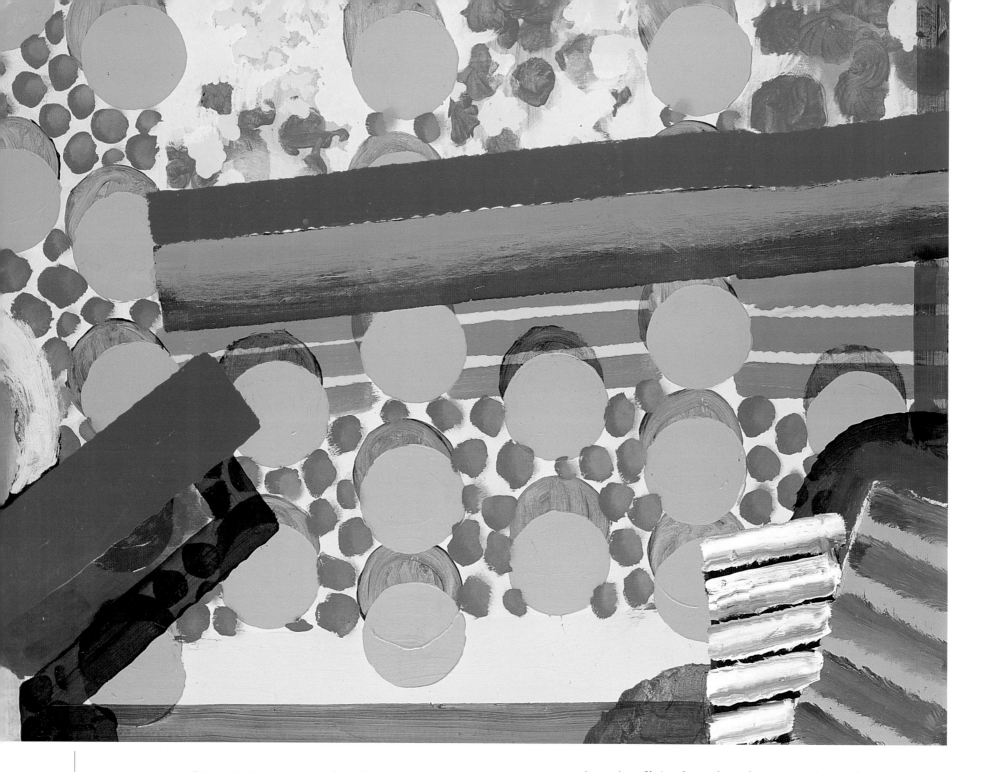

Sir Howard Hodgkin
Dinner at the Grand Palais, 1975

Courtesy of Private Collection/Christie's Images

Howard Hodgkin studied at the Camberwell School of Art in London and then Bath Academy of Art, where he later taught (1956–66). Although his painting does not fit neatly into any particular movement he was influenced by William Scott, his teacher at Bath, to regard painting as a physical object. An early but lifelong attraction to the Mughal art of India is also evident in the range of brilliant, contrasting colour. His paintings have a superficial impression of being abstract, but a closer examination reveals that they are truly representational, mostly of interiors or encounters, with figures caught in a split second. These qualities are evoked strongly in his masterpiece *Dinner at Smith Square*, painted in oil on wood between 1975 and 1979, now in the Tate Gallery. He was awarded the Turner Prize for contemporary British art in 1985 and was knighted in 1992.

Movement Modern English
Other Works *Lovers; Menswear; Interior at Oakwood Court*
Influences William Scott, Mughal art
Sir Howard Hodgkin *Born* 1932 London, England
Paints in London

Gilbert and George

Helping Hands, 1982

Courtesy of Private Collection/Christie's Images

Italian-born Gilbert Proesch first met George Pasmore when they were both students at St Martin's School of Art in London and have worked together since graduating in 1969. George had previously studied at Dartington Hall and the Oxford School of Art, while Gilbert had attended the Academy of Art in Munich. Since the late 1960s they have worked as performance artists, principally as living sculptures, their faces and hands covered with gold paint and holding the same pose for hours on end. Subsequently they developed two-dimensional art, often comprising a series of framed photographs which are integrated to form a single entity. Their very conservative images in these collaborative works often clash with the subject matter, in which bodily functions and overt references to homosexuality feature prominently. Controversy surrounds their work, which is often seen as promoting rather than condemning fascist or racist attitudes, although they claim to be attempting to define the 'new morality'.

Movement Modern British School
Other Works *Fear; Flying Shit; England; The Nature of Our Looking*
Influences Op Art, Performance Art
Gilbert Proesch *Born* 1942 Dolomites, Italy
Worked in Italy, Germany and England
George Pasmore *Born* 1943 Devon, England
Paints in England

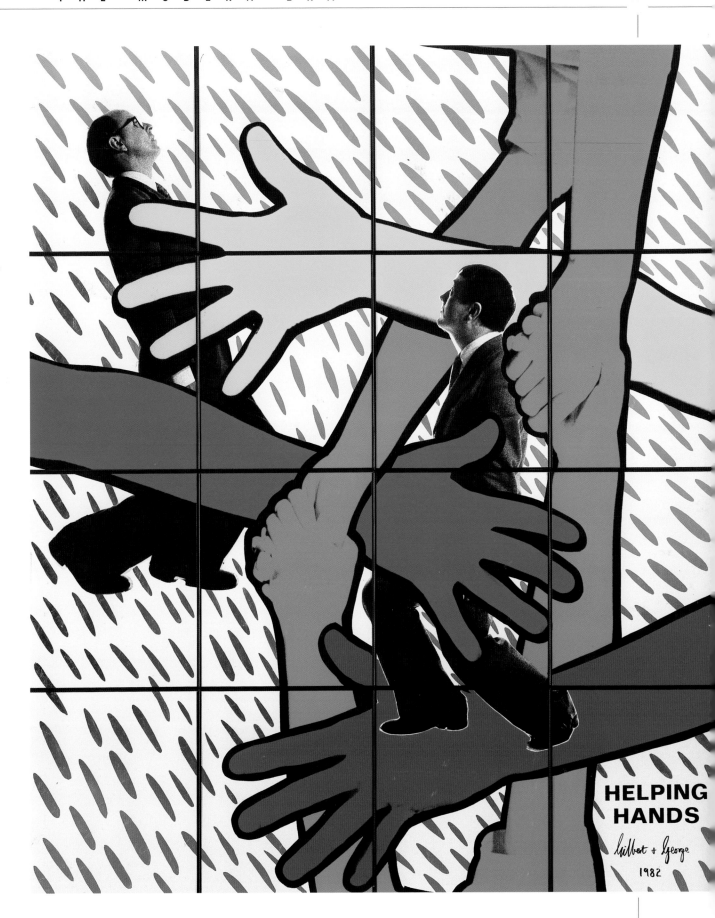

HELPING
HANDS

Gilbert + George

1982

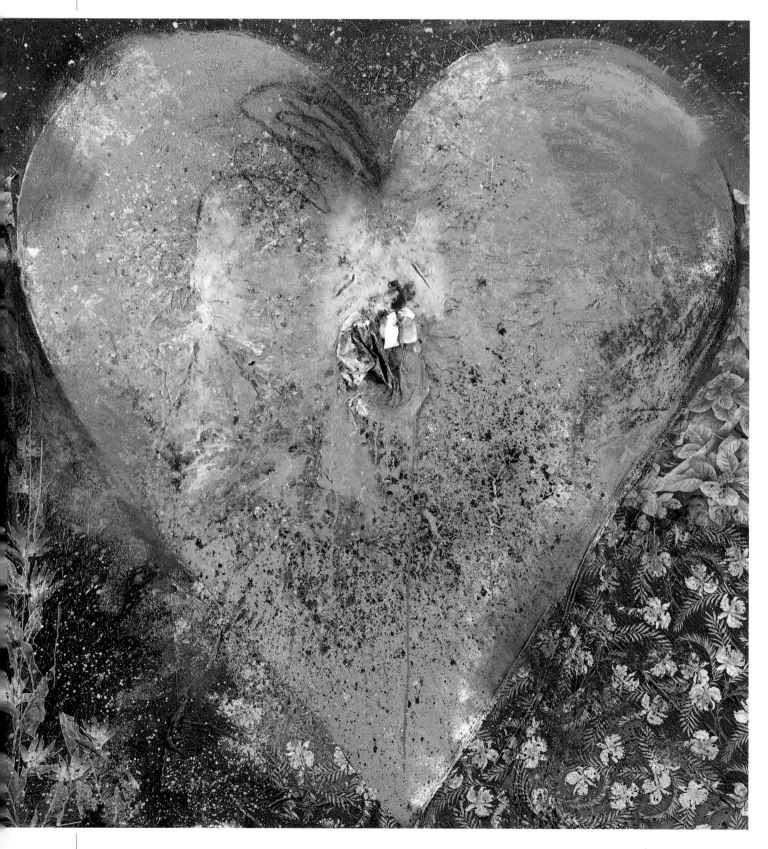

Jim Dine
The Heart called 'Rancho Pastel', 1982

Courtesy of Private Collection/Christie's Images/© ARS, NY and DACS, London 2002

Trained at the University of Cincinatti, the Boston Museum of Fine Arts and the University of Ohio, Jim Dine was one of the foremost exponents of Pop Art. He held his first exhibition of objects as images in 1959, alongside Claes Oldenburg, with whom he subsequently collaborated on a number of projects. Like the Dadaists, he believed in the combination of many different media and the use of ready-made objects or fragments of them in creating his compositions. Taking this process to its logical conclusion, in the late 1950s he began organizing a series of 'happenings' – live performances which combined his art with his experience of life. These, in effect, were the forerunners of the Performance Art that came to fruition a few years later. In more recent years, however, Dine has returned to a more representational and figurative style of painting. He has combined oils with collage, or etching and painting on hand-coloured paper.

Movement Performance Art, Pop Art
Other Works *The Toaster; Wiring the Unfinished Bathroom*
Influences Dada, Surrealism, Abstract Expressionism
Jim Dine *Born* 1935 Cincinatti, Ohio, USA
Paints in Cincinatti, Boston and New York

Chuck Close
Cindy II, 1988

Chuck Close studied art at Yale from
1962 to 1964 and settled in New
York City in 1967. In that year,
influenced by the photographic self-
portraits produced by Claude Cahun
in the 1920s, he began painting
photographs of portraits, meticulously
reproducing the tiniest detail. Every
line and wrinkle, every pore and
individual strands of hair are carefully
delineated. In fact, appearances can
be deceptive; closer examination
often reveals slight distortion or
blurring around the ears or shoulders
in order to convey the impression
that the face is looming towards the
viewer. In this way the artist remedies
the shortcomings of the camera lens.
In more recent years he has taken
this a stage further, combining this
photo-realism with such techniques
as finger-painting, a microscopic
stippled effect and collages.

Movement Hyper-realism
Other Works *John*
Influences Claude Cahun
Chuck Close *Born* 1940 Monroe,
Washington State, USA
Paints in New York

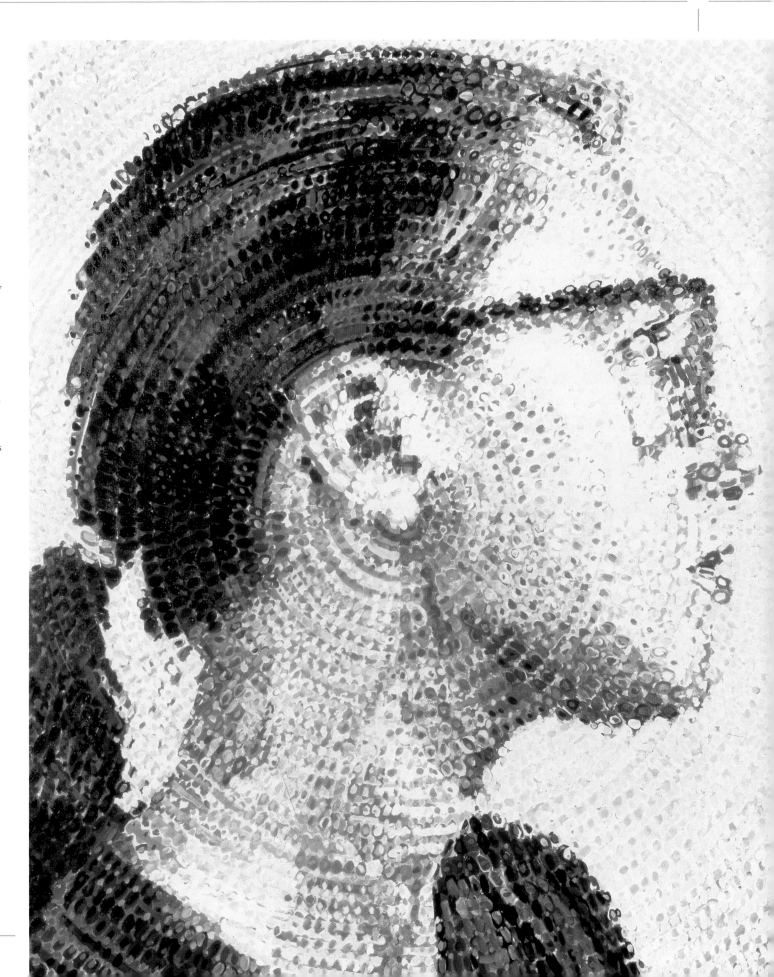

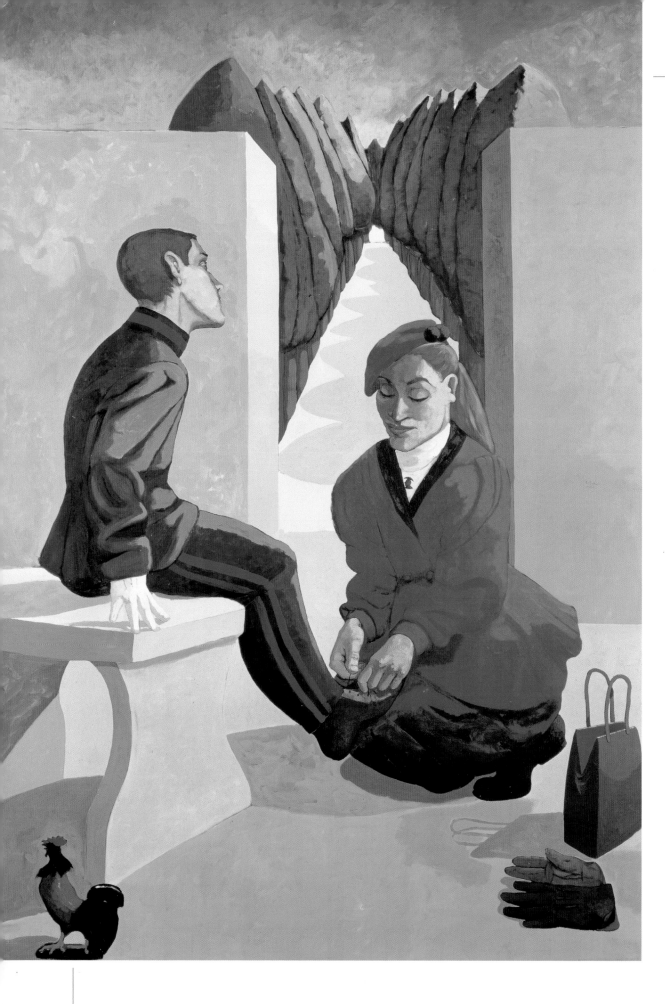

Paula Rego
The Cadet and his Sister, 1988

Courtesy of Private Collection/Bridgeman Art Library/© The Artist

Rego was born in Lisbon, but her father worked for Marconi in Essex and she was educated at an English school. In 1952, she entered the Slade School of Art, where she trained under Coldstream. There she met Victor Willing, a fellow painter, who became her husband in 1959. They lived in Portugal until 1963, after which they resided principally in England.

Rego's early work was strongly influenced by Dubuffet. She also produced semi-abstract collages, sometimes with political overtones. Increasingly, though, she turned to figurative painting, drawing much of her inspiration from children's illustration, nursery rhymes and her own memories of childhood. In mature works, such as *The Maids*, these playful elements are transposed into unsettling contexts, hinting at games of a very sinister kind. Rego's paintings have brought her success, both in Portugal and the UK. She has twice represented her native land at the Bienal in São Paolo, and on one occasion for Britain. In 1990, she became the first Associate Artist of the National Gallery in London.

Movement Symbolist Figuration
Other Works *Crivelli's Garden; The Policeman's Daughter*
Influences Jean Dubuffet, Pablo Picasso, Walt Disney, James Gillray
Paula Rego *Born* 1935 Lisbon, Portugal
Paints in Britain and Portugal

Lucian Freud
Annabel, 1990

Courtesy of Private Collection/Christie's Images/
© Lucian Freud

A naturalized British painter, Lucian Freud is a leading member of the School of London. Freud was born in Berlin, the grandson of the famous psychoanalyst Sigmund Freud. As a Jewish family living in the shadow of Nazism, the Freuds left Germany in the 1930s, settling in London. Lucian joined the Merchant Navy, becoming an artist after he was invalided out of the service in 1942. He trained under Cedric Morris, and the hallucinatory realism of his early style hints at an admiration for Surrealism and Neue Sachlichkeit. His greatest influence, however, was Ingres. Freud emulated the meticulous draughtsmanship of the Frenchman, apparently attempting to depict every strand of hair on his sitters. His virtuoso skill was recognized when in 1951, his remarkable *Interior at Paddington* won a prize at the Festival of Britain.

Freud's style changed in the late 1950s, when he replaced his fine sable brushes with stiffer, hog-hair ones which led to a more painterly approach, in which the artist conveyed his flesh-tones through thicker slabs of colour. Freud's favourite subject matter has been the 'naked portrait': starkly realistic nudes, devoid of any picturesque or idealizing elements.

Movement Realism, School of London
Other Works *Hotel Bedroom; Francis Bacon*
Influences Cedric Morris, Jean-Auguste-Dominique Ingres, George Grosz
Lucian Freud *Born* 1922 Berlin, Germany
Paints in Britain

Bridget Riley
Close By, 1992

Bridget Riley studied at Goldsmiths College of Art
(1949–52) and the Royal College of Art (1952–55) in
London. She had her first one-woman exhibition at Gallery
One, London, in 1962 and has had many other shows all
over the world in subsequent years. Influenced by the
Futurists Giacomo Balla and Umberto Boccioni, she began
to develop an optical style in the 1960s – now known as Op
Art – in which hallucinatory images were created in black
and white, in geometric or curvilinear patterns endlessly
repeated to produce the illusion of rippling or undulating
movement. By 1966 she had moved into colour, which
enabled her to widen the scope of these images
considerably; her colours vary in depth and tone and add
subtlety to the overall pattern. Widely acclaimed in
England, she made an impact on the international scene in
1968 when she became the first British artist to win the
top award for painting at the Venice Biennale.

Movement Op Art
Other Works *Cataract I; In Attendance; Fission; Fall*
Influences Giacomo Balla, Umberto Boccioni,
Joseph Albers
Bridget Riley *Born* 1931 London, England
Paints in London

Index

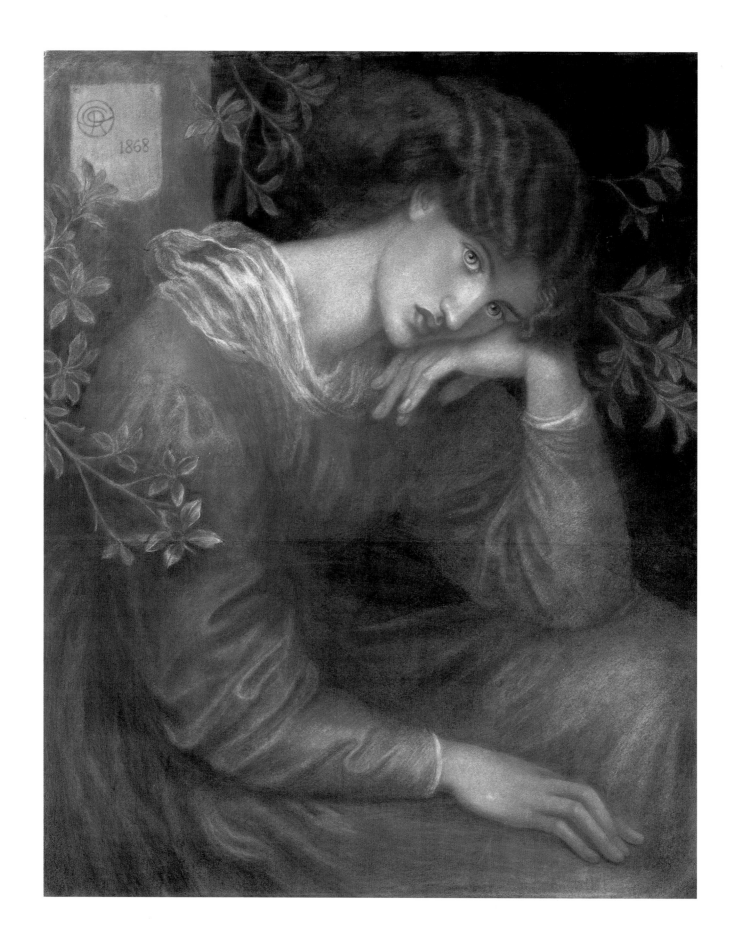